HUNGRY?
NEW YORK CITY

THE LOWDOWN ON

WHERE THE

REAL PEOPLE

EAT!

Edited by Charles Battle

Copyright (c) 2008 by Hungry City Guides
All rights reserved.

Except as permitted under the United States
Copyright Act of 1976, no part of this publication
may be reproduced or distributed in any form or by
any means, or stored in a database or
retrieval system, without the prior written
permission of the publisher.

Printed in the United States of America

First Printing: January, 2008

10 9 8 7 6 5 4 3 2 1

Library of Congress Cataloging-in-Publication Data
Hungry? New York City:
The Lowdown on Where the Real People Eat!
by Hungry City Guides
256 pages
ISBN 13: 978-1-893329-39-3
I. Title II. Food Guides III. Travel IV New York City

Production by Bonnie Yoon Design

Visit our Web site at www.HungryCityGuides.com

To order this Hungry? or our other
Hungry City Guides,
or for information on using them as corporate gifts,
e-mail us at Sales@HungryCity.com. or write to:
Hungry City Guides
P.O. Box 86121
Los Angeles, CA 90086

Hungry City Guides are available to the trade
through SCB Distributors:
(800) 729-6423
www.SCBDistributors.com

THANKS A BUNCH...

...to our contributors
Ryan Auer, Charles Battle, Dynasty Blackburn, Tom Brennan, Samantha Charlip, Alexandra Collins, Brian Crandall, Tracey David, Mike Dooly, Jane Elias, Brett Estwanik, Stephanie Hagopian, Marnie Hanel, Graham Harrelson, Mary Higgins, Emily Isovitsch, Alicia Kachmar, Alexa Kurzius, Jessica Lapham, Laura Lee Mattingly, Eddie McNamara, Kashlin Michaels, Sara Popovich, Emily Roberts, Pamela Schultz, Jen Sotham, Mina Stone, Jennifer Treuting, Emily Tsiang, Sarah Turcotte, Jessica Tzerman, Aly Walansky, Camilla Warner, Ben Wieder

...and to the people who helped make it all happen
Mari Florence (the mastermind behind the Hungry? guides), Jennifer Chang, Kaelin Burns, Barbara Jarvik, and Jessica Lapham for taking the book through its final stages, and Stella Subadra at SSP Services and Bonnie Yoon (for their talents in book production).

CONTENTS

Key to the Book ... vi
Map of the Town .. viii
Please Read ... x
Introduction .. xi

Manhattan
 Financial District .. 2
 Downtown East ... 4
 Downtown West ... 23
 East Village .. 35
 Washington Square .. 63
 Sixth Avenue to the Hudson .. 75
 Flatiron/Union Square/Gramercy ... 99
 Midtown East ... 111
 Midtown West .. 125
 Upper East Side ... 135
 Upper West Side .. 140
 The Harlems .. 151

The Bronx
 Yankee Stadium/Bronx Zoo/City Island 160

Queens
 Astoria/Flushing Meadows/Sunnyside/Central Queens 166

Brooklyn
 North Brooklyn .. 184
 Downtown Brooklyn East .. 185
 Downtown Brooklyn West ... 192
 Prospect Park ... 195
 South Brooklyn ... 209

Staten Island ... 215

Glossary .. 221
Alphabetical Index ... 231
Category Index ... 235
About the Contributors .. 241

v

KEY TO THE BOOK

ICONS

Most Popular Menu Items

 Great Breakfast spot　　 *Beer*

 Great Lunch spot　　 *Cocktails*

 Great Dinner spot　　 *Tea*

 Fish or Seafood　　 *Coffee*

 Vegetarian or Vegan-friendly　　 *Wine*

 Desserts/Bakery

Ambience

 It's early and you're hungry　　 *Live Music*

 It's late and you're hungry　　 *Patio or sidewalk dining*

 Sleep is for the weak　　 *In business since 1976 or before*

 Nice places to dine solo　　 *Editor's Pick*

 Get cozy with a date　　 *Food on the run*

 Food Cart　　 *Long Waits*

Cost

HUNGRY?
Cost of the average meal:

$ $5 and under
$$ $9 and under
$$$ $14 and under
$$$$ $15 and over

Payment

Note that most places that take all the plastic we've listed also take Diner's Club, Carte Blanche and the like. And if it says cash only, be prepared.

- Visa
- MasterCard
- American Express
- Discover

Tipping Guide

If you can't afford to tip, you can't afford to eat. Remember, if the food is brought to your table, you should probably leave a some sort of tip. Here's a guide to help you out:

Cost of Meal	Scrooge <15%	17.5%	Hungry? 20%	Hungry! 25%	22.5%	27.5%	Sinatra >40%
$ 15	<2.25	2.63	3	3.75	3.38	4.125	>6
$ 25	<3.75	4.38	5	5.62	5.62	6.88	>10
$ 35	<5.25	6.13	7	8.75	7.88	9.63	>14
$ 45	<6.75	7.88	9	11.25	10.12	12.38	>18
$ 55	<8.25	9.63	11	13.75	12.38	15.12	>22
$ 65	<9.75	11.38	13	16.25	14.62	17.88	>26

MAP O' THE TOWN

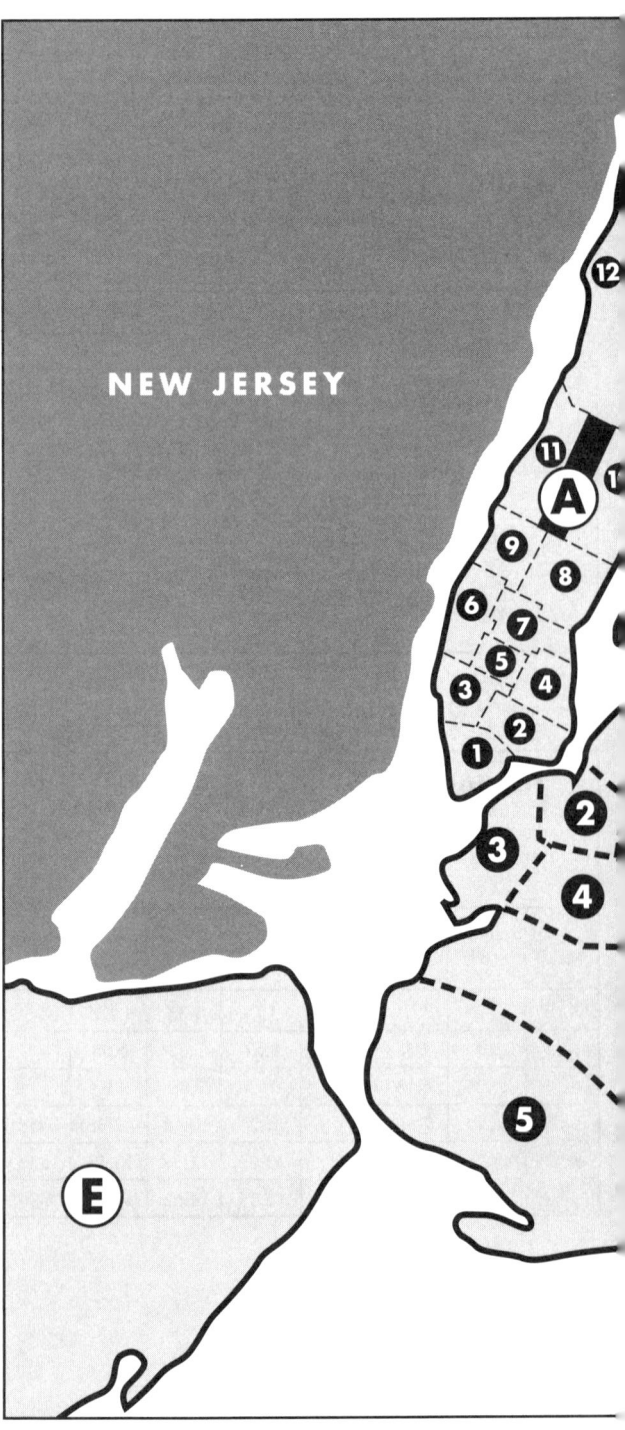

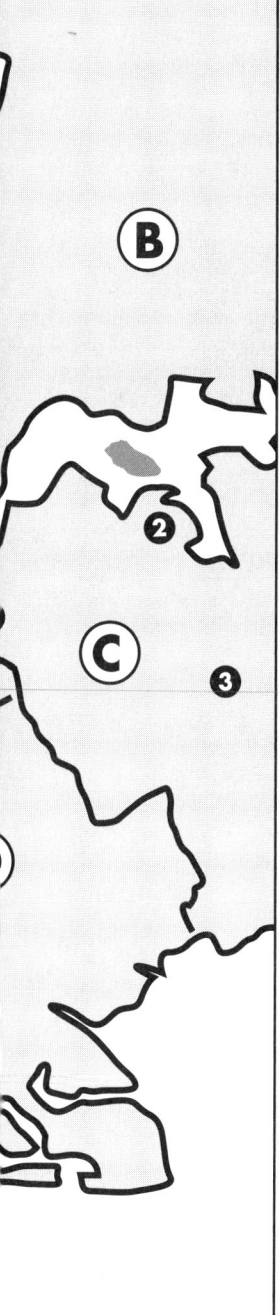

Ⓐ MANHATTAN
1- Financial District
2- Downtown East
3- Downtown West
4- East Village
5- Washington Square
6- Sixth Ave. to the Hudson
7- Flatiron/Union Square/Grammercy
8- Midtown East
9- Midtown West
10- Upper East Side
11- Upper West Side
12- The Harlems

Ⓑ BRONX
Yankee Stadium/Bronx Zoo/City Island

Ⓒ QUEENS
1- Astoria/Flushing Meadows/Sunnyside/Central Queens
2- Ride the 7
3- Central Queens

Ⓓ BROOKLYN
1- North Brooklyn
2- Downtown Brooklyn East
3- Downtown Brooklyn West
4- Prospect Park
5- South Brooklyn

Ⓔ STATEN ISLAND

PLEASE READ

Disclaimer #1
The only sure thing in life is change. We've tried to be as up-to-date as possible, but places change owners, hours and menus as often as they open up a new location or go out of business. Call ahead so you don't end up wasting time crossing town and arrive after closing time.

Disclaimer #2
Every place in this guide is recommended, for something. We have tried to be honest about our experiences of each place, and sometimes jab or two makes its way into the mix. If your favorite spot is slammed for something you think is unfair, it's just one person's opinion! And remember, under the Fair Use Doctrine, some statements about the establishments in this book are intended to be humorous as parodies. Whew! Got the legal stuff out of the way.

And wait, there's more!
While we list hundreds of eateries in the book, that's just the beginning of the copious eating and drinking opportunities in New York City. Visit HungryCityGuides.com for additional reviews, eating itineraries, updates, and all the information you need for your next dining out adventures.

Tip, Tip, Tip.
If you can't afford to tip you can't afford to eat and drink. In the United States, most servers make minimum wage or less, and depend on tips to pay the rent. Tip fairly, and not only will you get better service when you come back, but you'll start believing in karma (if you don't already).

Road Trip!
And, next time you hit the road, check the Hungry City Guides to destinations including: Seattle, Las Vegas, Chicago, New Orleans, Boston, Los Angeles, and many, many more!

Don't Drink and Drive.
We shouldn't have to tell you this, but we can't say it enough. Drink responsibly. Don't drive after you've been drinking alcohol, period. If a designated driver is hard to come by, take the bus or call a cab to take you home. Split the costs with your friends to bring the cost down.

Share your secrets.
Know about a place we missed? Willing to divulge your secrets and contribute? Visit our website at www.HungryCityGuides.com and click on "Contact Us". We'll be happy to hear from you!

INTRODUCTION

Why Another Guidebook?

New York. A city where on a single block you might walk by a dimly-lit Irish pub, a kitschy, kid-friendly PB&J shop, a Jamaican jerk chicken stand, a family-owned Italian eatery, a cozy wine bar, and a Chinese-owned-and-operated "Tex-Mex" taqueria (eel quesadilla, anyone?). Each day New Yorkers and visitors to this great city are subjected, at a level beyond that of any other metropolitan area, to what social scientists call the paradox of choice; the more choices we're presented with, the more stultifying the process of choosing becomes. Faced with so many dining options on just one city block, not to mention five boroughs of city blocks, the process of selecting one New York establishment over another can thwart even the most determined would-be patrons. Sure, there are formulas and equations and even a couple of Venn diagrams you could utilize, but that requires time and effort and, hey, you're in New York, there are better things you could be doing (the parks are nice this time of year and I hear there are some famous museums and stuff).

Fortunately, the good people at The Hungry City Guides, having read all the latest sociological and psychological case studies and papers (okay, abstracts of papers), have seen fit to create a guide—ahem, this guide—that filters out the best the city has to offer. In it, you'll find our favorite places to get your grub on without having to donate plasma to finance the meal. Whether you're looking for hearty Polish fare or a feast of delectable dumplings and succulent shumai, it's all here. And the best part: all the restaurants, bars, and coffee shops listed are affordably-priced!

Wait, Define "Affordably-Priced" . . .

Okay, maybe affordably-priced for New York is more accurate. Still, we promise—that's promise, not guarantee, mind you—that you can dine at all of the establishments contained herein for less than $20 a person. Even Rachel Ray will tell you that's not easy in New York City, and she gets paid a lot of money to scout out stuff like that.

Seriously, any fool can stumble upon a memorable fine dining experience in NYC—after all, this is a city famous for celebrity chefs touting their Zagat ratings and Michelin stars—but that experience comes at a hefty price. The challenge for the real people, living day-to-day on a budget, is to find the gems of the underground, the off-the-radar, on-the-cheap places the locals know and love and won't normally tell you about. Well, I've talked to the locals—friends, coworkers, friends of coworkers, coworkers of friends. I've enticed them with tales of the fame and fortune that having one's name in a guidebook bestows, and, despite having seen through those well-intentioned mistruths, they've agreed to let readers in on their favorite spots anyway. What can I say, they're nice people.

So You Covered All the Great Places, Right?

Umm, remember that part above about all the choices on one

block? There are literally tens of thousands of restaurants and bars in New York City and a book ten times the size of this one surely couldn't contain reviews of them all. Have we left out some notable places? Yes, I'm certain we have, and I hope that the editor of the third edition continues to add to the book by including the places we've neglected to mention this go-around.

In the end, all I can say is that we've tried hard to create a useful, practical, competently-written—at times, we hope, amusing—guide to help you navigate the vast and varied world of New York City dining. Think of the places in this book as starting points from which to begin your gustatory journey through one of the world's most fascinating and culturally-inspired cities. So read on, break free from the chain restaurants, and celebrate the exhaustive offerings that this inimitable, indefatigable city kindly extends to those of us lucky enough to call it home, even if just for a long weekend. In a city that never sleeps, you need plenty of nourishment to last through the night—get busy eating!

—*Charles Battle*

MANHATTAN

MANHATTAN

FINANCIAL DISTRICT

Blockheads
(See p. 111)
Mexican
250 Vesey St., Manhattan 10281
Phone: (212) 619-8040

Bread and Olive
The Middle East makes its place on Wall Street
$$
20 John St., Manhattan 10038
(between Broadway and Nassau St.)
Phone (212) 385-2144 • Fax (212) 385-2146
www.breadnolive.com

CATEGORY	Middle Eastern
HOURS	Daily: 11 AM-9 PM
PARKING	Take the 4,5 or 2,3 express trains downtown to Fulton St.
PAYMENT	VISA MasterCard AMERICAN EXPRESS DISCOVER
POPULAR DISH	Falafel sandwich: fresh, biting, and completely satisfying.
UNIQUE DISH	This is the only Middle-Eastern grub you'll find in the financial district aside from food carts. Craving falafel *and* a place to sit down and eat it? This is the place to go.
DRINKS	No alcohol, but a good selection of juices, tea, coffee, and soda.
SEATING	Lots of small tables, which can be difficult to snag during lunch hours.
AMBIENCE/CLIENTELE	Extremely laid back, but expect it to be packed with Wall St. execs during lunch. Still, the line moves very quickly. Dinner service is mostly take-out, so it's generally very quiet during the evenings. Owner is engaging, sweet, and usually offers up a free piece of baklava.
EXTRAS/NOTES	Money saved can be spent at the Off Track Betting establishment across the street!
OTHER ONES	• Midtown: 24 W. 45th St. (between Fifth Ave. and Sixth Ave.), Manhattan 10036, (212) 391-7772

—*Alexandra Collins*

Burritoville
(See p. 81)
Mexican
36 Water St., Manhattan 10004
Phone: (212) 757-1100

MANHATTAN

Haute Cuisine on the Cheap

In a city notorious for top chefs and 5-star cuisine, it's painfully easy to drop over $100 per person on a meal. After spending money on hotels, airfare, cab rides, and museums, the last thing you need while visiting the city is an overpriced meal. Up until now, only native New Yorkers really knew the secrets to getting a great meal at a fabulous price. Follow these tips and you can join the ranks of those who are truly in-the-know:

One of the greatest secrets New Yorkers take advantage of happens twice a year. If you plan your vacation accordingly, you could score a 5-star dining experience for the price of a meal at your local Olive Garden. It's called Restaurant Week and it happens in both the winter and summer, sometimes extending for a month or more, with many of the city's greatest and most famous restaurants participating. The menus are limited, but usually feature the "signature" dishes for each specific venue. Both lunch and dinner are prix fixe for a 3-course meal. Lunch runs you $24 and dinner usually costs $35. Visit www.nycvisit.com for participating restaurants and specific dates.

If you find you can't be too flexible with travel dates, there are other options for getting a good deal. Many pricey restaurants in NY feature year-round prix fixe meals, especially during less popular times and days. Your best bet is usually to check out the website of a restaurant you're interested in to see if they have any specials posted. Usually such deals occur in the early evening and on Sunday or Monday nights. Even more restaurants feature excellent lunch prix fixe meal deals as well. If your budget is tight but you still want the 5-star experience, simply go for lunch and you'll easily save $25-50 per person.

I also recommend you sign up for Dining Fever; a weekly email that gives you specials and deals on both casual and fine dining restaurants in the city. Go to www.diningfever.com/cities.asp for more details.

Below is a list of restaurants (organized by cuisine) with particularly amazing prix fixe deals year-round:

Italian
Primitivo Osteria, 202 West 14th St., Manhattan 10011, (212) 255-2060, www.primitivorestaurant.com

French
Rene Pujol, 321 W 51st St., Manhattan 10019, (212) 246-3023, www.renepujol.com

L'Ecole (the French Culinary Institute's restaurant), 462 Broadway, Manhattan 10013, (212) 219-3300, http://www.frenchculinary.com/lecole_menus.htm

New American
Thalia, 828 8th Avenue (at 50th St.), Manhattan 10019, (212) 399-4444, www.restaurantthalia.com

Eclectic/International
Knife and Fork, 8 East 4th St., Manhattan 10003, (212) 228-4885, www.knife-fork-nyc.com/home.html

—*Stephanie Hagopian*

MANHATTAN

Burritoville
(See p. 81)
Mexican
20 John St., Manhattan 10038
Phone: (212) 766-2020

Burritoville
(See p. 81)
Mexican
144 Chambers St., Manhattan 10007
Phone: (212) 964-5048

Café Habana
(See p. 25)
Cuban
17 Prince St., Manhattan 10012
Phone: (212) 625-2002

'Inoteca
(See p. 88)
Italian
98 Rivington St., Manhattan 10012
Phone: (212) 614-0473

P.J. Clarke's
(See p. 122)
American Pub
4 World Financial Center, Manhattan 10281
Phone: (212) 285-1500

Pret a Manger
(See p. 121)
British sandwich shop
60 Broad St., Manhattan 10004
Phone: (212) 825-8825

DOWNTOWN EAST

Amin
(See p. 75)
Indian
110 Reade St., Manhattan 10013
Phone: (212) 285-2466

MANHATTAN

Cube 63
*Chic BYOB shoebox with blinding
neon lights and epic sushi*
$$$$

63 Clinton St., Manhattan 10002
(between Rivington St. and Stanton St.)
Phone (212) 228-6751 • Fax (212) 228-6753
www.cube63.com

CATEGORY	Japanese
HOURS	Sun-Thurs: 5 PM-Midnight Fri/Sat: 5 PM-1 AM
PARKING	Street parking is very limited and the subway is three blocks west . . . cab it!
PAYMENT	
POPULAR DISH	Dynamite roll, spicy tuna roll
UNIQUE DISH	Try it all! All sushi is prepared in front of you, so walk to the back to see what fish looks freshest.
DRINKS	BYOS (Bring Your Own Saki) . . . live it up.
SEATING	Tight quarters, loud and fast.
AMBIENCE/CLIENTELE	A hot and sexy crowd that you won't mind rubbing elbows with. Get loud and loose.
EXTRAS/NOTES	BYOB and fast, fast, fast. If you have an 8 PM rez don't plan to stay past 10.
OTHER ONES	Brooklyn: Cube 63 Brooklyn, 234 Court St. (at Baltic St.), 11201, (718) 243-2208

—*Brian Crandall*

Dash Dogs
All dogs go to heaven
$

127 Rivington St., Manhattan 10002
(between Essex St. and Norfolk St.)
Phone (212) 254-8885

CATEGORY	Hot dog stand
HOURS	Mon-Weds: Noon-Midnight Thurs-Sat: Noon-4 AM Sun: Noon-Midnight
SUBWAY	Take the F, J, M, Z to Delancey Street.
PAYMENT	Cash only
POPULAR DISH	Sure, you might think a hot dog is just a hot dog, but with over twenty different types of toppings, suddenly your dog is elevated to new heights of culinary delight. Sliders, aka mini-burgers, are also available. Interested in a coronary? Go for "Fat Baby": a dog smothered in chili, sour cream, and bacon. Not into meat? Dash does veggie dogs and patties too. The only downside to this popular joint is the lack of sides—combos come with extra dogs or sliders, not fries.
UNIQUE DISH	Avocado salsa and pineapple chutney might not seem like your average hot dog toppings, but they're divine. The hot dogs here might be your everyday Hebrew Nationals, but it's really the toppings that set Dash Dogs apart from the rest. Besides individual topping options, Dash also offers "signature" topping combinations, often named after local businesses. Pickles and kraut are provided by The Pickle Guys of LES fame.
DRINKS	Soda, fruit punch, lemonade.

MANHATTAN

SEATING	Three stools are conveniently placed under the counter area, but honestly, it's either stand 'n' eat or eat 'n' go.
AMBIENCE/CLIENTELE	Service is fast and friendly—who knew a hot dog could be so personable? During lunch and dinner hours, you'll find neighborhood regulars, hipsters, and the like; late night you'll run into drunk bar-hoppers seeking sustenance.
EXTRAS/NOTES	Can't make it to Dash Dogs, but need a fix? For orders of $8 or more, they'll deliver free if you're within a six-block radius. Or, if you're in the mood for some chic seafood, check out Tides, around the corner. The older brother to Dash Dogs, this little bistro shares the same owners.

—*Jennifer Treuting*

Dumpling House
If we had such a thing as half a dollar sign, we'd use it for this unbelievably cheap, terrifically tasty dumpling, porridge, and noodle joint.

$
118 A Eldridge St.
(south of Broome St.)
Phone (212) 625-8008

CATEGORY	Chinese Dumpling and Noodle House
HOURS	Daily: 8 AM-10 PM
SUBWAY	4, 5, 6, J, M, Z to Brooklyn Bridge/City Hall
PAYMENT	Cash only
POPULAR FOOD	Made-in front of you dumplings—have the vegetable steamed dumplings (eight per order); also several dollar breakfast specials, pork noodle soup, *lo mein*, and *chow fun*, as well as hot and sour soup
UNIQUE FOOD	Try the sweet *mung* bean porridge with a chive and egg steamed bun—very filling
DRINKS	Soda, juice, tea
SEATING	Seats about six at a counter
AMBIENCE/CLIENTELE	Narrow space not for those prone to claustrophobia; and bring patience—the staff is friendly, but speaks very little English
EXTRAS/NOTES	Some items on the menu may not be available. Then again, a slew of non-listed treats are. So, look around and see what the neighborhood folk are munching on and do a lot of pointing and smiling.

—*Marie Estrada*

Essex
Cure your hangover for $15.
$$$$

120 Essex St., Manhattan 10009
(at Rivington St.)
Phone (212) 533-9616
www.essexnyc.com

CATEGORY	Restaurant/Bar
HOURS	Tues-Thurs: 6 PM-midnight Fri: 6 PM-1 AM Sat: 11 AM-4 PM, 6 PM-1 AM

MANHATTAN

	Sun: 11 AM-11 PM (Kitchen closes 1 hr before bar)
PARKING	Take the F,J,M, or Z train to Delancey. There's also a municipal parking garage across from the restaurant on Essex St.
PAYMENT	VISA, MasterCard, American Express, Discover
POPULAR DISH	Manchego mac & cheese with chicken apple sausage; lobster benedict; crispy potato pancakes (with sautéed apples and honey-cream sauce); oysters
UNIQUE DISH	Challah french toast (with bananas foster sauce); Mexican matzo brei (scrambled eggs with tortilla crisps, Monterey jack cheese, avocado, black beans, and pico de gallo)
DRINKS	Flavored mojitos, margaritas, and bellinis; innovative martinis (Cucumber Vodka Saketini, Fresh Watermelon Martini); original shots (try the Japanese Seduction)
SEATING	Essex has a lot of tables on two levels, but it fills up fast; during brunch be prepared to wait 30 minutes to an hour. Can accommodate big groups, but be sure to call ahead.
AMBIENCE/CLIENTELE	In a warehouse-like space with high, high ceilings and a lot of natural light, Essex is loud, vibrant, and inviting. You'll find a good mix of folks here—some students, some hipsters, some yupsters—but the feeling is generally that of a relaxed, boozy after-party.
EXTRAS/NOTES	The first thing to know about Essex is that it offers a $15 brunch on the weekends that includes—yes, that's right, *includes*—a drink: your choice of mimosa, screwdriver, or bloody Mary. The second thing is that it serves $1 oysters and 1/2 price drinks on Thursdays. Amazingly, the food is as impressive as the weekly specials. Service can be slow, but is generally friendly.

—Laura Lee Mattingly

Excellent Dumpling House

As authentic an American-Chinese restaurant experience as you're gonna find.
$$

111 Lafayette St., Manhattan 10013
(at Canal St.)
Phone (212) 219-0212

CATEGORY	Chinese
HOURS	Daily: 11 AM-9 PM
SUBWAY	1,2,3,A,C,E,N,Q,R,W,J,Z,6 to Canal St. Walk west to Lafayette St.
PAYMENT	Cash only
POPULAR DISH	Not the dumplings . . . just kidding. Steamed shau lon pau are very good, but let them cool or the first bite will be watery. The fried pork dumplings are also high on my list. The dough is thick and chewy. Drip a bit of chili sauce on there to open up the pork flavor. If you want to mix it up, you could finish with the vegetable-heavy kung pao chicken or the deliciously oily vegetable lo mein.

MANHATTAN

UNIQUE DISH	Clearly there are a lot of Chinese restaurants in Chinatown. What sets this one apart from all the others is its degree of Chinese-ness. Things are loud, fast-moving, disciplined.
DRINKS	Tsing Tao beer, Coke, Green Tea. They may have a few other things but you won't see anyone drinking anything else.
SEATING	You can fit a large ping pong team in this place. (approx. 75 people)
AMBIENCE/CLIENTELE	I went with my girlfriend. We sat next to a family with three kids. An older lady with a lot of bags sat at the table in front of me. Behind her, a late teenage girl with a black trench coat and dyed black hair ate with her mother. These people were all white. Everyone else in the restaurant was Chinese.
EXTRAS/NOTES	I love this place. The menu sprawls. The food comes out piping hot, faster than you would expect (but not alarmingly so), and in no particular order—and don't bother asking for X to start and Y as a main course because it comes out how it comes out.
OTHER ONES	Sushi Excellent, 366 New Dorp Ln., Staten Island 10306, (718) 667-5362

—Ryan Auer

Fried Dumpling

Cheaper than a subway ride, and tastier, too!
$
99 Allen St., Manhattan 10079
(between Broome St. and Delancey St.)
Phone (212) 941-9975

CATEGORY	Chinese
HOURS	Daily: 7:30 AM-9 PM
SUBWAY	F,J,M,Z to Delancey Street
PAYMENT	Cash only
POPULAR DISH	Fried dumplings. Not only are they filled with a delicious blend of pork and chives, but a dollar will get you five. Seriously, you can eat like a king for five bucks. Other menu favorites include pork buns, sesame cake (ask for it with beef—you won't be sorry!), and vegetable steamed dumplings. If you're a rabid fan, they do wholesale: a crisp Lincoln will get you a frozen bag of 30 to take home and make whenever the craving hits. (Your friends will be impressed!)
UNIQUE DISH	Besides the eponymous staples, Fried Dumpling serves congee, a thick soup of rice and red beans, and tea eggs ($1), a traditional hard-boiled snack that's infused with spices (4/$1). For prices like these, take the risk!
DRINKS	Besides the normal canned sodas and water, Fried Dumpling features an array of bubble teas (iced teas with edible black tapioca "pearls" floating around the bottom) as well as large plastic containers of soy milk.
SEATING	Three small tables with stools and a counter area on the side.

MANHATTAN

AMBIENCE/CLIENTELE It's easy to miss Fried Dumpling with all of the neon hustle and bustle on Allen Street. To put it gently, this little hole in the wall is unassuming. No frills, no presumption—just dumplings. There's usually a small line at the counter during peak meal times, but it moves quickly. The staff doesn't speak much English, but not a lot is needed when you order—just what you want and how many of 'em. Lots of neighborhood folks come in for a quick bite, but don't be surprised to find a down-and-out hipster artist or two.

—Jennifer Treuting

Golden Unicorn

Swift banquet-style dining room
does big brunch business
$$

18 East Broadway, Manhattan 10002
(between Catherine St. and Market St.)
Phone (212) 941-0911 • Fax (212) 941-0911

CATEGORY Chinese
HOURS Mon-Fri: 9 AM-11 PM
Sat/Sun: 9 AM-Midnight
SUBWAY B, D to Grand St.; N, R, Q, W, J, M, Z, 4, 6 to Canal St.
PAYMENT
POPULAR DISH The roast pork buns may be the best in the city, but the steamed are also delicious. The steamed shrimp puffs are amazing, and the custard tarts are a great finish to the meal.
UNIQUE DISH Though this place has traditional Chinese entrees, dim sum is the real star. During the hours of 9 AM-3:30 PM, there are several carts rolling around this multi-layered restaurant, each with layer upon layer of bamboo steamers. The carts come equipped with pictures for those not versed in Mandarin, but if you still don't quite get it you can ask for a sneak peek before you commit to any dish.
DRINKS Tea is served at every table.
SEATING Large, family-style dining rooms. If you're going with a small group there's a good chance you'll be seated with another party. Don't be shy!!!
AMBIENCE/CLIENTELE The clientele consists mainly of Chinese families, with a smattering of late night partygoers. The atmosphere is hectic and you spend a lot of time watching the carts roll around wishing they would come your way. N.B.: for the timid, this place is best done with a seasoned dim sum eater.
EXTRAS/NOTES Arrive early to secure a table by the kitchen so you can get to the carts first. This place is all about location in the room. If you haven't been dealt a good seat and you see something you want on the other side of the room, don't be scared to go up and grab it. Also, the large, family-style-portioned entrees are enough to share with the table if you're also eating dim sum.

—Emily Isovitsch

MANHATTAN

Hop Kee Restaurant

Basement location is easy to miss, but the food sure isn't.
$$$
21 Mott St., Manhattan 10013
(between Mosco St. and Bowery)
Phone (212) 964-8365

CATEGORY	Cantonese Chinese
HOURS	Sun-Thurs: 11 AM-Midnight
	Fri/Sat: 11 AM-4 AM
SUBWAY	4, 5, 6, J, M, Z to Brooklyn Bridge/City Hall
PAYMENT	Cash only
POPULAR FOOD	Chinese broccoli with oyster sauce; steamed sea bass; boneless steamed chicken; salted pork chop with hot peppers; the wildly popular house special, seafood combination Cantonese *chow mein* or *lo mein*, feeds two to three—studded with fresh, sweet shrimp, cuttlefish, and scallops, this dish, like most of the food here, never needs extra salting
UNIQUE FOOD	Unusual soups include roast duck won ton; watercress with pork; winter melon with chicken; seaweed with pork and corn with chicken; also, snails Cantonese style.
DRINKS	Soda, juice
SEATING	Seats about 150
AMBIENCE/CLIENTELE	Pay no mind to the chaos or the harshly lit basement space—this may look like a factory cafeteria, but your taste buds will tell you otherwise. Cutlery for the table comes in stainless steel columns, to better serve the huge delegations of Chinese and Filipinos who flock here on weekends and service is admirably attentive, even if you're stuck in one of the far-off corner tables, as will often be the case when the place is full.
EXTRAS/NOTES	Chinese tea sets and Jasmine teas are for sale.

—*Melissa Contreras*

Ini Ani Espresso & Wine Bar

Sophisticated wireless wine and coffee bar
$$
105 Stanton St., Manhattan 10002
(at Ludlow St.)
Phone (212) 254-9066
www.ini-ani.com

CATEGORY	Espresso and wine bar
HOURS	Mon-Thurs: 8 AM-11 PM
	Fri: 8 AM-2 AM
	Sat: 10 AM-2 AM
	Sun: 10 AM-9 PM
SUBWAY	Take the F,V to 2nd Ave, or the F, J,M,Z to Delancey Street.
PAYMENT	VISA MasterCard
POPULAR DISH	Day menu features lighter fare like salads, grains, and bagels; night menu features a variety of bruschettas, paninis, fondues, and antipasti platters.
DRINKS	Homemade sangria. A number of well-chosen red and white wines, available by the bottle or the glass, and a choice selection of imported beers, including Peroni, Stella Artois, and Hoegaarden.

MANHATTAN

SEATING Tables for two and four.
AMBIENCE/CLIENTELE A hip, trendy, yet somehow homey, wine bar on the LES. The exciting interior was inspired by take-out coffee cup materials and designed by innovative architectural firm Lewis.Tsurumaki.Lewis. A warm spot with a pleasant staff and a low-key crowd.
EXTRAS/NOTES A DJ spins on weekends and there's a great happy hour on weeknights: $2 off almost anything for a few hours starting at 5 PM. The "soulful brunch" on the weekends puts an eclectic, European spin on traditional bacon and pork combinations and comes with your choice of mimosa or bellini and coffee, tea, or orange juice, all for $12. Wi-Fi available.
—*Taylor Marqs*

That's the Spirit! Creative Cocktail Craze

We all have those days where we sit at our desks, staring blindly into our computer screens, counting down the hours until we can recapture our sense of cheer over a chilled martini before schlepping ourselves home for dinner. And after a crazy work day, nothing will hit the spot better than a crazy cocktail.

Whether you go for sweet or spicy, dirty or fruity, crazy cocktails are definitely in. Whether you are craving the classic gin martini or are eager for some raspberry in your already-chic cosmopolitan, there's a venue for your fancy. Here are some of the best spots for inventive imbibing, before, during or after a meal.

Blockheads offers affordable Mexican fare in Murray Hill, but the main draw is their crazy-affordable cocktails. Any night, all night, jumbo margaritas of myriad flavors are just $3.50. Try the Black Flower—it's a sangria-flavored margarita, for those of us who love both drinks and find it hard to choose. *499 3rd Ave., Manhattan 10016, (212) 879-1999*

Aside from being my favorite Thai food on earth, **Klong** has an unparalleled, Thai-inspired bar selection. Whether you favor the Royal Siam Pom Martini or the Lychee Sake, the drinks are delicious, potent, and reasonably priced. *7 St. Marks Pl., Manhattan 10003, (212) 505-9955, www.klongnyc.com.*

Public is a decadent visit to the "nice side of things." Its rustic-meets-intimate feel will make even the most mediocre of dates feel passionate, and the ginger cosmopolitans or pear bellinis are sure to seal the deal. Sip a little bit of exotic perfection. It'll cost you, but it'll be the best money you've ever spent. *210 Elizabeth St., Manhattan 10012, (212) 343-7011, www.public-nyc.com.*

Verlaine is a Vietnamese-themed bar on the LES with a seven-days-a-week, 4-hour-long happy hour special. My friends and I have spent many an evening chatting over their lychee martinis, ginger beer, and southeast sangria, while nibbling on tapas. Dive bar prices with a fancy lounge look—during happy hour, most drinks are $4. *110 Rivington St., Manhattan 10002, (212) 614-2494*

—*Aly Walansky*

MANHATTAN

Joe's Shanghai
1.3 billion people can't be wrong.
$$$
9 Pell St., Manhattan 10013
(between Doyers St. and Bowery)
Phone (212) 233-8888 • Fax (212) 233-0278
www.joeshanghairestaurants.com

CATEGORY	Chinese
HOURS	Daily: 11 AM-11:15 PM
SUBWAY	6, N, R to Canal St. Walk east on the south side of Canal until you hit Mott. Turn right on Mott and then left onto Pell St.
PAYMENT	Cash only
POPULAR DISH	You will be hard pressed to find a table *not* adorned with several baskets of Joe's famous soup dumplings. With either of the two options, pork, or a crab/pork mix served in simple bamboo baskets lined with cabbage, you really can't go wrong with this totally addictive delicacy unless, of course, you accidentally break a dumpling while placing it on your spoon and spill the soup. In this case, you will definitely be bummed.
UNIQUE DISH	The shredded turnip shortcakes are the perfect way to kick off a meal here, especially when dipped in the too-good-for-words Ponzu sauce given to every customer upon arrival. The Shanghai fried flat noodles w/ beef and the pork and squid sautéed with minced Jalapeños are as good as it gets, and both are share-able.
DRINKS	Wine and Beer
SEATING	Though there are a few small square tables in the front, Joe's ample seating is community-style, meaning you will most likely be dining elbow to elbow with strangers.
AMBIENCE/CLIENTELE	Sometimes Joe's feels more like a soup dumpling factory than a restaurant, as it's *always* packed to maximum capacity. The service is more hurried than harried, though if you're not bold and aggressive you may feel neglected. The clientele consists of half bona fide Chinese people and half true-blue New Yawkers, with a sprinkling of tourists lucky enough to have been given the insider tip. Joe's is always noisy, though the murmur is a cacophony of clinking plates, shouting waiters and slurping – as the patrons are too busy happily stuffing their faces to talk.
EXTRAS/NOTES	Be prepared to wait at least half an hour to be seated, though that time may decrease if your party is smaller. While you're waiting outside, the ooh's and ahh's of the sated customers leaving the restaurant will increase your anticipation. Be sure to study the *New York Times* cartoon in the front window describing how to properly eat a soup dumpling. Otherwise, you'll likely wind up with a hot dumpling stuck to your upper lip and scalding hot soup running down your chin, and, really, no one likes that.
OTHER ONES	• Flushing: 13621 37th Ave., Queens, 11354 (the original, and perhaps the best, Joe's, right in the heart of Flushing's ever-growing Chinatown – there's more seating here than the one on Pell

MANHATTAN

St., though the restaurant is just as busy). Take the 7 train to Main St.
• Midtown: 24 W. 56th St., between 5th and 6th Ave. (the "upscale" version of Joe's, in which the food is pricier, the service snootier, and the food strikingly inferior). Take the N, R to 57th St. Midtown.

—*Jen Sotham*

Katz's Delicatessen
"Send a Salami to Your Boy in the Army."
Since 1888
$$

205 E. Houston St., Manhattan 10002
(corner of Ludlow St.)
Phone (212) 254-2246, or 1-800-4-HOT-DOG • Fax (212) 674-3270
www.katzdeli.com

CATEGORY	Delicatessen
HOURS	Sun-Tues: 8 AM-10 PM
	Wed/Thurs: 8 AM-11 PM
	Fri/Sat: 8 AM-3 AM
SUBWAY	F to 2nd Avenue
PAYMENT	VISA, MasterCard, American Express
POPULAR FOOD	Frankfurters and chili dogs to die for, gargantuan pastrami and corned beef sandwiches, delicious Katz salami sandwiches, New York egg cream, and traditional potato *latkes* and blintzes
UNIQUE FOOD	Everything at Katz's is unique in that quintessentially New York way: mountains of fresh meats piled high on rye or whole-wheat or whatever you desire, homemade salami. Also of note and not to be missed is Katz's tongue sandwich, cured in house.
DRINKS	Don't miss the New York egg cream—this is as real as it gets. Katz's also has a line of specialty beers, plus a million other standard restaurant beverages.
SEATING	Plenty of table seating in a cafeteria-like setting
AMBIENCE/CLIENTELE	Worn and cluttered, but somehow bright and open at the same time, here's where the fun starts: Get a green piece of paper when you walk in the door, and it's literally your meal ticket (whatever you do, for God's sake, don't lose your ticket!!!) and once you've gotten your meal, have a seat at one of the old wooden tables and enjoy the photos of famous patrons, from Bill Clinton and Tony Curtis to Dan Aykroyd and Bill Zane. Service is fast, but Katz's can be absolutely packed on the weekends with tourists, New York old-timers, village hipsters, and the occasional celeb.
EXTRAS/NOTES	Katz's deli has a wonderful history—it was established across Ludlow St. from its present location (it moved in the early twentieth century), and became a popular neighborhood hangout immediately—something that hasn't changed in over 100 years. Back in WWII, Katz's set up a sausage-mailing service for the boys overseas: "Send a Salami to Your Boy in the Army." And yes, it's the site of the famous faked orgasm in "When Harry Met Sally."

—*Brad Wood*

MANHATTAN

Kuma Inn
Asian tapas in Lower East Side hideaway.
$$$$
113 Ludlow St., 2nd Fl.,
Manhattan 10002
(between Delancey St. and Rivington St.)
Phone (212) 353-8866
www.kumainn.com

CATEGORY	Asian Tapas
HOURS	Tues-Sun: 6 PM-Midnight
SUBWAY	Take the F,V to Delancey or the J,M,Z to Essex.
PAYMENT	VISA MasterCard American Express Discover
POPULAR DISH	Regulars recommend the sautéed Chinese sausage, especially when dipped in the truly-addictive Thai chili lime sauce. The seared Ahi tuna, served with Thai chili miso vinaigrette, is also a good choice.
UNIQUE DISH	Menu is comprised entirely of Asian tapas, from pan-roasted scallops (cooked with bacon, calamari, and sake) to deep fried pork belly. Great family style sharing allows you to sample practically the entire menu.
DRINKS	Beer, wine, sake.
SEATING	Lots of small tables. Very difficult to walk in, so best to call in advance for reservations.
AMBIENCE/CLIENTELE	Tucked away on the second floor of a building, Kuma feels nicely removed from the regular LES hullabaloo. In-the-know foodies adore this place. Other patrons are mostly a mixed bag of hipsters, locals, and prepsters.

—*Alexandra Collins*

Mei-Ju Vege Gourmet
I'd eat here every day— if I lived in the area.
$$
154 Mott St.
(between Broome and Grand Sts.)
Phone (646) 613-0643

CATEGORY	Chinese Vegetarian Buffet
HOURS	Daily: 8 AM-8 PM
SUBWAY	4, 5, 6, J, M, Z to Brooklyn Bridge/City Hall
PAYMENT	Cash only
POPULAR FOOD	With over twenty choices to mound on your plate, leave room for the savory sweet and sour gluten and the vermicelli noodle
UNIQUE FOOD	You won't have room, so take the wrapped rice roll with sauteed onion or the mushroom and seitan steamed bun to go.
DRINKS	Soda, juice, tea
SEATING	Seats three at stools and a counter
AMBIENCE/CLIENTELE	Not a large operation, the food buffet (as it should) monopolizes the space—friendly service and very happy customers

—*Marie Estrada*

MANHATTAN

New Pasteur
*No pretense here, just good, solid,
Vietnamese food.*
$$
85 Baxter St., Manhattan 10013
(at Canal St.)
Phone (212) 608-3656 or 608-4838

CATEGORY	Vietnamese
HOURS	Daily: 11 AM-9:30 PM
SUBWAY	6, Q, W, N, R, J, M, Z to Canal St.
PAYMENT	Cash only
POPULAR FOOD	*Muc chien don* (crispy squid in a little salt and pepper), is the most popular dish, according to the waiter; also try piping-hot ever popular Vietnamese staple *pho*, available with beef, seafood, shrimp, chicken, or vegetables, enormous portions; or have the simple but fantastic rice vermicelli with curried chicken—if chicken's not your thing, try the barbecued shrimp, pork, beef, or vegetables; or the steamed shrimp rolls served with peanut dipping sauce
UNIQUE FOOD	If you're feeling adventurous, try the *ech um xa ot* (frog legs with curry sauce in casserole, served with various vegetables, all drowned in a delicious and spicy curry sauce—one of the pricier items on the menu, but well worth it
DRINKS	You can get everything from soda to green bean with coconut milk to salty plum soda. Hot coffee with condensed milk is a tasty treat.
SEATING	Four tables of four, three tables of six, and two round tables (which can seat four to six)
AMBIENCE/CLIENTELE	Situated directly across from a juvenile detention facility, New Pasteur is not a restaurant you go to for the atmosphere (i.e., it's not the place for a romantic first date), but it's not without charm—white muslin curtains on the window hide the view of the corrections facility, while white plastic plateware are decorated with blue flowers, a large "painting" of a water scene at sunset with a boat and a Japanese maple hangs on one wall, and the white sign outside is rimmed with blinking colored lights—and its straightforward lack of pretense weeds out the tourists and the snooty upper crust.
EXTRAS/NOTES	New Pasteur is filled with neighborhood folk, students complaining vocally about their love lives, and New Yorkers who know good, cheap Vietnamese food when they see it. Here you can sit for hours without being bothered. The waiter assures me that there are a lot of regulars and no tourists—a feature he clearly doesn't want to change.

—*Sarah Winkeller*

"Manhattan is a narrow island off the coast of New Jersey
devoted to the pursuit of lunch."

—*Raymond Sokolov*

MANHATTAN

New Green Bo
A Chinatown find!
$

66 Bayard St., Manhattan 10013
(between Elizabeth St. and Mott St.)
Phone (212) 625-2359

CATEGORY	Chinese
HOURS	Daily: 11 AM–Midnight
SUBWAY	6, N, R, W to Canal St.
PAYMENT	Cash only
POPULAR FOOD	The pan-fried noodles with shredded pork and cabbage are simultaneously crispy and creamy. As you wait for the dish to cool down, the crunchy noodles absorb the incredibly flavorful juices from the vegetable and pork. Every bite is delicious beyond belief. Steamers of dumplings ornament every table, and the soup dumplings are the most popular. They melt in your mouth. Steamed tiny buns with pork are also a favorite, and at $4.25 for eight buns, how can you resist?
UNIQUE FOOD	While New Green Bo offers the standard Chinese restaurant fare, a second glance at the menu is like a lesson from an obscure culinary dictionary. Large dishes such as duck's web with celery, jelly fish, ham and winter melon soup, and king sea cucumber in shrimp sauce will definitely pique your curiosity. Go ahead and sample some of the more unusual items. New Green Bo is definitely a good place to experiment.
DRINKS	Beer and Wine
SEATING	Large, round communal tables. There isn't a lot of seating, but service is fast, so lines move very quickly.
AMBIENCE/CLIENTELE	Absolutely none. Zip. Zilch. The dining room can get very noisy, but you won't hear it for long, since your satisfied taste buds will transport you to a perfect state of foodie bliss. Though the service can be of the dismissive and grumpy variety, you're not likely to find a better value anywhere. You will stare in disbelief at the bill, as even the most gluttonous will be sated for less than $10!
EXTRAS/NOTES	Chinatown Ice Cream Factory is just across the street. Indulge in their famous lychee or red bean ice cream after a very filling and scrumptious meal at New Green Bo.

—*Camilla Warner*

"Cut off as I am, it is inevitable that I should sometimes feel like a shadow walking in a shadowy world. When this happens I ask to be taken to New York City. Always I return home weary but I have the comforting certainty that mankind is real flesh and I myself am not a dream."

—*Helen Keller*

MANHATTAN

Pink Pony
THE downtown hang-out for artists, writers,
actors, intellectuals, and street fashion designers.

$$$$
176 Ludlow St., Manhattan 10002
(between Houston and Stanton Sts.)
Phone (212) 253-1922

CATEGORY	Blue-collar French Cuisine, French Coffeeshop Café Literaire
SUBWAY	F, V to Second Ave.
HOURS	Daily: 10 AM-2 AM
PAYMENT	Cash only
POPULAR FOOD	A continuous conveyor belt of tuna melts, and assorted other warm sandwiches served to the starving artist types to keep them looking fashionably waifish, but never starving
UNIQUE FOOD	A nightly fixed menu for 16 bucks; every night it is something different, and everybody eats the same—quaint, huh?
DRINKS	Fine wines by the glass, imported beers; highest quality Italian coffees at 99¢ a-cup!
SEATING	Plenty of seats in a spacious area with romantic banquettes
AMBIENCE/CLIENTELE	Warm and welcoming by day, warm, welcoming and packed by night
EXTRAS/NOTES	The three-course prix fix meal is the economical way for an *artiste* to see and be seen, as well as chow down. The food preparation is overseen by Lucien (of the reputable First Avenue bistrot of his namesake). Remember that "old Village" used bookshop, Tompkins Square Books, that saw its demise last year? Well it lives on in the vast bookshelves of the Pink Pony's library. Feel free to worm your way into a book, or bring your laptop along to write your own; catch up with the impromptu goings-on of their cinema club, and poetry readings, or look into one of the most eclectic jukeboxes in town.

—Nemo Librizzi

Pho Bang Restaurant
Modest appearance hides cunning contender
for best Vietnamese food in NYC.

$$
157 Mott St., Manhattan 10013
(between Grand and Broome Sts.)
Phone (212) 966-3797

CATEGORY	Vietnamese
HOURS	Daily: 10 AM-10 PM
SUBWAY	J, M, N, Q, R, W, Z, 6 to Canal St., S to Grand St., J, M to Bowery
PAYMENT	Cash only
POPULAR FOOD	Your buck gets a bang with the *pho*: rice noodle beef soup; choice of extra large bowl or regular bowl—regular should satisfy most appetites; it's

17

MANHATTAN

always delicious, but read the menu descriptions carefully if any of the following terms make you uneasy: brisket, tendon, *omosa* (we don't know what this is), navel—you're bound to find something that won't offend your delicate sensibilities

UNIQUE FOOD The *bún* (rice vermicelli) dishes are awfully good
DRINKS Beer, tea, soda
SEATING Thirty-five at tables
AMBIENCE/CLIENTELE Straddles conventional take-out and relaxed sit-down motifs. Vietnamese beer ads, depicting the country's stunning geography and its pretty (traditionally dressed) models, line the walls—nothing fancy, but comfortable, and the largely Vietnamese clientele (not to mention the brisket, tendon, *omasa*, and navel) suggests that you're dealing with the real thing here.
EXTRAS/NOTES Pho Bang is a chain.

—Joe Cleemann

Public

Dine on delicacies from down under in a trendy library-style setting.
$$$$
210 Elizabeth St., Manhattan 10012
(between Prince St. and Spring St.)
Phone (212) 343-7011
www.public-nyc.com

CATEGORY Australian
HOURS Mon-Weds: 6 PM-10:30 PM
Thurs-Sat: 6 PM-midnight
Sun: 6 PM-10 PM
SUBWAY Take the 6 train to Spring St. and walk east a few blocks to Elizabeth St.
PAYMENT
POPULAR DISH Though Aussies have well-earned reputations as carnivores, the seafood at Public is where it's at. The roast cod on edamame risotto is especially delicious.
UNIQUE DISH Public boasts an eclectic Australasian menu that offers everything from grilled kangaroo on a coriander falafel (topped with a Bobby Flay-worthy green pepper relish) to snail and oxtail ravioli. Even the more basic dishes are, well, not basic. The grilled lamb tenderloin is served with ancho chili spiced chickpeas and a salad of radishes and queso fresco. Be bold in your order and you will likely be rewarded.
DRINKS A number of inventive cocktails, including a lemon and basil martini and a guava and red chili margarita. Beer, wine, and liquor also served.
SEATING Seating for all size parties, with various rooms available for private events. The bar serves the full menu as well.
AMBIENCE/CLIENTELE The décor might be best described as chic-institutional, evoking memories of libraries, schools, and warehouses (the two-floor space was once a bakery). There's a wooden library-card

catalogue near the coat check (Dewey Decimal what?) and the menus are presented on office clipboards.

EXTRAS/NOTES Brunch Sat-Sun 11 AM-3. Reservations are a must. If you don't have one, seats at the bar usually open up quickly.

—*Graham Harrelson*

The Stanton Social
For the chic, sophisticated late night crowd
$$$
99 Stanton St., Manhattan 10002
(between Orchard and Ludlow)
Phone (212) 995-0099
www.thestantonsocial.com

CATEGORY Lounge
HOURS Daily: 5 PM-3 AM
PARKING No parking, best to grab a cab or take the F train to 2nd Ave and walk a few blocks.
PAYMENT VISA, MasterCard, American Express, Discover
POPULAR DISH Stanton Social brings a whole new meaning to bar food. From potato-goat cheese pierogies to the Maine crabcake corndogs, you will be overwhelmed by the huge selection of delectable treats!
UNIQUE DISH The French onion soup dumplings are a stroke of genius, and even New Englanders can't resist the lobster roll sliders.
DRINK Pear-Ginger Sake Martini, refreshing and crisp with a little sweetness, too; Pink Grapefruit-Mint Martini—freshly squeezed grapefruit juice and fresh mint are the highlights in this great alternative to the mojito. Try the Black Magic, a curiously tasty combo of Guinness and champagne. And for those who like a little heat, try the Blood Orange Jalapeno Margarita, the perfect marriage of sweet and spice.
SEATING Posh leather banquettes, situated within the intimate seating of the lounge, allow for couples and groups alike to enjoy the cozy atmosphere. The larger downstairs dining room, blanketed in black, is accented by chic lighting and an open ceiling that allows guests to view the impressive wine selection.
AMBIENCE/CLIENTELE Located in the heart of the Lower East Side, The Stanton Social presents elegance and style in a modern, sophisticated fashion. Serving until the wee hours of the morning, this is a great place for a group of friends or a late-night rendezvous.

—*Tracey David*

MANHATTAN

Sticky Rice
Try this Thai BYOB ASAP!
$$$$
85 Orchard St., Manhattan 10002
(between Broome St. and Grand St.)
Phone (212) 274-8208

CATEGORY	Thai
HOURS	Mon-Thurs: 11 AM-11 PM
	Fri/Sat: 11 AM-Midnight
	Sun: 11 AM-11 PM
SUBWAY	F at Delancey St; J,M,Z at Essex St; B,D at Grand St
PAYMENT	VISA MasterCard
POPULAR DISH	Delightful variety of both traditional and modern Thai starters. From grilled marinated chicken satay with peanut dipping sauce to signature "Fire Crackers" filled with chicken, curry paste, and Thai herbs "jacketed with tofu skin," you can't go wrong. Among the great selection of classics, the heat in the spicy basil noodles will have you reaching for your BYO-Beverage of choice, and green and panang curries will wow you with sweet and spicy richness. BBQ dishes also stand out, served with house kimchee and a "World Famous Spicy Guss Pickle." Grilled short ribs marinated with ginger, scallion, and sesame seeds or grilled salmon wrapped in banana leaf with crisp-guajillo tamarind sauce won't disappoint.
UNIQUE DISH	Don't miss the lovely "mango-flower" dumplings, a "Royal" (don't be freaked out by the purple dough!) Thai appetizer comprised of chicken, chopped cilantro roots, and roasted peanuts. Look for the surprisingly yummy (and not too sweet) mango dipping sauce.
DRINKS	It's BYOB—what's not to love? Sample Sticky Rice's delectable Thai flavors and enjoy its hip, pretty atmosphere without blowing all your cash on overpriced cocktails and bottles of wine. Instead, check out the nearby Jade Liquor store and bring your choice of beer or wine to complement the meal. Or enjoy their variety of tasty teas, coffees, and sodas, including sweet specialty sodas.
SEATING	Although Sticky Rice is tiny, the very high ceilings make the small space seem airy and comfortable. Several booths along one side can seat up to six each. There's also one larger booth in the back. Multiple small tables line the opposite wall. The wait for two or a small group usually isn't too long, as service is fast and friendly; however, make a reservation if you don't want to chance it. A small, sleek bar in the back provides seating for a few lucky patrons.
AMBIENCE/CLIENTELE	Sticky Rice has a playful, yet sexy atmosphere with glowing red lanterns and chandeliers wrapped in plastic. The rustic brick walls contrast nicely with pink floral murals and large, exotic greenery. Red semicircular booths are pleasantly mismatched with both patterned and animal-

MANHATTAN

printed chairs. The wait staff is hip and yet friendly, fast-paced and yet accommodating. Expect to see a mixed crowd of couples on dates and small groups of trendy twenty- and thirty-somethings. This is a perfect spot for a girls-night-out or a birthday celebration.

EXTRAS/NOTES Look out for the weekday lunch specials. Delivery and take-out available. Free Wi-Fi on site.

—Sara Popovich

Sweet-N-Tart
Delicious, authentic, cheap Chinese cuisine.
$$$
13611 38th Street, Manhattan
(between Flushing and Main Street)
Phone (718) 661-3380 Fax (718) 661-3363
www.sweetntart.com

CATEGORY Chinese
HOURS Mon-Sun: 9 AM-Midnight
SUBWAY Take the N, R or 6 trains to Canal St., or the F Train to E. Broadway. The M101, M102 and M103 buses also stop at Chatham Square, which is practically across the street.
PAYMENT Cash only
POPULAR DISH The ginger-scallion noodles rule! And the scallion pancakes are perfect. Dumplings abound (personally I go for the pork variety), and the dim-sum selections are always a safe choice. The congee is also popular and, apparently, quite delicious if you can get past the phlegmy texture. Best of luck with that.
UNIQUE DISH Looking for something unique? To choose your own culinary adventure just open the gigantic menu to any page and point. Shredded jellyfish, broiled frog, and the 1,000-year-old egg are all available. Prefer to keep it simple? Don't worry, they have something here to satisfy all tastes.
DRINKS Beer and soda are ready and willing, but do yourself a favor and drink some tea. Hot, iced, or bubble, they're all here. If you haven't experienced it, bubble tea is one of those things that make the world a better place, and, if you're feeling full after the meal, it also makes a great dessert.
SEATING This place is pretty big, so even if you do have to wait for a table, it won't be for long. Try to get them to seat you upstairs, though, as the decor and overall atmosphere are a bit more engaging up there.
AMBIENCE/CLIENTELE I always judge Asian restaurants by how many Asians are actually eating there. If there are a lot, I know the place is the real-deal. Sweet-n-Tart is a neighborhood fixture and quite popular with the locals, so authenticity is assured.
EXTRAS/NOTES The staff is among the most accommodating in the area. Whatever you got, they're ready for you. Table for 1? 2? 5? 10? 18? Bring it on. The servers are friendly, helpful, and *fast*, making Sweet-n-Tart the perfect place to rest and refuel after a long day of buying bootleg DVDs and

MANHATTAN

knock-off designer bags for your friends and family back home. Go ahead, indulge – you've earned it!

OTHER ONES • Flushing: 136-11 36th Ave., Queens 11354, (718) 661-3380

—*Mike Dooly*

Verlaine
Trendy Vietnamese lounge.
$$
110 Rivington St., Manhattan 10002
(between Essex St. and Stanton St.)
Phone (212) 614-2494

CATEGORY	Lounge
HOURS	Daily: 5 PM-4 AM
SUBWAY	Very close to the Essex/Delancey stop on the F,J,M, and Z; not too far from the 2nd Ave. stop on the F,V.
PAYMENT	
POPULAR DISH	Vietnamese tapas, including delicious spinach dumplings, chicken satay, spring rolls, and garlic shrimp
DRINKS	Lychee martini, Southeast sangria, ginger beer.
SEATING	Stand at the bar, or be seated in the lounge.
AMBIENCE/CLIENTELE	Swanky LES lounge where local hipsters flock for happy hour. Also a perfect date spot.
EXTRAS/NOTES	Not at all kid-friendly, but it's a beautiful spot for birthdays, dates, or dinners with friends. Happy hour 7 nights a week until 10 PM—$4 signature cocktails—make this a very popular spot among the writers and artists of the area.

—*Aly Walansky*

'wichcraft
(See p. 74)
Sandwich Shop
69 Prince St. (at Equinox gym), Manhattan 10012
Phone: (212) 780-0577

Wo-Hop Restaurant
In-the- basement cheap Chinese.
Since 1938
$$

17 Mott St., Manhattan 10013
(at Mosco St., just south of Bayard St.)
Phone (212) 962-8617

CATEGORY	Chinese
HOURS	24/7
SUBWAY	4, 5, 6, J, M, Z to Brooklyn Bridge/City Hall
PAYMENT	Cash only
POPULAR FOOD	Famous for wonton soup, chow fun, and all kinds of noodle dishes—but I go for the world class cold sesame noodles

MANHATTAN

UNIQUE FOOD All your favorite and familiar dishes are here, but some of the lesser known such as noodles with pickled cabbage and spicy meat sauce or the fried squid with salt and pepper are worth a try.
SEATING Forty at tables
AMBIENCE/CLIENTELE This place is just right after a long night drinking or policing, as the 4 am crowd is equal parts cops and tipsy civilians. Expect-no-frills décor and attentive service
EXTRAS/NOTES Buy a Wo-Hop dragon t-shirt on the way out (white for hipster, black for mod or hesher or sound guy) and your wardrobe is complete.

—Steve Powers

DOWNTOWN WEST

24 Prince
Comfort food with a side of chic.
$$$$
24 Prince St., Manhattan 10012
(between Mott St. and Elizabeth St.)
Phone (212) 226-8624
www.24prince.com

CATEGORY American
HOURS Mon: 5:30 PM-11 PM
Tues-Sun: 11 AM-Midnight
SUBWAY N,R,W to Prince St.; 6 to Spring St.
PAYMENT
POPULAR DISH Home-cooked classics take on a modern twist at this neighborhood spot where it's easy to get a table and hard to leave it. The mac & cheese with smoked Gouda and pancetta is the most celebrated dish on the menu. Since it's also available in a small plate portion, you won't have to miss Grandma Easy's fried chicken to try it.
UNIQUE DISH The lump crab fritters are surprisingly delicious—Panko breadcrumbs create the perfect crunch. The baked lollipop chicken wings are a relatively mess-less alternative to their cousins in the bucket.
DRINKS The cocktail list is inventive without being cloying. The caramel apple (vodka, apple schnapps, apple juice, and caramel) is dangerously easy to drink.
SEATING There's room for 52 inside the restaurant and 30 in the garden. When the weather is nice, it's well worth the wait.
AMBIENCE/CLIENTELE As the evening progresses, the crowd veers towards hip, but in the early hours it's a mixed bag. The homey setting could diffuse difficult situations such as a mishmash group from work or an overdue breakup.
EXTRAS/NOTES A snack menu is served in the afternoons from 3:30 PM to 5:30 PM. Bunch, Saturday and Sunday, 11am-3:30pm

—Marnie Hanel

MANHATTAN

Bubble Lounge
You don't need a special occasion to break out the bubbly
$$$$
228 W. Broadway, Manhattan 10013
(between Franklin St. and White St.)
Phone (212) 431-3433
www.bubblelounge.com

CATEGORY	Lounge
HOURS	Mon-Thurs: 5 PM-2 AM Fri/Sat: 5 PM-4 AM Sun: Closed
SUBWAY	Conveniently located half a block from the 1 train at Franklin Street, or about a 15 minute walk from the A,C,E Canal Street station.
PAYMENT	VISA MasterCard AMERICAN EXPRESS
POPULAR DISH	With all the bubbly, you'll need some classy nosh to keep the red from your cheeks. The lounge offers "tasters" to tease the appetite, as well as sandwiches and salads. For the late night crowd, I would suggest sticking to the small plates.
UNIQUE DISH	The tuna tartare blini is delicious, and the jumbo crab cakes with mango are solid, too. If sharing with only a few people, try the brie with smoked duck and fig sandwich. Large plates are available for bigger groups, but they're pretty pricey. Advice for couples: order the chocolate fondue with fresh strawberries—a great compliment to a romantic evening.
DRINKS	Champagne, of course. I have never seen such a variety of the bubbly. Take it straight up, or choose from a variety of creative cocktails and martinis. You also gotta try the flights. Where else will you find such a selection? For a more daring drink, try a bubbly margarita—champagne with a tequila kick.
SEATING	Cozy, elegant, intimate. This is the perfect place for a small group of friends or a romantic first date. The velvet couches and royally upholstered chairs bring all the grace and class of the nineteenth century right to the middle of TriBeCa. You'll feel like you're in the salon of the Vanderbilts, and they're having a party just for you.
AMBIENCE/CLIENTELE	Be prepared to cross paths with trendy downtown types and Wall Street brokers. Though swanky and hip, Bubble Lounge is refreshingly low on pretension.
EXTRAS/NOTES	The music is a great mix, not too intrusive to those having a conversation, but loud enough to put some kick in your step.

—*Tracey David*

Sushi Two Ways

If there's one thing that is not difficult to find in New York, it's good eats. From street vendors to five-star dining, the city that never sleeps definitely offers it all. And while paring down my favorite foods does tend to be difficult, sushi without a doubt

MANHATTAN

reigns at the top five of my list. But this is New York!?! How can one possibly choose amongst the hundreds of sushi places located throughout the city? Well, to be honest, it takes a lot of committed time and effort (and money) to evaluate the city's delectable sushi bites. I've narrowed my list down to two fundamentally different favorites.

For those who love a quiet, intimate setting with traditional Japanese fare, **Blue Ribbon Sushi** is just for you. Located off the beaten path of SoHo shopping, this traditional Japanese domo-style find is perfect. Offering detailed selections of sashimi and maki rolls alike, the fish is the freshest you'll find. There are even items flown in straight from Japan! Blue Ribbon will definitely satiate even the pickiest sushi diner. Though some may find the selections too simple, you can't beat the freshness and quality of their products, or their outstanding care and friendliness in service. *119 Sullivan St. (at Prince St.), Manhattan 10012, (212) 343-0404, www.blueribbonrestaurants.com/sushimanhattan_about.html*

With a new generation of foodies taking over, "traditional" has come to mean "boring" for some. For those seeking something different and unique, with a fun, "infused" twist, **Sushisamba** is the place. From the Samba Park Roll (Spicy Lobster Tempura with passion fruit) to the Tuna Sashimi with Red jalapeno chimichurri, this Japanese-Peruvian-Brazilian fusion wonder offers up fresh and inventive selections for those tired of tuna and avocado rolls. *245 Park Avenue South, Manhattan 10167, (212) 475-937 and 87 7th Avenue South, Manhattan 10014, (212) 691-7885, www.sushisamba.com*

—Tracey David

Café Habana
¿Cubana? Si, mama.
$$$
17 Prince St., Manhattan 10012
(at Elizabeth St.)
Phone (212) 625-2002

CATEGORY	Cuban
HOURS	Daily: 9 AM–Midnight
SUBWAY	N,R,W to Prince; B,F,V to Broadway-Lafayette
PAYMENT	VISA, MasterCard, American Express, Discover
POPULAR DISH	Day or night, the hottest little Cuban dive this side of Havana never disappoints. The huevos rancheros, enchiladas suizas, and traditional Cuban sandwich are all flavorful and authentic, but the grilled corn packed with cotija cheese and sprinkled with paprika draws the crowds. (Take advantage of the toothpicks served in tandem.)
UNIQUE DISH	The menu is consistently tasty. You could order blindfolded and you'd be pleased.
DRINKS	Full bar, selection of Dominican and Mexican beer, sangria.
SEATING	They don't take reservations, so prepare to stand in line. The restaurant seats about 40; the counter seats an additional handful.

MANHATTAN

AMBIENCE/CLIENTELE	A crammed diner filled with the neighborhood crowd, where the waitresses are as gorgeous as the clientele. It may not be romantic, but it sets the stage for a rollicking night.
EXTRAS/NOTES	If the wait is long and the smell of melted cheese and fresh pork start to drive you crazy, round the corner to the take-out window and picnic in Washington Square Park.
OTHER ONES	Its sister restaurant, Habana Outpost, is a favorite summertime hangout on Fulton Street in Fort Greene, Brooklyn.

—Marnie Hanel

Centovini
100 Reasons to sip and snack.
$$$$
25 W. Houston St., Manhattan 10012
(between Mercer St. and Greene St.)
Phone (212) 219-2113
www.centovinibar.com

CATEGORY	Trendy wine bar
HOURS	Mon-Sat: Noon-Midnight Sun: Noon-11 PM
SUBWAY	Parking is doable (there's a garage on Mercer), but thirsty patrons are better off taking the B,D,V, or F train to the Broadway/Lafayette stop and walking two-and-a-half blocks west.
PAYMENT	VISA, MasterCard, American Express, Discover
POPULAR DISH	There are separate Italian-inspired full menus for lunch and dinner, along with a weekend brunch menu. Each dish is meant to evoke a specific region or technique in the Italian gastronomic canon, and reflects the influence of co-owner Nicola Marzovilla's mother, Adoloratta, who makes all of the pastas by hand.
DRINKS	Wine (and specifically Italian wine) is the draw at this SoHo newcomer. At $17 a glass, the 2004 Antico Broilo Cabernet Franc isn't cheap, but it's worth every penny. From a winery and a varietal that are both en vogue right now (think 2007's Argentinian malbec), this particular Cab Franc comes from the Friuli region of Italy, which has been producing some of the world's best wines since the days of Napoleon. Like many wine bars, Centovini rounds out its wine list with the obligatory section of sparkling offerings. You'll get more than just the standard white and sweet varieties here, though; the effervescent red Lambrusco Mantovano is like drinking pop rocks.
SEATING	There is seating at the bar, as well as individual tables of two and four. Centovini isn't spacious but it's not hard to settle in and become comfortable.
AMBIENCE/CLIENTELE	With its expertly designed open, airy space, Centovini is the perfect place to tuck in for a glass of wine. Light and breezy during the day,

the mood turns cozy and warm by nightfall, and the clientele follows suit. The chandeliered dining room fills up quickly with local workers, models, and residents sipping from Zwiesel crystal glasses alongside suits and media types who've migrated from midtown in search of a place to mingle and unwind. And since Centovini is the result of a partnership between the owners of the design shop cum show space, Moss, and the owner of I Trulli restaurant, you'll no doubt see expense account groups talking business beside neighborhood artists whose nearby galleries have just closed for the night.

EXTRAS/NOTES The wine list is varied enough to please even the most discerning oenophiles, with virtually every region of Italy covered, including an impressively large amount of offerings from Friuli, the northeastern area in the Veneto bordering Slovenia. Friuli is one of the oldest wine regions in Italy and is renowned for its Cabernet Franc, Pinot Grigio and Schiopettino varietals. Additionally, Centovini doubles as a wine shop where you can purchase many of the wines you may have sampled and fallen in love with over the course of lunch or dinner.

—Jessica Tzerman

Crepe Café
Oh yeah, I'll eat a crepe on the street.
$

Corner of Prince St. and Broadway
(in front of the Swatch watch store)

CATEGORY Crepe cart
HOURS Sat/Sun: 11 AM-6 PM
SUBWAY N, R to Prince St.
PAYMENT Cash only
POPULAR FOOD Sweet and savory crepes of all kinds—try the super-filling Italienne made with mozzarella, marinara, and ricotta cheese or the *champignon* made with fresh mushroom; and for the ultra sweet lover, *dulce de leche* made with caramel milk and sugar
UNIQUE FOOD Argentinian *empanadas* stuffed with meat and fresh herbs
DRINKS Juice, soda, bottled water
SEATING Two can eat at the cart while standing, otherwise walk with it
AMBIENCE/CLIENTELE In the heart of one of the busiest corners of SoHo, a welcome addition to the hot dog, pretzel, and roasted nut street family
EXTRAS/NOTES Mon-Fri, Midtown West takes Crepe Café, which can be found on W. 53rd St. somewhere between Fifth and Sixth Aves. Same hours. Same food.

—Marie wEstrada

MANHATTAN

Ear Inn
*Grab a pint of old New York while
you still can.
Since the mid-1800's*
$$

326 Spring St., Manhattan 10013
(between Greenwich St. and Washington St.)
Phone (212) 226-9060

CATEGORY	Burger Joint
HOURS	Daily: 11 AM-4 AM
SUBWAY	1 to Houston St.; C,E to Spring St.
PAYMENT	VISA, MasterCard, American Express
POPULAR DISH	The burgers, which come with salad and roasted potatoes, are always a good bet.
UNIQUE DISH	With the construction of The Urban Glass House, a luxury residential high-rise next door, the endurance of this 19th-century establishment—which offers fare at as close to 19th-century prices as you'll find in SoHo, with many dishes under $10—seems even more remarkable. That, and the ghosts who've been known to haunt the place, including Mickey, a sailor who was hit by a car outside the Inn.
DRINKS	Many claim they pour the best pint of Guinness in New York City; good selection of single malt scotches and brandies.
SEATING	Tables for two and four in the front near the bar; tables in the back are often pushed together to accommodate larger parties.
AMBIENCE/CLIENTELE	Weekends draw more of the twenty- and thirty-something hipster crowd, but you are often bound to find some mix of locals, bikers, artists, writers, and old-timers, who've been coming round for over 25 years.
EXTRAS/NOTES	Built in 1817, the James Brown House is one of the few Federal houses remaining in NYC, and is now a designated landmark on the National Register of Historic Places. The apartment upstairs has over the years served as a boardinghouse, a smugglers' den, and a brothel. What is now the Ear Inn had been a brewery in the mid-1800's, then a speakeasy during Prohibition. It wasn't until 1977 that the name "Ear Inn" was bestowed. (After Prohibition the bar had no formal name and was commonly known as "The Green Door.") A new sign would have required a review by the Landmark Commission, so the "B" in the existing neon "BAR" sign was painted over to read "EAR," naming the bar after the Ear Magazine, which was published upstairs. A row of old bottles and jugs taken from the brewery's cellar now stands above the bar, reminding you, along with the 19th-century windows and door, just how long this place has been around. Make sure you obey the signs and don't use your cell phone (there's a phone booth inside). Happy Hour Mon-Fri, 4-7 PM, $1 off all drinks. Kitchen closes at 2 AM Sun-Thu; 3 AM Fri & Sat. Brunch on Sundays. Live music Mon-Wed nights. Poetry reading series every Sat at 3 PM.

—*Jane Elias*

MANHATTAN

Hampton Chutney Co.
Out-of-this-world Indian flavors, by way of Long Island.
$$$
68 Prince St., Manhattan 10012
(at Broadway)
Phone (212) 226-9996 • Fax (212) 226-7278
www.hamptonchutney.com

CATEGORY	Indian Sandwich Shop
HOURS	Daily: 11 AM–9 PM
SUBWAY	N, R to Houston St.
PAYMENT	VISA, MasterCard, American Express
POPULAR FOOD	Specialties are *dosas* and *uttapas*, enormous savory sandwich crepes made from an out-of-this-world sourdough rice pancake (*dosas* are thin; *uttapas* are thicker), stuffed with all manner of delicious Indian and American goodies such as *kalamata* olives, Indian-spiced potato, asparagus, goat cheese, grilled portabello, and curry chutney chicken, and served with your choice of six eponymous chutneys in flavors like pumpkin, curry, cilantro, and peanut.
DRINKS	Try their very special cardamom coffee, a spiced hot milk and coffee concoction that is at once exotic and comforting; BYO for alcohol
SEATING	Three tables and seats at the counter make room for about 19
AMBIENCE/CLIENTELE	Very informal; mostly caters to the neighborhood
EXTRAS/NOTES	Any of the *dosas* or *uttapas* is huge enough to share with a friend. I highly recommend the curry chutney chicken, spinach, and balsamic roasted onion *dosa*. As the name indicates, they started as an actual chutney company in Amangansett, Long Island, and opened their first restaurant there. If you plan to be in the neighborhood, call ahead for details: (631) 267-3131.

—*Joanna Jacobs*

Ivo & Lulu
No lame ducks (confit) served here.
$$$
558 Broome St., Manhattan 10013
(at Varick St.)
Phone (212) 226-4399

CATEGORY	Caribbean
HOURS	Tues-Sat: 6 PM-11 PM
PARKING	Street parking is nonexistent. Take the 1 or 9 to Varick/Canal or the A,C,E to Grand St.
PAYMENT	Cash only
POPULAR DISH	Baked d'Anjou pear with blue cheese in clover honey & garlic oil
UNIQUE DISH	Try the boar sage sausage with blueberry sauce or the broiled chicken with goat cheese papaya puree.
DRINKS	BYOB
SEATING	The space is really narrow with less than a dozen small tables, including one prime window seat.
AMBIENCE/CLIENTELE	The vibe is funky, with an island feel befitting the Caribbean food and atmosphere. The mix

MANHATTAN

	of couples and groups of four varies from night to night, but you'll see artists, trendy SoHo residents, and people looking for an out-of-the-way, but not out-of-the-scene, place to find quality cheap food.
EXTRAS/NOTES	Despite its dim lighting and intimate interior, this often-overlooked gem on the outskirts of western SoHo truly sparkles and shines, and the short seasonal menu is so affordable visitors can afford to splurge on a nice bottle of wine to bring to dinner. Expect a wait after 7 PM on Fridays and Saturdays.
OTHER ONES	Ivo & Lulu is an off-shoot of the popular uptown BYO spot "A".

—*Jessica Tzerman*

Karahi Indian Cuisine
Chicken tikka masala so good you'll order it three times a week for a year.
$$$
508 Broome St., Manhattan 10013
(between W. Broadway and Thompson St.)
Phone (212) 965-1515 • Fax (212) 219-9766
www.karahi.com

CATEGORY	Northern Indian
SUBWAY	A, C, E to Canal St.
HOURS	Mon-Sat: Noon–3 PM (buffet lunch) Mon-Sun: 5 PM–10:30 PM
PAYMENT	VISA MasterCard AMERICAN EXPRESS
POPULAR FOOD	Curry, lamb *vindaloo*, *moiley*, and tadoori chicken; 11 course buffet lunch (entrees change daily)
UNIQUE FOOD	*Murg tikka masala*; *kulfi* (specialty from India: thickened milk, cooked for several hours, then frozen, which has nutty taste of almonds and pistachios)
DRINKS	Full bar, lassi, sweet, salty, mango, coffee, tea, juices (orange, mango, cranberry), soda
SEATING	Tables for 65
AMBIENCE/CLIENTELE	As different from Sixth St. Christmas lights and tinsel as you can get—tastefully decorated, warm woods inflected with bright colors—and authentic Indian ornamentation
EXTRAS/NOTES	Karahi earns high marks for its perfect presentation of any and all Indian delicacies. A newcomer with the determination to prove itself in a field crowded with old-timers resting on their laurels.

—*Steve Powers*

Lovely Day
The perfect spot to Thai one on.
$$$
196 Elizabeth St., Manhattan 10012
(between Prince St. and Spring St.)
Phone (212) 925-3310

CATEGORY	Thai
HOURS	Daily: Noon-11 PM

MANHATTAN

PARKING	Some street parking, though the best method is the 6 train to Spring St. or the B,D,F,V to Broadway/Lafayette.
PAYMENT	American Express
POPULAR DISH	Regulars keep coming back for the sublimely crunchy ginger fried chicken with spicy aioli and lime.
UNIQUE DISH	The pork chop with mashed potatoes, thyme and sautéed Fuji apples (dinner only) is a stand-out on this Asian-inspired menu. And though mostly organic (with a few vegan offerings), Lovely Day also offers, surprisingly, a delicious BLT.
DRINKS	The beer margarita is unbelievably refreshing. They also serve a delicious green tea latte and have an enviable selection of Thai teas.
SEATING	The restaurant is larger than most neighborhood joints, with tables, spacious booths, and spots to eat at the bar. There are also sidewalk benches for those who enjoy people-watching and al fresco dining.
AMBIENCE/CLIENTELE	Though the food is always fresh and would be worth the trip from any place in the city, Lovely Day is not a destination dining spot. Neighborhood regulars check in daily for their "usual" breakfast, lunch, and dinner picks. And the servers all seem to be on the verge of making it big in the acting or music scene, so, if you're like me, you'll always feel a little cooler just for having eaten there.
EXTRAS/NOTES	Neighborhood regulars congregate in front of the restaurant to share a laugh, a cup of tea, or, most frequently, just to be a part of the artsy, hipster scene. Though people will wait for hours for a table, the best seats are at the bar where you can watch the food being made and hear the servers gossip about the regulars.

—*Jessica Tzerman*

Lupe's East L.A. Kitchen
It's tough to find good Mexican food in New York, but Lupe's comes through strong.
$$
110 Sixth Ave., Manhattan 10013
(corner of Watts St.)
Phone (212) 966-1326

CATEGORY	Mexican Diner
HOURS	Sun-Tues: 11:30 AM-11 PM Weds-Sat: 11:30 AM-Midnight
SUBWAY	A, C, E, to Canal St.
PAYMENT	Cash only
POPULAR FOOD	Those in the know go for the chili *relleno* (mild green chili stuffed with cheese and served with two sauces) or the *pollo norteño* (pieces of marinated chicken breast grilled with onions, tomatoes, and grilled chilis); all entrees served with rice, beans, and salad.
UNIQUE FOOD	Staple Mexican fare prepared uniquely; enchiladas *suizas* (chicken, cheese, sour cream in a green chili sauce); enchiladas *mole* (chicken in a

MANHATTAN

	dark chili sauce of 20 ingredients—including chocolate)
DRINKS	Domestic and Mexican beer, tequila, *Café con leche*, Mexican hot chocolate, Mexican soda, *agua frescas*
SEATING	About 50 at tables
AMBIENCE/CLIENTELE	All the elements of East LA are subtley displayed in this clean diner with wonderful Mexican music lingering with the chatter of customers
EXTRAS/NOTES	Can't-believe-it-super-cheap weekend brunch menu (Sat/Sun: 11:30 am-4 pm). Plenty of fat burritos, quesadillas, tamales, and tacos for vegetarians and non-vegetarians as well. This is legit East LA Mexican food—down to the freshly made *horchata*.

—*Steve Powers*

How Do You Say HUNGRY? In... AFRICA

Amheric or **Amarënya** (Ethiopia): *rabeny t'emany!* Pronounce the 'e' as in her and 'ny' as in canyon
Hausa (Northern Nigeria, Niger):
I'd like breakfast: *ina son karin*. Sounds like: eena sawn carin.
I'd like lunch: *ina son kumallo*. Sounds like: eena sawn coomawloh.
I'd like dinner: *ina son abincin*. Sounds like: eena sawn abinchin.
Swahili (Kenya, also Tanzania and Uganda): *nina njaa!*
Wolof (Senegal, Coastal Gambia): *da ma xiif*. Sounds like: daw maw kif.

M & O Grocery & Imported & Domestic Products

This is where to get a great sandwich on Portuguese bread.
124 Thompson St., Manhattan 10012
(corner of Prince St.)
Phone (212) 477-8222

CATEGORY	Deli
HOURS	Daily: 7:30 AM-1:30 AM
SUBWAY	C, E to Prince St.
PAYMENT	Cash only
POPULAR FOOD	Go on Tuesday or Friday and get the perfectly prepared turkey sandwich; otherwise, sandwiches of all kinds made with freshly baked meats are available every day of the week (salami, roast beef, pork loin, meatloaf, pastrami, or spiced ham); meatballs
UNIQUE FOOD	BLT with M & O's special tangy fresh herb dressing; M & O potato and spinach knishes
DRINKS	Sodas, vitamin waters, juices, coffee, tea
SEATING	Carry out only—eat the sandwich while window shopping at the never-ending row upon row of SoHo boutiques.
AMBIENCE/CLIENTELE	Larger than an average deli, smaller than a big grocery—expect lunch lines ten deep, but the staff is fast and friendly.

—*Steve Powers*

MANHATTAN

Once Upon a Tart
One tart, two tart, three tarts and more.
$$
135 Sullivan St., Manhattan 10012
(between Houston St. and Prince St.)
Phone (212) 387-8869 • Fax (212) 387-9330
www.onceuponatart.com

CATEGORY	French Bakery
HOURS	Mon-Fri: 8 AM-7 PM
	Sat: 9 AM-7 PM
	Sun: 9 AM-6 PM
SUBWAY	1 to Houston or A,C,E,B,D,F,V to W. 4th St.
PAYMENT	VISA MasterCard AMERICAN EXPRESS
POPULAR DISH	Any of the sweet tarts, sweet breads, muffins or sandwiches.
UNIQUE DISH	A small gem in SoHo, perfect for a shopping break, coffee break, or the occasional celeb sighting.
DRINKS	No alcohol here, but there are a number of delicious coffee concoctions.
SEATING	Small Café-style tables both indoors and out. The space is tight, so plan to sit within earshot of another table.
AMBIENCE/CLIENTELE	A mix of everything: NYU students, lost shoppers who've ventured to the edge of SoHo, celebs. All in all an ideal place to people-watch for a spell.

—*Pamela Schultz*

Palacinka
A crepe place for lunch or dinner.
$$$
28 Grand Street, New York 10013
(between Thompson St. and 6th Ave.)
Phone (212) 625-0362

CATEGORY	European Café
HOURS	Daily: 10:30 AM-11:30 PM
SUBWAY	Take the A,C,E to Canal Street or 1,9 to Varick Street.
PAYMENT	Cash only
POPULAR DISH	The crepes are all to-die-for and off-the-press fresh at this secret SoHo spot. If you crave savory, the ham, gruyere, and egg crepe is always done to golden perfection: soft-yet-crunchy on the outside with gooey deliciousness in the middle. For dessert (or a sweet meal), try the crepes with caramelized bananas and nutella.
UNIQUE DISH	Though the crepes are the stars, neighborhood regulars always go for the panini. The chicken, ham and gruyere panino is a favorite, and anything with their homemade olive tapenade is a winner. As an added bonus, the coffee is hands-down the best cup of Joe in the city.
DRINKS	Beer, wine and liquor, along with specialty cocktails made from hand-squeezed juices and eclectic sodas.
SEATING	The space is small, but there are communal tables, stand-alone two tops and stools at the window suitable for parties of all shapes and sizes.

MANHATTAN

AMBIENCE/CLIENTELE	The scene is like being in a young, well-run, laid back cafe in any European capital: trendy and cool without being self-consciously so. This is not the place for models, hipsters, and those who generally want to be seen; however, brunch and lunchtime regulars and first-timers all tend to be uncannily attractive and interesting. At night, when the mood changes and the lights go down, there's a definite artsy, creative vibe and it becomes crystal clear why they film so many movies here.
EXTRAS/NOTES	The waits are long, but the food and the happy, casual atmosphere it's served in are totally worth it. And there's always lots of SoHo people-watching to pass the time.

—Jessica Tzerman

Pravda
A note from underground: this is the premier vodka cocktail lounge.
$$$$
281 Lafayette St., Manhattan 10012
(between Houston St. and Prince St.)
Phone (212) 226-4944
www.pravdany.com

CATEGORY	Lounge
HOURS	Mon-Weds: 5 PM-1 AM Thurs: 5 PM-2 AM Fri/Sat: 5 PM-3 AM Sun: 6 PM-1 AM
SUBWAY	6 train to Spring St.; N,R trains to Prince St.; B,F trains to Broadway/Lafayette St. Best to take the subway or grab a taxi, as street parking is always a struggle.
PAYMENT	VISA MasterCard AMERICAN EXPRESS DISCOVER
POPULAR DISH	They do offer a full dinner menu, chock full of Russian delights like chicken Kiev, caviar, and blinis—all stylishly executed.
UNIQUE DISH	Try the blini and potato pancakes with smoked salmon or the crispy horseradish oysters—yum!
DRINKS	Anything you could think of with vodka. With over 70 different vodkas, 10 of which are infused in-house, you can't miss. The Leninade is a classic combination of citrus vodka, lemon juice, and fresh mint, and the Vladimir martini is an inventive blend of fig vodka and Russian tea syrup. For the gin lovers, the winter pear martini combines fresh pear puree with prosecco and gin—daring flavors, sure, but the taste is wonderful!
SEATING	Can work for larger parties, but it's always best to call ahead. The place itself is like a swanky basement, with intimate booths and tables scattered throughout. No real "private" rooms for parties, but there is a small upstairs bar that is good for couples or small groups.
AMBIENCE/CLIENTELE	At first glance, Pravda appears to be little more than an inconspicuous stairwell leading into a dark basement. As soon as you enter, though, you'll be enveloped by the music and the cozy vibe. Though the décor is reminiscent of a

MANHATTAN

grand, eighteenth-century Russian parlor, the atmosphere remains casual and friendly. This is a great place to impress a vodka-swilling date.

EXTRAS/NOTES Like a McDonald's in post-glasnost Moscow, there's usually a line to get in. You don't have to be a celebrity, though, just be patient and your turn will come.

OTHER ONES Sister restaurants include Balthazar, Pastis, Lucky Strike, and Schiller's.

—Tracey David

EAST VILLAGE

7A Café
24-hour drinking and dining with East Village locals.
$$$
109 Ave. A, Manhattan 10009
(at 7th St.)
Phone (212) 475-9001
www.7Acafe.com

CATEGORY Café
HOURS 24/7
SUBWAY Take the F,V to Houston St., or the L to 1st Ave.
PAYMENT VISA MasterCard American Express
POPULAR DISH The nachos (fabled to be the best in the city) and the Greek salad are favorites. Brunch is also hugely popular. For $9.95 you get an entrée (try the Brioche French Toast), coffee or tea, and your choice of house wine, screwdriver, mimosa, bloody mary, or fresh-squeezed orange juice. The food here won't wow you, but you will be satisfied every time, and the prices are tough to beat. The salads are impressively fresh and crunchy.
UNIQUE DISH Mango gazpacho (not always on the menu, but worth asking your waiter for); shrimp and portobello sandwich with fresh tomato and basil on French bread.
DRINKS Great specialty cocktails for $7-$8.
SEATING The dining room is fairly small, but there's both indoor and outdoor seating. It's ridiculously crowded for brunch, though, so be prepared to wait.
AMBIENCE/CLIENTELE Dimly lit with a funky feel, 7A is a gathering spot for those East Village hipsters looking for tasty, affordable food, whether at 3 AM or 4 PM.
EXTRAS/NOTES 2-for-1 Happy Hour drinks, weekdays from 1 PM to 7 PM. Breakfast dishes served from 2 AM until 5 PM. Brunch on weekends and public holidays from 10 AM to 5 PM.

—Laura Lee Mattingly

MANHATTAN

Angel's Share
Expertly mixed cocktails served with civility.
$$$
8 Stuyvesant St., New York 10003
(between 9th St. and 3rd Ave.)
Phone (212) 777-5415

CATEGORY	Japanese
HOURS	Daily: 6 PM-2 AM
SUBWAY	6 to Astor Pl.; N,Q,R,W to 8th St.
PAYMENT	VISA MasterCard American Express
POPULAR DISH	The bar serves up tasty appetizers to accompany your swanky cocktail, such as the sashimi assortment ($12) and the dim sum plate ($8).
DRINKS	The extensive drink menu covers everything from Irish coffee to Japanese whiskey, but to make the most of your visit, try one of the jazzy "original cocktails" ($10-$12), like Scenes in the City (citron, lychee liquer, and grapefruit juice), Love Supreme (eau du vie, framboise, calpico, lemon juice, and champagne), or Moment's Notice (plum wine, sake, peach liquer, yamamomo).
SEATING	Sit at the bar and gaze at the mural painted above it, or, if you prefer, grab one of the few booths in the front room. The back room, with its warm leather banquettes and elegant chandeliers, offers additional intimate seating.
AMBIENCE/CLIENTELE	The mostly twenties and thirties crowd here enjoys quiet conversation and delicious pre- or post-dinner drinks. The orange-painted walls, dim lighting, and draped windows overlooking Third Ave. and Stuyvesant St. make for a serene oasis within the more bustling restaurant on the same floor.
EXTRAS/NOTES	A truly hidden gem: walk up the stairs and through the Japanese restaurant and you'll find Angel's Share behind an unmarked wooden door, beside which is a sign bearing "the rules" (no parties larger than four, no yelling, no screaming). And there's no standing, either, which is a pleasure because it means one of the crisply-dressed servers, in white shirt, black vest, and tie, will promptly attend to your party and seat you. This can sometimes mean a wait, but it's worth it.

—*Jane Elias*

B & H Dairy Restaurant
From the shtetl to the city.
Since 1938
$$
127 2nd Ave., Manhattan 10003
(between St. Mark's Pl. and E. Seventh St.)
Phone (212) 505-8065

CATEGORY	Jewish Dairy Kosher Vegetarian
HOURS	Daily: 7am-11pm
SUBWAY	N, R to Eighth St., 6 to Astor Pl.
PAYMENT	MasterCard VISA
POPULAR FOOD	For breakfast, the "famous" challah French toast; for dinner, daily specials of such favorites as

MANHATTAN

	blintzes, *pierogies,* smoked whitefish, and potato pancakes all served with a cup of soup; a number of vegetarian entrées
UNIQUE FOOD	Soups (vegetable, mushroom barley, lentil, split pea, cabbage, potato, lima bean, hot borscht, matzo ball, yankee bean), plus delicious buttered challa, make for an excellent meal by themselves; as with most kosher Jewish cuisine, the food is hearty but calm to the palate.
DRINKS	Fresh-squeezed juices, tea, coffee, soda
SEATING	12 at small tables, 10 at counter
AMBIENCE/CLIENTELE	B & H serves mostly locals in a cramped, unremarkable, diner-like interior, where the countermen are gruff but friendly—just how New Yorkers like it.

—*Peter Davis*

Babycakes
Enjoy guilt-free gluttony at this vegan bakery.
$

248 Broome St, Manhattan 10002
(between Orchard St and Ludlow St.)
Phone (212) 677-5047
www.babycakesnyc.com

CATEGORY	Armenian
HOURS	Mon: Closed Tues-Thurs: 10 AM-10 PM Fri/Sat: 10 AM-11 PM Sun: 10 AM-8 PM
SUBWAY	F,V,J,M,Z to Delancey Street or the B,D to Grand Street
PAYMENT	VISA MasterCard
POPULAR DISH	I am in love with the vegan sugar-free chocolate cupcakes with chocolate icing.
UNIQUE DISH	Everything is all natural at this vegan bakery, but you can still have yummy cakes, cookies, brownies, and cupcakes. Delicious coffee, too.
DRINKS	Coffee and tea are a perfect way to wash down your snack.
SEATING	There's limited seating near the front, but this is not the place for large groups.
AMBIENCE/CLIENTELE	This is a neighborhood joint where the staff is friendly and helpful and will teach you about the different varieties of goods.
EXTRAS/NOTES	I'm a little psycho about my diet options (unless in booze form), so a guilt-free cupcake has my name all over it. The chocolate icing is super yum too. Seriously, even those who don't care for organic/vegan/healthy desserts should give this place a try.

—*Aly Walansky*

MANHATTAN

Brunch

What's Brunch? As usual, a character from the Simpsons explained it best. In this case, bowling-alley gigolo Jacques, who said: "You'd love it. It's not quite breakfast, it's not quite lunch, but it comes with a slice of cantaloupe at the end. You don't get completely what you would at breakfast, but you get a good meal."

Here are just a few places to get it in New York . . .

Cafeteria
119 Seventh Ave. (at 17th St.), Manhattan
(212) 414-1717
Just like your high school's cafeteria…if you went to Beverly Hills 90210. "Upscale American comfort food" and booze. *Sat/Sun 11 am-5 pm*

Foodbar
149 Eighth Ave. (btwn 17th & 18th Sts.), Manhattan
(212) 243-2020
Hot boys, hot wait staff, full on *gay fabulous*—but also full on fun. Skip the mimosa or bloody Mary and go for the watermelon margarita. *Brunch served Sat/Sun 11 am-4:30 pm*

The Comfort Diner
214 E. 45th St. (at Third Ave.), Manhattan
(212) 867-4555
142 E. 86th St. (at Lexington Ave.), Manhattan
(212) 426-8600
Comfort food in a comfy setting…great for when friends visit from the Midwest. No alcohol. *Brunch served Sat/Sun 9 am-4 pm*

Sarabeth's West
423 Amsterdam Ave. (btwn 80th and 81st Sts.), Manhattan
(212) 496-6280
Fab omelets, pancakes and waffles don't necessarily fit our criteria for cheap eats…but it is THE place to go for the lady who brunches. Bar. *Brunch served Sat/Sun 8 am-4 pm*

The Viceroy
160 Eight Ave. (at 18th St.), Manhattan
(212) 633-8484
Great people-watching during brunch and an even better spot to be watched. Scrumptious prix fix menu and champagne mimosas. *Brunch served Sat/Sun 11 am-5 pm*

Sylvia's
328 Malcolm X Blvd. (btwn 126th and 127th Sts.), Manhattan
(212) 996-0660
A bit out of our price range, but worth a splurge. Go early and beat the after church crowd. Yes, you want everything covered in gravy. Full bar. *Brunch served Sat/Sun 12:30 pm-4 pm*

Paris Commune
411 Bleeker St. (btwn 11th & Bank Sts.), Manhattan
(212) 929-0509
Grab a book and some smokes and experience what brunching is all about. Not quite a French café, and not quite the kind of place Louise Michel would have hung around, it's a popular hot spot.

MANHATTAN

So be prepared to wait outside. Omelets, French toast, pancakes, alcohol. *Brunch served everyday 11 am-3:30 pm (starts 10 am on Sat/Sun.)*

Flea Market
131 Ave. A (btwn St. Marks's and 9th St.), Manhattan
(212) 358-9280
There's this small cafe in Paris….wait, we're not in Paris? Alcohol served. *Brunch served Sat/Sun 10 am-4 pm*

Rocking Horse Mexican Cafe
182 Eighth Ave. (btwn 19th & 20th Sts.), Manhattan
(212) 463-9511
Inventive Mexican brunch, *huevos rancheros*—yum yum. Full bar. *Brunch served Sat/Sun 11 am-3:30 pm*

EJ's Luncheonette
447 Amsterdam Ave. (at 81st St.), Manhattan
(212) 873-3444
Diner fare and a child friendly environment. Beer and wine. *Brunch served Sat/Sun 8:30 am-3 pm*

Old Devil Moon
511 E 12th St. (btwn Ave. A & Ave. B), Manhattan
(212) 475-4357
Showcases the glorious culinary achievements of the "White Trash" culture so many New Yorkers disdain. Southern Food with veggie selections. Beer and wine. *Brunch served Sat/Sun 10 am-4 pm*

Tea & Sympathy
108-110 Greenwich Ave. (at Seventh Ave.), Manhattan
(212) 807-8329
What is there to say except that this tiny place is a fave? We don't really want you to go 'cause then we won't get in. Standard British fare in a small, bustling café setting. Bring Your Own Bottle. *Brunch served Sat/Sun 9:30 am-1:30 pm*

—*Michael Connor*

Bread and Olive
(See p. 2)
Middle Eastern
210 E. 14th St. (between Second Ave. and Third Ave.), Manhattan 10003
Phone: (212) 254-9500

Burritoville
(See p. 81)
Mexican
141 Second Ave., Manhattan 10003
Phone: (212) 260-3300

MANHATTAN

Chickpea
Fala-full for under $10!
$$
23 Third Ave., Manhattan 10003
(between St. Mark's Pl. and E. 9th St.)
Phone (212) 228-3445
www.getchickpea.com

CATEGORY	Middle Eastern
HOURS	Mon-Weds: 10 AM-1 AM
	Thurs/Fri: 10 AM-4 AM
	Sat: 10 AM-5 AM
	Sun: 10 AM-1 AM
SUBWAY	6 to Astor Place
PAYMENT	VISA MasterCard American Express Discover
POPULAR DISH	Shawarma (turkey with lamb or chicken available) and falafel are main staples here. Have it dished up as a platter with salad and rice, or go for the pita sandwich: your choice of filling cozied up next to chopped salad and hummus. Really hungry? Get the combo for $3 more and add a soup and a drink to your meal. If you have a sweet tooth, baklava and honey cake make appealing desserts.
UNIQUE DISH	Can't decide between shawarma or falafel? Try the shawafel, an intriguing combination of both. Also, Chickpea happens to be kosher, so you can indulge without the guilt.
DRINKS	Juice, water, soda, iced tea, lemonata.
SEATING	A few small tables in the front and in the back, along with counter space along the wall. This is not the best place for a big group. During peak meal times, it's better to get take-out or delivery, as it can get pretty crowded.
AMBIENCE/CLIENTELE	Picture a clean, fast McDonalds and replace burgers with falafel and grease with greens: you're getting close to Chickpea's vibe. Hipsters, students, and office workers alike flock to this joint at meal times, but the crowd becomes a little more homogenous at night as the bar and night life crowd seeks a healthy pick-me-up in between scenes. While it's clean and efficient, it's not exactly cozy—definitely not a place to impress a date or linger.
EXTRAS/NOTES	Thanks to two different locations, their delivery range is quite large, extending from E. 28th St. to Broome St. going North/South, and Ave. C to 6th Ave. going East/West. Delivery minimum is $10. Factoid: Chickpea got its name when the owners, Erez Itzhaki and Nissim Oron, held an internet contest; the winning moniker came from a Brooklyn resident.
OTHER ONES	• 210 E. 14th St. (between Second Ave. and Third Ave.), Manhattan 10003, (212) 254-9500

—*Jennifer Treuting*

Chino's
(See p. 83
Pan-Asian
173 3rd Ave., Manhattan 10003
Phone (212) 578-1200

MANHATTAN

Crif Dogs
Where dogs go to get hot.
$
113 Saint Marks Pl.,
Manhattan 10009
(between First Ave. and Ave. A)
Phone (212) 614-2748

CATEGORY	Hipster bar/restaurant
HOURS	Mon: Noon-Midnight
	Tues-Thurs: Noon-2 AM
	Fri/Sat: Noon-4 AM
	Sun: Noon-Midnight
SUBWAY	Parking is a nightmare; you can get there taking the 4,5,6 to Astor Place.
PAYMENT	Cash only
POPULAR DISH	The Sourcheese Dog, topped with thin-sliced sour pickles and melted cheddar cheese, is a culinary masterpiece the French can't (or maybe won't) take credit for.
UNIQUE DISH	If you're feeling daring, try the Spicy Redneck, a bacon-wrapped hot dog, heaped with chili, coleslaw, and jalapenos. Bubba never saw it coming.
DRINKS	Beer, margaritas
SEATING	One dining room, generally not too crowded. A bar makes it easy if you're just looking to eat and run, and smaller tables allow you to kick back with your friends.
AMBIENCE/CLIENTELE	Crif's is a chill hipster hangout with lots of attitude. In what other restaurant does the CPR sign begin with "Hey Assholes"? It's got that New York charm down pat.
EXTRAS/NOTES	A guaranteed cure for any Sunday hangover, but if you're not in the mood for one of the dogs, you can just chill and play old-school 80's video games, or watch trash-talking comedians on the television.

—Mary Higgins

El Castillo de Jagua Restaurant
The perfect place for comfort food after a night drinking on Ludlow.
$$
113 Rivington St., Manhattan 10002
(corner of Essex St.)
Phone (212) 982-6412/3

CATEGORY	Dominican
SUBWAY	F,V to Second Ave. or Delancey St.
HOURS	Daily: 8 AM-Midnight
PAYMENT	Cash only
POPULAR FOOD	Rice and beans: fortunately they come with just about everything and go perfectly with popular dishes such as fried chunks of chicken, roast pork, and Dominican style fried beef. Wash it all down with a papaya milkshake or a *Café con leche*.
UNIQUE FOOD	Why not try the *mofongo*—mashed green plantains with pork skin, seasoned with garlic

MANHATTAN

and salt, or the *pescado en escabeche* (pickled fish), or *pulpo enchilado* (octopus in hot sauce)?
DRINKS Natural juices, fruit milk shakes, *Café con leche*, tea, soda
SEATING About 65 at tables, including counter seating
AMBIENCE/CLIENTELE Always busy, and filled with East Village old timers, new timers, Dominican teens, lone diners, and families—point if you don't speak Spanish.
EXTRAS/NOTES Some seafood specialties of the house can get quite pricey—otherwise you can eat tremendously well for under eight bucks.

—Marie Estrada

Elvie's Turo-Turo
Point and eat till you drop—for under $10.
$$
214 First Ave., Manhattan 10009
(between E. 12th and E. 13th Sts.)
Phone (212) 473-7785

CATEGORY Filipino
HOURS Daily: 11 AM-9 PM
SUBWAY L to First Ave., 4, 5, 6, N, R to Union Sq.
PAYMENT VISA, MasterCard, American Express
POPULAR FOOD *Adobo* (meat simmered in vinegar, garlic, and soy sauce); barbecue; *longanisa* (spicy pork sausage); *nilaga* (stew); *pinakbet* (sautéed vegetables with fish paste); *halo-halo* (tropical fruits on shaved ice drizzled with milk and topped with yam-flavored ice cream and flan)
UNIQUE FOOD *Paksiw na lechon* (pig's trotters simmered in vinegar and soy sauce); *dinuguan* (pig's blood stew); assorted rice cakes; *turon* (caramelized bananas fried in spring roll wrappers); *puto bumbong* (sticky rice roll steamed in bamboo and rolled in coconut); *balut* (duck embryos)
DRINKS *Sarsi* (the native sarsaparilla) and other sodas, *buko* (young coconut) and mango juices
SEATING 18 at tables
AMBIENCE/CLIENTELE Filipinos and others, students, tourists—a generally eclectic bunch typical of the neighborhood—discover the joys of meat and sweet, sticky snacks at this cheerfully decorated, friendly cafeteria.
EXTRAS/NOTES Take a tray, point to what you want (*turo turo* means "point, point"), and pay up. The menu is on the blackboard behind the counter and changes daily. Most entrées are served with a mountain of rice. And yes, you can get vegetables and fish here, too. Die-hard vegetarians can also console themselves with sublimely sticky, rich Filipino desserts, particularly the mountainous *halo-halo*, silky *leche* flan, *ube* (purple yam jam) and vari-colored rice cakes. The cassava cake, baked with coconut milk and sugar, will totally change your perception of root crops.

—Melissa Contreras

42

MANHATTAN

Flor's Kitchen
Don't have a Venezuelan grandmother?
Flor's more than makes up for it.
$$$
149 First Ave., Manhattan 10003
(at E. Ninth St.)
Phone (212) 387-8949
http://www.florskitchen.com

CATEGORY	Venezuelan
HOURS	Sun-Thurs: 11 AM-11 PM
	Fri/Sat: 11 AM-Midnight
SUBWAY	6, N, R to Astor Pl.
PAYMENT	VISA MasterCard AMERICAN EXPRESS
POPULAR FOOD	The barbecue gets high marks—look for the magic word: *Asado. Criollas empanadas*, flaky, fried dough pockets, full of spiced goodies, also keep the crowds coming.
UNIQUE FOOD	*Arepas*, Venezuela's answer to the Mexican tortilla: "fried cornmeal" price, *apepas* taste
DRINKS	Beer, wine, Sangria, tea, coffee, fresh juices including pineapple and guava
SEATING	Seats approximately 18
AMBIENCE/CLIENTELE	Hip east-siders, along with others who have heard about the authentic Venezuelan meals served here, often form lines for the tiny, colorful, cozy seating area makes you feel as though you're in someone's kitchen. The heavenly smells only add to the effect

—*Tanya LaPlante*

How Do You Say HUNGRY? In...
ASIA

Mandarin: *wo en le!* Sounds like: Waw (rhymes with raw) uh luh!
Literally means: I'm hungry already!
Cantonese: *nogH touH nogH!* Sounds like: Naw (deeper sound, like "bog") toe naw!
Literally means: My stomach's hungry! Idiomatically, this is more common than just saying "I'm hungry."
(You may notice that the Cantonese version is very difficult, especially since "I" and "hungry" are very close (but actually sound very different). Don't ask me why there are capital H's everywhere—that's how Yale does it.
Hokkien: *gua ya iyao!*
Hindi: *aap ko bhook lagi hai.* Sounds like: awppkoh booklawgeehey) – 'g' is gutteral.
Japanese: *onaka ga suki mashita.*
Korean: *bego pawyo.* 'e' in pego is pronounced like e in leg. bae-ko-p'a-yo
Maylay or **Bahasa Indonesia** or **Bahasa Melayu** (Brunei, Indonesia, Singapore): *Saya mau makan*. Literally means: I want to eat!
Tibetan: *nga throgaw-tog giy du.*

MANHATTAN

Frank Restaurant
(See p. 49)
Italian
88 2nd Ave (between 4th
and 5th St.)
Phone: (212) 420-0202.

Frank Restaurant
(See p. 49)
Italian
88 2nd Ave (between 4th and 5th St.), (212) 420-0202.
Phone: (212) 391-7772

Frutti di Mare
Comfort Italian for the anti-foodsnob.
$$$
84 E. 4th St., Manhattan 10003
(at 2nd Ave.)
Phone (212) 979-2034 • Fax (212) 982-2700

CATEGORY	Italian
HOURS	Daily: Noon-Midnight
SUBWAY	6 train to Bleecker St.; F train to 2nd Ave.
PAYMENT	Cash only
POPULAR DISH	This is the place to go if you're hurting for a big bowl of pasta and your tastes have evolved beyond the standard "linguine marinara," "baked ziti," or "penne ala vodka" offerings of most Italian joints in this price range. The combos are inventive, the seafood super fresh, the sauces hearty, and the portions big enough to induce sleep.
UNIQUE DISH	The pumpkin ravioli in creamy pesto and the squid ink linguine with shrimp in a pink Pernod sauce are so delish you'll double-check the prices.
DRINKS	Full bar, ample wine list
SEATING	The place is pretty small. Because the secret's been out for a while, it's best to make a reservation, especially for parties of 5 or more.
AMBIENCE/CLIENTELE	The best thing about Frutti di Mare is its lack of pretension. The wait staff makes you feel like you're attending dinner at a favorite uncle's home (only without the heated political discussions). The restaurant manages to be simple, casual, and affordable without being divey.
EXTRAS/NOTES	$20 bucks still too lofty for your bare bones budget? Pay Frutti di Mare a visit between Noon and 6:30 PM for the *real* deal – a $9.95 prix-fixe, which includes two courses and a glass of wine. And save your expense account for Tribeca Grill, as Frutti Di Mare only accepts cash. I repeat, *cash only*.

—Jen Sotham

MANHATTAN

Grey Dog Coffee
(See p. 87)
Coffeeshop
90 University Pl. (between 11th St. and 12th St.), Manhattan 10003
Phone: (212) 414-4739

Gyu-Kaku
Meat has never looked sexier.
$$$$
34 Cooper Square, Manhattan 10003
(between E. 5th St. and E. 6th St.)
Phone (212) 475-2989
www.gyu-kaku.com

CATEGORY	Japanese Steakhouse
HOURS	Mon-Thurs: 5 PM-11 PM Fri/Sat: 5 PM-Midnight Sun: 5 PM-10 PM
SUBWAY	Take the 6 train to Astor Place and walk south one block.
PAYMENT	VISA MasterCard American Express Discover
POPULAR DISH	Choose your weapons, point, and shoot. You pick your type of meat, your cut of meat, your marinade, your dipping sauce, your side veggies and then you cook it yourself to your preferred temperature. The mustard miso dressing on the gyu-kaku salad is on-point, the ahi poke (raw tuna, Hawaiian style) is a fish lover's heaven and the yuzu (Japanese citrus) marinade is tangy perfection.
UNIQUE DISH	Affordable Kobe beef is nearly impossible to find, so go for it. The portions are small and inexpensive, so it's best to order a few different items and give your palate a party.
DRINKS	There is a full bar, an ample wine and beer list, and an impressive selection of saki. For a new twist on an old fave, try one of the sho-chu mojitos. (sho-chu is a vodka-ish alcohol similar to Korean Soju).
SEATING	The place is *humongous*, but gets packed. Best bet is to make reservations on the website.
AMBIENCE/CLIENTELE	Picture Benihana's dressed in a tuxedo. It's sleek and fabulous, but not snobby, and always filled with festivity.
EXTRAS/NOTES	Gyu-Kaku means "bull's horn," a name that reflects the management's emphasis on high-quality service. The bull's horn is meant to represent an antenna that is attuned to the needs of each customer. Hey, don't ask me, it's an Eastern thing.
OTHER ONES	Apparently, there are 800 locations worldwide, with 8 in the US and 2 in New York. • Midtown: 805 3rd Ave., 2nd Floor (between 49th St. and 50th St.), Manhattan 10022, (212) 702-8816. This location is also open for lunch (Mon-Sat: 11:30 AM-2 PM)

—Jen Sotham

MANHATTAN

Holy Basil
Village Thai that's literally steps above the rest.
$$$
149 Second Ave., New York 10003
(between 9th St. and 10th St.)
Phone (212) 460-5557
www.holybasilrestaurant.com

CATEGORY	Thai
HOURS	Mon-Thurs: 5 PM-11:30 PM
	Fri: 5 PM-Midnight
	Sat: 4 PM-Midnight
	Sun: 4 PM-11:30 PM
SUBWAY	Take the 6 to Astor Place, or the N,R,W to 8th Street. Also accessible by the M15 (Second Avenue) bus
PAYMENT	VISA MasterCard American Express Discover
POPULAR DISH	Try the popular duck spring rolls for an appetizer. For your main course, you can't go wrong with any of the delicious curries (spiciness can be adjusted to your taste), which can be prepared with either chicken, beef, or pork. Also offered are an array of vegetarian options and daily specials.
UNIQUE DISH	The menu features four different duck dishes and a good selection of seafood entrees, including a whole striped bass in chili sauce and holy basil leaves.
DRINKS	The full bar offers some interesting cocktail choices, with tasty variations on your typical mojito or martini. Ask your server about the featured drink.
SEATING	The main dining area has wooden tables for two and four; upstairs in the windowed room overlooking Second Avenue are another few tables offering a more intimate seating option.
AMBIENCE/CLIENTELE	Especially on the weekends, the restaurant is bustling and lively, mostly with twenty- and thirty-somethings. The dim lighting, polite wait staff, and warm decor help to make this a good date spot.
EXTRAS/NOTES	It's easy to walk right by the restaurant. To enter, walk up the stairs located next to Telephone Bar. It can get crowded, especially on weekends, so it's best to make reservations (and you may still have to wait a bit). If you want to do some East Village people-watching while you eat, sit in the upstairs dining area.

—*Jane Elias*

Hummus Place
The best hummus this side of the Dead Sea.
$$
109 Saint Marks Pl., Manhattan 10003
(between 1st Ave and Ave. A)
Phone (212) 529-9198 • Fax: (212) 529-9198
www.hummusplace.com

CATEGORY	Middle Eastern
HOURS	Mon-Thurs: Noon-Midnight

MANHATTAN

	Fri/Sat: Noon-2 AM
	Sun: Noon-Midnight
PARKING	Take the 6 train to Astor Place, then walk east on St. Marks.
PAYMENT	VISA, MasterCard, American Express, Discover
POPULAR DISH	Hummus lovers only. With a few (literally few) exceptions, your options are hummus, hummus, or hummus. Thankfully, it's damn good hummus, served with the fluffiest, puffiest pita.
UNIQUE DISH	If you want to sidestep the hummus here, the shakshuka, (a Mediterranean tomato and vegetable stew topped with two eggs) is the way to go.
DRINKS	They offer a very limited wine and beer selection. But you'd be a fool not to try their homemade lemonade garnished with mint leaves.
SEATING	Teeny, tiny. But don't let the packed front of the restaurant deceive you, as there are twice as many tables hidden in the back.
AMBIENCE/CLIENTELE	The place itself is kind of like a chick pea. It's little, earthy, modest and has it's own distinct flavor.
EXTRAS/NOTES	This is the kind of place you want to visit with a good friend or a good book, and your pocketbook won't be worse for the wear.
OTHER ONES	• 99 MacDougal St. (between W. 3rd St. and Bleecker St.), Manhattan 10012, (212)533-3089 • Upper West Side: 305 Amsterdam Ave. (between 74th St. and 75th St.), Manhattan 10023, (212) 529-9198

—*Jen Sotham*

Kenka
Five dollar special on bull penis!
$$$
25 St. Marks Pl., Manhattan 10003
(between 2nd Ave. and 3rd Ave.)
Phone (212) 254-6363

CATEGORY	Japanese/sushi
HOURS	Mon-Thurs: 6 PM-2 AM Fri/Sat: 6 PM-4 AM Sun: 6 PM-2 AM
SUBWAY	6 to Astor Place
PAYMENT	VISA, MasterCard, American Express
POPULAR DISH	Over 100 items are offered, but don't come expecting a full sushi menu. Standbys like shumai, gyoza, ramen, chicken satays, and rice bowls are offered, and all of it is greasily delicious. Combo plates run from $6.50-$7.50, including an entrée, soup, and salad, but you get better variety if you order á la carte and share with friends.
UNIQUE DISH	Feel adventurous after a slew of $1.50 Sapporo's? Try the bull penis. Or, if you're wondering what the Japanese take on an American favorite is, go for the "hamburg steak" and french fries.
DRINKS	With over twenty different kinds of sake, and nearly as many varieties of shochu, Kenka has

MANHATTAN

something for everyone. However, the main draw is definitely the $1.50 Sapporo drafts—all night, every night. A limited selection of Japanese teas and sodas is also available.

SEATING If you're a group, be prepared to put your name in early and wait, but Kenka can easily accommodate groups of about ten people. Couples and small groups sit at smaller tables dotting the floor, as well as at the bar. Extra stools are available for last minute friends.

AMBIENCE/CLIENTELE Mostly a hipster/college/bar crowd, though Kenka attracts diners of all stripes with its variety of small plates and cheap beer. Expect it to be packed and be prepared to wait. Staff move very quickly and efficiently—once you've ordered, food appears like magic! Great for groups and as a stop in between bars, but not so good for romantic dates. Japanese pop and vintage songs play (loudly) in the background. It looks like a Tokyo Goodwill threw up in there—all sorts of odd knick knacks and sundries adorn the walls and bar—making for a wonderfully odd and kitschy Asian décor.

EXTRAS/NOTES There's a $20 minimum for credit cards, and $6.50 minimum per customer per table. Also, if you're wondering why a dish of pink sugar comes with your check, there's a cotton candy machine out front—you get to make your own! A word of caution: watch others first, because if you screw up you don't get more sugar.

—*Jennifer Treuting*

Klong
Best Thai food in New York City
(a bold statement, I know . . .)
$$$

7 Saint Marks Pl., New York 10003
(between 2nd Ave. and 3rd Ave.)
Phone (212) 505-9955
www.klongnyc.com

CATEGORY Thai
HOURS Mon-Thurs: 11:30 AM-Midnight
Fri-Sun: 11:30 AM-2 AM
SUBWAY Take the 6 to Astor Place, the N,R to 8th St., or the F to 2nd Ave.
PAYMENT VISA MasterCard American Express Discover
POPULAR DISH I live for their pad kee mao with tofu. Also try their Royal Siam Pomegranate Martini, or their faux duck tofu dish.
UNIQUE DISH Eclectic Thai cuisine and cocktails, with a number of healthy vegetarian options.
DRINKS Great happy hour specials on all martinis, beers, and wines.
SEATING A large space, with seating at the bar and in the restaurant. Be prepared for a crowd late at night and on weekends.
AMBIENCE/CLIENTELE Trendy East Village clientele, attracted to the authentic food and affordable prices.

MANHATTAN

EXTRAS/NOTES Aside from being my favorite Thai restaurant in the city, Klong has now become one of my favorite bars. Whether it's the Royal Siam Pom Martini or the Lychee Sake, it's delicious, potent, and reasonably priced. Their veggie pad kee mao is intensely spicy, and their batter-fried turnips with chili sauce quickly became my favorite appetizer. (Who knew I liked turnips?)

—*Aly Walansky*

Lil' Frankie's
No, that's not drool, it's your mouth crying tears of joy!
$$$
19 1st Ave., Manhattan 10003
(between 1st St. and 2nd St.)
Phone (212) 420-4900
www.lilfrankies.com

CATEGORY Italian

HOURS Mon-Thurs: 11 AM-2 AM
Fri/Sat: 11 AM-4 AM
Sun: 11 AM-2 AM

SUBWAY Take a cab or ride the F train to the 2nd Ave. stop.

PAYMENT VISA

POPULAR DISH Genuine thin-crust, brick oven pizza with the perfect amount of toppings. They're all delicious, but my personal favorite is the "Napoletana": tomatoes, garlic, capers, oregano, olives, and Sicilian salted anchovies. The only other way you'll ever get pizza this legit is to head to that country that's shaped like a boot.

UNIQUE DISH The portobello mushroom al forno, roasted in their wood-oven (yeah, they have a wood oven, too) and served with arugula and gorgonzola dolce, is the perfect appetizer.

DRINKS The wine list is extensive and has something suitable for all tastes and desires (and incomes). If you're more in the mood for beer, well then check this out: They have Moretti ON TAP! Which is just further proof that God exists. And drinks beer.

SEATING The front room is large and hopping with energy, the back room is much cozier and mellow. On nice days, a small garden is available.

AMBIENCE/CLIENTELE Don't make the mistake of misinterpreting the casual, laid-back attitude of the staff as rudeness. The waiters are incredibly smart, knowledgeable, and more than willing to help you in any way they can. The energy is positive and all the diners are kept happy. A meal here feels like a great party at your Grandma's house.

EXTRAS/NOTES If you make a reservation, be sure your whole party arrives on time, as they won't seat you otherwise. If you do have to wait, well, there's

MANHATTAN

plenty of wine just beggin' to be sipped (or gulped).

OTHER ONES Lil' Frankie's was born out of Frank Restaurant, located at 88 2nd Ave (between 4th and 5th St.), (212) 420-0202.

—*Mike Dooly*

Little Veselka
(See p. 59)
Eastern European
75 East 1st St., Manhattan
Phone: (212) 228-9682.

Mama's Food Shop
Home cooking without the family.
$$
200 E. Third St., Manhattan 10009
(between Aves. A and B)
Phone (212) 777-4425

CATEGORY	American home cooking
HOURS	Mon-Sat: 11 AM-10:30 PM
SUBWAY	F to Second Ave.
PAYMENT	Cash only
POPULAR FOOD	Everything is popular and served in HUGE can't-eat-it-all-in-two-days portions; all six entrées: meatloaf, fried chicken, grilled chicken, grilled salmon, roasted chicken, and veggie plate, come with one side, and you can add an extra side for a buck
UNIQUE FOOD	Homemade gingermint iced tea
DRINKS	Homemade iced tea and lemonade, Coke, Diet Coke, coffee, and tea
SEATING	Seats about 20; bad for large groups, cozy for couples
AMBIENCE/CLIENTELE	Punky, funky, downtown flea market; as the menu says, "Mama Doesn't Do Decaf!" and "Shut Up and Eat It!!!" The staff has adopted mama's unique flair for customer service.
EXTRAS/NOTES	The food really does taste homemade by mama, and despite the dodgy service, Mama's is one of the best places to eat in NYC. Heat up your own food in the microwave next to the cashier (this isn't as bad as it sounds—honest). Bus your own table and put your dishes in the proper wash bin opposite where you ordered your food.

—*Michael Connor*

Max
Village va bene!
$
51 Ave. B., Manhattan 10009
(between 3rd St. and 4th St.)
Phone (212) 539-0111

CATEGORY	Italian
HOURS	Daily: Noon-midnight

MANHATTAN

SUBWAY	F to 2nd Ave.
PAYMENT	Cash only
POPULAR FOOD	Any of the pastas priced at $10.95, especially the lasagna "fatta in casa," served old-school-style in an earthenware bowl, are ooh- and ahh-worthy. It could be the best lasagna in the city. Do not leave without ordering the rigatoni napoletana, fettuccine al sugo Toscano (meat sauce), or sautéed spinach.
UNIQUE FOOD	Max is known for its inexpensive, yet consistently delicious and authentic dishes. There are occasionally fish specials such as mahi mahi or seafood ravioli, but stick with the homemade fettuccine or any of the other generous, mouth-watering pastas.
DRINKS	Well-priced wine list as well as homemade sangria.
SEATING	Three little dining areas. One in the front, a smaller section near the bar, and a homey outdoor patio. No reservations.
AMBIENCE/CLIENTELE	Low lighting and a dark wood interior make Max sexy and romantic. The setting is relaxed enough that the waiters will even sit at your table as you choose from the number of delicious dishes on the menu. This can mean slow service at times, but the food is definitely worth the wait. Although there are three small areas to dine in, the hit is the outdoor patio in the back. Clothes hang from lines above your head, giving Max a sense of hominess and coziness you're not likely to find on the street.

—Camilla Warner

Momofuku Noodle Bar
Consider yourself a lucky peach!
$$$
163 1st Ave., Manhattan 10003
(between 10th St. and 11th St.)
Phone (212) 475-7899 • Fax (212) 504-7967
www.eatmomofuku.com

CATEGORY	Japanese
HOURS	Sun-Thurs: Noon-11 PM Fri/Sat: Noon-Midnight
SUBWAY	Take the L to 1st Ave., or the 6 to Astor Pl.
PAYMENT	VISA MasterCard American Express
POPULAR DISH	Every bowl of noodles at Momofuku is truly out of this world, but the Momofuku Ramen is a favorite among regulars. The hearty noodles swim in a giant bowl of tasty broth, and are smothered in a combo of salty, shredded Berkshire pork and thicker-cut bacon. The bowl's vegetables are beautifully arranged, hovering above the noodles and the broth. But the greatest ingredient of all is a slow-poached egg, the creaminess of which adds a velvety dimension to the dish, making it impossible not to devour the entire bowl.
UNIQUE DISH	The steamed buns may sound ordinary, but they are anything but. Filled with chicken, shiitake mushrooms, or Berkshire pork, the fillings are

MANHATTAN

	then mixed with scallions, bunned-up, steamed, and served with a delectable hoisin sauce. The menu also features a variety of interesting shellfish dishes, such as Sichuan-spiced red crawfish and pan-roasted Bouchot mussels from Maine.
DRINKS	Great selection of sake. Bottles of Junmai, Ginjo, Daiginjo, and specialty sake dominate the menu, but Stella Artois and Hitachino beer are also available. Soda and bottled water.
SEATING	Momofuku is wonderfully cozy and snug, and maintains the atmosphere of an upscale, trendy noodle joint. A long bar overlooks the quaint kitchen, where you can watch the chefs prepare the dishes. There are a couple of other counter seats, but the place is so narrow, you can barely extend your arms completely without touching the wall.
AMBIENCE/CLIENTELE	Everyone comes here, from solo diners contently reading their magazines at the bar to couples exchanging bites and furtive glances. The waiters are incredibly friendly, and everyone is always in good spirits.
EXTRAS/NOTES	Momofuku means "lucky peach," and their adorable logo adorns every menu. The prices may seem high for a bowl of noodles, but the portions are enormous and every dish is beyond fresh and artfully prepared. Momofuku's chef, David Chang, was nominated for the James Beard Foundation's "Rising Star" award in 2006.

—*Camilla Warner*

Mamoun's Falafel
(See p. 68)
Middle Eastern
22 St. Mark's Place, Manhattan 10003

Panna II Garden Indian Restaurant
Indian comfort food with an in-your-face décor that rivals the lights of Times Square.
$$
93 First Ave., Manhattan 10003
(between E. Fifth and E. Sixth Sts.)
Phone (212) 598-4610

CATEGORY	Indian
HOURS	Daily: Noon-midnight
SUBWAY	6 to Astor Pl., F to Second Ave.
PAYMENT	Cash only
POPULAR FOOD	Chicken *korma* and lamb curry, or have the *shag*. Don't forget an order of *naan* to round out the meal, which also comes with a variety of side dishes and a complimentary dish of Mango ice cream with every meal—YUM!
UNIQUE FOOD	Banana fritters
DRINKS	Cola, tea, and coffee
SEATING	Seats about 50; tables seat two to four in very tight quarters

MANHATTAN

AMBIENCE/CLIENTELE	You can find all kinds of people at this restaurant—from local neighborhood patrons to the occasional fashion model or Hell's Angel. With walls covered in Christmas tinsel, Fourth of July decorations, wrapping paper and chili pepper lights, Panna II provides an entertaining, if not dizzying, place to eat out with friends.
EXTRAS/NOTES	They don't serve alcoholic beverages here, but customers are encouraged to bring their own. So if you're up for drinking, be sure to stop by one of the local stores and pick up a six-pack on your way to the restaurant. Also, Panna II is located next door to another well-lit and gaudily decorated Indian restaurant. As soon as you hit the steps leading up to these restaurants, be ready to be accosted by the maîtres d' of both restaurants.

—Shannon Godwin

Podunk

Amazing tea, but small bladders beware: no bathroom!
$$$
231 East 5th St., Manhattan 10003
(between 2nd Ave. and Cooper Sq.)
Phone (212) 677-7722

CATEGORY	Tea room
HOURS	Mon: Closed Tues-Sun: 11 AM-9 PM
SUBWAY	6 to Astor Place
PAYMENT	Cash only
POPULAR DISH	Besides tea, Podunk offers a number of Teas (as in the meal, not the drink). Prices run the gamut, starting on the "low" end for some scones and tea, and ranging much higher for fancier fare (tarts, tea sandwiches, savory pies). Some items are also available a la carte. Keep in mind, this is Tea, not Supper, so the food tends to be on the lighter side. Filling up can become very pricey here.
DRINKS	With iced teas, chai, green teas, and black teas, it's sometimes easiest to describe what you like or what you're in the mood for and let Elspeth, the kindly owner, make a recommendation. However, you can't go wrong with the chocolate mint tea. Delectably smooth with wonderfully subtle flavors, try it with milk for extra creaminess. The verbena rose is also a winner, light and delicate, great for a summer or spring day. Podunk's custom blends are a good place to look if you're in the mood for something new. The creamsicle blend is a great black tea blended with orange rind, terrific with milk and some sugar. The toasted coconut also offers up something different.
SEATING	Seven small tables, some for 2, some for small groups. Emphasis on small. Some sidewalk seating also available.
AMBIENCE/CLIENTELE	If you scorn Starbucks and its wi-fi squatters, you'll thank owner Elspeth Treadwell for her disdain of laptops and cell phones. Visitors are

MANHATTAN

encouraged to stay and linger in this quaint and eclectic tea shop, but attention should be paid to tea, scones, and good friends, not e-mail. This makes for a quiet atmosphere that families, friends, and couples can all enjoy. The small tea shop has a mix of comfy mismatched chairs, benches and tables, and a large bookcase full of children's classics.

EXTRAS/NOTES Family friendly, people friendly, but also a little quirky, Podunk has its own rules: no tips and no table service. Most importantly, for those of us who may have small bladders or small children, Podunk does not have a bathroom.

—*Jennifer Treuting*

Pommes Frites
Best fries in the city, Belgium style.
$$
123 Second Ave., Manhattan 10003
(between 7th St. and 8th St.)
Phone (212) 674-1234
www.pommesfrites.ws

CATEGORY Store front French fries
HOURS Mon-Thurs: 11:30 AM-1 AM
Fri/Sat: 11:30 AM-3:30 AM
Sun: 11:30 AM-1 AM
SUBWAY 6 to Astor Place; R,W to 8th Street/NYU; F to Second Ave.
PAYMENT Cash only
POPULAR DISH Frites! Not your average fries, these babies are twice-fried making them perfectly crispy on the outside and soft and warm on the inside. If you go for a special sauce (which you should), try the Rosemary Garlic Mayo or Curry Ketchup. (Sauces are $.75 each or three for $1.75.)
UNIQUE DISH Poutine: a French-Canadian dish comprised of fries, chicken gravy, and curd cheddar cheese. This is the only item on the menu besides straight-up frites, and you should try it at least once just to say you did.
DRINKS Water, sodas, juices.
SEATING The few tables and counter seats can accommodate about 12 at the most. But the good news is that the frites, served in convenient paper cones, are perfect to take on the go. Another cool thing: the tables and counters have holes in them that hold your cones of frites upright—pure genius!
AMBIENCE/CLIENTELE Small and cozy with dark wood paneling and an authentic feel, Pommes Frites is bustling with East Village locals of all flavors. It is busiest during the wee hours of weekend nights for obvious reasons, so expect both a line and a rowdy crowd if you go at that time. The staff is super-friendly and even lets you sample the frites and sauces until you find the perfect combination. Now that's service!

MANHATTAN

EXTRAS/NOTES	Insider tip: Don't go at 3:45 AM after a long night of drinking, bang on the window, and expect them to let you in. They won't. This place closes at 3:30 sharp.

—Laura Lee Mattingly

Quartino Bottega Organica

Fresh, healthy, authentic Italian food – stuff your face and still feel foxy!

$$$

11 Bleecker St., New York City 10012
(between Lafayette St. and Bowery)
Phone (212) 529-5133

CATEGORY	Italian
HOURS	Mon-Weds: Noon-11 PM Thurs-Fri: Noon-11:30 PM Sat: 11 AM-11:30 PM Sun: 11 AM-10 PM
SUBWAY	6 Train to Bleecker; B, D, F, V to Broadway/Lafayette St.; N, R, W to Prince St.
PAYMENT	Cash only
POPULAR DISH	The pizza, which is made with whole-wheat crust, is fan-freakin-tastic. Go ahead and eat the entire thing yourself, as it makes a great entree, or split one between two people for the perfectly sized appetizer. If the shrimp-fettuccine asparagus is on the specials menu, order it! The focaccia has a very good reputation around the neighborhood. Get busy.
UNIQUE DISH	All the courses are organic and made with fresh, quality ingredients. This not only gives the food an authentic Italian taste, but makes it easier for you to eat until you're full without feeling like a bloated, sleepy pig afterward.
DRINKS	The wine list has an excellent organic selection, but if you simply must have your sulfites, don't worry, they offer great non-organic wines, too. The beer selection is minimal but getting better, and what they lack in choice is made up for in quality.
SEATING	25-30 available seats, with some outdoor seating in the back during nicer weather. On busier nights people will be sitting close to each other, so if you have a problem with that . . . well, what are you doing in Manhattan to begin with???
AMBIENCE/CLIENTELE	The atmosphere is very laid-back, and on colder days a nice comfortable blaze in the fireplace keeps patrons cozy and warm; the music they play is not only unobtrusive, but usually damn good, too.
EXTRAS/NOTES	My girlfriend and I found this place and decided to be greedy and not tell any of our friends about it. As such, it's become our temporary get-away-for-a-few-hours spot. So yeah, now I'm spilling the beans and telling you, but honestly, they deserve the business and you deserve the great food. And I still ain't gonna tell any of my friends. N.B.: For parties of more than two, it might not be a bad idea to call ahead. Brunch is served on Saturdays and Sundays.

—Mike Dooly

MANHATTAN

Sala
Tiny plates bursting with big flavor.
$$$$
344 Bowery, New York 10012
(between Great Jones St. and Bond St.)
Phone (212) 979-6606
• Fax (212) 979-5392
www.salanyc.com

CATEGORY	Spanish
HOURS	Daily: 5 PM-2 AM
SUBWAY	B, F, V, D, 4 or 6 to Broadway/Lafayette. Parking lot on Great Jones St. but parking is a nightmare. Take the subway.
PAYMENT	VISA, MasterCard, American Express
POPULAR DISH	The fried goat cheese with honey and caramelized onions has to be one of the best dishes on the menu. Other favorites include: artichoke hearts sautéed with Serrano ham and garlic, the garlic shrimp, spicy fried potatoes, and the marinated pork on crispy olive oiled bread with melted gruyere and roasted red peppers. The paella, which requires a lengthy preparation time, is also very good and definitely worth the wait.
DRINKS	Full bar and a wide selection of Spanish and Italian wines, though Sangria is la especialidad de la casa. 2 for 1 drinks from 5-7 PM, Mon-Fri.
SEATING	There's a small dining area that seats about 25. Food is also served in the larger lounge area downstairs.
AMBIENCE/CLIENTELE	Despite the well-heeled clientele that frequents Sala, the atmosphere is cozy and welcoming. Whether you wear jeans or a dress, you'll be comfortable.
EXTRAS/NOTES	The tiny plates range from $5-$18 dollars and, if you're drinking and not careful, you can end up spending $30-$40 a person for dinner. It's best to get 2-3 plates per person and share. Larger entrees, which range from $20-$30, are also available, though tapas are king here, especially from 5-7 PM on Tues–Thurs, when they're half price. Make reservations if you plan on going after 7 PM.
OTHER ONES	• Sixth Avenue to the Hudson: 35 W. 19th St., Manhattan, 10011, (212) 229-2300

—Emily Isovitsch

Soba-ya
They say: "No Sushi, No Reservations."
We say: Noodles worth the wait.
$$$
229 E. Ninth St., Manhattan 10003
(between Second and 3rd Aves.)
Phone (212) 533-6966

CATEGORY	Japanese noodle shop and sushi bar
HOURS	Daily: Noon-4 PM, 5:30 PM-10:30 PM
SUBWAY	N, R to Eighth St., 6 to Astor Pl.
PAYMENT	VISA, MasterCard, American Express, Discover
POPULAR FOOD	*Soba* and *Udon,* hot and cold: four basic permutations expand into almost two-

MANHATTAN

	dozen dazzling varieties of Japanese noodle dishes. Lunch specials include a bowl of the aforementioned noodles, along with a generous assortment of appetizers and extras. Early birds can get to Soba-ya before 6:30 pm and take advantage of the dinner special, a similar combo.
UNIQUE FOOD	The *Kamonan* (noodles with slices of duck) makes the best dinner; it's also one of the most expensive items on the menu; the *Shumai* (shrimp dumplings) are a treat.
DRINKS	Sake, beer, tea, way overpriced soda
SEATING	35 comfortably at tables
AMBIENCE/CLIENTELE	Simple, elegant and tasteful. Wood and back-lit translucent wall paneling give the feel of a far-off place—an extraordinarily trendy hamlet in the Japanese countryside. Cool bathrooms (a bidet for the ladies!); frequented by many native Japanese and not a few homosexuals

—Joe Cleemann

Spice
(See p. XX)
Thai
114 Second Ave., Manhattan 10003
Phone: (212) 988-5348

Spice
(See p. 93)
Thai
60 University Pl., Manhattan 10003
Phone: (212) 982-3758

St. Dymphna's
The patron saint of the mentally ill can be found on St. Mark's Place.
$$$
118 St. Mark's Pl., Manhattan 10009
(between First Ave. and Ave. A)
Phone (212) 254-6636
www.stdymphnas.com

CATEGORY	Irish Pub
HOURS	Daily: 11 AM-4 AM
SUBWAY	6 to Astor Pl.
PAYMENT	VISA MasterCard AMERICAN EXPRESS DISCOVER
POPULAR DISH	Though it's an Irish pub, Dymphna's offers everything from crispy calamari and crab cake appetizers to a roast rack of lamb chop entree. But you'd be best served by staying close to home—Ireland, that is. To that end, burgers are always a safe pairing with your pint of Guinness.
UNIQUE DISH	For something hearty, try the beef and Guinness casserole ($9) or their very own Dymphna's Pie ($12), a creamy chicken stew cooked with

MANHATTAN

	mushrooms and bacon in a flaky crust. Irish breakfast is served daily until 4 PM (vegetarian version also available).
DRINKS	Guinness is the favorite; other imported beers and Strongbow Cider also on tap
SEATING	Inside are small, rustic wooden tables and benches, and with no standing in the bar area, the everyone-gets-a-seat result lends an air of civility. In the warmer months, you can sit outside on the back patio.
AMBIENCE/CLIENTELE	Unique amid the din of St. Mark's Place are the more relaxed environs here, where students, artists, assorted East Villagers, and displaced Irish can often be found. Even at its busiest (dinnertime), the dim lighting and close conversation keep things cozy.
EXTRAS/NOTES	As described on the St. Dymphna's website, St. Dymphna is "the patron saint of those suffering from nervous and mental disorders." According to legend, the young Dymphna had fled to Belgium to escape her widower father, who wanted to marry Dymphna in the wake of his wife's death. After she was tragically beheaded by her father's hand, Dymphna was entombed in a cave in Gheel, Belgium. Allegedly, people with mental disorders who visited the site were miraculously cured of their ailments. While a pint and a pie at this East Village outpost may not cure you of your neuroses, you can expect some temporary relief.

—*Jane Elias*

SushiSamba Park
(See p. 95)
Japanese/Sushi
245 Park Ave. South, Manhattan 10003
Phone: (212) 475-9377.

Tiengarden Vegan and Natural Kitchen
A place where even a meat-head like my father can go and leave feeling as though he'd actually eaten something.
$$
170 Allen St., Manhattan 10002
(between Stanton and Rivington Sts.)
Phone (212) 388-1364

CATEGORY	Chinese Vegan
SUBWAY	F,V to Second Ave.
HOURS	Mon-Sat: 12 PM–10 PM
PAYMENT	MasterCard VISA American Express Discover
POPULAR FOOD	Everyone drools over the Buddha's Delight—*shiitake* mushroom and mixed vegetable in brown sauce. Also recommended, the *Seitan* Innovation (braised wheat gluten and veggies in ginger sauce), or the sweet and sour soy nuggets with

MANHATTAN

	pineapple and side of mixed rice (brown, red and wild rice)—sublime
UNIQUE FOOD	What they call "edible sculptures" we might call dim sum, but after eating it we too will call it edible sculpture—the pan fried seaweed-tofu rolls are most honorable, (tofu rolled in *nori* seaweed and bean curd sheets, served with lemon).
DRINKS	Assortment of bottled, all-natural beverages, hot tea
SEATING	16 seats at tables
AMBIENCE/CLIENTELE	A pristine white, meditative environment—no LSD inspired murals
EXTRAS/NOTES	This is the best vegetarian restaurant in the whole wide world.

—*Nemo Librizzi*

Two Boots Pioneer Theatre
(See p. 97)
Cajun/Creole/pizza
155 East 3rd St., Manhattan 10009
Phone: (212) 591-0434

Two Boots Pizzeria
(See p. 97)
Cajun/Creole/pizza
42 Ave. A, Manhattan 10009
Phone: (212) 254-1919

Two Boots Restaurant
(See p. 97)
Cajun/Creole/pizza
37 Ave. A, Manhattan 10009
Phone: (212) 505-2276

Veselka
Plumping up the east village, one pierogi at a time.
Since 1954
$$
144 Second Ave., Manhattan 10003
(at 9th St.)
Phone (212) 228-9682
www.veselka.com

CATEGORY	Eastern European
HOURS	24/7
SUBWAY	Take the F,V to 2nd Avenue and walk 9 blocks north; the 6 to Astor Place and walk north 3 blocks and east to 2nd Ave.; or the L to 1st Ave. and walk south 5 blocks and west to 2nd Ave.
PAYMENT	VISA MasterCard American Express Discover

MANHATTAN

POPULAR DISH It all depends on what time of day you hit Veselka. The shining stars on their full scale diner style breakfast menu are the challah French toast and the cheese blintzes with raspberry sauce. The Eastern European fare is famous worldwide, and a great way to get a good sampling of the menu is to try one of Veselka's affordable 3-course combination plates—available for both veggie-heads and meat lovers.

UNIQUE DISH The pierogies are to die for. With six different fillings (feel free to mix and match) and your choice of fried or boiled, these delectable dumplings will cater to any palate.

DRINKS Veselka offers a small selection of wines, features Ukrainian and Czech beers, and does an excellent bottomless cup o' Joe. But for those longing for the diner days of yore, try an old fashioned egg cream or lime rickey.

SEATING Though the dining room is of fair size, it is always justifiably crowded and isn't equipped to accommodate big parties. For solo or duo diners, scoring one of the coveted counter seats will get you better service, an opportunity to rub elbows with the neighborhood regulars, and a birds-eye view of the kitchen.

AMBIENCE/CLIENTELE This place almost has an electricity about it. With a clientele ranging from edgy east villagers to indie film stars to disgruntled old men, you'll never be at a loss for good people watching. And there's always the feeling that the guy sitting next to you may be a budding Allen Ginsburg.

EXTRAS/NOTES Veselka (the Ukrainian word for "rainbow") has undergone many makeovers since its establishment as a candy shop and newsstand in 1954. The addition of a luncheonette counter was a result of the east renaissance of the 1960's, and the restaurant withstood the mid-seventies economic depression in the area by further expanding the menu and adding one of the first lottery terminals in the city.

OTHER ONES Little Veselka (a mini-me version of the original), 75 East 1st St. (at Houston St.), Manhattan 10003, (212) 228-9682.

—Jen Sotham

Viva Herbal
The pizza Ray would make if he was a healthy hippie.
$$$
179 Second Ave., Manhattan 10003
(between E. 11th and E.12th Sts.)
Phone (212) 420-8801

CATEGORY Organic/Vegan/Kosher dairy pizzeria
HOURS Mon-Thurs: 11 AM-11:30 PM
Fri/Sat: 11 AM-1 AM
Sun: 11 AM-11:30 PM
SUBWAY L to 14th St.
PAYMENT VISA AMERICAN EXPRESS MasterCard

MANHATTAN

POPULAR FOOD	A range of pizzas, salads, and pastas for any diet: kosher dairy, vegan, or organic; slightly more expensive than the average pizza joint, but you can eat well.
NIQUE FOOD	A wide variety of vegan pizzas on spelt (non-wheat) crusts are heaped high with miso-tofu, veggies, and other colorful, exotic toppings. Recommended are Zen (with green tea tofu and pesto) and Ganja (with hempseeds, when available) pies—slices and whole pies available.
DRINKS	Natural sodas and juices, regular sodas, and an extensive tea bar with varieties of green and herbal teas
SEATING	15 inside at small tables and a counter, 12 outside at small tables
AMBIENCE/CLIENTELE	The customers are more yuppie than hippie; the place has a warm, colorful, Californian feel. Bright, fanciful, and occasionally psychedelic art by a local painter adorns the walls.
EXTRAS/NOTES	Part of a New York backlash against Ray's-style pizza-as-usual places, Viva Herbal was created by owner Tony Iracani to give vegans a pizza place to call their own. If you crave tofu, soy sausage, and macrobiotic *nomato* sauce, this is the place to eat. And even if you're not a vegan, you may be pleasantly surprised by the variety and taste of these creative pizzas. Free delivery.

—*Peter Davis*

Yakitori-Taisho
Japanese dive serves up tasty skewers
$$$
5 St. Marks Place, New York 10003
(between 2nd St. and 3rd St.)
Phone (212) 228-5086
www.yakitoritaisho.com

CATEGORY	Japanese hole-in-the-wall
HOURS	Mon-Weds: 6 PM-1:30 AM Thurs-Sat: 6 PM-3:30 AM Sun: 6 PM-1:30 AM
SUBWAY	6 to Astor Place, N,W,R to 8th St. Parking is very limited.
PAYMENT	VISA MasterCard AMERICAN EXPRESS DISCOVER
POPULAR DISH	This hole-in-the-wall proudly serves up traditional Japanese street food. Either as a snack or a full-blown meal, the grilled skewers come hot, juicy, and piled high. Play it safe with the bara (pork), yotsumi (chicken) or tsukune (chicken meat ball). For more eclectic tastes, give the gyutan (beef tongue) or the ozura (quail egg) a try.
DRINKS	Beer, wine, sake
SEATING	The seating is cramped. The restaurant refuses to open before 6 PM so there is a constant wait, albeit a short one. Still, you won't be disappointed.
AMBIENCE/CLIENTELE	Local students frequent the place for its cheap, filling, and tasty fare, which pretty much means the place is bustling nightly. Servers fly by with

MANHATTAN

high piles of skewers and bowls full of steaming noodles. Don't let the constant flow of people or the less-than-pristine environs intimidate you into trying one of the less-authentic Japanese places down the street.

—Emily Isovitsch

Xunta
Sabor español auténtico
$$
174 First Ave., Manhattan 10009
(between 10th St. and 11th St.)
Phone (212) 614-0620 • Fax: (212) 567-3460
www.xuntatapas.com

CATEGORY Spanish
HOURS Mon-Thurs: 4 PM-Midnight
Fri/Sat: 4 PM-2 AM
Sun: 4 PM-Midnight
SUBWAY L train to First Ave., walk south 3 ½ blocks; 6 Train to Astor Place, walk to First Ave. and up 2 blocks.
PAYMENT VISA, MasterCard, American Express
POPULAR DISH The menu at Xunta proffers a huge selection of traditional tapas, which can be overwhelming. And that's the beauty of tapas: small, affordable plates offer you the opportunity to sample a little bit of everything. Some crowd pleasers include the Chorizo con Vino e Cebolla (Spanish sausage with wine and onions), Queso Cabrales (Cabrales blue cheese), which is a perfect topper for the rustic homemade bread, and Datiles a Plancha con Bacon (grilled dates with bacon).
UNIQUE DISH If you're a seafood lover, you'll be delighted by how *not* chewy the Polvo Fiera (octopus with paprika) and Luas Anel (fried calamari) are. Also, while the prices have increased due to Xunta's growing popularity in recent years, it's still considered moderately-priced by New York standards.
DRINKS Xunta's wine list is sensational. They offer many of the wine selections by the glass, and the friendly staff is more than willing to help you pair to perfection. That said, if you look around, you'll notice sangria (red, white, or cava) a-flowin,' and justifiably so.
SEATING Depending on your personality, the seating at Xunta can either be its downfall or what makes it a true gem. The place is very small, and most of the tables are simply bar stools around rum barrels, with a few communal picnic-style tables in the back. This is not, by any means, a place to go if you're claustrophobic or if you're a food sprawler.
AMBIENCE/CLIENTELE Xunta is small, dark, loud, and lively, i.e. the vibe is akin to what you'd expect to find in a port-side tapas bar in Spain.
EXTRAS/NOTES The live flamenco show on Thursday nights from 8:30-10:30 is not to be missed.

—Jen Sotham

MANHATTAN

WASHINGTON SQUARE

Arturo's
Jazz, coal oven pizza and beer—need we say more?
$$
106 W. Houston St., Manhattan 10012
(at Thompson St.)
Phone (212) 677-3820

CATEGORY	Pizza/Italian
HOURS	Mon-Thurs: 4 PM-1 AM
	Fri/Sat: 4 PM-2 AM
	Sun: 3 PM-Midnight
SUBWAY	1 to Houston; A, C, E, F, V to West 4th; or the F, V, 6 to Broadway/Lafayette
PAYMENT	VISA, MasterCard, American Express, Discover
POPULAR DISH	Authentic, delicious coal oven pizza, which rivals the popular favorites in town and is perfect for sharing . . . or taking home . . . or delivery.
UNIQUE DISH	A perfect restaurant for almost any night or occasion. Although the focus is pizza, a wide variety of wonderful Italian dishes are also available.
DRINKS	Beer (including Italian beers), wine, and mixed drinks.
SEATING	Perfect for groups (if you call in advance) but there are also plenty of small tables. Outdoor seating is available, weather permitting.
AMBIENCE/CLIENTELE	Romantic, friendly, cozy, and inviting, Arturo's attracts a crowd of regulars, interspersed with students, tourists, and the odd celebrity (and yes, most of them are odd). Staff is super friendly, even if you have to tackle them to get their attention from time to time.
EXTRAS/NOTES	A small jazz combo presides near the kitchen on many nights, so even a wait at the crowded bar is entertaining and enjoyable.

—*Pamela Schultz*

How Do You Say HUNGRY? In...
THE ISLANDS AND AUSTRALIA

Haitian Creole: *Grangoo.* Sounds like: Ghrawngoo (g is gutteral on both counts)
Hawaiian: *pōloli au.* Sounds like: PUH low li.
Ilocano: *Mabisín nak.* Sounds like: muBEEsin knock.
Tagalog: *Nagugutom ako.*
Maori (or Te Kōrero Maori) (New Zealand): *e hia kai ana ahau!*
Kriolu: Capeverdian Creole: *N sta ku fomi.*

MANHATTAN

Bagels on the Square
Great bagels in a great variety with a full line of spreads.
$
7 Carmine St., Manhattan 10014
(between Bleecker St. and Sixth Ave.)
Phone (212) 691-3041

CATEGORY	Bagel shop
HOURS	24/7
SUBWAY	A, C, E, V, F, S to W. Fourth St.
PAYMENT	Cash only
POPULAR FOOD	With 33 items to choose from, everything is popular—try the sundried tomato Tofutti spread and pat yourself on the back for being so good to yourself
UNIQUE FOOD	Seven types of tofu-based spreads
DRINKS	Soda, juice, coffee, tea, hot chocolate
SEATING	Carry out
AMBIENCE/CLIENTELE	Efficient service morning noon and night

—*Steve Powers*

Caffé Reggio
As seen in Shaft!
Since 1927
$$
119 McDougal St., Manhattan 10012
(at W. Third St.)
Phone (212) 475-9557

CATEGORY	Italian Café
HOURS	Sun-Thurs: 9 AM-2:30 AM Fri/Sat: 9 AM-4 AM
SUBWAY	A, C, E, F, V, S to W. Fourth St.
PAYMENT	Cash only
POPULAR FOOD	Italian pastries
UNIQUE FOOD	Anchovies and mozzarella sandwiches, hot or cold with pickles, hard-boiled egg, olives, and potato salad on toasted Italian bread offer a wicked mix of flavors; *affogato* (assorted ice cream with espresso and fresh whipped cream) is unforgettable.
DRINKS	Reggio's Espresso (they also serve American coffee); a nice frothing cappuccino to push you right over the ledge of dangerous self-indulgence; the Reggio, a cup of Irish coffee with liqueur and fresh whipped cream—will pick you up or put your head to bed depending on when you have it and what last night was like
SEATING	Six sidewalk tables and 18 indoor tables can be rearranged and supplied with additional chairs.
AMBIENCE/CLIENTELE	Reggio was a featured locale in the original *Shaft*, and gave its name to an Isaac Hayes–penned musical interlude on the soundtrack. In the sultry red and wooden interior, which is hung with ornate wooden frames holding Italian Renaissance–style paintings, you'll find students and regular folk alike chatting, meeting, and planning across marble-topped tables while getting their caffeine on.

MANHATTAN

EXTRAS/NOTES It's been rumored that those dirty Beat poets used to hang around the joint.

—*Matthew Gurwitz*

DeMarco's
Unauthorized off-shoot of Di Fara's serves up tasty slices.
$$
146 Houston St., Manhattan 10012
(at Macdougal St.)
Phone (212) 253-2290

CATEGORY	Italian
HOURS	Mon-Thurs: Noon-10 PM
	Fri/Sat: Noon-1 AM
	Sun: Noon-10 PM
SUBWAY	A,C,E,B,D,F,V to West 4th St.
PAYMENT	VISA, MasterCard, American Express, Discover
POPULAR DISH	Pizza. Square or triangle, DeMarco's serves up some of the finest pizza in Manhattan.
UNIQUE DISH	Slices are expensive ($2.75 for regular, $3.75 with a topping) but the ingredients and toppings are all top-notch. Freshly grated Parmesan and red pepper in olive oil, available at the counter, are a nice touch.
DRINKS	Regular and Italian sodas.
SEATING	Two tables and a few stools.
AMBIENCE/CLIENTELE	The now-defunct restaurant portion of DeMarco's was recently the starting point in a horrific shooting spree. One rumor has it that the shooter, killed by police after murdering two auxiliary police officers, was a former regular. All this notwithstanding, the takeout portion is still going strong and seems to draw young, unarmed denizens of the neighborhood. On a recent trip, the table next to me was engaged in weighing the relative merits of various hedge funds.
EXTRAS/NOTES	DeMarco's was founded by two children of Dominic DeMarco, founder of Di Fara Pizzeria in Midwood, Brooklyn. Though general consensus seems to be that père DeMarco's joint is superior, as the youngsters grow more and more comfortable, the Manhattan establishment is bound to continue improving.
OTHER ONES	• Brooklyn, Di Fara Pizzeria, 1424 Ave. J (between 14th St. and 15th St.), 11230, (718) 258-1367

—*Ben Wieder*

"I can't wait to get back to New York City where at least when I walk down the street, no one ever hesitates to tell me exactly what they think of me."

—*Ani DiFranco*

MANHATTAN

Down the Hatch
Get your Suicidal Atomic Wings fix at this college dive, literally.
$$
179 West Fourth St., Manhattan 10012
(between Sixth and Seventh Aves.)
Phone (212) 627-9747
www.nycbestbars.com

CATEGORY	American Pub
HOURS	Mon-Sat: Noon– 4 AM
	Sun: Noon–Midnight
SUBWAY	A, C, E, F, V, S to W. Fourth St., 1, 9 to Christopher St.
PAYMENT	VISA MasterCard AMERICAN EXPRESS
POPULAR FOOD	Try some fine buffalo chicken wings by the dozen with plenty of celery to take the edge off, or a veggie or turkey burger topped with jack cheese, jalapeños, grilled onions. Don't miss the Smothered Fries—wafer fries topped with cheese, chili, and jalapeños.
UNIQUE FOOD	Combo basket of wafer and onion fries is inspired; Chicken Littles—sliced skinless chicken breast on a bed of lettuce with choice of eight Dipmania! sauces (atomic, pepper parmesan, horseradish, sweet and sour, blue cheese, honey mustard, ranch, and barbecue).
DRINKS	Full bar with plenty of beer—five on tap, 16 bottled varieties
SEATING	Seats 20 at booths and stools
AMBIENCE/CLIENTELE	Completely casual, underground, brick walls, wood, filled with jocks
EXTRAS/NOTES	Play some foosball.

—Steve Powers

Hump-Day Heaven: Marx Is Dead, Drink in the Middle of the Week

Since Karl Marx and the Pope put their heads together and invented the 5-day work week, youngish people have dawned the cap of weekend warrior—forging ahead from Monday to Friday with the focus of a steely mongoose, then getting smashed on the weekends. But the market economy has changed. The internet, for example. And with the proliferation of college educations and the corresponding decline in the virtues of moderation, responsibility, and probably chastity, it is no longer reasonable or appropriate to go off the sauce for five days. Call them what you will, the new libertines of libation are moderating their moderation and with a more reasonable standard deviation of two days, have annexed Wednesday for the weekend. Let's have a look at some of the places where they're getting pissed:

T.G. Whitney's is a loosen-the-tie, wrinkle-the-suit-pants, laid back, after work, go to a dark non-descript place place, which may be what you're looking for come the middle of the week. This dive comes complete with antediluvian cash registers behind the bar, Golden Tee up front, and a touch-and-go Photo Hunt machine in the back. On the days when said machine is

MANHATTAN

inoperative, go upstairs to the patio and dream it's Friday (which, incidentally, is karaoke night). T.G.'s makes it easy for you: $5 pom-tinis, apple-tinis, and watermelon-tinis. (Regular well Martinis are $20. Just kidding.) $3 Bud Light draughts, and $4 Newcastles. The sliders are solid, but other than that the food is kind of iffy. *244 E. 53rd St. (between Second & Third Aves.), Manhattan 10022, (212) 888-5772, www.tgwhitneys.com.*

Black Bear Lodge is *the* hump-day stop for the beer connoisseur who likes to play flip-cup. Wood paneling, Big Buck Hunter machines, and antler-bedecked chandeliers all work together to convince you that this east side bar is more than a bar—it's a lodge. And not just any lodge, it's a hunting lodge. And it works. The whole range of bar goers are found under this roof: regulars and newcomers, young and old, hip and nerdy, sharp and not sharp, sober and tipsy, beer and nuts, east village and Weehawken, Abercrombie and salvation army, homeowners and floppers, table tennis fans and arm-wrestling aficionados. Consider these Wednesday specials: 6 packs of PBR for $15, $4 beer of the month, $1 for 4 cherries soaked in liquor, $4 wells and draughts. *274 Third Ave (between 21st & 22nd Sts.), Manhattan 10003, (212) 685-2589, www.bblnyc.com.*

Proof is the closest thing to a public frat house that I know of in the city. If you are in the mood to seriously blow off steam, you want to go here. There are tables, though, in case you just want to sit down and have a hundred shots and a nice chat with your best new girlfriend. The night I was there, the bartender was slow, drunk, and friendly as hell. As he should be. A college basketball game played on 20 televisions. When it was over, 80s karaoke. Oh yeah. Posted drink specials for Wednesday are as follows: $3 Jager shots, 2 for 1 Stoli drinks, $5 apple and watermelon martinis and cosmos, and $3 Bud Light and Michelob Ultra Drafts. Also, you can get a beer and a cheeseburger for $6. Not too shabby. *239 Third Ave (between 19th & 20th Sts.), Manhattan 10003, (212) 228-4200, www.proofnyc.com.*

Boss Tweeds refers to itself as a saloon. It may have been once, but not any more. Now it is just a watering hole, deliciously dark, mellifluously moldy, cheap. Every time I go here, I have a great time, and the check is never more than peanuts. Once, I struck up a conversation with the bartender who has this tasty Australian accent. It was going really well for us, and the shots and beers were piling up, and she even joined me and my mates for a game of beer pong, and her eyes flashed that limpid watery silver indicating she had had at least five too many drinks. I remember she sank the winning shot. Then a convivial embrace. I could feel her breasts against my neck. She was a lot taller than me. We exchanged receipts. I think I threw up that night, but it was beautiful. Everyday specials: $3 Bud and Bud Light pints, $4 Natty Light double cans, $10 Bud and Bud Light pitchers, and—my favorite—$5 shot and beer. *115 Essex St. (between Rivington St. & Delancy St.), Manhattan 10002, (212) 475-9997, www.bosstweeds.com.*

—Ryan Auer

MANHATTAN

Joe's Pizza
A damn fine slice of pizza...maybe the best in NYC, but why start a fight?
$
233 Bleecker St., Manhattan 10014
(corner of Carmine St.)
Phone (212) 366-1182

CATEGORY	Pizzeria
HOURS	Daily: 9 AM-6 AM
SUBWAY	A, B, C, D, E, F, V, S to W. 4th St., 1, 9 to Carmine
PAYMENT	Cash only
POPULAR FOOD	Get the fresh mozzarella, plain cheese, or pepperoni and walk with it—or sit and have a gyro or salad.
DRINKS	Soda, Snapple, juice, water
SEATING	About 30 at tables
AMBIENCE/CLIENTELE	Not very glamorous or chic—just good pizza
EXTRAS/NOTES:	Joe's Pizza around the corner came first (same owners), about twenty-five years ago, but this is the Joe's to go to.
OTHER ONES	• Manhattan: 7 Carmine St., 10014, (212) 255-3946

—*Steve Powers*

Mamoun's Falafel
Arguably the best (and cheapest) falafel around. Since 1971
$
119 MacDougal St., Manhattan 10012
(between Bleecker St. and W. 3rd St.)
Phone (212) 674-8685
www.mamounsfalafel.com

CATEGORY	Middle Eastern
HOURS	Daily: 10 AM-5 AM
PARKING	Take the A,C,E or the B,D,F,V to W. 4th Street. Walk east on W. 3rd to MacDougal.
PAYMENT	Cash only
POPULAR DISH	As the name suggests, falafel is king here, either plopped in a pita and topped with lettuce, tomato, and tahini (and, for the brave, an extremely spicy red sauce) or served on a platter with salad. For more substantial fare, try either the chicken kebab or the shawerma sandwiches.
UNIQUE DISH	There are falafel joints all over town, sure, but Mamoun's has been satisfying folks in the Village since the early 70's. In an area where restaurants have a shelf-life similar to that of celebrity relationships, such staying power is a testament to the quality of the ingredients and the ridiculously cheap prices.
DRINKS	A variety of teas, coffees, juices, and sodas.
SEATING	Two ancient wooden booths and, in nice weather, minimal outdoor seating. Mamoun's is really a glorified food stand, though, so it's best to get your falafel to go.
AMBIENCE/CLIENTELE	Dimly-lit with a predominantly wooden interior, Mamoun's appears to have changed very little in its 30-plus years of business. The decor is simple,

but certainly thought-provoking (ponder the implications of the strange, apocalyptic poster on the wall as you wait in line). Patrons generally consist of students, locals, and tourists looking for cheap grub in between the raucous bars that litter MacDougal Street.

EXTRAS/NOTES A line out the door is almost a guarantee. Don't be dissuaded, though, as it moves quickly. Also, word to the wise, try not to dilly-dally when ordering. Speak clearly and quickly, pay the man, grab your sandwich, and get moving.

OTHER ONES • 22 St. Mark's Place (between 2nd Ave. and 3rd Ave.), Manhattan 10003

—*Charles Battle*

Meskerem

Traditional Ethiopian cooking in a communal dining environment.
$$$$
124 MacDougal St., Manhattan 10012
(at W. Fourth St.)
Phone (212) 777-8111

CATEGORY Ethiopian
HOURS Daily: 11 AM-11 PM
SUBWAY A, C, E, F, V, S to W. 4th St.
PAYMENT VISA, MasterCard, American Express
POPULAR FOOD *Doro wat*: chicken seasoned with onions, garlic, sautéed in butter, finished with red wine and ground red pepper; all dishes served with *injera*, a spongy Ethiopian flat bread
UNIQUE FOOD Meskerem Combo: pan cooked prime beef (sautéed with ground red pepper, prime beef seasoned with garlic, onions, and ginger served with collard greens), lamb (sautéed in butter garlic, ginger and mild curry, split lentils cooked with ginger, garlic, onions, olive oil and mild curry), and lentils cooked with garlic, onions, olive oil topped with ground red pepper
DRINKS *Bedele* (an Ethiopian beer similar to Heineken), Corona, scotch, whiskey, and cognac, red and white wine, and five kinds of honey wine: some light, one fuller bodied and more honey-sweet, cranberry and blackberry flavored
SEATING Seats 34, including four at the bar
AMBIENCE/CLIENTELE Cozy garden floor restaurant with view of MacDougal Street through small paned windows; subtle track lighting; Ethiopian panels depicting Mary and the disciples of Christ; photos of Ethiopian people, countryside, mountains
EXTRAS/NOTES Traditional Ethiopian garments and jewelry, along with popular Ethiopian CDs, are for sale. Meskerem means September; Ethiopian New Year is Sept. 1.
OTHER ONES • Midtown: 468 W. 47th St., 10036, (212) 664-0520

—*Matthew Gurwitz*

MANHATTAN

Peanut Butter & Co.
$$
No corners cut, just crusts, honey, crusts.
240 Sullivan St., Manhattan 10012
(at Bleecker St.)
Phone (212) 677-3995
www.ilovepeanutbutter.com

CATEGORY	Peanut butter boutique
HOURS	Sun-Thurs: 11 AM-9 PM
	Fri/Sat: 11 AM-10 PM
SUBWAY	A, C, E, F, V, S to W. 4th St.
PAYMENT	VISA MasterCard AMERICAN EXPRESS DISCOVER
POPULAR FOOD	Peanut Butter Sandwiches with fluff, jams, jellies, and one with cream cheese and chocolate chips called the Cookie Dough Surprise—all between four and six bucks—crusts on all sandwiches removed upon request
UNIQUE FOOD	Any peanut butter purveyor would be a peon if it didn't bow to the king of Graceland's crowning culinary delight. Keep it regal with the Elvis, a banana-stuffed grilled peanut butter sandwich slathered with honey; bring home the bacon for about $1 more.
DRINKS	Along the usual bottled beverages (water, juices, and pop): old-fashioned root beers and cream sodas, and real cherry lime rickeys; ultimately one of the utterly smooth milks—chocolate, strawberry, and malted—is the perfect match for peanut butter. Suck one through a silly straw for an extra quarter.
SEATING	Seating for 20
AMBIENCE/CLIENTELE	Country-Kitchen-meets-50s-soda-shop aesthetic is a throw back to Rockwellian Americana, all except for the moonlighting tattooed-and-pierced NYC bike messengers who deliver take-out orders in brown paper lunch bags.
EXTRAS/NOTES	Are you a smoothie, or a crunchy nut? Or maybe you got a feelin' for the flavor: put a white or dark chocolate or Cinnamon Raisin swirl in your world. You're covered however you like it. PB&C's home-blends its own peanut butters to go (in recycled glass containers).

—*Matthew Gurwitz*

Pizza Booth
A slice good enough for Springsteen.
$
165 Bleecker St., Manhattan 10012
(between Sullivan St. and Thompson St.)
Phone (212) 982-8663 • Fax: (212) 982-8039

CATEGORY	Italian
HOURS	Mon-Weds: 11 AM-1 AM
	Thurs-Sat: 11 AM-4 AM
	Sun: 11 AM-1 AM
PARKING	Take the A,C,E or B,D,F,V to W. 4th St. Walk south on Sixth Avenue to Bleecker and then walk two and a half blocks east.
PAYMENT	VISA MasterCard AMERICAN EXPRESS DISCOVER

MANHATTAN

POPULAR DISH	The plain slice. It's simple and beautifully done and will only set you back $2. More extravagant varieties, like the pepperoni and spicy chicken dabbed with ricotta, start at $3.25. Slices are huge, so one will usually suffice. Calzones are also a tasty, affordable option.
UNIQUE DISH	Calling it unique may be a stretch, but the spicy chicken sandwich is a delicious alternative to pizza. Served hot on a crusty hero, they take the same spicy chicken featured on their pizzas and then top that with lettuce, tomato, and mayo. It's no-frills, sure, but the ingredients are fresh and the sandwich is pretty hefty for just $6.
DRINKS	A small selection of domestic and imported beers, fountain sodas, Gatorade, and bottled water.
SEATING	Seating for about twenty, with a bunch of small tables that can be pulled together to accommodate medium-sized groups. The lifeblood of the Booth, however, is take-out, so feel free to grub your slice on the streets (hey, look at the blown-up photo of Bruce on the wall—that's how The Boss eats *his* slice).
AMBIENCE/CLIENTELE	Owing to the close proximity of NYU, a lot of students frequent the Booth. There's usually a mixture of locals and tourists, too, the latter having generally overtaken this area of Bleecker Street. If you're looking for an intimate spot to canoodle with a new love interest, go elsewhere. If you're at that point in the relationship where you're both comfortable shaking extra garlic powder on your slice, well, this is the place for you.
EXTRAS/NOTES	You've left the bar, you're hungry, but you don't think any places are going to be open for a quick late-night fix. Look no farther, friend. The Booth is open until 4am on weekends, so come join the other bleary-eyed souls looking to ward off their impending hangovers.

—*Charles Battle*

Temple in the Village
Old World Mom and Pop Eatery increases health, wealth, and wisdom of its clientele.
$$
74 W. Third St., Manhattan 10012
(between LaGuardia Pl. and Thompson St.)
Phone (212) 475-5670

CATEGORY	Vegetarian Buffet
HOURS	Mon-Sat: 11 AM-10 PM
SUBWAY	A,C,E,F,V, S to W. 4th St., Q to W. 4th St.
PAYMENT	Cash only
POPULAR FOOD	Of the endless array of fresh Korean and Japanese dishes, proprietor/Taoist Immortal in disguise says the Tofu Jim is the most popular attraction-although the spinach salad also has a strong following
UNIQUE FOOD	Seven Grain Rice—a mixture of brown rice, barley, millet, *aduki* beans, brown sweet rice, white and black soy beans

MANHATTAN

DRINKS	A selection of fresh squeezed juices, bottled 'all-natural' drinks, hot and iced teas
SEATING	Seats 20, take-out available
AMBIENCE/CLIENTELE	Not the hippy-dippy atmosphere we expect from a health-food joint. Serious folks, serious about their bodies, reading books, scribbling notes, listen to the limpid flow of classical music that makes this dining experience all the more enlightening.
EXTRAS/NOTES	I know what you're thinking, Seven Grain Rice—big whoop, right? Well, eat it and see the Popeyesque effect it will have on your organism.

—*Nemo Librizzi*

Town Tavern
Home of the daily drink special
$$
134 West 3rd St., Manhattan 10012
(between Macdougal St. and 6th Ave.)
Phone (212) 253-6955
www.towntavernnyc.com

CATEGORY	Neighborhood bar
HOURS	Daily: 11 AM-4 AM
SUBWAY	Town Tavern is conveniently located in the heart of the West Village. Take the A,C,E or B,D,F,V lines to West 4th and Town Tavern is just one block away. You could also take the 1,2,3 to Christopher St. and head east toward 6th Avenue.
PAYMENT	VISA MasterCard AMERICAN EXPRESS Discover
POPULAR DISH	A huge array of typical bar-eats at very affordable prices. Most everything on their appetizer menu is between $3-5 and dinner peaks out at $9. Appetizer half-price specials occur daily, so it's highly possible to grab some fries for $1.50.
DRINKS	Hitting up Town Tavern on Wednesday (or Thursday if you're a lady) will make this one a no-brainer: grab a Bud Light pitcher on Wednesdays for just a dollar during happy hour or, if you happen to be blessed with two X chromosomes, consider dropping by after work on Thursdays, where there's no cover and free drinks and appetizers until 8pm! The focus here is really on affordability, more than drink selection. You can literally spend a night at Town Tavern and get out the door for $10 or less! Being female certainly has its advantages, but beer pong specials and game viewings obviously cater more to the male patrons, which pretty much evens things out. Bottom line is everyone wins at Town Tavern.
SEATING	Seating can be a definite problem during drink special hours (i.e. until 8 PM), so grab a table as early as you can. The upstairs is frequently partitioned off for special events and parties, which further limits seating. Fortunately, Town Tavern usually provides ample distractions from

	the seating arrangements with the wide array of special contests and games held there every single evening.
AMBIENCE/CLIENTELE	Town Tavern consistently draws a huge after-work contingent, which is certainly their intention. Many suits saunter up to the bar during happy hour, though fortunately those ties get loosened fairly quickly once a few pitchers have been consumed. The atmosphere is always fun, loud, and lively. It's almost impossible not to relax and forget about your workday woes as you throw those little white Ping Pong balls into plastic cups and watch the game on one of the many big-screen TVs surrounding the bar. Looking for a quiet lounge to remove yourself from the bustle of NYC? Sorry, look again—Town Tavern is in the thick of it.
EXTRAS/NOTES	An amazing drink special list for every single day of the week. *Sunday*: "Sunday Bloody Sunday"—the legendary build-your-own bloody Mary bar, $12 unlimited vodka refills from noon-5 PM and $2 Brooklyn Beer; *Monday*: "Merchandise Mondays & Jack Bauer Power Hour"—sport your Town Tavern gear and everything is half-price. Watch *24* on 12 flat screen TVs with surround sound. *Tuesday*: "Out of Town Taco Tuesday"—all out of state drivers licenses and international passports receive half-price pints all night long. $2 Taco Trios. *Wednesday*: "Wild on Wednesday" 25¢ domestic pitchers from 5-8 PM for beer pong. *Thursday*: "Thigh High Thursdays"—$10 open bar for all ladies from 5-8 PM. War of The Shores Summer House Competition From 9-Close. *Friday*: "Grad & Law Student Happy Hour"—$20 top shelf open bar and unlimited mini burger buffet. *Saturday*: "Summertime Saturdays"—Kill the Keg, $10 Unlimited Domestic Drafts From 7-10 PM, $2 Bud pints, 25¢ buffalo wings.

—*Stephanie Hagopian*

Vol de Nuit

Eat your heart out, Time Cop: Belgian beer washes down mussels from Brussels!
$$$$
148 W. 4th St., Manhattan 10012
(at Sixth Ave.)
Phone (212) 979-2616
www.voldenuitbar.com

CATEGORY	Belgian Beer and Frites Joint
HOURS	Sun-Thurs: 4 PM–2 AM Fri/Sat: 4 PM-4 AM
SUBWAY	A, C, E, F, V, S to W. Fourth St.
PAYMENT	VISA AMERICAN EXPRESS MasterCard Discover
POPULAR FOOD	Heaps of Belgian *frites* served in a paper cone
UNIQUE FOOD	$10 and change gets you mussels served in the kind of pot your mom would use to cook potatoes
DRINKS	World-class selection of beer and wine

MANHATTAN

SEATING	Seats 50
AMBIENCE/CLIENTELE	Attracts people who don't count calories
EXTRAS/NOTES	Started out as a mere *frites* stand and grew into a beer and *frites* joint.

—Jeremy Poreca

'wichcraft
Colicchio's crafted sandwiches hold organic appeal.
$$$
60 E. 8th St., Manhattan 10003
(at Mercer St.)
Phone (212) 780-0577
www.wichcraftnyc.com

CATEGORY	Sandwich Shop
HOURS	Mon-Fri: 8 AM-6 PM Sat/Sun: 10 AM-6 PM
SUBWAY	Take the N,R,W to 8th Street, or the 6 to Astor Place.
PAYMENT	VISA, MasterCard, American Express, Discover
POPULAR DISH	A vegetarian favorite is the goat cheese sandwich on multi-grain bread with a walnut pesto, avocado, celery, and watercress. For meatier fare give the slow roasted pork a try: hand pulled pork, red cabbage, jalapeños, and mustard on a ciabatta roll.
UNIQUE DISH	All ingredients are hand crafted to suit each gourmet sandwich and all are handpicked from small producers with green market vegetables. 'wichcraft is a serious blend of fine dining—to go.
DRINKS	Coffee, tea, hot chocolate, Ronnybrook yogurt drinks, Boylan sodas, and Red Jacket Orchard apple juice.
SEATING	Plenty of open seating with lots of room to spread out. A great place to study or work for an hour or two.
AMBIENCE/CLIENTELE	Typical cafe atmosphere, with a clientele consisting mostly of college students and business types.
EXTRAS/NOTES	Viewers of Bravo's *Top Chef* might recognize 'wichcraft as part of Tom Colicchio's Craft restaurant empire. Free wi-fi is available at all locations; ask one of the staff members for the password to log on.
OTHER ONES	• 69 Prince St. (at Equinox gym), Manhattan 10012, (212) 780-0577 • Flatiron/Union Square/Gramercy: 555 5th Ave., Manhattan 10018, (212) 780-0577 • Midtown: Bryant Park (four kiosks located on the 6th Ave. side of the park), Manhattan 10110, (212) 780-0577 • Sixth Avenue to the Hudson: 269 11th Ave., Manhattan 10001, (212) 780-0577 • 397 Greenwich St., Manhattan 10013, (212) 780-0577 • Union Square (delivery only), Manhattan 10003, (212) 780-0577

—Emily Isovitsch

MANHATTAN

Yatagan Kebab House
Yet again, the Döner Kebab turns up to entice the Hungry?
$$$
104 MacDougal St., Manhattan 10012
(between Bleecker and W. Third Sts.)
Phone (212) 677-0952

CATEGORY	Turkish/Middle Eastern
HOURS	Daily: 10 AM-5 AM
SUBWAY	A, C, E, F, V, S to W. 4th St.
PAYMENT	Cash Only
POPULAR FOOD	Falafel; the *Döner* kebab—so named for the Turkish word for "to turn"—is made fresh daily from breast of lamb layered with ground beef and (more) lamb, slow cooked on a rotisserie: one is stuffed with enough succulent slices of meat, onions, tomatoes, and lettuce to feed you twice
DRINKS	*Ayran*, a traditional Turkish drink made from yogurt, water, and salt (like an unsweetened Indian *lassi)*; lack tea with cardamom seeds, coffee, soda, water
SEATING	Tables seat 16
AMBIENCE/CLIENTELE	Village dwellers looking for a bite after the pubs close, taxi drivers in need of fuel, "some belly dancers," not a few speaking Turkish; narrow brick interior, hung with photos of the Blue Mosque in Istanbul, an enormous (and considering his Westernizing agenda, rare) photo of Ataturk in Ottoman dress
EXTRAS/NOTES	Opened in 1983 by Gultekin Ismihanli, a Turkish immigrant, Yatagan is now run by Nedret Akan. Turhan Ismihanli, Gultekin's son, can usually be found behind the counter; he's a fountain of five borough food knowledge. Across the street is a deli that claims to stock 400 exotic beers.

—*Matthew Gurwitz*

SIXTH AVENUE TO THE HUDSON

Amin
Shamefully overlooked (and wonderfully inexpensive) neighborhood Indian haunt.
$$$
155 Eighth Ave., Manhattan 10013
(between W. 17th and W.18th Sts.)
Phone (212) 929-7020

CATEGORY	Indian
HOURS	Daily: Noon-10:30 PM
SUBWAY	A, C, E to 14th St.
PAYMENT	VISA MasterCard AMERICAN EXPRESS DISCOVER
POPULAR FOOD	All the standards done well, especially creamy curry sauces; *kurma* (light cream, almond and tomato sauce) with lamb, beef, chicken, *keema* (Indian sausage), or vegetables; delicious *malai* (slightly spicy coconut sauce) with same choice of meats or vegetables; for vegetarians, *bindi bhajee*

MANHATTAN

	(okra with tomatoes and onions) is melt-in-your-mouth wonderful; even if it's not on the menu, you can ask for the terrific *mottor ponir* (fried mild cheese in a pea sauce); generous portions of rice, *dal* and condiments included for entrée price
UNIQUE FOOD	*Pakhee* (marinated quail stuffed with meat and almonds, as an appetizer or as a main course)
DRINKS	Domestic and imported beers including a few Indian varieties, house red and white wines, mango or plain sweet *lassi*, soda, tea, and coffee
SEATING	Table seating for about 40
AMBIENCE/CLIENTELE	Low-key and very low lighting; however, the wallpaper is a fabulous patterned red velvet; friendly wait staff occasionally throws in complementary rice pudding for dessert
OTHER ONES	• Manhattan: 110 Reade St., 10013, (212) 285-2466 • Brooklyn: 140 Montague St., 11201, (718) 855-4791

—Joanna Jacobs

End Your Day the Writer's Way at One of Manhattan's Famous Literary Drinking Establishments

On his deathbed, Chekhov sipped champagne. Hemingway, famously drunk, said "drinking is a way to end the day." Dylan Thomas, wrecked and ruddy-faced after a bout of heavy imbibing while on a speaking tour in November of 1953, went somewhat raucously into that goodnight after he collapsed inside his favorite watering hole, White Horse Tavern; death proved it did have at least some dominion when Thomas died shortly thereafter at St. Vincent's hospital. For whatever reason, and there are theories and postulations and anecdotal examples aplenty, there has always been a complex, often precarious, kinship between writers and strong drink. New York, being a city of ample artistic repute, has been home to many wordsmiths over the years and below is just a sample of the extant hotel bars, dives, pubs, and jazz joints that once served up spirits to some of our most eminent inebriates.

Arguably the most famous speakeasy in New York—maybe even the United States—**Chumley's** in Greenwich Village has been serving anti-temperance beverages, both legally and illegally, since 1922. Behind a nondescript door on Bedford Street, locals, tourists, and locals with tourists in tow dine on decent pub fare while drinking one of the bar's signature brews. Of course, what the food lacks in flare Chumley's more than makes up for in historic charm. Placed on the Literary Landmarks Register in 2000, Chumley's has served some of the most important and celebrated American authors of the twentieth century, writers of such stature that we know them solely by their surnames: Faulkner, Steinbeck, Cather, O'Neill, Dreiser, Cummings. Diners curious as to which authors in particular frequented the establishment need only look at the dust jackets on the wall—every author up there has been a patron of the pub at one time or another. It's sort of like a museum for bibliophiles, if museums served beer, chicken wings, and blue cheese mashed potatoes (which are excellent, by the way). *86 Bedford St.*

MANHATTAN

(between Grove St. and Barrow St.), Manhattan 10014, (212) 675-4449.

Dylan Thomas wasn't the only literary figure to frequent the **White Horse Tavern**, though the various portraits of him and the broadsides of his poetry on the walls might lead you to that conclusion. I guess if you overdose in a place you sort of become its patron saint by default. The tavern's other notable barstool bards include James Baldwin, Jack Kerouac, Norman Mailer, Hunter S. Thompson, and Bob Dylan. Having opened for business in 1880, White Horse continues to be a popular spot for West Village locals and tourists alike. Outdoor seating is an attractive asset in the fairer seasons, while the dark wooden interior creates a warm, cozy atmosphere in winter. White Horse offers a limited menu of pub grub—the burger is delicious—and a nice selection of draught beer, in addition to wine and liquor. If you're a true Dylan Thomas acolyte, order the Welshman's beverage of choice, a whiskey sour. *567 Hudson St. (at 11th St.), Manhattan 10014, (212) 243-9260.*

Just a short stumbling distance from the White Horse Tavern sits **Kettle of Fish**, a former bohemian hangout that now draws a mingled crowd of haggard locals, gays and lesbians, and college students. Though the bar has changed locations three times since it opened in the Fifties, when you might have sipped your beer next to Jack Kerouac or Bob Dylan, the name and the attitude remain untouched. There's nothing frou frou about this place: there are pitchers of beer, darts and a pinball machine in the back room, and football on television (the current owner is a huge Packers fan). That may not be high-minded enough for some of the New York literati, but it works for us. *59 Christopher St. (at 7th Ave. South), Manhattan 10014, (212) 414-2278.*

The Algonquin Hotel, located farther up the island, rented its first room over a century ago, though it wasn't until 1919, when the hotel became the sight of the Algonquin Round Table meetings, that it achieved its true cultural cachet. Members of the Round Table included a rotating cast of not only poets, editors, and playwrights—such as Dorothy Parker, Harold Ross, and Robert Sherwood—but also actors and composers—such as Robert Benchley, Harpo Marx and Deems Taylor. This "Vicious Circle" exchanged witty repartee almost daily over lunch and together helped redefine American art and culture in the early twentieth century. The table where they sat is still set, with the members' name cards in place for visitors to peruse while sipping tea and dining on "retro dishes drawn from the Algonquin's culinary archives." *59 W. 44th St. (between 5th Ave. and 6th Ave.), Manhattan 10036, (212) 840-6800, www.algonquinhotel.com.*

Opening in 1939, at the end of the Harlem Renaissance and the birth of the be-bop era, the **Lenox Lounge** in Harlem was not only a popular meeting place for black novelists, poets, and activists—James Baldwin, Langston Hughes, and Malcolm X were all known to hang out there from time to time—it also showcased some of the most notable jazz acts of the twentieth century. Miles Davis, John Coltrane, and Billie Holiday all performed regularly on the lounge stage, and national-touring musicians as well as up-and-comers continue to draw large crowds in both the gloriously swanky Zebra Room and the noisier, more casual front area. Drinks are reasonably priced and the kitchen offers a small menu of soul food- and Creole-inspired appetizers and entrees. Locals recommend the

MANHATTAN

Poor Man's Jumbo, a savory concoction of okra cooked with bacon, corn, andouille sausage, shrimp, and tomatoes. Admission for live music usually runs about $20 per set with a one-drink minimum. Check the website for up-to-date information. *288 Lenox Ave. (between 124th St. and 125 St.), Manhattan 10027, (212) 427-0253, http://lenoxlounge.com/index.html.*

—Charles Battle

Amy's Bread
Homemade breads steal the spotlight on Bleecker Street.
$$
250 Bleecker Street, Manhattan 10014
(at Leroy St.)
Phone (212) 675-7802
www.amysbread.com

CATEGORY	Bakery/Café
HOURS	Mon-Fri: 7:30 AM-11 PM
	Sat: 8 AM-11 PM
	Sun: 8 AM-9 PM
SUBWAY	A, C, E, B, D, F, V to West 4th St. and take the 3rd St. exit.
PAYMENT	Visa, MasterCard, American Express, Discover
POPULAR DISH	Perfectly crafted bread. The cupcakes, cookies, and bread twists are masterpieces in and of themselves, but you can't help but notice the large crusty loaves peeking out from behind the register. If you're looking for something special, give the prosciutto and black pepper twist a try. The focaccia raisin twist is also a neighborhood favorite. The traditional country white and rustic Italian are also great sellers.
UNIQUE DISH	Familiar flavors stand out when served on Amy's delicious bread. Try the NY State goat cheese, served on a French baguette with roasted tomato, roasted eggplant, black olive tapenade, and fresh thyme. The grilled NY State cheddar sandwich, with a spicy chipotle pepper puree, sliced red onions, tomatoes, and fresh cilantro, is a great cold weather soother. (It requires a few minutes of preparation, but it's worth the wait!)
DRINKS	Espresso and coffee drinks, tea (iced and hot), hot chocolate, root beer, ginger beer, and Fizzy Lizzie drinks.
SEATING	Small cafe with limited seating.
AMBIENCE/CLIENTELE	A soothing atmosphere that welcomes anyone looking to sit for a while
OTHER ONES	• Sixth Avenue to the Hudson: Chelsea Market, 75 9th Ave (at 15th St.), Manhattan 10011, (212) 462-4338
	• Sixth Avenue to the Hudson: 672 9th Ave. (between 46th St. and 47th St.), Manhattan 10036, (212) 977-2670

—Emily Isovitsch

MANHATTAN

A Salt and Battery
"In Cod We Trust."
$$$
112 Greenwich Ave., Manhattan 10011
(at Jane St.)
Phone (212) 691-2713
www.asaltandbattery.com

CATEGORY	Fish and chip shop
HOURS	Daily: Noon-10 PM
SUBWAY	A, C, E, 1, 2, 3 to 14th St.
PAYMENT	VISA, MasterCard, American Express
POPULAR FOOD	Fish (cod, haddock, tilapia, or whiting) and chips; hold the chips and pay less
UNIQUE FOOD	Chip butty (french fries in a buttered roll), mushy peas, deep-fried Mars bar
DRINKS	British and American beer, sodas
SEATING	Seats seven at the counter
AMBIENCE/CLIENTELE	A mix of British expatriates craving a taste of home and Village locals looking for a quick and satisfying meal
EXTRAS/NOTES	The restaurant's motto is "In Cod We Trust," and the tender, flaky fish and chips—fried by an authentic ex–British Navy cook (tattoos add authenticity) —are the reason to be here. It's even more British than Britain, where they've abandoned the practice of wrapping their fish and chips in newspaper. Not so here: you can read bits of the *Observer* after your meal, if you don't mind a little grease and malt vinegar blotting the headlines. Owned by Tea and Sympathy, the English restaurant next door.

—Phil Curry

Beard Papa's Sweets Café
(See p. 99)
Bakery
5 Carmine St., Manhattan 10014
Phone: (212) 989-8855

Bone Lick Park
Kitschy, clean Southern comfort BBQ in fast-times setting.
$$$
75 Greenwich Ave., Manhattan 10014
(between 7th Ave. and Bank St.)
Phone (212) 647-9600 • Fax (212) 647-9625

CATEGORY	American BBQ
HOURS	Daily: 11:30 AM-11 PM
SUBWAY	Take the 1,2,3 to 14th St., or the A,C,E to 14th St.
PAYMENT	VISA, MasterCard, American Express, Discover
POPULAR DISH	Try the combo platter: your choice of any 2 meats and a side (the mac and cheese is a favorite among regulars).
UNIQUE DISH	The Carolina pork ("chopped, not pulled") will make you forget you're in Manhattan. The beef

79

MANHATTAN

ribs may sit a little heavy, but they're delicious going down.

DRINKS Iced tea and soda

SEATING Bar seating and standard cafeteria-like tables

AMBIENCE/CLIENTELE Has a comfortable Americana feel, with the requisite retro Coca-Cola sign behind the bar. Diners are usually of the fast, in-and-out variety, with some lingering bar-nicles. Good mix of families, diverse couples, and small groups, all looking to get their BBQ on.

EXTRAS/NOTES $3 margaritas and mojitos until 7 PM. Also offers a delicious Southern brunch on Saturdays and Sundays from 11:30 AM to 4:30 PM. Dine on bayou fried oysters with cheddar grits and collards and wash down all that yummy cholesterol with a bloody Mary or a Red Bull mimosa.

—*Brian Crandall*

Buddha Bar

Psst . . . what's the password?
Hidden temple thrives in heart
of meatpacking district.
$$$
25 Little West 12th St., #311, Manhattan 10014
(between 9th Ave. and Washington St.)
Phone (212) 647-7314
www.buddhabarnyc.com

CATEGORY Lounge

HOURS Daily: 5:30 PM-4 AM

SUBWAY Taxi, taxi, taxi. You could take the subway, but it's a hike from the nearest station. There is street parking, but not your first choice in the city.

PAYMENT VISA MasterCard AMERICAN EXPRESS

POPULAR DISH Though you'll need a reservation, Buddha Bar does offer a full dinner and sushi menu (the rolls are crafted right before your eyes in the sushi bar). The entrees tend to be pricey, and for the wait and the crowds, it can be a challenge just to get in. If you do choose to dine, though, the tuna tartare and rice-cracker salmon are excellent.

DRINKS Full bar, but they are particularly popular for infusing exotic fruits into vodka cocktails. The Buddha Lemonade is both refreshing and powerful—great in the summer or when the heat in the temple gets to you. Or, for something really exotic, try the Arabesque, with vodka, pear, and curry. Did you ever think you'd have curry mixed in a drink?

SEATING The place is huge! It's broken up into three main areas, each slightly spilling over into the other. You have the bar/lounge area, where many tables are reserved ahead of time for those purchasing late night bottle service; the main dining area, where you'll have an awe-inspiring view of a 25-foot Buddha; and the quieter sushi bar, tucked away behind the "smoker's" lounge. While space is not a problem, the crowds can be if you go on weekend nights without a reservation.

MANHATTAN

AMBIENCE/CLIENTELE It's the meatpacking district, so it's chic and sleek with a clientele that includes trendy New Yorkers and celebrities. The feel is ultra-hip, so be prepared for a little pretentiousness if you're not on the list. Plan ahead and dress accordingly, and you shouldn't have a problem.

EXTRAS/NOTES Reminiscent of the speakeasies of the 20's, this place can be easy to miss. You could walk right by the steel doors and never know the wonderment within. Be alert!

—*Tracey David*

Burritoville
Enlightened caudillo of Manhattan's burrito scene tailors to all tastes, preferences, and diets.
$$
264 W. 23rd St., Manhattan 10011
(between Seventh and Eighth Aves.)
Phone (212) 367-9844
www.burritoville.com

CATEGORY Mexican
HOURS Sun-Thurs: 11 AM-Midnight
Fri/Sat: 11 AM-1 AM
SUBWAY C, E to 23rd St.
PAYMENT VISA, MasterCard, American Express, Discover
POPULAR FOOD Innovative burritos for consumers of white, dark, and no meat; the Bob Marley's Last Burrito (jerk chicken spiced with chilies, clove and cinnamon); chili *con carne* (spicy ground beef, chili, and two beans), the Lost in Austin (steamed spinach and mushrooms), and many more; the 13 inch tortilla wrappers sometimes overwhelm the filling, so tear away excess starch and enjoy.
UNIQUE FOOD Wraps, salads, soups, stews, and more vegetarian options than you'd expect (Burritoville shares ownership with Veg City Diner, see p. xx); better yet are the tortilla chips which, along with a variety of salsas, are free while you wait
DRINKS "Bottomless" fountain sodas and Burritoville's own line of bottled drinks: lemonade, fruit juice, tea, *horchata*; beer
SEATING Seats about 75
AMBIENCE/CLIENTELE Clean; old maps, old Mexican movie posters, and old photos of rail-riding revolutionaries; Burritoville's secret is out—so even this deep-in-the-heart-of-Chelsea location attracts those who aren't locals.
EXTRAS/NOTES The first Burritoville opened on the Upper East Side ten years ago. Since then, this hamlet has expanded into a Burritoempire, with 13 locations across Manhattan and outposts as far flung as New Jersey and Connecticut. Plays Charley the Gent to lower-rent Fresco Tortilla's (see p. xx) Terry Malloy, except without the crookedness.
OTHER ONES • Midtown: 352 W. 39th St., 10018, (212) 563-9088
• Sixth Avenue to the Hudson: 625 Ninth Ave., 10036, (212) 333-5352

MANHATTAN

- Upper West Side: 166 W. 72nd St., 10023, (212) 580-7700
- Upper West Side: 451 Amsterdam Ave., 10024, (212) 787-8181
- Flatiron/Union Square/Gramercy: 1606 Third Ave., 10128, (212) 410-2255
- Manhattan: 1489 First Ave., 10021, (212) 472-8800
- Flatiron/Union Square/Gramercy: 866 Third Ave., 10022, (212) 980-4111
- Manhattan: 141 Second Ave., 10003, (212) 260-3300
- Manhattan: 20 John St., 10038, (212) 766-2020
- Manhattan: 36 Water St., 10004, (212) 757-1100
- Manhattan: 144 Chambers St., 10007, (212) 964-5048

—Joe Cleemann

Chez Brigitte
Continental cuisine on a counter.
Since 1958
$$$
77 Greenwich Ave., Manhattan 10014
(At Seventh Ave.)
Phone (212) 929-6736

CATEGORY	French
HOURS	Daily: 11 AM–10 PM
SUBWAY	1, 2, 3 to 14th St.
PAYMENT	Cash only
POPULAR FOOD	Simple, homey food with a French country twist: daily specials include beef, veal, chicken, and fish standbys. The *côtes de poulet*, chicken breast sautéed with mushrooms in brown sauce, is especially good and comes with a healthy selection of side vegetables and starches (roast potatoes, yellow rice, peas, and salad).
UNIQUE FOOD	You'll find *boeuf bourgignon* or *ragoût de veau* at other French restaurants in the city, but never so well prepared in so short a time and in such a charming setting.
DRINKS	Iced and hot tea and coffee; juice, milk, soft drinks; no wine, but feel free to bring your own
SEATING	As the sign on the wall says, "Chez Brigitte will serve 250 people 11 at a time." Two narrow rows of stools at counters
AMBIENCE/CLIENTELE	Just a slice of a room, really, but this welcoming lunch counter is perfect for when you can't make it home for your *mere's* cooking
EXTRAS/NOTES	According to the menu, Marseilles-born Brigitte Catapano opened Chez Brigitte in 1958. Since her retirement in the mid-1980s (and her death some years later), the restaurant has been run by Rosa Santos, who had been an employee. Great prices. Slide into the counter, place your order, and one of the very pleasant chefs/waiters will cook right in front of you.

—Joanna Jacobs

MANHATTAN

Chow Bar
Chow down in style.
$$$$
230 W. 4th St., New York 10014
(at W. 10th St.)
Phone (212) 633-2212

CATEGORY Pan-Asian

HOURS Mon-Thurs: 5 PM-11 PM
Fri: 5 PM-Midnight
Sat: Noon-Midnight
Sun: Noon-11 PM

SUBWAY Take the 1,9 to Christopher Street and walk west.

PAYMENT VISA MasterCard American Express Discover

POPULAR DISH The "side order" of spicy lobster fried rice is the most insane item on the menu—a huge portion of warm and flavorful rice mixed with bite-sized chunks of fresh lobster. It's immensely satisfying without being too heavy or greasy, and at $9 it's the perfect dish to share with a friend or a date.

UNIQUE DISH There are Asian-flavored dishes for every palate, with items for both the health-conscious and the self-indulgent. The Szechuan Black Angus steak comes with a spicy soy chili sauce that's sure to clear your sinuses and mustard spiced matchstick fries so light you'll forget they're, well, fried.

DRINKS The bar is a huge draw at this West Village staple. They have a full sake menu, an impressive selection of white and red wines, and a slightly tropical collection of cocktail offerings.

SEATING Reservations are recommended, as the seating goes quickly. There are booths and tables, along with bigger spots for large groups. Additionally, small plates are available at the bar.

AMBIENCE/CLIENTELE Chow Bar has two great things going for it: 1) Night after night, the scene is dependably trendy in that West Village banking/fashion/publishing industry 20-somethings watering hole sort of way and 2) a reservation at a reasonable time is never terribly hard to secure. With intimate lighting, a long list of cocktails, and small plates meant to be shared, it's also the perfect place for a first or second date.

OTHER ONES • Chino's, 173 3rd Ave. (between 16th St. and 17th St.), Manhattan 10003, (212) 578-1200. More casual than Chow Bar, Chino's has the same great food, including the crowd-pleasing lobster fried rice.

—*Jessica Tzerman*

"They say life's what happens when you're busy making other plans. But sometimes in New York, life is what happens when you're waiting for a table."
—*Sarah Jessica Parker*

MANHATTAN

Corner Bistro
Vegetarians beware: the burgers could convert the most committed of you. Since the "early 20th Century."
$$
331 W. Fourth St., Manhattan 10014
(at Jane St.)
Phone (212) 242-9502 • Fax (212) 242-9502
www.cornerbistro.citysearch.com

CATEGORY	Burger Joint
HOURS	Mon-Sat: 11:30 AM-4 AM Sun: Noon-4 AM
SUBWAY	A, C, E, L to W. 14th, 1, 2 to Christopher St./Sheridan Sq.
PAYMENT	Cash only
POPULAR FOOD	Burgers, from the plain ham-variety to the impressive bacon/chili/cheese-class, and fries
DRINKS	Full bar
SEATING	34 at tables and more at the bar, always crowded
AMBIENCE/CLIENTELE	From neighborhood regulars to the midtown crowd, word has gotten out and lines start forming at 7 pm
EXTRAS/NOTES	Jukebox plays tunes, as long as you speak nicely to it.

—*Tanya Laplante*

Dirty Bird To Go
Good-for-you organic fast food chicken.
$$$
204 W. 14th St., New York 10011
(between 7th Ave. and 8th Ave.)
Phone (212) 620-4836 • Fax (212) 620-4837

CATEGORY	Southern/Soul Food
HOURS	Daily: 11 AM-10 AM
SUBWAY	A,C,E to 14th St.; F,V to 14th St.
PAYMENT	VISA, MasterCard, American Express, Discover
POPULAR DISH	Free-range chicken fingers. They are big bits of heaven. Sign up!
DRINKS	No alcohol. Best lemonade ever.
SEATING	Though primarily a take-out joint, five stools are available at the counter. Grab a stool. You won't want to wait a second longer than you have to to tear into your meal.
AMBIENCE/CLIENTELE	In a crazed part of the city where cheap eats can be difficult to find, this place offers a heavenly reprieve from the hustle and bustle. Very laid back and clean, Dirty Bird is populated with twenty- and thirty-somethings who are nostalgic for greasy college grub, but are a bit more health conscious (damn those slower metabolisms…)
EXTRAS/NOTES	Organic take-out, where every item is fresh, tasteful and filling. All the greasy food flavor, none of the morning-after guilt.

—*Alexandra Collins*

MANHATTAN

El Cocotero
Go Venezuelan, the NYC alternative to Mexican
$$$
228 W 18th St., Manhattan 10011
(between 7th Ave. and 8th Ave.)
Phone (212) 206-8930

CATEGORY	Venezuelan
HOURS	Mon-Fri: 9 AM-11 PM Sat/Sun: 9 AM-Midnight
SUBWAY	Take the 1 to 18th Street, or the 2,3,A,C,E,L to 14th Street.
PAYMENT	VISA MasterCard American Express
POPULAR DISH	Start out with an arepa (stuffed cornbread) or the appetizer sampler Degustacion (arepitas, yuca fries, and plantains served with four fillings of shredded meats and beans). Fill up with Pabellon Criollo (stewed flank steak with rice, black beans and plantains) and finish with Torta Tres Leches (three milks cake) or the coconut cake. Leave contento.
UNIQUE DISH	Be sure to try these other Venezuelan dishes that will guarantee a party in your mouth: Camarones Cocotero (sauteed shrimp in cilantro mojo), Palmito (marinated hearts of palm salad in citrus vinaigrette), Hallaca (a traditional holiday dish of corn tamale with stewed chicken wrapped in banana leaves). Any order of arepas should be properly doused with Guasacaca (saucier version of guacamole).
DRINKS	Do not leave without ordering a Chicha de Arroz (rice & sweetened milk shake). Absolutely delicioso. If you're with a group, a pitcher of Sangria or Guarapita (passion fruit) will be sure to bring the tranquile out of everyone. Even Bush and Chavez would share an arepa here.
SEATING	There are several small tables for groups of four or less and a booth area that works well for larger groups.
AMBIENCE/CLIENTELE	This charming Café is the kind of place where old friends gather to share a good meal without breaking the bank or fretting about reservations. Chef Luis and his team have created the perfect haven to escape the hustle and bustle of the city. From the palm trees to the family photo installation in the bathroom, you'll feel like you've migrated south.
EXTRAS/NOTES	Located on a nondescript block across the street from a post office garage, you can easily miss this gem. Look out for the chalkboard and blue awning on the south side of the street.

—*Emily Tsiang*

"The glamour of it all! New York! America!"
—*Charlie Chaplin*

MANHATTAN

F&B
Glorified fast food joint: Euro-dogs—a wide selection of unique hot dog variations, and pommes frites.
$$
269 W. 23rd St., Manhattan 10011
(between Seventh and Eighth Aves.)
Phone (646) 486-4441
www.fandbrestaurant.com

CATEGORY	European Street Food
HOURS	Monday: 7:30 AM–10 PM
	Tues-Fri: 7:30 AM–11 PM
	Sat: 11 AM-11 PM
	Sun: 11 AM–10 PM
SUBWAY	C, E at 23rd St
PAYMENT	VISA MasterCard AMERICAN EXPRESS
POPULAR FOOD	The Great Dane combination (an authentic Danish *pølser,* which comes with fried onion flakes and sweet mustard, and pommes frites with lemonade or iced tea); *pommes frites,* onion *frites,* zucchini *frites,* or sweet potato *frites* with a diverse selection of toppings (garlic aioli, pesto, Thai chili, lemon pepper, etc.); Belgian waffles
UNIQUE FOOD	A large selection of unique hot dogs and dressings, including the Farm Dog (smoked chicken and apple hot dog with corn relish), the *Gaucho* Dog (garlic sausage with *Chimichurri* sauce), and the Sweet Dog (fried banana on a vanilla waffle bun with strawberry preserves, whipped cream, and chocolate sauce) —many of which can be ordered as vegetarian.
DRINKS	Freshly made lemonade and iced tea, chilled chai tea, and a limited selection of imported beers, coffee, tea, soft drinks
SEATING	Two counters span the length of the narrow location—about 20 seats total
AMBIENCE/CLIENTELE	Very pop, and clean. Lots of brushed steel and baby blue paint. Euro-retro: the hotdog equivalent of Ikea
EXTRAS/NOTES	While F&B hotdogs may seem a little pricier than most, they're not at all your normal hotdogs, and are well worth the scratch. F&B deserves kudos for taking what is traditionally a one-note food and completely reinventing it into various hip, exciting, and extremely delicious variations. The occasionally long lines and limited seating will attest to F&B's popularity (though the good thing about hotdogs is they don't take long to make or eat, so the wait is never too bad). F&B delivers between 33rd and 13th Sts., from Fifth to 11th Aves.

—*Brad Wood*

Famous Famiglia
(See p. 147)
Italian/Pizza
686 Eighth Ave., Manhattan 10036
Phone: (212) 382-3030

MANHATTAN

Famous Famiglia
(See p. 147)
Italian/Pizza
61 Chelsea Piers, Manhattan 10011
Phone: (212) 803-5552

Grey Dog Coffee
This food is for people.
$$
33 Carmine St., New York 10014
(between Bleecker St. and Bedford St.)
Phone (212) 462-0041
www.thegreydog.com

CATEGORY	Coffee Shop/Café
HOURS	Mon-Thurs: 6:30 AM-11:30 PM
	Fri: 6:30 AM-12:30 AM
	Sat: 7:30 AM-12:30 AM
	Sun: 7:30 AM-11:30 PM
PARKING	1 to Houston or A,C,E,V,F to W. 4th St.
PAYMENT	VISA MasterCard American Express
POPULAR DISH	You can't go wrong with any of the sandwiches, but the apple, brie, raspberry mustard, and turkey sandwich is one of the best. For heartier fare, try the chicken pot pie or the beer battered Baja tacos. Grey Dog also offers a number of large, tasty salads, including the seared tuna steak salad, served over mixed greens with fried potatoes, wasabi sauce, and an Asian ginger dressing.
UNIQUE DISH	The sandwiches, which range from the standard (PB, & J) to the more inventive (goat cheese, spinach, tomato & roast peppers on toast), are served on your choice of freshly baked breads, so that's what you'll find most regulars munching on. Take a half of your favorite sammy, pair it with one of Grey Dog's delicious soups or salads, and you're sure to have a winning combination.
DRINKS	Grey Dog would not be the same without the coffee, hence the name. Also serves Grey Dog Ale, various beers and wine. On a winter day, mulled wine is sometimes on the menu.
SEATING	Don't turn away when you see a line; the staff will seat you. Trust them. Also, some not-so-subtle reminders that people are waiting to be seated (look for the "No Parking" sign) usually guilt people into leaving shortly after they've finished their meals, so turnover is quick. This is not the place to bring your laptop and literary aspirations—go find a Starbucks, F. Scott. There's sure to be one right around the corner.
AMBIENCE/CLIENTELE	A small gem in the West Village, where the staff always greets you with a smile. Expect loud music, a bustling atmosphere, and a young crowd.
EXTRAS/NOTES	Music can be deafening and the lights are dim, so I wouldn't plan on reading. Eat, drink, be merry, and leave all the quiet introspection at home.
OTHER ONES	Manhattan: 90 University Pl. (between 11th St. and 12th St.), 10003, (212) 414-4739

—*Pamela Schultz*

MANHATTAN

Hummus Place
(See p. 46)
Middle Eastern
**99 MacDougal St.,
Manhattan 10012**
Phone: (212)533-3089

'Ino
Small cafe and wine bar that hopes panini will never go out of style.
$$$$
21 Bedford St., Manhattan 10014
(between Houston St. and Downing St.)
Phone (212) 989-5769
www.cafeino.com

CATEGORY	Italian
HOURS	Daily: 9 AM-2 AM
SUBWAY	1 to Christopher; F, V to W. 4th St.
PAYMENT	VISA MasterCard AMERICAN EXPRESS DISCOVER
POPULAR DISH	The prosciutto, mozzarella and tomato panino is absolutely delicious. The flavors are equally balanced and the ingredients perfectly proportioned; just enough to be satisfying and delicious. The antipasti are incredibly fresh assortments of cheeses, olives, peppers and meats. Tiny croustades accompany the platter to make bite sizes easier to handle.
UNIQUE DISH	In an area known for small but pricey restaurants, this place beats other romantic, unique nooks in both price and quality.
DRINKS	An extensive wine menu.
SEATING	Very small. Often lines to get inside. Long and rectangular dining space with no more than ten or so tables.
AMBIENCE/CLIENTELE	Cozy, unpretentious, and very romantic, though the din of the diners can sometimes be a little much. Attracts a wide array of people, but the crowd mostly consists of neighborhood locals. An impressive wine list makes this sandwich/panini shop feel a bit more upscale.
OTHER ONES	• Manhattan: ('inoteca) 98 Rivington St. (at Ludlow St.), 10012, (212) 614-0473

—Alexandra Collins

Joe's Pizza
(See p. 68)
IPizza Joint
7 Carmine St., Manhattan, 10014,
Phone: (212) 255-3946

MANHATTAN

Lederhosen
Beers... sausages... Ditka
$$$
39 Grove St., Manhattan 10014
(between Bleecker St. and Bedford St.)
Phone (212) 206-7691 • Fax: (212) 206-8562
www.lederhosennyc.com

CATEGORY	German
HOURS	Mon: 4 PM-Midnight
	Tues/Weds: Noon-Midnight
	Thurs-Sat: Noon-4 AM
	Sun: 1 PM-10 PM
PARKING	Take the 1 to Sheridan Square or the A, C, E, B, D, F, V to W. 4th St.
PAYMENT	VISA MasterCard American Express Discover
POPULAR DISH	The best is the wurst, and it's available in many varieties including knackwurst, bratwurst, baurnwurst, weisswurst (my personal favorite), and currywurst. Get the two wurst platter (#25): your choice of two sausages served with either delicious German fried potatoes, red cabbage, sauerkraut, and mustard, or equally delicious German potato salad, stringbean and cucumber salad, and mustard. Either way you get a ton of food without breaking the bank.
UNIQUE DISH	There are a number of authentic German dishes for those folks who don't dig on sausages (alas, it's true, they do exist). The schnitzels (breaded chicken, pork, or veal cutlet) are served four different ways, and the sauerbraten is a beefsteak simmered with carrots in a flavorful wine vinegar gravy.
DRINKS	As good as the food is, this place is really all about the beer. German brands like Radeberger, Dortmunder, Spaten, and HB are all on tap and come in sizes ranging from little fella (0.3 liter) to Chuck Bronson (1 liter). If you were the type of kid who fancied the "suicide" fountain soda concoction, then you'll probably enjoy the Radler (beer and 7-Up) or the Diesel (beer and Coke), though why you'd sully one of these beautiful beers with a sweetened carbonated beverage is beyond my comprehension.
SEATING	There's a small bar and a quaint living room-style area with couches and a fireplace in the front. However, most of the action takes place in the expansive back room, which is as close to an indoor beer garden as you'll find in New York. Sit at one of the many picnic tables and admire the mural of the Alps painted on the walls. This place gets packed most days of the week, so parties of 3 or more should call ahead for a reservation.
AMBIENCE/CLIENTELE	European expatriates and West Village locals fill this place to the brim on weekends. Luckily drinks are filled to the brim, too, making this one of the most jovial joints around. The bar and wait staff are extremely friendly and will often reward your visit with a free post-meal shot.
EXTRAS/NOTES	If you think dinner is a steal, check out the lunch prices. Free Wi-Fi access now available, too.

—*Charles Battle*

MANHATTAN

Lips
It's like the Rocky Horror Picture Show with food!
$$$
2 Bank St., Manhattan 11231
(at Greenwich Ave.)
Phone (212) 675-7710 • Fax (617) 216-1947
www.lipsnyc.com

CATEGORY	Theme Restaurant/Bar
HOURS	Mon-Thurs: 5:30 PM-Midnight Fri-Sun: 5:30 PM-1 AM
SUBWAY	Take the A,C,E train to 14th St.
PAYMENT	VISA MasterCard American Express Discover
POPULAR DISH	Standard American fare in a wig and heels, where each item on the menu is cleverly named after a transvestite. The grilled chicken breast is "The Rupaul." The filet mignon marsala is "The World Famous Divine." The food is good but is outlasted by the experience.
UNIQUE DISH	Each night of the week boasts a special theme: on Latin Night (Monday), they have a delicious Mexican prix fix menu ($14.95) and $2 frozen margaritas, on Wednesday it's Bitchy Bitchy Bingo Night. This one is my favorite because not only do you have the opportunity to win a sex toy, but the "girls" tell blue jokes in the process. Check out the Lips website for the full schedule.
DRINKS	Lips trumpets their cocktails. Yvonne's frozen cosmo supersized is 23 ounces of sweet, frozen sauce. Sure it's enough to choke a horse, but it goes down so smooth! If size isn't your thing, sit back and enjoy a shot ("Blow Job," "Screaming Orgasm," "Buttery Tittie Twister" . . . you get the idea). They may be small but you can think about baseball and make them last longer.
SEATING	Bring your sorority but not your whole class. Large downstairs opens up on Friday and Saturday. If you have a party larger than four, you will want to make a reservation two weeks in advance.
AMBIENCE/CLIENTELE	Drag heaven, but down to earth. The girls will sit down and have long conversations with their customers. Don't be surprised if you run across a bachelorette party or a sweet sixteen. In general, clientele run the gamut just like any other restaurant: young, old, gay, straight, fat, skinny.
EXTRAS/NOTES	It may sound funny to say this, but Lips has a family feel to it. The staff members are a close knit group and there is very little turnover, which means you'll likely see the same friendly, made-up faces each time you visit.

—*Ryan Auer*

"One belongs to New York instantly, one belongs to it as much in five minutes as in five years"

—*Thomas Wolfe*

MANHATTAN

Manna's Soul Food Restaurant
(See p. 184)
American Soul Food
2331 8th Ave., Manhattan 10027,
Phone: (212) 749-9084

Moustache
Comfortable Middle-Eastern cuisine in a casual setting.
$$
90 Bedford St., Manhattan 10014
(between Barrow St. and Grove St.)
Phone (212) 229-2220

CATEGORY	Middle Eastern
HOURS	Daily: Noon-Midnight
SUBWAY	Take the 1 to Christopher St.
PAYMENT	Cash only
POPULAR DISH	Fresh, delicious dips abound and are served with puffed-up, straight-from-the-brick oven pitas. The babaganough is a favorite among regulars, as are any of the signature "pitzas," which come topped with a variety of ingredients, from a rag of ground lamb, onion, tomato, and parsley to leeks and scallions—a surprisingly delectable fusion of Middle-Eastern and Western civilizations, which, though it may not inspire world leaders, will certainly leave you satisfied.
UNIQUE DISH	The ouzi is Middle-Eastern comfort food at its best. Similar to pot pie, it's a hearty concoction of chicken, carrots, sweet peas, onions, golden raisins, almonds, and basmati rice, all encased in flaky filo dough and served with a tangy yogurt sauce (similar to tzatziki). It's perfect for sharing, provided that you and your guest are comfortable enough with each other to spill ouzi innards all over the table. Don't worry, your waitress won't berate you for your messiness.
DRINKS	Beer, wine; assorted teas, juices, and sodas.
SEATING	A large number of two-person tables which can be pushed together to accommodate most any size party. The place fills up quickly during dinner, so you may have to wait a few minutes to be seated. And don't be surprised when you're elbow-to-elbow with the group next to you once you are.
AMBIENCE/CLIENTELE	With its dim lighting, exposed brick, and ambient World music, Moustache is a cozy spot that is perfect for a casually romantic dinner (think Romeo in a t-shirt and tennis shoes). If all goes well, the hummus might not be the only thing you end up sharing.
EXTRAS/NOTES	The East Village location offers outdoor seating during the warmer months.
OTHER ONES	• Manhattan: 265 E. 10th St., 10009, (212) 228-2022

—Charles Battle

MANHATTAN

Pinkberry
(See p. 132)
Yogurt
41 Spring St., Manhattan 10012
Phone: 212-274-8883

Pinkberry
(See p. 132)
Yogurt
170 8th Ave., Manhattan 10011
Phone: 212-488-2510

Pret a Manger
(See p. 122)
British sandwich shop
Manhattan: 530 Seventh Ave., Manhattan 10018
Phone: (646) 728-0750

Pret a Manger
(See p. 122)
British sandwich shop
Manhattan: 1350 Sixth Ave., Manhattan 10019
Phone: (212) 307-6100

Rare Bar and Grill
(See p. 124)
Burger joint
228 Bleecker St. (between 6th Ave. and Carmine St.), Manhattan 10014
Phone: (212) 691-7273

Rice: MOTT ST.
(See p. 191)
Asian
277 Mott St., Manhattan 10012
Phone: (212) 266-5575

Rue des Crêpes
New York's crêpe constituency finally gets a street name—and, better yet, a great place to get crêpe.
$$$
104 Eighth Ave., Manhattan 10011
(between W. 15th and W. 16th Sts.)
Phone (212) 242-9900 • Fax (212) 242-3687
www.ruedescrepes.com

MANHATTAN

CATEGORY	Crêpes
HOURS	Sun-Thu 11 AM-10 PM Fri-Sat 11 AM-Midnight
SUBWAY	4, 5, 6 to 86th St.
PAYMENT	VISA MasterCard AMERICAN EXPRESS DISCOVER
POPULAR FOOD	Wide variety of creative, main dish meat, cheese and veggie crêpes; it's hard to top the classic sliced banana and Nutella, but the cinnamon apple crêpe (the apples come baked with a crispy oatmeal raisin mixture) and the mixed berry (fresh strawberries, blueberries, and raspberries) are certainly contenders
UNIQUE FOOD	American departures from French form: The Vegetarian incorporates vegetables, *tabouleh*, white beans, and a *miso* ginger sauce; the wild mushroom crêpe with shallots and tarragon is simple and elegant, while the turkey, fontina cheese, spinach, and mushroom crepe is hearty and satisfying.
DRINKS	Full complement of teas and coffees, as well as sodas and seasonal hot and cold drinks, and wine
SEATING	About eight small tables
AMBIENCE/CLIENTELE	The interior decorator took the name literally, creating an inside outdoor Parisian Café, complete with French street signs and cobblestones on the floor

—*Joanna Jacobs*

Sala
(See p. 56)
Spanish
35 W. 19th St., Manhattan, 10011
Phone: (212) 229-2300

Spice
Innovative Thai food—grab the lunch specials.
$$$$
199 Eighth Ave., Manhattan 10011
(at 20th St.)
Phone (212) 989-1116
www.spicenyc.net

CATEGORY	Modern Thai
HOURS	Mon-Fri: 11:30 AM-11 PM Sat/Sun. 11:30 AM-Midnight
SUBWAY	A, C, E to 23rd St.
PAYMENT	VISA MasterCard AMERICAN EXPRESS
POPULAR FOOD	Fresh Ginger and Pineapple, a tangy mix of surprisingly zingy fresh ginger and citrus caramelized in soy; *Massaman* curry, a peanut-infused sauce with potatoes; Drunk Man Noodles, a chili-and-basil–spiced noodle concoction with tender shrimp and squid that's miles away from the noodle dishes you find on most Thai menus
UNIQUE FOOD	A few game and seafood specialties exceed $10.00 but are well worth it, including the Geyser Shrimp in a Clay Pot (with vegetables and

93

MANHATTAN

	noodles). Chelsea Crispy Duck with Sweet and Sour Sauce gets high marks.
DRINKS	Small selection of beers, wine, soft drinks, Thai coffee, and tea
SEATING	Seating for about 40
AMBIENCE/CLIENTELE	Stylish but not aggressively so; aerodynamic furniture, lovely, low-key décor
EXTRAS/NOTES	Extraordinary lunch specials. Seven days a week, from 11:30 am-3:30 pm, 15 of Spice's beautifully prepared menu options are available not only at slashed prices ($6-$8) but with one of their creative and tantalizing appetizers free.
OTHER ONES	• Manhattan: 114 Second Ave., 10003, (212) 988-5348 • Manhattan: 60 University Pl., 10003, (212) 982-3758

—Joanna Jacobs & Laramie Flick

The Spotted Pig
This heavily hyped gastro pub stands on sturdy legs
$$$$
314 W. 11th St., Manhattan 10014
(at Greenwich St.)
Phone (212) 620-0393
www.thespottedpig.com

CATEGORY	European restaurant/pub
HOURS	Mon-Sun: 11 AM-2 AM
SUBWAY	A,C,E to 14th St., or 1 to Christopher St. S
PAYMENT	VISA, MasterCard, American Express, Discover
POPULAR DISH	Roquefort and shoe string char-grilled burger, calves liver with pancetta and mash
UNIQUE DISH	Ricotta gnudi with sage butter
DRINKS	The beer on tap is always tasty and unique. All drinks are prepared with experience.
SEATING	Seating for 40 downstairs, 50 upstairs, and standing room. Small private room upstairs holds around 15 and usually is booked by noteworthy individuals—celebs and the like.
AMBIENCE/CLIENTELE	Loud and festive crowd, trendy and smart, casual sophisticated consumers
EXTRAS/NOTES	Lots of offbeat star sightings keep this place crowded every night. The upstairs bar is the preferred choice for friendly gatherings and jovial cocktails.

—Brian Crandall

Sucelt Coffee Shop
Spanish home-cooking orchestrated by a bevy of most-authentic Colombian matriarchs.
$$
200 W. 14th St., Manhattan 10011
(at Seventh Ave.)
Phone (212) 242-0593

CATEGORY	Latino Diner
SUBWAY	1, 2, 3, F, L, A, C, E to 14th St.

MANHATTAN

HOURS	Mon-Fri: 7 AM-9:30 PM
	Sat: 7 AM-10 PM
	Sun: 8 AM-9 PM
PAYMENT	Cash only
POPULAR FOOD	Take your pick of daily specials; savory stews never too spicy, opulent soups, fluffy rice, firm beans, caramelized plantains.
UNIQUE FOOD	Famous tamales. Unwrap the leaf sheath and a whoosh of steam rises from this melt-in-your-mouth dumpling with vegetarian or Venezuelan, Puerto Rican, Colombian, or Panamanian-style meat fillings.
DRINKS	*Café con leche* is prepared with aplomb, but don't sleep on their fruit shakes, or *batidas*, which may be super-sugary unless you request otherwise.
SEATING	Counter seats 10 comfortably, 15 intimately
AMBIENCE/CLIENTELE	Established in 1977, Sucelt looks typical diner but tastes, dependably, extraordinary; not a lot of flummery, just good clean food. Look around—all the patrons are Hispanic.
EXTRAS/NOTES	I have never been disappointed with Sucelt, though after ordering I have, on occasion, found myself envious of another customer's plate.

—Nemo Librizzi

SushiSamba 7
West Village sushi bar with Brazilian flare.
$$$$
87 7th Ave., Manhattan 10014
(at Barrow St.)
Phone (212) 691-7885
www.sushisamba.com

CATEGORY	Japanese
HOURS	Mon-Fri: Noon-Midnight
	Sat: Noon-2 AM
	Sun: 11:30 PM-Midnight
SUBWAY	Take the 1 to Christopher Street, or any of the West 4th Street subway lines.
PAYMENT	VISA MasterCard AMERICAN EXPRESS DISCOVER
POPULAR DISH	Sushi Samba boasts some of the best sushi in the city, as well as a colorful variety of delicious tapas and main dishes.
UNIQUE DISH	The hangar teriyaki steak with sweet potato fries is a perfect fusion of Brazilian and Japanese cuisines.
DRINKS	The Samba juice, a delicious Brazilian cocktail of Acai juice, raspberry puree, and rum, is almost margarita-like in its frothy yumminess.
SEATING	A lounge area near the bar for an intimate cocktail and ample seating in the dining areas. Make a reservation, though, as this place gets crowded.
AMBIENCE/CLIENTELE	When Paris Hilton comes to NY for sushi, this is where she goes. Get the picture? If you have a special occasion coming up, this is the spot. Beautiful decor, beautiful people: an elegant restaurant with unparalleled food.
EXTRAS/NOTES	SushiSamba is pricey, sure, but they frequently offer brunch and early bird specials.

MANHATTAN

OTHER ONES • SushiSamba Park, 245 Park Ave. South (between 19th St. & 20th St.), Manhattan 10003, (212) 475-9377.

—*Aly Walansky*

Taim
Not just another falafel stand.
$$
222 Waverly Pl., Manhattan 10014
(between Perry St. and W. 11th St.)
Phone (212) 691-1287
www.taimnyc.com

CATEGORY	Middle Eastern
HOURS	Daily: 11:30 AM-10 PM
SUBWAY	1 to Christopher St.
PAYMENT	VISA MasterCard AMEX DISCOVER
POPULAR DISH	Falafel here comes in three different flavors: green, roasted red pepper, and harissa, each with its own distinctive taste. It is the freshest fried food you can find in the city. The falafel retains a crunchy outside, but has a soft—not soggy—interior. The generously sized pita sandwiches are filled with creamy hummus and pickled veggies. The fries are outrageously good.
UNIQUE DISH	The Sebich sandwich is composed of simple ingredients not typically mixed together in the US: fried eggplant, hummus, parsley, hard-boiled egg, israeli salad, and tahini sauce. The results are delicious.
DRINKS	Delicious smoothies with unique and surprisingly tasty combinations: date, lime, banana; strawberry, raspberry, thai basil; pinapple, coconut water; and cantaloupe, ginger. Sodas, gourmet sodas, and water also available.
SEATING	Like most good falafel joints, this place is tiny, offering just four bar stools facing out the restaurant's one bay window.
AMBIENCE/CLIENTELE	A mixed bag of neighborhood locals and hipsters.

—*Alexandra Collins*

Tortilla Flats
Good food and festivities at this West Village institution
$$$$
767 Washington St., Manhattan 10014
(at West 12th St.)
Phone (212) 243-1053
www.tortillaflatsnyc.com

CATEGORY	Mexican
HOURS	Mon-Thurs: Noon-Midnight Fri/Sat: Noon-4 AM Sun: Noon-11 PM
PARKING	Parking is a nightmare in this section of the West Village. The best way to get here is by cab.
PAYMENT	VISA MasterCard AMEX

MANHATTAN

POPULAR DISH	The black bean soup is hearty but not greasy, with just the perfect amount of sherry and sour cream. The chile con carne, with loads of chunky beef and no useless beans, is delicious as an appetizer.
UNIQUE DISH	The hand-rolled tamales and fish and vegetarian offerings go beyond standard Mexican fare and stand as a nice contrast to the predictable (but still fun) kitschy decor.
DRINKS	The full-bar is an attraction in and of itself, with lots of different tequilas and rums. The margaritas and sangria are refreshing and potent. For the teetotalers, the strawberry slush is a perfect non-alcoholic treat.
SEATING	There are tables of all shapes and sizes for parties large and small. And for individual diners, the bar also serves a full menu.
MBIENCE/CLIENTELE	It's Cinco de Mayo every day at Tortilla Flats, and everybody's celebrating some occasion or another—from birthdays to going-away parties to welcome-back parties. As a result, there's a sense of anything-goes hedonism to the predominately college-aged and twenty-something crowd that permeates the place. And the best part: you're almost certain to be waited on or served a drink by an off-Broadway or out-of-work television actor you'll vaguely recognize.
EXTRAS/NOTES	While it's definitely not a nightclub, Tortilla Flats boasts its own kind of live entertainment. There's bingo one night a week (winning table wins a round of shots) and hula-hoop contests another, and if it's your birthday you can bank on being serenaded by not only the wait staff but also by bus boys, other diners, and pretty much anyone else within earshot. It's the perfect place for large groups, and, with such a festive atmosphere, you'll likely leave with more friends than you came with.

—Jessica Tzerman

Two Boots To Go West
New Orleans flare meets the New York slice
$$
201 West 11th St, Manhattan 10014
(between 11th St. and 7th Ave.)
Phone (212) 633-9096
www.twoboots.com

CATEGORY	Cajun/Creole/pizza
HOURS	Mon-Weds: 11 AM-11 AM
	Thurs: 11 AM-1 AM
	Fri/Sat: 11 AM-2 AM
	Sun: 11 AM-Midnight
SUBWAY	Take the 1 to Christopher St./Sheridan Sq. or the F, V to 14th St.
PAYMENT	VISA MasterCard AMERICAN EXPRESS DISCOVER
POPULAR DISH	Neighborhood favorites include "The Bird," a white pie topped with boneless buffalo chicken wings, blue cheese dressing, scallions, and jalapeños, and the "The Newman," sopressata, sweet Italian sausage, and mozzarella on the Two Boots famous cornmeal crust.

MANHATTAN

UNIQUE DISH Since this is where Italy meets Louisiana (the eponymous "two boots"), the pies incorporate some inventive fusion ingredients. "The Dude" (honoring Los Angeles County's laziest man, famously played by Jeff Bridges) is topped with tasso, andouille, ground beef, cheddar, and mozzarella; "The Bayou Beast" features BBQ shrimp, crawfish, andouille, jalapeños, and mozzarella.
DRINKS Assorted Pepsi & Boylan's Sodas, Arizona & Teany Iced Teas, Fizzy Lizzy, San Pellegrino, bottled water
SEATING Small tables.
AMBIENCE/CLIENTELE This particular location is best for a quick slice or take-out, as there is little in the way of seating or atmosphere.
EXTRAS/NOTES Two Boots also specializes in independent film rentals at Two Boots Video and independent and foreign film showings at the Two Boots Pioneer Theater.
OTHER ONES
- Two Boots Restaurant, 37 Ave. A, Manhattan 10009, (212) 505-2276
- Two Boots Pizzeria, 42 Ave. A, Manhattan 10009, (212) 254-1919
- Two Boots To Go-Go, 74 Bleeker St., Manhattan 10012, (212) 777-1033
- Midtown: Two Boots Grand Central, Grand Central Terminal (Lower Dining Concourse), Manhattan 10017, (212) 557-7992
- Midtown: Two Boots Rock Center, 30 Rockefeller Center, Manhattan 10112, (212) 332-8800
- Two Boots Video, 44 Ave. A, Manhattan 10009, (212) 254-1441
- Two Boots Pioneer Theatre, 155 East 3rd St., Manhattan 10009, (212) 591-0434

—*Emily Isovitsch*

Two Boots To Go-Go
(See p. 97)
Cajun/Creole/pizza
74 Bleeker St., Manhattan 10012
Phone: (212) 777-1033

'wichcraft
(See p. 74)
Sandwich Shop
397 Greenwich St., Manhattan 10013
Phone: (212) 780-0577

'wichcraft
(See p. 74)
Sandwich Shop
269 11th Ave., Manhattan 10001
Phone: (212) 780-0577

MANHATTAN

FLATIRON/UNION SQUARE/GRAMERCY

Beard Papa's Sweets Café
French pastry with an Asian spin.
$

740 Broadway, Manhattan 10003
(between Astor Pl. and Waverly St.)
Phone (212) 353-8888 • Fax: (212) 353-3231
www.muginohousa.com

CATEGORY	Bakery
HOURS	Mon-Thurs: 9 AM-9 PM Fri/Sat: 9 AM-10 PM Sun: 9 AM-9 PM
SUBWAY	Catch the R or the W to 8th Street.
PAYMENT	VISA MasterCard American Express
POPULAR DISH	You can't mention Beard Papa's without touching on the famous dessert that got them started. Composed of a crispy choux shell that's literally oozing with smooth, creamy custard, the puffs are subtle, yet decadent. Unlike its French predecessor, the pastry is baked, not fried, and each treat is sprinkled with powered sugar before being distributed to ravenous patrons. Flavors range from the standard—vanilla, chocolate, and coffee—to the more eclectic—green tea, Earl Grey tea, and pumpkin.
UNIQUE DISH	The fondant au chocolate, a bunt cake-like volcano that explodes with a river of Belgian chocolate when sliced, is both an experience and a treat. So too is the green tea mochi, a plastic-wrapped ovoid "ice cream" that has the consistency of a Hollywood implant. A seemingly unusual sight among the French-inspired cuisine, this Japanese staple harkens back to Papa's roots in Osaka, Japan.
DRINKS	The mango lassi and Vietnamese iced coffee stand out in a drink menu dominated by less flashy beverages like Teas Tea and chai lattes.
SEATING	Don't worry if you can't snag one of the few tables along the wall—cream puffs are just as good on-the-go.
AMBIENCE/CLIENTELE	The décor is a cross between a hospital and a rave. Servers are dressed in matching stark white uniforms and minimalist touches rein throughout, but the shop's unique color combo (bright orange and school bus-yellow) along with the Asian-influenced plastic furniture give Beard's that retro East Village vibe that's just short of chic.
EXTRAS/NOTES	Back when Beard Papa's first came to NYC, lines stretched around the corner! Now that opening-day hype has died down and the shop has branched out to include multiple locations, foodies can have their puff and eat it too . . . minus the two-hour wait.
OTHER ONES	• Upper West Side: 2167 Broadway, Manhattan 10024, (212) 799-3770

MANHATTAN

- Midtown: Café Zaiya, 18 East 41 St., Manhattan 10017, (212) 779-0600
- 5 Carmine St., Manhattan 10014, (212) 989-8855

—*Samantha Charlip*

Burritoville
(See p. 81)
Mexican
866 Third Ave., Manhattan 10022
Phone: (212) 980-4111

Burritoville
(See p. 81)
Mexican
1606 Third Ave., Manhattan 10128
Phone: (212) 410-2255

Café Medina
Prime lunch fare in Union Square.
$$
9 E. 17th St., Manhattan 10003
(between Fifth Ave. and Broadway)
Phone (212) 242-2777 • Fax (212) 242-6617
www.cafemedina.com

CATEGORY	Mediterranean
HOURS	Mon-Fri: 7 AM-8 PM Sat/Sun: 7 AM-7 PM
SUBWAY	Take either the N,Q,R,W or the 4,5,6 or the L train to Union Square. Also not far from the 14th St. stop on the F,V line.
PAYMENT	VISA, MasterCard, American Express
POPULAR DISH	You can't go wrong with any of Medina's gourmet soups. The selections change daily and include everything from pumpkin corn bisque to Tuscan tomato bread to African chicken peanut. During the summer, the gazpacho is a refreshing alternative for those who have a hankering for salsa but don't want to trouble themselves with those pesky tortilla chips. Spoons scare you? Don't worry, happens to the best of us. Medina also offers a wide assortment of gourmet sandwiches and salads. The Cobb salad is especially popular.
UNIQUE DISH	With the countless sandwich shops and delis in the Union Square area, what draw people to Medina are the gourmet ingredients that constitute the soups, sandwiches, and salads. Whether you order the grilled vegetable and goat cheese sandwich, hot pressed in a pita with olive tapenade and sundried tomato remoulade, or the Indian charred chicken sandwich, served with brie, mango chutney, and arugula on toasted whole wheat, the food at Medina is never humdrum.

MANHATTAN

DRINKS	A wide variety of coffee drinks and teas; soda, fresh-squeezed juices, and blended smoothies are also available.
SEATING	Approximately fifteen two-person tables, which fill up quickly during the busy weekday lunch rush. Turnover is fast, though, and take-out is always a good option.
AMBIENCE/CLIENTELE	Given its proximity to Union Square, Medina attracts all kinds. During the weekdays, though, you're most likely to share the air with young professionals and publishing types.
EXTRAS/NOTES	If you're not sure which soup to get, the staff manning the ladles will kindly offer you a sample of any of the day's selections (no soup Nazis here). While custom generally dictates that you try no more than two samples before placing an order, you can usually get away with a third or fourth if you ask nicely and avoid making eye-contact.

—*Charles Battle*

Café Viva

If Café Viva was running for president, it would be the Green candidate.

$$
2578 Broadway, Manhattan 10025
(at W. Ninth St.)
Phone (212) 663-8482

CATEGORY	Pizzeria
HOURS	Daily: 11 AM-11:30 PM
SUBWAY	1, 9, 2, 3 to 96th St.
PAYMENT	Cash only
POPULAR FOOD	Regular slice and Sicilian
UNIQUE FOOD	Whole wheat dairy-free lasagna (with soy cheese and organic tomato sauce)
DRINKS	Soda (including china cola and ginger brew), juices, teas, no alcohol
SEATING	Six tables of four; outdoor seating for 32 in the summer
AMBIENCE/CLIENTELE	Casual, families, neighborhood atmosphere—great for a quick bite before heading to Symphony Space
EXTRAS/NOTES	The menu of this friendly and delicious Upper West Side take-out and dine-in Italian eatery proudly proclaims KOSHER DAIRY and below this, NATURALLY ITALIAN. Not only can every pizza be ordered with either regular, wheat, corn meal or spelt crust, but Café Viva also offers healthy dishes like artichoke lasagna and organic tofu spinach ravioli. However, even though this may sound like a bad outtake from Woody Allen's send-up of California cuisine in *Annie Hall*, everything at Café Viva is as tasty as it is good for you, not to mention cheap. Macro health and flavor for micro budgets; wide menu for vegetarians, including unbleached flour and no preservatives. Be sure to try the amazingly tasty garlic bread, or have a salad served with knotty, homemade croutons.

—*Jeff Gomez*

MANHATTAN

Cosmic Cantina
Straight outta Durham, good organic Mexican and cheap brews.
$$
105 Third Ave., Manhattan 10003
(at 13th St.)
Phone (212) 420-0975

CATEGORY	Mexican
HOURS	Mon-Sun: 11 AM-5 AM
PARKING	Take the L to 3rd Ave. Or take any of the trains to Union Square and walk two blocks.
PAYMENT	Cash only
POPULAR DISH	Nachos, tacos, burritos and chimichangas—nothing too far off the beaten path. Not the cheapest, but the ingredients are fresh and the combinations tasty.
UNIQUE DISH	Everything on the menu is organic and is available in half-sizes.
DRINKS	The reason to visit the Cantina. Beer, sangria, "Fruit-O-Hols" (fresh squeezed juice 'n' booze) and margaritas. Flavored water (Volvic and mint, Volvic and chamomile) and fresh juice for the less bacchanalianly inclined. Until 8 PM, all beers are $2 (a great range of Californian and Mexican varieties), sangria's $3, and pitchers of sangria and beer (Tecate) are cheap. The "Super Pitcher," $15 during happy hour and $17 normally, might be the largest pitcher of beer you've ever seen.
SEATING	Elevated tables with high backed chairs and counters along the wall in the brightly-lit front room. A half-dozen or so tables on the street in nicer weather and another half-dozen or so tables in the dimly-lit bar area in the back.
AMBIENCE/CLIENTELE	In College? Wish you were back in College? If so, this is the place for you.
EXTRAS/NOTES	Happy Hour is until 8 PM. The music can be loud and somewhat jarring (think dancey, mainstream hip-hop, often of Mexican origin), but it's hard to think of a better place to meet a few friends for a post-work/class drink. $2 Dos Equis and deluxe nachos (ask for melted cheese, if you're not into the cold stuff) This mini-chain (three locations) has its origins in Durham, North Carolina, home of the hated Duke Blue Devils.

—*Ben Wieder*

Eisenberg's Sandwich Shop
Depression -era lunch counter proves Old Deals make the Best Meals.
Since 1929
$$
174 Fifth Ave., Manhattan 10010
(at 22nd St.)
Phone (212) 675-5096

CATEGORY	Lunch Counter
HOURS	Mon-Fri: 6:30 AM-8 PM
	Sat: 7:30 AM-5 PM
	Sun: 7:30 AM-4 PM

MANHATTAN

SUBWAY	N. R to 23rd St.
PAYMENT	MasterCard, VISA, Discover, American Express
POPULAR FOOD	Standard fare like burgers and club sandwiches, deli goods like liverwurst, hot pastrami, and turkey and chopped liver, but "if you don't see what you want on the menu, ask us if we can make it for you."
UNIQUE FOOD	You can eat here for under $5, especially if you come for breakfast: variously prepared eggs, bacon, French toast and home fries. Nothing's expensive (least of all the coffee: 75¢ at press time).
DRINKS	Coffee, juice, soda (can or fountain), Lime Rickeys, lemonades, ice cream sodas, fresh milk shakes
SEATING	Seats around 35—most at the long counter, but a few at small tables along the wall.
AMBIENCE/CLIENTELE	Eisenberg's is an old restaurant in an old room where customers young and old cram in along an old lunch counter: sincere, simple, and, as expected, old-fashioned Can a place this small be a landmark? You wouldn't use it as a navigation aid, but it certainly has its spot marked as far as the neighborhood's history is concerned. Old and well-loved, it's as close as any restaurant to the Flatiron Building—which is an undisputed landmark.

—Joe Cleemann

How Bagels Made it to New York and How New York Makes Bagels

The bagel was born in the late 17th century in Vienna and given to the King of Poland as a "thank you" for saving the city from invaders. Sources differ on the origin of the bagel species. The shape of the bagel (more oblong in its formative years) was to resemble a stirrup, or bugel in German, since horseback riding was the King's favorite hobby *or* perhaps, it was because the freed Austrians grabbed hold of the king's stirrups as he galloped by. (Sources note that eventually bagels became gifts for women in labor and later as teething rings for their babies—which is apparently still done today!) Whichever the origin, by the 1900s, bagels were in New York, and at first the only people who ate them were those who brought them to us—Eastern European Jews. And bagels were sold in Jewish bakeries to everyone, made of flour, water, yeast, and malt, and neighbors got curious. [Note: The best bagels are hand rolled, boiled—which makes it soft and chewy, and then baked to create the semi-tough shell—each step must be completed precisely to make the ultimate bagel. Ask anybody who makes 'em. They are very *serious* about the process.] Around that time, instead of Americanizing their meals as Americans were often encouraged to do, we began to venture out of bounds when it came to their taste buds—we tried new things! And as cities began to diversify ethnically, eventually, bagels became available everywhere. In due course, someone decided to slather cream cheese, butter, jelly, whitefish, chopped liver and even eggs and bacon(!) on these "stirrups from the old country", and voila! You have the New York Bagel.

MANHATTAN

H & H Bagels is arguably the most famous bagelry in New York. They opened in 1972 and were the first to ship bagels to Israel (they finally made it to their homeland!). These are do-it-yourself bagels, leaving you to put your toppings on elsewhere, and their freshness doesn't last more than a day. You can buy homemade Kosher toppings at the store and some drinks are available, but this is literally and simply a bagel store. H & H is very proud of its list of satisfied celebrity customers. To name a few: Bill Clinton, Kevin Bacon, Cher, Tom Hanks, Ann Landers, and Jerry Stiller (both George Castanza and Ben Stiller's dad). H & H ships fresh bagels all over the world, and you can order from their website www.handhbagel.com if you so desire. If you'd rather take a short jaunt up to 2239 Broadway at 80th St or 639 West 46th St at 12th Ave, H & H is open 24-7. That's right. This is New York.

Next up is **Murray's Bagels** —another favorite bagel shop in NYC. More like a little café, Murray's offers A-1 bagels and many, many terrific varieties of cream cheese (try the Sundried Tomato and Roasted Garlic). All the smoked fish you could hope for, and great deli sandwiches, served of course, on bagels. Four different soups daily, and famous Guss's Sour Pickels for 40 cents a pop. The bagels are done just right and if you can't get a table inside, there are benches outside. 2 locations: 500 Sixth Ave between 12th and 13th Sts. and 242 8th ave between 22nd and 23rd (646-638-1335). Free delivery/minimum order $7.00.

Pick a Bagel on Third is a nice, big sit-down or take-out diner-type bagel shop. They've got whatever you want: bagels, appetizers, baked goods, deli meats, salads, catering, espresso, juice and tossed salad bars, etc. The menu notes that bagels are hand-rolled; of course, the mark of a true bagelry. Try the Walnut and Raisin cream cheese or the chopped liver, just to be authentic. Tons of smoked fish to try. 297 3rd Ave between 22 and 23rd. Free Delivery/ minimum depends on distance and time of order.

Last but not least in what could be an exhausive listing of bagel places in NYC is **Ess-a-Bagel**. Established in 1976, this fully Kosher shop is small and serves line-order style, and has a few slightly cramped tables. But wait! It's entirely worth the little bit of elbow room you get for their famous bagels. They've got all the fixin's and offer catering too. Go to Ess-a for a taste of authentic New York.

These are just some of the stellar bagels in New York. There's not nearly enough space to describe them all. Don't be afraid to do a taste-test of your own—there are plenty of shops to choose from, and who knows, you might just come upon the best chopped liver you've ever tasted.

—Lindy Settevendemie

Famous Famiglia
(See p. 147)
Italian/Pizza
1630 Broadway, Manhattan 10019
Phone: (212) 489-7584

MANHATTAN

Haru Japanese Restaurant
(See p. 128)
Sushi/Japanese
220 Park Ave. S (at 18th St.), Manhattan 10003
Phone: (646) 428-0989

Home's Kitchen
Why go to Chinatown when you can eat at Home's?
$$
22 E. 21st St., Manhattan 10010
(between Broadway and Park Ave.)
Phone (212) 475-5049 • Fax (212) 777-1819

CATEGORY	Chinese
HOURS	Mon-Fri: 11 AM-11 PM Sat/Sun: Noon-11 PM
SUBWAY	N, R to 23rd St.
PAYMENT	VISA MasterCard American Express
POPULAR FOOD	Choose anything: *General Tso*: tofu and chicken are batter-covered and perfectly fried, drenched in a soy-based sticky spicy tangy sauce, and mixed with baby corn, green peppers, and the occasional carrot—during lunch, comes with bowl of white or brown rice, and choice of soup, soda or egg roll .
UNIQUE FOOD	Try the wheat gluten sautéed in a ginger and scallion soy-based sauce, mixed with winter bamboo, and black mushrooms, atop layers of veggie-ham
DRINKS	Home's Punch—a blend of pineapple juice, lemonade, and ginger ale, Home Made Ice Tea, Home Made Lemonade, virgin piña colada, soda, and hot tea
SEATING	Tables for forty
AMBIENCE/CLIENTELE	Friendly, helpful, and efficient staff—especially during the lunchtime crunch, when the food comes within seconds of ordering
EXTRAS/NOTES	While the regular menu is decently priced and well within the *Hungry?* budget, flip the menu over and go for the incredible lunch and dinner specials that come with so many extra treats.

—*Marie Estrada*

Moe's Falafel
Flatiron favorite for Falafel.
White sauce? Hot sauce? You bet.
$
SW corner of 21st St. and 5th Ave., Manhattan 10010
(corner 21st St.)

CATEGORY	Falafel Cart
HOURS	Mon-Fri: 10 AM-3 PM (extended summer hours include weekends and evenings)
SUBWAY	N, R to 23rd St.
PAYMENT	Cash only

MANHATTAN

POPULAR FOOD	Great falafel sandwich (on pita) for a song; during lunch rush, meat trays (including rice, lettuce, falafel, and sauce) sell like hotcakes would at some kind of freaky hotcake cart.
UNIQUE FOOD	The combination platter gives you a lot of everything (chicken, falafel, and lamb) for about $4
DRINKS	Soda, Snapple, water
SEATING	No seats
AMBIENCE/CLIENTELE	Enjoy lunch on the streets of the world's greatest city. Moe's is a favorite among cabbies and office workers, and the latter form long lines around lunchtime (cabbies have their own arrangements—no one said life is fair).

—*Joe Cleemann*

Molly's Pub & Restaurant

Sawdust on the floor, rebels on the wall, Guinness on draught, and terrific pub food on your plate.
Since 1960
$$$
287 3rd Ave. Manhattan 10010
(at 23rd St.)
Phone (212) 889-3361

CATEGORY	Pub
HOURS	Mon-Sat: 11 AM-4 AM Sun: Noon-4 AM
SUBWAY	6 to 23rd Street
PAYMENT	VISA MasterCard AmericanExpress Discover
POPULAR FOOD	Big burgers for hungry workers, idlers, and drinkers; a huge plate of fish and chips may be too much food for the casual eater, but experts will make the extra effort and go home bloated—which isn't the worst thing that can happen . . .
UNIQUE FOOD	The buffalo burger tastes as good as its bovine rival, and probably encourages renewal of America's tragically depleted bison [that's what nerds call buffalo –ed.] population—such are the sad ironies of capitalism, that one might save an animal by eating it—*bon appétit*
DRINKS	Full bar, water, soda, etc.
SEATING	Seats 50 or so, at tables, in booths, and along the bar
AMBIENCE/CLIENTELE	Dark paneling; not much light; James Connelly and Co. get the place of honor on the wall. It could be a dump, but it's welcoming instead; draws an eclectic crowd

—*Joe Cleemann*

Old Town

A down-to-earth, old-fashioned pub, serving New Yorkers since the second Cleveland Administration.
Since 1892
$$$
45 E. 18th St., Manhattan 10010

(between Broadway and Park Ave.)
Phone (212) 529-6732

CATEGORY	Pub Food
HOURS	Mon-Sat: 11:30 AM–1 AM
	Sun: 11:30 AM–Midnight
SUBWAY	L, N, R, Q, W, 4, 5, 6 to Union Square
PAYMENT	VISA, MasterCard, American Express
POPULAR FOOD	Nothing fancy, but great burgers and sandwiches (chicken caesar, BLT)
UNIQUE FOOD	The daily specials, such as Friday's fish 'n' chips, are basic and irresistible. While not unique, Old Towne's chili dog stands apart from the pack—it's an absolutely delicious grilled dog completely smothered by mounds of perfectly seasoned chili.
DRINKS	All the basics plus a large selection of beer from the full bar downstairs
SEATING	Lots of worn, wooden booths and tables over two floors
AMBIENCE/CLIENTELE	An ancient, weathered pub: slightly crooked staircase leading to the upstairs restaurant, dented tin ceilings, patched-up cushions in the wooden booths; framed photos and signed book jackets on the walls suggest up-and-coming literati have eaten here.
EXTRAS/NOTES	Old Town has a reputation for being a popular publishing hangout, among both editors and authors. It's also appeared in the movie *The Last Days of Disco,* and the downstairs bar used to appear in the opening credits to *Late Night with David Letterman.*

—Brad Wood

Rainbow Falafel

Cheap, tasty Middle Eastern grub vegetarians can eat and meat-eaters can love.
$
26 E. 17th St., Manhattan 10003
(Union Sq. West)
Phone (212) 691-8641

CATEGORY	Middle Eastern
HOURS	Mon-Sat: 11 AM–6 PM
SUBWAY	L, N, R, Q, W, 4, 5, 6 to 14th St./Union Sq.
PAYMENT	Cash only
POPULAR FOOD	There aren't too many items on the menu, but Rainbow is one of New York's favorite spots for falafel—as in falafel sandwich. Also chicken *shawarma* sandwich and lentil soup
DRINKS	Soda (try the coconut), iced tea, coffee, tea, Turkish coffee
SEATING	No seating available
AMBIENCE/CLIENTELE	If you come anywhere near lunch time (noon-2 pm), be prepared to wait outside: the line runs down the block and other lunch spots in the area have started to give away free samples in the hopes of tempting the regulars away.
EXTRAS/NOTES	If you are looking for a cheap place to eat (like on the day before payday when you have to scrape together change from the couch for lunch), this

MANHATTAN

is the place to hit. The owner, Hamal, took over the space eight years ago from a friend who was running a candy store. He says that the reason Rainbow Falafel is so popular is the healthy vegetarian choices and his grandmother's unique recipe for Falafel.

—Larry Ogrodnek

Republic
Cheap noodles communally served in a cavernous room.
$$$
37 Union Square W., New York 10003
(between 16th St. and 17th St.)
Phone (212) 627-7172
www.thinknoodles.com

CATEGORY	Pan-Asian
HOURS	Mon-Weds: 11:30 AM-10:30 PM
	Thurs-Sat: 11:30 AM-11:30 PM
	Sun: 11:30 AM-10:30 PM
SUBWAY	Take the 4,5,6,N,Q,R,W or L to Union Square.
PAYMENT	VISA MasterCard AMERICAN EXPRESS DISCOVER
POPULAR DISH	I'm partial to the curried duck noodles and the grilled beef noodles. The tender grilled calamari skewers and tasty salmon sashimi salad are good starters.
UNIQUE DISH	The dishes here each manage to have a unique flavor that doesn't necessarily correspond to any particular Asian cuisine. This is Pan Asian cuisine in the true sense of the term.
DRINKS	A full bar and fresh juices (which make for tasty cocktails). Thai iced tea, coffee, and Espresso for those looking for an energy buzz. Soda, San Pellegrino, Asian basil lemonade, and hot apple cider for everyone else.
SEATING	Long, communal tables with hard wooden benches in the huge main room, a handful of red, leather stools at the bar up front. Outdoor seating during the summer
AMBIENCE/CLIENTELE	This place is constantly buzzing. The communal tables are loud and the room is nearly always packed. The young, hip clientele is as much of an attraction as the cheap, tasty food. This isn't really the place for a quiet, romantic meal, though you'll see couples try.
EXTRAS/NOTES	Free delivery.

—Ben Wieder

Rice: LEXINGTON
(See p. 191)
Asian
115 Lexington Ave., Manhattan 10016

MANHATTAN

Uncle Moe's Burrito & Taco Shop
Strap on the feedbag: these burritos are huge.
$$
14 West 19th St., Manhattan 10011
(at Fifth Ave.)
Phone (212) 727-9400

CATEGORY	Mexican Eat-in/Take-out/Delivery
HOURS	Mon–Fri: 11:30 AM-9 PM Sat: Noon-6 PM
SUBWAY	N, R to 23rd St. L, N, R, Q, W, 4, 5, 6 to 14th St./Union Sq. F, V to 23rd St. or 14th St.
PAYMENT	American Express, MasterCard, VISA
POPULAR FOOD	The Uncle Moe's burrito (meat or vegetable filling with cheese and *pico de gallo*) is a favorite; appetizers like the *quesadilla*, the super *quesadilla*, and the super nachos are meals unto themselves; platters give you rice, beans, *pico de gallo*, and whatever else you're willing to pay for
UNIQUE FOOD	Have some yarbles—if you got any yarbles, that is—dig deep, loosen your belt, and order the California Burrito (two fillings, guacamole, *pico de gallo*, cheese, lettuce, and sour cream or no-fat yogurt, the SUV of burritos); or opt for the Watsonville, "a smaller version of the California Burrito"
DRINKS	Lemonade, juice, water, soda; or bring your own bottle
SEATING	Seats around 50
AMBIENCE/CLIENTELE	As the hours tend to suggest, Uncle Moe is targeting (and nailing) office workers; but he's on the border of the Flatiron District and Chelsea, so this isn't the really stiff kind of office worker: it's the fun kind—the kind that sees the humor in Dilbert.
EXTRAS/NOTES	The Park Slope digs are a more laid back, cool. Whereas the Flatiron location is adorned with photos of southwestern taco joints, Brooklyn opens up space for psychedelic rock concert posters. And it has longer hours, especially on the weekends (Sun-Thurs noon-10 pm, Fri/Sat noon-11 pm). *And* it sells beer.
OTHER ONES	Brooklyn/Park SlopeL: 341 Seventh Ave., 11215, (718) 965-0006

—*Joe Cleemann*

Vinny Vincenz
Maybe the best square pizza found on the island
$
231 1st. Ave., Manhattan 10003
(between 13th St. and 14th. St.)
Phone (212) 674-0707
www.vinnyvincenz.com

CATEGORY	Italian
HOURS	Mon-Thurs: 11 AM-1 AM Fri-Sun: 11 AM-4:30 AM
SUBWAY	L to 1st Ave.

MANHATTAN

PAYMENT	VISA, MasterCard, American Express
POPULAR DISH	The square pizza is easily among the finest in New York. The crust is light and crunchy and the ingredients are fresh. You can't go wrong with any of the varieties—the marinara, the regular—or with any of the toppings. As with any pizza place, whatever is freshest out of the oven, whether square or Neapolitan, is probably your best bet.
UNIQUE DISH	Nothing strays too far off the beaten path. The key here is quality of ingredients and care in preparation.
DRINKS	Beer on tap and in bottles; wine by the glass and by the bottle. For a buck, you can have a beer "while you wait."
SEATING	Plenty of seating available—black, wooden tables for two or four and a counter and high-backed chairs facing out toward First Avenue.
AMBIENCE/CLIENTELE	During the day, Vinny Vincenz draws a mix of employees from the local hospital and parents and children. Into the later hours, the crowd becomes a bit younger, hipper and, on the weekends, more inebriated.
EXTRAS/NOTES	Pizza, by definition, is just about the most kid friendly food in the world. On the weekends, a jazz band has been known to stop by and play some tunes. The last time I saw them, they launched into Lee Morgan's "The Sidewinder" and everyone in the house was in high spirits.
OTHER ONES	Vinny Vincenz has a mobile pizza van. Check the website for the most up-to-date information on its current location.

—*Ben Wieder*

'wichcraft
(See p. 74)
Sandwich Shop
555 5th Ave., Manhattan 10018
Phone: (212) 780-0577

'wichcraft
(See p. 74)
Sandwich Shop
Union Square, (delivery only)
Phone: (212) 780-0577

"When it's three o'clock in New York, it's still 1938 in London."

—*Bette Midler*

MANHATTAN

MIDTOWN EAST

Blockheads
Deliciously affordable Mexican food chain
$$
499 3rd Ave, Manhattan 10016
(between 33rd St. and 34th St.)
Phone (212) 213-3332 • Fax: (212) 686-2904
www.blockheads.com

CATEGORY	Mexican
HOURS	Mon-Thurs: 11 AM-11 PM
	Fri/Sat: 11 AM-Midnight
	Sun: 10 AM-11 PM
SUBWAY	Close to both Lexington Avenue and Herald Square subway lines
PAYMENT	VISA MasterCard AMERICAN EXPRESS Discover
POPULAR DISH	I'm partial to the chicken taco salad, but my friends are gaga over the burritos. Start with the guacamole.
UNIQUE DISH	If you don't dig on meat or dairy, you can substitute tofu and soy cheese on any entrée. They also offer whole wheat tortillas and brown rice.
DRINKS	It's very rare to get any cocktail for $4 in Murray Hill, let alone a satisfying and delicious mixed drink. Try the Black Flower, a sangria-flavored margarita. Large and potent, it's the best bargain in town. They also serve sangria, tequila shots, beer, and wine.
SEATING	There are plenty of tables, and the quick service makes for speedy turnover.
AMBIENCE/CLIENTELE	Twenty- and thirty-something creative types mingle with college students and families of all ages and sizes.
EXTRAS/NOTES	Who needs happy hour? Blockheads' margaritas are under $4 ALL THE TIME! And they're huge! Very kid- and family-friendly, Blockheads is good for both groups and dates. Great brunch and lunch deals as well.
OTHER ONES	• Upper East Side: 1563 2nd Ave. (between 81st St. and 82nd St.), Manhattan (212) 879-1999
	• 250 Vesey St., (between N. End Ave. and W. Side Hwy.), Manhattan (212) 619-8040
	• Midtown: 322 W 50th St., (between 8th Ave. and 9th Ave.), Manhattan (212) 307-7029
	•Midtown: 954 2nd Ave., (between 50th St. and 51st St.), Manhattan (212) 750-2020

—*Aly Walansky*

Bread Bar at Tabla
Eat to the beat of an Indian drum.
$$$
11 Madison Ave., Manhattan 10010
(at 25th St.)
Phone (212) 889-0667
www.tablany.com

CATEGORY	Indian

MANHATTAN

HOURS	Mon-Thurs: Noon-11 PM Fri: Noon-11:30 PM Sat: 5:30 PM-11:30 PM Sun: 5:30 PM-10:30 PM
SUBWAY	Take the 6 to 23rd St.
PAYMENT	VISA, MasterCard, American Express
POPULAR DISH	Traditional Indian food is revolutionized by Chef Floyd Cardoz, who likes to combine Indian flavors with local ingredients in home-style dishes. Everyone loves the street sandwiches, like the "naanini," a toasted sandwich of naan (incredibly addictive Indian bread), pulled lamb, and mustard-mashed potato. "Thalis," or combination platters for $20, are a wonderful option that include Goan-spiced fish tikki with cucumber-onion salad and rosemary naan. Donut holes with orange blossom essence are on every table for dessert.
UNIQUE DISH	Chef Cardoz's innovative techniques bring new life to every dish. Chutneys and raita are not to be missed, especially the pomegranate raita with daikon, organic yogurt, and mint. The aromas and tastes are electrifying, and Bread Bar is a truly amazing experience if you love unusual flavors.
DRINKS	There is a large selection of non-alcoholic drinks, including the Tibetan Tiger Latte, mango lassi, and GuS sodas. There is also an extensive list of wines and unusual cocktails.
SEATING	You can eat and drink at the beautiful bar while you stare at the stunning mosaic ceiling. During warmer months, the outdoor patio is perfect for people-watching on busy Madison Ave.
AMBIENCE/CLIENTELE	There is a fun vibe at Bread Bar. The outdoor tables are always crowded, and the inside is always bustling. The upstairs dining room at Tabla is expensive and more formal, but Bread Bar is very casual, perfect for drinks after work or a leisurely lunch, snack, or dinner. There is no snobby factor at all.
EXTRAS/NOTES	Be sure to munch on the spiced popcorn while you wait for your drink at the bar.

—*Camilla Warner*

Café Zaiya
(See p. 99)
Bakery
18 East 41 St., Manhattan 10017
Phone: (212) 779-0600

Divine Bar West
Enjoy a huge martini at this "divine" date spot.
$$$$
236 W 54th St, Manhattan 10019
(between 8th Ave. and Broadway)
Phone (212) 265-9463
http://divinebar.citysearch.com

CATEGORY Lounge

MANHATTAN

HOURS	Mon-Thurs: 4:30 PM-1:30 AM Fri/Sat: 7 PM-3 AM Sun: 6 PM-1 AM
SUBWAY	Not a lot of street parking, but very close to pay lots and the 59th Street/Columbus Circle subway lines.
PAYMENT	VISA, MasterCard, American Express, Discover
POPULAR DISH	Tapas and salads abound, delicious and affordable. Great dessert options as well.
DRINKS	Known for their wine flights, but also offer massive martinis. "The Last Martini" is a delicious blend of pomegranate and lychee juice.
SEATING	Many small tables and seats at the bar
AMBIENCE/CLIENTELE	A beautiful person's after work/happy hour lounge, Divine Bar is great for dates or special dinners.
EXTRAS/NOTES	The first floor gets busy during happy hour and slowly empties out as the night goes on. The second floor has a nice lounge area and outside deck. The wine selection, as one would expect from a wine bar, is quite good. A nice selection of beers, too: no flights, but good Belgian selections, US microbrews, and a few off-the-beaten-path bottles. If you plan to stay for dinner, the tapas menu is extensive.
OTHER ONES	Divine Bar East, 244 East 51st St. (between 2nd Ave. and 3rd Ave.), Manhattan 10022, (212) 319-WINE.

—*Aly Walansky*

Docks Oyster Bar and Seafood Grill
Sittin' on the dock of the East River.
$$$$
633 3rd Ave., Manhattan 10017
(at 40th St.)
Phone (212) 986-8080
www.docksoysterbar.com

CATEGORY	Seafood
HOURS	Mon-Thurs: 11:30 AM-11 PM Fri/Sat: 11:30 AM-Midnight Sun: 11:30 AM-10 PM
SUBWAY/PARKING	Take the 4,5,6,7, or S trains to Grand Central Station then walk east to Third Ave. and then two blocks south. Street parking is available after 7 PM Mon-Sat and all day on Sunday (watch out for the "Diplomat Only" parking signs, though). Docks also has an arrangement with Icon Parking Garage on 38th St. between Second and Third Aves. Just have your parking ticket stamped by the maitre'd.
PAYMENT	VISA, MasterCard, American Express, Discover
POPULAR DISH	With four varieties of East and West Coast oysters which change on a daily basis, this is a great place to slurp down a dozen (ideally over martinis with a hot date). The New England clam chow-dah will make you question your Yankees fandom, and you'll almost feel the Florida sunshine on

MANHATTAN

your face when you bite into the startlingly authentic key lime pie.

UNIQUE DISH Though the fresher-than-fresh seafood in Manhattan's money central generally comes with the expected price tag, knowing *when* to go can score you a discount dinner. On Sunday and Monday nights, it's all about the clambake: your choice of either two one pound lobsters ($35) or one two pound lobster ($42), served with a house salad to start, mussels, clams, corn on the cob and new potatoes as sides, and key lime pie or ice cream for dessert (no extra charge for the bib). Tuesday through Saturday, from 5-7 PM, Docks offers a three course prix-fixe for $28 with several options for each course (including oysters and lobster). You have to *ask* your server for the coveted pre-theater menu, as it's not prominently on display. Oh, and when you're getting a deal this good, no, substitutions are *not* okay.

DRINKS Docks will definitely appeal to your inner lush. The filled-to-the-brim 14 oz. martinis range from $10-$15. One will get you buzzed, two will get you sloppy. The beautiful circular bar serves a full menu and the barkeeps really know their stuff. As for entertainment—well, let's just say it's not uncommon to witness a high powered attorney falling off his barstool. Docks also has a thorough wine list, including a reserve list for those sporting corporate cards.

SEATING The dining room is enormous but almost always fills up during both the lunch and dinner rush. While reservations are recommended, they are not necessary, especially at off-peak hours. The "back room" is ideal for quieter dining and is available for private parties. If you want to impress your date, request table 17; if you want to make out with your date, try table 100.

AMBIENCE/CLIENTELE Lunchtime is CEO central at Docks. Dinnertime is a cocktail made up of one part corporate, one part Murray Hill resident, one part Japanese businessman, two parts tourist, and a splash of regular Joe. But don't let the abundance of suits intimidate you— Docks is definitely jeans- and sneaker-friendly.

EXTRAS/NOTES Docks has become something of staple in the twenty years it's kept afloat in the dynamic sea of NYC food. Even after changing hands five years ago, Docks has always stayed true to its roots as an old-school New England-style seafood restaurant. The service is fast and friendly, the food consistent, and the daily specials creative. On top of that, the potential celeb sightings are just gravy… er, drawn butter.

OTHER ONES • Upper West Side: 2427 Broadway (at 89th St.), Manhattan 10024, (212) 724 5588

—Jen Sotham

Halal Yeah!

Roll over hot dog, a new street treat is quickly becoming the New Yorker's go-to option for quick, cheap, and easy cart vendor dining. Whether parked in Midtown, the West Village, or Jackson Heights, halal carts are serving up some of the tastiest, line-around-the-block-worthy food this side of Kandahar.

"Halal" is an Arabic term meaning "permissible" and, in culinary terms, it refers to foods prepared according to guidelines established by Islamic law. Without going into the appetite-suppressing specifics—mostly concerning various approved and unapproved methods of slaughter—halal meat, usually chicken or lamb, is the result of relatively humane, scripturally-sanctioned practices. When placed in the context of your weekday lunch, this means a Styrofoam container filled with yellow basmati rice, lettuce & tomato, and your choice of chicken or lamb (or both), all topped with tangy white sauce, hot sauce, barbeque sauce, or some combination of the three. Because most carts generally offer the same menu options, a proprietor's sauces are what separate the average from the good from the exceptional. The white sauce served at the best carts is like the love child of ranch dressing and tzatziki, and covers up whatever sins of blandness or mysteriousness the meat it covers might have committed.

With most chicken-over-rice and lamb-over-rice platters starting at just $4, you really can't find a cheaper way to fill up. Due to the cuisine's growing popularity, there are carts available in most neighborhoods, often with two or more vendors competing for the same two or three blocks of patrons. It's easy to go wrong with so many choices, but here are some of the most dependable carts and their (approximate) locations.

Rafiqi's Halal Carts, 5th Ave and 13th St., Manhattan 10003 (and other locations). With 11 locations across the city, Rafiqi and his four brothers run a virtual halal cart empire. An especially piquant hot sauce and robust servings put Rafiqi's carts at the top of my list.

Sammy's Halal, 73rd St. and Broadway, Jackson Heights, Queens 11372 (and other locations). Winner of the 2006 Vendy Award for best street vendor food, Sammy's carts are among the most popular in the city. For more information about the Vendy Awards, visit http://streetvendor.org/vendies.html.

Halal Chicken and Gyro (aka 53rd and 6th), 53rd St. and 6th Ave., Manhattan 10019, www.53rdand6th.com. Famously located across from the Hilton in midtown Manhattan, this particular cart is known for its long lines and addictive white sauce. Unfortunately it's only open after 7 PM.

Halal Vendor, 50th St. and 6th Ave. (NW corner), Manhattan 10020. Nominated for a 2006 Vendy Award.

Kwik Cart #1, 45th St. and 6th Ave., Manhattan 10036 (and other locations). This markedly more haute cuisine cart option from Russian Tea Room alum, Mohammed Rahman, features lamb

MANHATTAN

marinated in cumin, yogurt, green papaya, and coriander.

Halal Food, 40th St. and Broadway, Manhattan 10018. Nominated for a 2006 Vendy Award.

Halal Cart, Broadway and W. Houston, Manhattan 10012. Nominated for a 2006 Vendy Award.

—*Charles Battle*

Goodburger
Stand for something good.
$$
200 2nd Ave., Manhattan 10017
(at 43rd St.)
Phone (212) 922-1700
www.goodburgerny.com

CATEGORY	Burger joint
HOURS	Mon-Thurs: 11 AM-10 PM
	Fri/Sat: 11 AM-11 PM
SUBWAY	4,5,6,7 and S at Grand Central
PAYMENT	VISA MasterCard AMERICAN EXPRESS
POPULAR DISH	The guys at Goodburger know the secret to the perfect patty: simplicity. The burger's goodness is in its high quality beef and fresh ingredients.
UNIQUE DISH	Just go with the burgers here. The cheeseburger ($6.25) has a blend of white and yellow cheddar cheese. A burger with the "works" comes with, well, everything. Each burger is made to order, and beer-battered onion rings and fries are must-have sides.
DRINKS	Goodburger is known for its incredible shakes made with the creamiest Vermont ice cream. Flavors include strawberry, black cow, cookies and cream, vanilla, and chocolate. There is fountain soda, fresh squeezed lemonade, and beer on tap.
SEATING	There are a couple of tables in this really clean, fun, diner-like setting. It's definitely a leap up from a burger joint, but a lot of people get their orders to go or delivered, since it is in such a business-oriented location
AMBIENCE/CLIENTELE	Goodburger is packed during lunch hours, when nearby business-folk wait to order their burgers and fries while bobbing to the popular music playing overhead.
EXTRAS/NOTES	Owner Nick Tsoulos is formerly of the Patsy's pizza family. Now his burgers are being lauded as "the best in NYC." Glad he switched! Goodburger eats are also available to order online and for delivery.
OTHER ONES	• Midtown: 636 Lexington Ave. (at 54th St.), Manhattan 10022, (212) 838-6000

—*Camilla Warner*

MANHATTAN

Gyu-Kaku
(See p. 45)
Japanese Steakhouse
805 3rd Ave., 2nd Floor, Manhattan 10022
Phone: (212) 702-8816

Haru Japanese Restaurant
(See p. 128)
Sushi/Japanese
280 Park Ave., Manhattan 10017
Phone: (212) 490-9680

Just Salad
Well, it's not just salad—it's everything that's good for you.
$$$
320 Park Ave., Manhattan 10022
(between Park Ave. and Madison Ave.)
Phone (212) 758-8900 • Fax: (212) 758-8911
www.justsalad.com

CATEGORY	Café
HOURS	Mon-Fri: 11:30 AM-8:30 PM Sat: 11 AM-4 PM
PARKING	6 train to 51st and Lexington.
PAYMENT	VISA, MasterCard, American Express, Discover
POPULAR DISH	The best dish comes from making your own dish. However, the Texas two-step tops the charts and has a nice bite.
UNIQUE DISH	In Midtown, where take-out food is generally sub par, Just Salad provides incredibly fresh, top-notch ingredients so you can eat a wholesome and healthy lunch. The menu is extensive, tailoring to the individual tastes and needs of its customers. Combinations are limitless and can be consumed in a wrap or in a typical salad.
DRINKS	Juice, water, and gourmet sodas.
SEATING	No seating available. Customers follow a U-shaped line from their first choice to the check out.
AMBIENCE/CLIENTELE	Not much charm or atmosphere here. The space is purely utilitarian and isn't meant to please the eye—only the stomach and body.
EXTRAS/NOTES	Just Salad is an environmentally friendly and eco-conscious restaurant. Salads are served in Tupperware and each time customers return with their containers they receive six free toppings, a policy that helps preserve not only the environment but also your hard-earned dollars.

—*Alexandra Collins*

MANHATTAN

Jaiya
Artful Thai sizzles on Third.
$$$
396 Third Ave., Manhattan 10016
(at E. 28th St.)
Phone (212) 889-1330
www.jaiya.com

CATEGORY	Thai
HOURS	Mon-Fri: 11:30 AM-Midnight
	Sat: Noon-Midnight
	Sun: 5 PM-Midnight
SUBWAY	6 to 28th St., N, R to 28th St.
PAYMENT	VISA, MasterCard, American Express
POPULAR FOOD	Hot basil, fresh chili, Indian and "jungle" curry—people come here for the nuanced and powerful spices: the Thai-style Chicken soup will clear your sinuses, but a tamer palate can enjoy less fiery dishes like the Beef with Mushrooms and Bamboo Shoots
UNIQUE FOOD	The menu is vast; some unique features are the Dancing Shrimp, a kind of Thai ceviche, and two variants of frog legs.
DRINKS	Full bar
SEATING	Seats 60 at comfortable tables.
AMBIENCE/CLIENTELE	Perfect for late dinners with friends, Jaiya is always crowded with casual diners and busy types angling for take-out
EXTRAS/NOTES	Owners Pok and Wanne started their first Jaiya in Elmhurst in 1978 and didn't stop at opening the Manhattan location. Most recently they started the Jaiya Beauty Salon, a few doors down from the original restaurant, allowing you to get a manicure and *pad* Thai from the same purveyors in a single afternoon.
OTHER LOCATIONS	•Queens: 81-11 Broadway, 10006, (718) 651-1330

—Esti Iturralde

Kalustyan's
International foods and a Mediterranean vacation for your palate.
Since 1944
$$
123 Lexington Ave., Manhattan 10016
(at 29th Street)
Phone (212) 685-3451
www.kalustyans.com

CATEGORY	Mediterranean
HOURS	Mon-Sat: 10 AM-8 PM
	Sun: 11 AM-7 PM
SUBWAY	6 to 28th St.
PAYMENT	VISA, MasterCard
POPULAR FOOD	Falafel, *Kibbi* sandwiches, *Basturma*, and Vegetarian Platters
UNIQUE FOOD	According to my veggie friends this has the best vegetarian soup in the city (it's great if you're a carnivore too)
DRINKS	Lots of unique sodas from Greece and even the Czech Republic in every flavor from mango to ginger and even milk, cans only

SEATING	Four small tables in the front window and one next to the counter
AMBIENCE/CLIENTELE	Bright and spotless; the take-away counter is upstairs on the 2nd floor: it gets crowds at lunch but they move the line fast—know what you want or the counter guy will skip over, moving on to one of the many moms with strollers who frequent the place.
EXTRAS/NOTES	Kalustyan's is a gourmet food shop that sells everything Indian and Mediterranean from tea sets to fresh dates, and the lunch counter is part—but not all—of its charm. Take a look at the produce while you're there for a bite, or do so on-line on the web site.

—*Michael Connor*

Lannam

Quality Vietnamese—without having to fly to Saigon!
$$
393 Third Ave., Manhattan 10016
(corner of E. 28th St.)
Phone (212) 686-5168 • Fax: (212) 686-6552

CATEGORY	Vietnamese
HOURS	Sun-Thurs: 11:30 AM-11:30 PM Fri/Sat: 11:30 AM-Midnight
SUBWAY	6 to 28th St.
PAYMENT	VISA MasterCard AMERICAN EXPRESS
POPULAR FOOD	Sliced fillet of beef with peanut sauce served with pineapple, cucumber, bean sprouts, tomato, herbs and roasted peanut with choice of brown, fried, white rice (take advantage of the lunch special); hot and sour soup with chunks of pineapple, straw mushrooms, celery, green paper, tomato, bean sprouts, roasted peanut, and fresh herbs—choice of fish and shrimp, chicken, shrimp wonton, or vegetables
UNIQUE FOOD	Sugar cane shrimp (shrimp wrapped in sugar cane, served with lettuce, fresh herbs, cucumber and light sauce); shredded bean curd salad with **nuoc cham** sauce; Home Made Spicy Pickle Salad (mustard greens, carrot, cabbage, sesame seed, and plum sauce); sticky rice with coconut and yellow bean
DRINKS	Full bar including imported beer, coconut juice, Vietnamese Espresso Filter Coffee (hot and iced), ginger iced tea, soda, fresh lemonade soda
SEATING	Seats 85-90
AMBIENCE/CLIENTELE	Everyone comes here—old, young, alone, big groups—and everyone feels comfortable
EXTRAS/NOTES	Unless you go for seafood, you can leave this fabulous joint with a big, satisfied gut for under eight bucks. The sticky rice is a must have—it's got little yellow lentils to give it a wonderful texture (perfect complex proteins, too). The place is pleasant during the weekend, when you may be in the company of the staff, using empty tables to chop mounds of vegetables.

—*Marie Estrada*

MANHATTAN

Manapaty Milant Corp.
Tiny shop brimming with delicious gourmet fare.
$$
158 E. 39th St., Manhattan 10017
(between Lexington and 3rd Ave.)
Phone (212) 682-0111 • Fax (212) 697-2276

CATEGORY	Gourmet take-out/specialty foods
HOURS	Mon-Fri: 7 AM-9 PM
	Sat/Sun: 10 AM-9 PM
SUBWAY	4, 5, 6, 7, S to Grand Central
PAYMENT	VISA, MasterCard, American Express, Discover
POPULAR FOOD	Try the "special" (available every day): heaping servings of any three of their gourmet salads, a "free" cup of soup and a piece of bread—it's enough food to last you for two meals; Basmati rice and chicken, smoked tuna with pasta, and bean salad; homemade chicken vegetable soup is tasty and not too salty, or try the soup of the day
UNIQUE FOOD	Gourmet salads, *Bococcini* (baby mozzarella) in olive oil with parsley and hot peppers, vegetarian naan, crab meat cakes with onion and fresh herbs, veggie burgers, mini spinach pies with feta cheese, humus, *baba ganoush,* half a lemon roasted chicken and two salads with a cup of soup (offered every night), and gourmet sandwiches: French brie, sun-dried tomato, pine nuts and olive oil on semolina bread; *baba ganoush* or hummus with mixed greens and fresh tomato in pita bread; crabmeat cake with fresh tomato, lettuce and mayonnaise on French bread; tuna with apple and fresh dill on rye with lettuce and tomato
DRINKS	Brewed Colombian coffee (regular and decaf), herbal and regular tea, juice and soda
SEATING	Strictly take-out; find a park
AMBIENCE/CLIENTELE	Midtown workers enjoy grabbing their lunch here; the staff is friendly, and incredibly efficient: you barely have to nod in the direction of a salad before it's in a container, wrapped and ready to go, while the guy at the cash register looks at your wallet expectantly.
EXTRAS/NOTES	Milant's menu claims it has the lowest prices in New York on cheese, coffee beans, olive oils and smoked salmon, as well as the best prices on baguettes, be they French, semolina or whole wheat. The sheer quantity and variety of options is overwhelming, and choosing is not helped by the fact that everything here looks like it could be the best thing you've ever eaten. You won't be able to linger too long over making up your mind if you come here when it's crowded—Milant has standing room for at most five people, and you'll get to know them all extremely well by the time you're done ordering. Good luck making up your mind in a hurry—it's almost impossible to choose between the delectables in the display case.

—*Sarah Winkeller*

MANHATTAN

Mishima
The red lantern marks the spot of this Japanese standout.
$$$
164 Lexington Ave., Manhattan 10016
(at E. 30th St.)
Phone (212) 532-9596 • Fax (212) 448-0171

CATEGORY	Japanese/Sushi
HOURS	Mon-Fri: Noon-2:30 PM, 5:30 PM-10:30 PM Sat/Sun: 5 PM-10:30 PM
SUBWAY	6 to 28th St., N, R to 28th St.
PAYMENT	VISA MasterCard AMERICAN EXPRESS DISCOVER
POPULAR FOOD	Individual rolls start at hard-to-beat prices (just over $2) and are known for their remarkable freshness.
UNIQUE FOOD	Regulars rave about the soft-shell crab roll.
DRINKS	Beer, wine, and sake
SEATING	Seats 60 at tables and bar, mostly upstairs
AMBIENCE/CLIENTELE	This high-value sushi joint has finally added a second floor, making the most of the crowds it usually draws. The expansion brought in glossy new tables and décor, an improvement on the formerly cramped and somewhat drab restaurant

—Esti Iturralde

P.J. Clarke's
The little saloon that could . . .
Since 1912
$$$$
915 Third Ave., Manhattan 10022
(at 55th St.)
Phone (212) 317-1616
www.pjclarkes.com

CATEGORY	American Pub
HOURS	Daily: 11:30 AM-3 AM
SUBWAY	Take the 6, E, or V train to 51st St. and walk four blocks north. Or take the 4,5,6,N,R to 59th St. and Lexington, walk one avenue east and four blocks south.
PAYMENT	VISA MasterCard AMERICAN EXPRESS DISCOVER
POPULAR DISH	The burgers get quite a bit of hype and much of it is well-deserved, though patrons with high expectations may complain about the burger's small size or the a la carte side dishes. It's true that P.J.'s burger is never going to impress the super-size-me's of the world, but those who prefer quality over quantity won't be disappointed. Feeling especially hungry? Spring for the bernaise burger with a side of the too-good-for-words onion strings.
UNIQUE DISH	P.J.'s menu resonates with New York character, from the hodgepodge of items that constitute "Traditional American" fare to the odd numbered prices that seem to have no rhyme or reason. There's nothing too eclectic here, but it's all good.
DRINKS	It was nearly a century ago that an Irish immigrant named Patrick Joseph Clarke imprinted his name forever in New York's history. And, although the

MANHATTAN

SEATING	joint has evolved way beyond typical pub food, it would be a crime to experience P.J. Clarke's without a couple of beers in ya.
	The main dining room in the back has ample seating for small parties. For more than four people during peak hours, expect a long wait. For more than six people, go elsewhere.
AMBIENCE/CLIENTELE	From the red-and-white tablecloths to the smoke-stained ceiling to the aged wood inlaid with beveled glass to the long broken phone booth—stepping into P.J. Clarke's is the closest you can come to stepping back into old New York. The front bar is usually packed beyond comfort with those unwinding after work (some of whom apparently forget to go home). The beauty of the dining room, besides the fact that it is completely separated from the bar area, is that no matter where you sit there is a sense of intimacy. At any time you almost expect the waiter to call you by your childhood nickname.
EXTRAS/NOTES	This little red brick beacon has defiantly stood its ground as the sky around it has been gradually swallowed up. In over one hundred years of business, it has played host to the likes of Marilyn Monroe, Frank Sinatra and Jackie O. P.J.'s bacon cheeseburger was dubbed the "Cadillac of burgers" by Nat King Cole and the restaurant served as "Nat's Bar" in Billy Wilder's *The Lost Weekend*. Fortunately, the recent change of hands left both the ambiance and the burgers intact.
OTHER ONES	• 4 World Financial Center, Manhattan 10281, (212) 285-1500
	•Also, a third P.J. Clarke's at Lincoln Center is slated to open this year.

—*Jen Sotham*

Pret a Manger
Marge Simpson once said "Homey, we can't afford to shop at any store that has its own philosophy." Tthe sandwich bargains at this New Age British Import prove her wrong.
$$
287 Madison Ave., Manhattan 10017
(between E. 40th and E. 41st Sts.)
Phone (212) 867-0400
www.pretmanger.com

CATEGORY	British sandwich shop
HOURS	Mon-Fri 7:30 AM-6 PM
SUBWAY	S, 4, 5, 6, 7 to 42nd St./Grand Central
PAYMENT	Cash only
POPULAR FOOD	Brie, basil, and fresh tomato on a baguette, Super Club, Big BLT, roasted peppers and parmesan cheese wrap, lemon cake
UNIQUE FOOD	Double Cheddar sandwich sauced with fruit and onion chutney (made with balsamic—not the cheap stuff—vinegar and stewed for hours); Thai Chicken Miracle Mayo sandwich made with coconut and shrimp

MANHATTAN

DRINKS	100% natural fresh squeezed vegetable and fruit juices, yogurt drinks and fruit "blends" or smoothies, cappuccino, latte, mocha
SEATING	Indoor
AMBIENCE/CLIENTELE	Starbucks meets Ikea meets the new breed of spa-like trendy *au natural* sandwich shop you'll find downtown: Midtown's lunch gang shows up in force to take advantage of tasty, interesting, and surprisingly affordable handmade sandwiches, wraps, sushi, and baked goods made ready quickly.
EXTRAS/NOTES	If you're a Babe fan, or a concerned meat eater, know that Pret ham comes from pigs that have been reared outdoors on a vegetarian diet and that Pret uses only fresh, high quality ingredients.
OTHER ONES	• Manhattan: 60 Broad St., 10004, (212) 825-8825 • Sixth Avenue to the Hudson: 530 Seventh Ave., 10018, (646) 728-0750 • Sixth Avenue to the Hudson: 1350 Sixth Ave., 10019, (212) 307-6100 • Midtown: Manhattan: 425 Madison Ave., 10017, (646) 537-0020 • check website for more locations

—*Joe Cleemann & Marie Estrada*

Pretzel, Hot Dog, and Sausage Cart

Pretzel or hot dog on the go?
Mohamed's your man.
$

Northeast corner of 41st St. and Third Ave., Manhattan 10017
(at 41st St. & Third Ave.)

CATEGORY	Cart
HOURS	Mon-Fri: 11/11:30 AM-6 PM (summer) Mon-Fri: 11/11:30 AM-4:30 PM (winter)
SUBWAY	4, 5, 6, 7, S to 42nd St. Grand Central
PAYMENT	Cash only
POPULAR FOOD	There are three items on the menu, and you could buy all three (plus a drink or two) for less than $10: the extra-large pretzels are crispy and golden brown on the outside, soft, warm, and doughy on the inside, and have the perfect amount of salt; you can also get a good, solid hot dog, or a nice thick Golden-D sausage
DRINKS	Soda (Pepsi, Diet Pepsi, Coke, Diet Coke, Lipton Iced Tea), Snapple
AMBIENCE/CLIENTELE	Two red and yellow umbrellas, a stack of large, plump pretzels, and a menu written in six-inch high mustard yellow letters are enough to get any hungry passerby to whip out his wallet . . . and many business people do, eating for $3 or $4
EXTRAS/NOTES	Vendor Mohamed has been working this corner for four and half years. Before that, he was at 34th and 5th for seven years. No one can say the food's unique, but who goes to a hot dog and pretzel cart looking for innovation? Besides, there's nothing quite like holding a warm New York pretzel in your mittened hand on a nippy fall afternoon.

—*Sarah Winkeller*

MANHATTAN

Rare Bar and Grill
The best burgers are served Rare
$$$
303 Lexington Ave., Manhattan 10016
(at 37th St.)
Phone (212) 481-1999
www.rarebarandgrill.com

CATEGORY	Burger joint
HOURS	Mon-Thurs: Noon-11 PM Fri: Noon-Midnight Sat: 11 AM-Midnight Sun: 11 AM-11 PM
SUBWAY	4,5, 6 to 33rd St.
PAYMENT	VISA
POPULAR DISH	Some sing the praises of the simple burger: a juicy patty, a single slice of cheese, and a solid bun. Rare takes that simple philosophy and throws it out the window. The 8-oz burgers are packed with gourmet ingredients and unconventional additions. The favorite M&M burger boasts whiskey-flambéed meat, caramelized shallots, cheddar, and apple smoked bacon. It is definitely pricier than most burger places, but the delicious ingredient combinations cannot be enjoyed anywhere else in the city.
UNIQUE DISH	The California lump crab "burger" is complete with avocado, cucumber, and red pepper coulis. The innovative options don't stop there. Each week, a different cheese from the famed Murray's Cheese shop adorns a special burger. Wanna plop something extra-special on top of it? Rare's burger toppings are a little more haute cuisine than the standard lettuce, tomato, onion. Spruce up your burger with truffle butter, red wine poached foie gras, or a fried egg. Add a side of their delicious sweet potato fries and you'll be good to go.
DRINKS	During the steamier months, Rare extends to the roof of the Shelburne Hotel with its bar, Rare View. As you'd expect, the views of the Empire State and Chrysler buildings are amazing, and the drinks are good, too. Enjoy a glass of wine or one of the more than 20 bottled beers they offer.
SEATING	The bar is a great place to eat, but there are also tables with high stools. The roof is a spectacular place to go for after-work drinks during the spring and summer.
AMBIENCE/CLIENTELE	Dark lighting and hearty eating and drinking make Rare a solid after-work place. Good date spot, too.
EXTRAS/NOTES	Rare will cost more than you usually spend for burgers and fries, but it's worth it for the chill atmosphere, the inventive and delicious burgers, and the cold beer. On weekends, Rare serves a traditional brunch menu from 11 AM-4 PM.
OTHER ONES	• 228 Bleecker St. (between 6th Ave. and Carmine St.), Manhattan 10014, (212) 691-7273

—*Camilla Warner*

MANHATTAN

Two Boots Grand Central
(See p. 97)
Cajun/Creole/Pizza
Grand Central Terminal (Lower Dining Concourse), Manhattan 10017,
Phone: (212) 557-7992

MIDTOWN WEST

Blockheads
(See p. 111)
Mexican
322 W 50th St., Manhattan 10019
Phone: (212) 307-7029

Bread and Olive
(See p. 2)
Middle Eastern
24 W. 45th St. (between Fifth Ave. and Sixth Ave.), Manhattan 10036,
Phone: (212) 391-7772

Burritoville
(See . 81)
Mexican
352 W. 39th St., Manhattan, 10018
Phone: (212) 563-9088

Chickpea
(See p. 40)
Middle Eastern
24 W. 45th St. (between Fifth Ave. and Sixth Ave.), Manhattan 10036
(212) 391-7772

THIRSTY, But No $$$? Dive Bar Ho!

What happens after you've emptied your wallet out at that posh restaurant, and need to drown your spender's guilt in a mixed drink? Behold! The wonder that is, and will always be, the dive bar.

A dive bar is not necessarily divey. Such is simply a drinking establishment (nay, a watering hole!) with a rundown or no-frills appearance. The drinks are traditionally cheap and plentiful, hence the appeal. Rumor has it the term was originally coined in the nineteenth century, when bars of ill repute were often located

MANHATTAN

below street level, and thus patrons had to "dive" in to catch their buzz. As the term itself evolved, so has the institution, and now dive bars have become so popular they have often out-trendified those very bars from which they were once a calm escape.

Still, there's a certain purity to the dive bar, it feels more personal, less forced. It's the intimacy of friendship vs. the designer duds of being "seen." Not everyone knows about these places, and those who do are the people you would rather be around anyway. To those who appreciate the thrill of discovery, I share my golden key.

Patriot Saloon is a dive bar in the truest sense of the word. But I must say, it's also one of my favorite bars in the entire city. A good friend of mine and I once walked in here and had random dudes buy us mysterious pink shots before we even took our coats off . . . and we didn't even have to speak to them! On another occasion, a ladies night, my friends and I got free kamikaze shots just for dancing on the bar. It's the special sort of joint where pitchers of beer are well under $10, and you can bring in takeout and sit for hours without getting dirty looks. Yes, there's the occasional vermin in the bathroom, but at these prices, in this ambiance, more power to them. *110 Chambers St., Manhattan 10007, (212) 748-1162.*

The Back Fence is a dump, right down to the peanut shells on the floor, but it's a dump with character. If you want to have a drink or two at a saloon with a down-home feel, with folding chairs and plaid-shirt-wearing men wielding acoustic guitars, this is your place. The beers are cold, the peanuts are gratis, and the troubadours onstage have been known to honor even the most outlandish requests from time to time. What's not to like? *155 Bleecker St., Manhattan 10012, (212) 475-9221.*

Whoever invented the concept of drunken skee ball should be knighted. Seriously. In the heart of the East Village, where you can't take three steps without hitting a bar, it takes a special sort of dive to stick out. Video games and cozy seating areas make **Ace Bar** the perfect spot for everything from a birthday party to date night. *531 E. 5th St., Manhattan 10009, (212) 979-8476.*

One beautiful fall night, after a riveting showing of *Bikini Blood Bath* over at the Pioneer Theater, I had my maiden **Double Down Saloon** experience. It wasn't long before I was sending drunken text messages to all my friends proclaiming this my new favorite bar. Why, you ask? Pony Rides! Yes, there is a mechanical pony . . . and black-and-white porn on the overhead projector, a tattered pool table, and a punk-only juke box. Sure, there are scary cocktails like ass juice and bacon martinis, but doesn't that just add to the charm? *14 Avenue A, Manhattan 10003, (212) 982-0543.*

—Aly Walansky

Cho Dang Gol
Tofu dishes that won't impugn one's manhood.
$$$$
55 West 35th Street, Manhattan 10001
(at Sixth Ave.)
Phone (212) 695-8222

MANHATTAN

CATEGORY	Korean
HOURS	Daily: 11:30 AM-10:30 PM
SUBWAY	B, D, F, V, N, R, Q, W to 34th St./Herald Square
PAYMENT	VISA, AMERICAN EXPRESS, MasterCard, DISCOVER
POPULAR FOOD	Free appetizers (small bowls of fish, *kimchi*, etc.), are all very good. The first ten items under "Main Dishes" stay just within budget range: these include heaping flavorful Korean casseroles, some with meat and nearly all of which incorporate Cho Dang Sol's signature ingredient, delicious hand rolled tofu..The "large" is large enough for two; come at lunchtime and find these same dishes at a discount.
UNIQUE FOOD	The aforementioned hand rolled tofu finds its way into many of the dishes and tastes good even for those who consider tofu subversive; if you have the financing, try one of the pan-fried specialties: they arrive on very hot stone plates, many accompanied by leafy vegetables and sauce ("special, "seasoned," etc.) to eat as you would *moo shu* pork at a Chinese restaurant.
DRINKS	Tea, soda, wine, beer (Korean and domestic), Korean liquor, sake, Korean rice wine; no complicated mixed drinks
SEATING	Seats about sixty at the *maru* and at conventional tables
AMBIENCE/CLIENTELE	Fine woodworking buttresses the platform upon which the *maru*—a very low table (you can sit there if you're willing)—rests; clientele includes many Koreans, and plenty of everyone else (Cho Dang Gol is a block from the Empire State Building).

—Mayu Kanno

Gourmet Wok
Very Cheap Chinese: we're talking dinner for less than five bucks.
$
597 10th Ave., Manhattan 10036
(at W. 43rd St.)
Phone (212) 947-6808

CATEGORY	Take-out Chinese
HOURS	Mon-Thurs: 11 AM-11 PM Fri/Sat: 11 AM-Midnight Sun: Noon-11 PM
SUBWAY	A, C, E to 42nd St.
PAYMENT	Cash only
POPULAR FOOD	A pint of Hunan Shrimp contains six (count 'em, six) fresh jumbo shrimp with broccoli, baby corn, peppers, watercress, carrots and snow peas; expansive menu includes Cantonese style noodles with shrimp in soup and Chicken with *udon* (Japanese rice noodles) in curry sauce; chef's specials, served only in quarts, feature popular General Tso's, the Seafood Delight (lobster, scallops, and shrimps with mixed vegetables)..... If you're feeling healthy, you can get most dishes steamed, with the sauce served on the side, for an extra 25¢

MANHATTAN

UNIQUE FOOD	Fried chicken wings (worth a little guilt; 4 at a time or individually), fried half chicken, French fries: the folks at the Gourmet Wok have a fryer, and they're not afraid to use it
DRINKS	Soda and Snapple
SEATING	Six tables, seating about 20, but most business is carry-out and delivery
AMBIENCE/CLIENTELE	Very brightly lit; the almost ubiquitous picture of a Chinese waterfall is so enormous that the image is noticeably warped in places; open view of the woks in action... clean, lavender interior helps, but no one is making the trip here to sit down; service known to perk up if you can speak Mandarin or Cantonese, even at a grade-school level.
EXTRAS/NOTES	The Gourmet Wok is a Chinese take-out place, like many other run-of-the-mill renditions throughout New York (and elsewhere). But it's a GOOD Chinese take-out place. And it actually prices pints and quarts, making a meal for one more economical than you'd have a right to expect. Food tastes exactly like you think it would, coming from a good Chinese take-out joint, with a measure of freshness that keeps regulars returning. Stay away from the fried seafood though—it's all breading.

—Andrew Yang

Haru Japanese Restaurant
Melt-in-your-mouth sushi
$$$$
205 W. 43rd St., Manhattan 10036
(between Broadway and 8th Ave.)
Phone (212) 398-9810
www.harusushi.com

CATEGORY	Sushi
HOURS	Mon: 11:30 AM-11 PM Tues-Thurs: 11:30 AM-Midnight Fri: 11:30 AM-Midnight Sat: 12:30 PM-Midnight Sun: 12:30 PM-11 PM
PARKING	Haru is located steps from Times Square, so while you wouldn't necessarily want to find parking there, lots and subway stops abound.
PAYMENT	VISA, MasterCard, American Express, Discover
POPULAR DISH	Delicious sushi, artistically prepared.
UNIQUE DISH	"Sumo" and "Kabuki" combination platters, king crab steamed dumpling appetizer, myriad sushi options, and deliciously intense ginger dressing on the salads
DRINKS	Extensive cocktail menu; I am partial to their lychee martini, but they have many varieties of wine, sake, beer, and martinis.
SEATING	Seating at tables and at the bar. It gets crowded, so reservations are advised.
AMBIENCE/CLIENTELE	Very popular with the after-work crowd
EXTRAS/NOTES	Haru offers a beautiful, romantic atmosphere in which the trees surrounding the dining area are lit up with white twinkling lights. Service is

MANHATTAN

OTHER ONES	excellent, and the food comes very quickly. Best sushi I've ever eaten.

- Midtown: 280 Park Ave. (at 48th St.), Manhattan 10017, (212) 490-9680
- Flatiron/Union Square/Gramercy: 220 Park Ave. S (at 18th St.), Manhattan 10003, (646) 428-0989
- Upper East Side: 1329 Third Ave., (at 76th St.), Manhattan 10021, (212) 425-2230
- Upper West Side: 433 Amsterdam Ave. (between 80th St. & 81st St.), Manhattan 10024, (212) 579-5655
- Upper East Side: Haru Sake Bar, 1327 Third Ave. (at 76th St.), Manhattan 10021, (212) 452-1028

—Aly Walansky

Island Burgers and Shakes

Great burgers (and chicken sandwiches), but it shows in the tab.
$$$

766 Ninth Ave., Manhattan 10001
(Between W. 51st and W. 52nd Sts.)
Phone (212) 307-7934

CATEGORY	Burger Joint
HOURS	Mon-Thurs: Noon-10:30 PM
	Fri: Noon-11 PM
	Sat/Sun: Noon-10:30 PM
SUBWAY	C, E to 50th St.
PAYMENT	Cash only
POPULAR FOOD	63 types of burgers (and as many *churascos*—grilled chicken sandwiches—in the same varieties), including: the Tijuana (with bacon, jack, guacamole, and onion), the cowboy (barbecue sauce, onion, bacon, cheddar, ranch, sourdough), the Slick Willie's (ham, relish, American, bacon, sour cream, barbecue sauce, onion)
UNIQUE FOOD	As if 63 forms of burger isn't unique enough… a fair vegetarian selection: *Tabouleh* Salad and Capo San Lucas Salad (chips, cheddar, jack, salsa, guacamole, jalapeno, onion, peppers and tomato), as well as a Genoa sandwich (pesto, roasted peppers, mozzarella, tomatoes, onions, *ciabatta*). . . Island doesn't serve fries—there's no room for a fryer in the facility; instead, there are big baked potatoes, "naked" and with bacon, butter, sour cream, cheddar, and chives
DRINKS	Island does not serve alcohol, though they'll let you bring drinks in from the convenience store across the street. Otherwise, it's soda, and, of course, the shakes (malteds, floats, milkshakes). The black and white (vanilla milk shake with chocolate sauce) is the most popular
SEATING	Seating for about 28 at round tables
AMBIENCE/CLIENTELE	Colored spheres illuminate primary-colored round tables. The dining room is oddly dim given all of the bright red and yellow scattered about; paintings and mirrors shaped like surfboards adorn the walls, with some aged, fading advertisements completing the '60s diner

MANHATTAN

	ambience; young regulars bring guests. Every other table seems to have someone telling a newcomer about how great the food is
EXTRAS/NOTES	Portions are very healthy, with the burgers consisting of thick, almost spherical slabs of ground beef, and the *churascos* far heftier than the portion you might think of with the phrase 'grilled chicken breast,' (they found some big chickens). Throw in a baked potato and one of the milk shakes, and this place starts to add up. Don't order takeout: the main appeal to Island is the fresh slab of meat with the ingredients virtually melting into it—the effect is lost unless you get it immediately, made to order and steaming hot.

—Andrew Yang

Joe's Shanghai
(See p. 12)
Chinese
24 W. 56th St., between 5th and 6th Ave. Manhattan

La Paloma Burritos
Outstanding value Mexican—tasty, cheap, even guilt-free
$$
359 W. 45th St., Manhattan 10036
(at 9th Ave.)
Phone (212) 581-3844

CATEGORY	Burrito Joint
HOURS	Daily: 11 AM-11 PM (delivery 11:30 AM-10 PM)
SUBWAY	A, C, E to 42nd St.
PAYMENT	VISA MasterCard AMERICAN EXPRESS
POPULAR FOOD	Regulars come for the House Special Asada Burrito—a flour tortilla filled with charcoal broiled beef or chicken, rice, red or black beans, cheese, sour cream and guacamole with a side of mild *pico de gallo*; veterans offer rapid-fire specifications that are followed reliably (e.g. Chicken Asada Burrito, black beans, no dairy). An Asada Burrito is nearly excessive for one diner, large enough to satisfy two dainty patrons—not that there are many of those visiting La Paloma
UNIQUE FOOD	The Maria Burrito—all of the ingredients of the Asada, but with steamed chicken as the main ingredient. The loss in flavor hurts, but anyone ordering the Maria Burrito isn't using flavor as their main criteria.
DRINKS	Sodas and Snapple, with a few Mexican sodas thrown in
SEATING	Three tables seat about 10
AMBIENCE/CLIENTELE	Not unpleasant: a bright, clean modest dining room adorned with Mexican pictures and knickknacks; the staff is quick and efficient— frequented almost exclusively by Hell's Kitchen

MANHATTAN

natives, who are there simply to keep their heads down, eat, and enjoy

EXTRAS/NOTES Has a local following, and becomes quite busy during peak take-out times, with the occasional 10-minute wait. Call your order in.

—*Andrew Yang*

Lakruwana
(See p. 217)
Sri Lankan
358 W. 44th St., Manhattan 10036
Phone: (212) 957 4480

Mandoo Bar
Thriving Pan-Asian dumpling house in the heart of K-Town.
$$
2 W. 32nd St., Manhattan 10001
(between Fifth and Sixth Aves.)
Phone (212) 279-3075 • Fax (212) 279-3073

CATEGORY	Pan-Asian Dumpling House
HOURS	Daily: 11:30 AM–11 PM
SUBWAY	B, D, F, V, N, R, Q, W to 34th St./Herald Square
PAYMENT	Cash only
POPULAR FOOD	Mandoo (dumplings) come ten per serving, boiled or fried; try the Vegetable Mool Mandoo–boiled vegetable dumplings made with bright green spinach dough; or Seafood Mandoo—pumpkin-colored dough filled with shrimp and scallops, and a mix of shallots, and scallions
UNIQUE FOOD	The steamed Kimchee Mandoo would satisfy any *kimchee* lover's cravings—filled with spicy spicy *kimchee* mixed with a tiny bit of tofu, pork, and vegetables.
DRINKS	OB—Korean import beer, Chung-Ha—red house wine, American beer, soda, and mineral water
SEATING	Twelve cafeteria-style tables with benches (and individual butt pads) seat twenty comfortably
AMBIENCE/CLIENTELE	Think Japanese fused with Dutch industrial—long narrow space, warm yellowish tones (plate ware and all), polished light wood tables on silver castors, black and white framed photos, and shadow box lighting.
EXTRAS/NOTES	From the street, you can watch the dumpling chef create the dumplings. Mandoo receives many thanks from those of us who've just about had it with overly doughy from the freezer Chinese takeout dumplings. And even if you've never thought much of tofu, try the Fried Tofu with special house sauce—you'll be pleasantly rewarded.

—*Marie Estrada*

131

MANHATTAN

Meskerem
(See p. 69)
Ethiopian
468 W. 47th St., 10036
Phone: (212) 664-0520

Pinkberry
A healthy dessert addiction.
$
7 West 32nd St., Manhattan 10014
(between Fifth Ave. and Broadway)
Phone (212) 695-9631 • Fax: (212) 695-9637
www.pinkberry.com

CATEGORY	Yogurt
HOURS	Mon-Thurs: Noon-11 PM Fri-Sun: Noon-11:30 PM
SUBWAY	Take the N,R,Q to 34th Street.
PAYMENT	VISA, MasterCard, American Express, Discover
POPULAR DISH	Light, creamy and just a tiny bit tart, Pinkberry's yogurt is the shop's main fare and claim to fame. The yogurt itself, what Berry's website calls "the canvas," comes in two flavors, Vanilla or Green Tea (loyalists swear by the former) and can be dressed with any of eighteen toppings, which include fruit, nuts, chocolate chips, cookie crumbs and an assortment of children's cereals. Gaining attention on both coasts, the signature treat is sometimes known as Crackberry, and it only takes one taste to see why.
DRINKS	Only two: the green tea smoothie and the strawberry smoothie. That's two drinks . . . total. If you need to wet your whistle on anything else, you'll have to fend for yourself.
SEATING	Unlike many fro-yo joints who concentrate more on dessert than design, Pinkberry takes it to the next level, with trendy Le Klint lamps and Phillip Starck chairs that give one the feeling of being in a fashionable restaurant rather than a chain yogurt shop.
AMBIENCE/CLIENTELE	Pinkberry's swift rise above lucrative competitor Tasti D-Lite is thanks in part to the hip, minimalist design of their establishment. Light pastels and a circular motif give the place a calm, inviting vibe that keeps with the Zen-like quality of their approach to dessert.
EXTRAS/NOTES	Back in LA, Pinkberry stirred up controversy with activist group Venice Unchained when they began leasing property in an area of Venice known as Abbott Kinney Boulevard. Members of the group argued that the yogurt shop is one of many chain stores that are altering the atmosphere of the California strip. No word yet on New Yorkers being anything but satisfied by Berry's arrival.
OTHER ONES	• Upper East Side: 1577 2nd Ave., Manhattan 10028, 212-861-0574 • Sixth Avenue to the Hudson: 170 8th Ave., Manhattan 10011, 212-488-2510 • 41 Spring St., Manhattan 10012, 212-274-8883

—Samantha Charlip

MANHATTAN

Soup and Smoothie Heaven
Soup too good to be healthy for you.
$
316 Fifth Ave., Manhattan 10001
(between 31st and 32nd Sts.)
Phone (212) 279-5444

CATEGORY	Soup shop
HOURS	Mon-Fri: 7:30 AM-7 PM
SUBWAY	B, D, F, V, N, R, Q, W to 34th St./Herald Square
PAYMENT	Cash only
POPULAR FOOD	Butternut Squash and Apple soup—buttery butternut squash with chunks of apple and vegetables; Lobster and Crab Bisque with generous morsels of seafood, and Cream of Broccoli with Monterey jack cheese (the cheese will throw you over the edge!)
UNIQUE FOOD	Chicken pot pie stew—just what it sounds like—chicken pot pie made into a stew
DRINKS	Fruit shakes, fruity power smoothies, and fresh squeezed vegetable and fruit juices
SEATING	None
AMBIENCE/CLIENTELE	Open your closet, hang some fruit and vegetables and there you have it—S&S Heaven
EXTRAS/NOTES	Soup options change every day and come in three sizes—and you get a free banana and a sesame roll with every medium or large order!

—Marie Estrada

Todai
An all-you-can-eat seafood buffet you won't regret . . . seriously
$$$$
6 E. 32nd St., Manhattan 10016
(between Madison Ave. and Fifth Ave.)
Phone (212) 725-1333
www.todai.com

CATEGORY	Pan-Asian buffet
HOURS	Mon-Sat: 11:30 AM-10 PM Sun: 11:30 AM-9 PM
SUBWAY	6 to 33rd Street; N,R,W to 34th Street, B,D,F to 34th Street
PAYMENT	VISA MasterCard AMERICAN EXPRESS
POPULAR DISH	Everything on the buffet is fresh and delicious. The snapper with spicy sauce is especially tasty, as are the cream puffs on the dessert bar.
UNIQUE DISH	Even if you loathe buffets and are skeptical of shellfish, you'll love Todai. The atmosphere is decidedly cheesy, but the food is fresh and innovative and it's impossible to go home hungry.
DRINKS	Beer and wine. Kirin and Sapporo are popular, of course.
SEATING	Expansive, bi-level building means little wait time, even during the lunch rush.
AMBIENCE/CLIENTELE	Casual professionals, not overly suity or intimidating
EXTRAS/NOTES	Seafood is their specialty, but a variety of meat and vegetarian items are also available. Fresh dishes are introduced throughout both services (lunch and dinner). Lunch is served from 11:30-2

MANHATTAN

	PM, dinner from 6-10 PM Monday through Friday. Saturdays, lunch is served from 11:30-3 PM and dinner from 5:30-10 PM. Sunday, lunch from 11:30-3 PM, dinner from 5:30-9 PM.
OTHER ONES	This is the only New York location. Todai began on the West Coast and moved into Texas before expanding to Virginia and New York

—Sarah Turcotte

Two Boots Rock Center
(See p. 97)
Cajun/Creole/Pizza
30 Rockefeller Center, Manhattan 10112
Phone: (212) 332-8800

'wichcraft
(See p. 74)
Sandwich Shop
Bryant Park (four kiosks located on the 6th Ave. side of the park),
Manhattan 10110,
Phone (212) 780-0577

Woorijip
Fresh, home-cooked food and friendly atmosphere justify the name—woorijip: "our house."
$$
12 W. 32nd St., Manhattan 10001
(at 5th Ave.)
Phone (212) 244-1115

CATEGORY	Korean
HOURS	Daily: 6 AM– 3 AM
SUBWAY	B, D, F, V, N, R, Q, W to 34th St./Herald Square
PAYMENT	VISA MasterCard AMERICAN EXPRESS DISCOVER
POPULAR FOOD	If you're looking to sample a variety of Korean dishes, or are just indecisive, the 16-item buffet (pay by the pound) is the ideal starting place: it changes daily, with *kimchi* pancakes, seasoned spinach, and *bul go gi* (marinated beef) among the staples. . . (here's a tip: don't weigh your plate down with rice; it's more economical to get a $1 order on the side)
UNIQUE FOOD	Many varieties of *dduk,* a sweet rice cake treat; fresh *kimchi* is available in several sizes; Woorijip makes amazing *miso* soup, packed with tofu and seaweed
DRINKS	Tea, coffee, beer, soda, and imported Korean beverages such *Haitai* crushed fruit drink
SEATING	Seats 60–70 at the Counter up front and at tables of varying sizes throughout
AMBIENCE/CLIENTELE	Bright, casual and lively: cheesy Asian pop music often blares over the speakers
EXTRAS/NOTES	In addition to the buffet, there's a noodle bar and a large selection of prepared *ban chan* (side dishes) and *DoSiLak* (complete meals). Imported packaged

MANHATTAN

snacks, such as crisps and candy, are found up front. So many choices make eating at Woorijip a bit overwhelming, so you'll definitely want to return. If you live or work in the neighborhood, you could easily eat there daily without getting tired of it.
—Bob Gourley

UPPER EAST SIDE

212 Restaurant & Bar
Travel abroad while keeping your NYC area code at this chic pan-ethnic spot
$$$
133 East 65th St., Manhattan 10021
(between Park Ave. and Lexington Ave.)
Phone (212) 249-6565
www.212restaurant.com

CATEGORY	Neighborhood Bar
HOURS	Daily: 5 PM-1 AM
PARKING	Not quite the norm for New York, but there is street parking (if you're lucky) and a parking garage on the street (if you want to pay). Otherwise, take the N,R or the 4,5,6 trains to the 63rd Street station on Lexington Ave.
PAYMENT	VISA, MasterCard, American Express
POPULAR DISH	The owners and chef have put a Pan-Euro/Asian twist on the cuisine, giving foodies more than enough to choose from. A full menu is offered until midnight on weekdays and until 1 AM on weekends. Many of the dishes may seem more style than substance, but give them a chance and you won't be disappointed.
DRINKS	This is *the* place to go for vodka. With a huge selection of brands and a variety of martinis and flavored mojitos (including apricot and watermelon), what else could you ask for? Try a Fruitini or a Lemonaya and you'll be set! They also offer a wide array of champagne and champagne cocktails, like the Azur, fresh peach, hypnotiq, and champagne, or the Kir Royale, fresh raspberry and champagne. For something more adventurous, the Spice Shooter is a small, but potent blend of inferno vodka and ginger liquor.
SEATING	The bar area can be a little overwhelming at the front entrance, but the main dining space is smaller. The best seats in the house by far are the few elevated tables in the back, which allow you to view the entire restaurant.
AMBIENCE/CLIENTELE	212 definitely has a neighborhood feel, albeit that of the elite UES neighborhood. Everyone in the crowd seems to know everyone else and they often greet each other with a kiss. It's a nice place to escape from the hustle and bustle of the big city while still retaining your sense of style.

—Tracey David

MANHATTAN

One-Handed Jobs On the Go
When you need one hand free: pickles, knishes, fist-sized sandwiches, fried rice balls, and Chinese tamales!

Pickles!
Guss's Pickles – since 1920
Head on over to the Lower East Side Tenement Museum on Sunday afternoon for one of Guss's glorious kosher gherkins, and while you're at it, learn all about the history of pickles. Did you know that America consumes over five million pounds of pickles a year? That pickles are mentioned at least twice in the Bible (11:5 and Isaiah 1:8)? That 17th century Dutch dealers sold pickled Brooklyn cucumbers at markets on Fulton, Washington, and Canal Streets in Manhattan? Guss's pickles available 11:30 am Sundays at the Lower East Side Tenement Museum. 97 Orchard St., Manhattan (212) 431-0233, www.tenement.org

Knishes!
Yonah Schimmel Knishery
One look, one sniff, one nosh of a world famous handmade "baked (not fried)" round-shaped extremely filling Yonah knish and you'll know why this great grandmama of knisheries has been around since 1910. Over a dozen varieties of potato or cheese knishes available. Eat the red cabbage (vinegary) as you go, and brown bag one spinach (with scallions) and one sweet potato. Follow with a cup of yogurt, which is made from a ninety-year old strain and rumored to have a calming effect on the stomach.
137 E. Houston St., Manhattan, (212) 477-2858

Fist-sized Sandwiches!
Soup & Smoothie Heaven
Slide over Whitecastle! The fist-sized sandwiches at S & S Heaven are made with sesame seed buns and come in a variety of choices such as tuna, turkey, and ham, dressed with tomato and lettuce, and wrapped in cellophane—for 99 cents a pop, why not have three!
316 Fifth Ave., Manhattan, (212) 279-5444.

Fried Rice Balls!
Rosario's Pizza, established in 1963, is known for an incredible slice, but eating a slice on the go is not as easy as some New Yorkers make it look – so pass on the slice and grab a fried rice ball or two—your outfit will thank you for it.
173 Orchard St., Manhattan, (212) 777-9813.

Chinese Tamales! (Zongzi)
May May Chinese Gourmet and Bakery
In Chinatown, you see them everywhere—*zongzi*—glutinous rice wrapped in green bamboo leaves in the shape of a triangle or—you guessed it, a rectangular Mexican tamale, and bundled with string. Generally, a layer of pork and vegetables is imbedded in the glutinous rice (glutinous rice is considered a luxury in China and is eaten on special occasions.) At May May, in addition to the pork and veg variety, you can find meatless *zongzi* filled with mung bean, mushroom, and marinated seitan or wheat gluten. 35 Pell St., 1000 (212) 267-0733.

MANHATTAN

Annie's

Brunch at this "cozy farmhouse" satisfies the most discriminating of UES palates.
$$$$
1381 Third Ave., New York 10021
(between 78th St. and 79th St.)
Phone (212) 327-4853

CATEGORY	Southern/soul food
HOURS	Sun-Thurs: 8 AM-11 PM
	Fri/Sat: 8 AM-11:30 PM
SUBWAY	Take the 6 to 77th St.
PAYMENT	VISA, MasterCard, American Express
POPULAR DISH	For brunch, try the banana bread French toast or the traditional eggs Benedict. For dinner, locals recommend the five spiced ahi tuna or the chicken pot pie.
UNIQUE DISH	Sweet peach pancakes are just one of the more unusual brunch offerings. The old fashioned country meatloaf may not sound that unusual, but it's not exactly standard fare on the UES.
DRINKS	Full bar, brunch cocktails (mimosas, bloody Mary's)
SEATING	Several bench-style tables in front with a large dining room in the rear; limited bar seating available.
AMBIENCE/CLIENTELE	Warm, elegant yet rustic feel, anointed with touches of fresh greenery, all of which encourages a relaxing atmosphere during brunch. The dining room can sometimes feel a bit cramped during the busiest hours.
EXTRAS/NOTES	The brunch rush can be frustrating, as longer-than-expected waits for seating are common. Likewise, the prep times for food can be uncommonly long (though the attentive staff will keep your coffee topped off while you wait). Don't expect a diner style "eat and run" experience. Neighborhood delivery is a great way to enjoy home-cooked, wholesome food without the hassle.

—Brett Estwanik

Blockheads
(See p. 111)
Mexican
1563 2nd Ave., Manhattan
Phone: (212) 879-1999

"New York is the biggest collection of villages in the world."

—Alistair Cooke

MANHATTAN

Burritoville
(See p. 81)
Mexican
1489 First Ave., Manhattan 10021
Phone: (212) 472-8800

Famous Famiglia
(See p. 147)
Italian/Pizza
1284 First Ave., Manhattan 10021
Phone: (212) 288-1616

Famous Famiglia
(See p. 147)
Italian/Pizza
1398 Madison Ave., Manhattan 10029
Phone: (212) 996-9797

Gauchas
Baked Argentinian style empanadas
$$
1748 1st Ave., Manhattan 10128
(between 90th St. and 91st St.)
Phone (212) 360-6400
www.gauchasnyc.com

CATEGORY	Argentinian
HOURS	Mon-Sun: 11 AM-11 PM
SUBWAY	4,5,6 to 86th Street.
PAYMENT	Cash only
POPULAR DISH	Try an assortment of the delicious empanadas, which are baked, not fried, and start at $2. Pair with the entrana (skirt steak) and you've got a delicious meal that can be easily shared.
UNIQUE DISH	Panqueques con dulce de leche, or de manzana—crepes filled with milk caramel or with apples and vanilla ice cream.
DRINKS	Soda and bottled water
SEATING	You may want to call ahead, as seating is limited.
AMBIENCE/CLIENTELE	It's a jam packed space and the service can be slow, but the food is worth it.
EXTRAS/NOTES	They offer delivery, with a $10 minimum order, and take out.

—*Kashlin Michaels*

Haru Japanese Restaurant
(See p. 128)
Japanese/Sushi
1329 Third Ave., (at 76th St.), Manhattan 10021
Phone:(212) 425-2230

MANHATTAN

Haru Sake Bar
(See p. 128)
Japanese/Sushi
**1327 Third Ave. (at 76th St.),
Manhattan 10021**
Phone: (212) 452-1028

Mustang Grill and Tequila Lounge
Seriously potent frozen margaritas.
$$$$
1633 2nd Ave., Manhattan 10028
(between 84th St. and 85th St.)
Phone (212) 744-9194 • Fax: (212) 744-1444
www.mustanggrill.com

CATEGORY	Lounge
HOURS	Mon-Weds: 2 PM-1 AM Thurs-Fri: 2 PM-3 AM Sat: 10 AM-3 AM Sun: 10 AM-1 AM
SUBWAY	6 train to 86th Street
PAYMENT	VISA MasterCard AMERICAN EXPRESS DISCOVER
POPULAR DISH	Serving brunch, lunch, and dinner, the food is all Tex-Mex, comprised of the usual burritos, fajitas, nachos, and quesadillas, with a few burgers and chicken dishes thrown in for good measure. The food isn't anything to write home about and it can be a little overpriced, but you're here for the tequila anyway.
DRINKS	Try out one of the 100 premium tequilas; in a tasting flight or in a margarita, frozen or on the rocks. Those who like their tequila, but also want to keep their wits, should go for the "cowgirl" frozen version. Unique is the 'Stang-Ria, Mustang's version of Sangria, is available in either white or red.
SEATING	A multi-level lounge with some outdoor seating. Private party rooms also available.
AMBIENCE/CLIENTELE	Vibrantly-decorated Southwestern style bar, complete with cow patterned seats, mounted animal heads, and lassos. Filled with a young and fun crowd, this place gets busy on Thursday, Friday, and Saturday nights.
EXTRAS/NOTES	Happy hour from 4-7 PM on the weekdays is available at the bar *only*, so choose your seats wisely.

—*Ryan Auer*

Pinkberry
(See p. 132)
Yogurt
1577 2nd Ave., Manhattan 10028
Phone: 212-861-0574

MANHATTAN

UPPER WEST SIDE

Abbey Pub
College flashbacks welcomed and encouraged
$$

237 W 105th St, Manhattan 10025
(between Broadway and Amsterdam Ave.)
Phone (212) 222-8713

CATEGORY	Dive Bar
HOURS	Daily: 4 PM-4 AM
SUBWAY	Two blocks away from the 1 stop at 103rd St and Broadway.
PAYMENT	VISA, Mastercard, American Express, Discover
POPULAR DISH	Abbey Pub offers a great food selection. Appetizers are generally the crowd favorites and come in large, pleasantly priced portions. Food is served until 11:30 PM on the weekdays and 1:30 AM on the weekends. Free popcorn and chips at the bar counter during happy hour, which sometimes lasts until 8 or 9, depending on how many of the regulars show up.
DRINKS	Abbey Pub, in the grand tradition of its genre, has an impressively wide and varied selection of beers on tap and by the bottle. Other popular choices include their seasonal spiked cider or some of the more standard well drinks. Don't expect anything too fancy at this low-key dive bar. A fruity cocktail wouldn't necessarily be sneered at, as the crowd is always friendly, but it would comprise the only flash of color in a room teeming with Buds and Heinekens. Highlights include Abbey Pub's selection of Belgian necessities, like Chimay and Duval, served in their proper glasses. In the wintertime, do *not* pass up their seasonal spiked cider. The rum and cider mix provides the armor you need for when you eventually tackle the Hudson River winds on your way home.
SEATING	Most of the regulars plant themselves at the bar seats, which stretch down a good third of the bar. Seating is always available, with booths and tables scattered throughout. Privacy varies, depending on what type of group you're going with, but Abbey Pub is able to satisfy almost everyone's preferences due to its size.
AMBIENCE/CLIENTELE	Like all good college dive bars, Abbey Pub gives you that delicate mixture of seediness and hospitality with just the right touch of charm to lure you back time and time again. The wood paneling and friendly clientele give the place a cozy feeling, making it the perfect venue to get a pint after a long day of work or to spill your sorrows to one of the patient and slightly bemused bartenders, who will likely offer to take a shot with you to dull the pain. Either way, you'll always find yourself leaving Abbey Pub with a smile on your face and an uncontrollable desire to show up there again.

MANHATTAN

EXTRAS/NOTES Bottomless bins of popcorn and chips make this a popular spot to hit up for happy hour, from 4 PM-7 PM every night. A dollar off all beer, wine, and well drinks helps, too.

—Stephanie Hagopian

Awash Ethiopian Restaurant
Refined East African so good you have to remind yourself to breath and chew.
$$$
947 Amsterdam Ave., Manhattan 10025
(at W. 107th St.)
Phone (212) 961-1416

CATEGORY	Ethiopian
HOURS	Mon-Fri: 1 PM-Midnight Sat/Sun: Noon-Midnight
SUBWAY	1,9 to 103rd or 110th St. 2,3 to 96th St.
PAYMENT	VISA MasterCard American Express
POPULAR FOOD	Both veg and non-veg folks swear by the vegetarian combo which includes all vegetable dishes and salad: *key sir alicha* (red beets, carrots, and potato in a sweet sauce), string beans and carrots in spicy garlic sauce, *gomen*—collard greens, onions, garlic, green peppers, *yemsir kik wat*—split red lentils in *berbere* sauce (hot red pepper sauce), *shiro*—ground chick peas, chopped onion, tomato, *yater kik alicha*—split peas, onions, green peppers, herbs; also popular is the Awash Special, which includes Awash *Tibs*—spiced beef, charcoal broiled, *kitfo*—steak tartar, chopped and seasoned with *kibbe* (herbed butter) and *mitmita* (very hot pepper), and choice of three vegetable dishes; *injera* (soured spongy flatbread) serves as food, plate, and utensils.
UNIQUE FOOD	*Gored gored*—raw beef cubes in *berbere* sauce with butter
DRINKS	Full bar stocked with *Tej*—honey wine, domestic, imported, and African beer such as St. George, Morechamp, and Addis, and spiced hot tea, iced tea, coffee, espresso, and cappuccino (hot or iced)
SEATING	60 at tables, three at bar counter
AMBIENCE/CLIENTELE	Ethiopians, locals, and academics happily feast in an open yet cozy and elegant setting that's as perfect for a romantic date as for large groups. Graceful owner Boge commissioned a famous Ethiopian artist to paint all of the oil paintings on the walls, including one of the Four Lost Kings of Ethiopia
EXTRAS/NOTES	Unless a ridiculously big eater is among your party, most entrees and combinations can easily feed two.

—Marie Estrada

MANHATTAN

Are You Ready for a Hot Beef Injection? The frank truth about New Yorkers and their beloved hot dogs...

Everyone wants a piece of hot dog fame. The *dachshund* sausage (German for "little dog") was invented in Frankfurt, Germany in 1484. Both Vienna, Austria and Coburg, Germany have laid counterclaims to the hot dog's antecedents—regarding the *dachshund* as a historical dead end. Whichever dog whelped it, the sausage was first served on a roll in the 1860s, and sold from a German immigrant's cart in Manhattan's Bowery—making it a New York specialty.

The origin of the name "hot dog" is still debated. Some claim that Yale students coined it to describe the sausages sold off of wagons by their dorms. Others say the name first appeared when used by an entrepreneurial vendor during one cold April baseball game at the Polo Grounds in 1901. Sports cartoonist Tad Dorgan supposedly portrayed the catchy name in his next illustration, after which the tasty (and cheap) snack reached instant and permanent fame. However, a copy of the fateful cartoon has yet to be found.

In New York, you usually can't go wrong with a dog from a street cart. It's the perfect filling snack for anyone on the run to her next appointment, or chronically strapped for cash. Stands serving **Sarbrett** and **Hebrew National** dogs usually charge between $1 and $2 (mustard and relish optional) and they're everywhere. But a number of permanent joints (even restaurants) serve both the classic dog and interesting variations of it.

And here's just a few places to go for dogs in Manhattan:

Better Burger (for the health-conscious): *565 Third Ave., Manhattan, 10016, (212) 949-7528. Daily: 11:30 am-9:30 pm.*

Dawgs on Park: *178 E. Seventh St., Manhattan, 10009, (212) 598-0667. Mon-Thurs: 7 am-11 pm, Fri/Sat: 7 am-3 am.*

F&B: *269 W. 23rd St., Manhattan, 10011, (646) 486-4441. Daily: 11am-11pm.*

Gray's Papaya: *2090 Broadway, Fl. 1, Manhattan, 10023, (212) 799-0243. Open 24/7.*
402 W. Eighth St., Manhattan, 10001, (212) 260-3532. Open 24/7.

Katz's Delicatessen: *205 E. Hudson St., Manhattan, 10013, (212) 254-2246. Sun-Thurs: 8 am-10 pm, Fri/Sat: 8 am-3am.*

Old Town: *45 E.18th St., Manhattan, 10003, (212) 529-6732. Daily:11:30 am-midnight.*

Papaya King: *255 W. 43rd St., Manhattan, 10036, (212) 944-4590. Sun-Thurs: 8 am-1 am, Fri/Sat: 8 am-3 am.*
179 E. 86th St., Manhattan, 10028, (212) 396-0648. Sun-Thurs: 8 am-1 am, Fri/Sat: 8 am-3 am.
121 W. 125th St., Manhattan, 10027, (212) 665-5732. Sun-Thurs: 8 am-1 am, Fri/Sat: 8 am-3 am.
(Source: web site of the National Hot Dog & Sausage Council, a project of the American Meat Institute—*www.hot-dog.org*)

—Brad Wood

MANHATTAN

Beard Papa's Sweets Café
(See p. 99)
Bakery
2167 Broadway, Manhattan 10024
Phone: (212) 799-3770

Brother Jimmy's
"Put some south in yo' mouth!"
$$

428 Amsterdam Ave., Manhattan 10024
(between 80th St. and 81st St.)
Phone (212) 501-7505
www.brotherjimmys.com

CATEGORY	Sports bar
HOURS	Daily: 5 PM-4 AM
SUBWAY	1 to 79th St.; 2,3 to 72nd St.; or B,C to 81st St.
PAYMENT	VISA, MasterCard, American Express, Discover
POPULAR DISH	A full menu of southern-style food is available until 1 AM on most nights. The barbecue is especially popular, and for good reason. Pulled pork, fried okra, and chicken fried steak are just a few of the delectable delights available. Portions are big, so come with an appetite!
DRINKS	The bar boasts a wide selection of bourbons, as well as a seemingly endless supply of bottled and draft beer. Come to Brother Jimmy's with a group of people and share one (or many) of their "large concoctions." Made in 16 oz mason jars, these drinks are served with plenty of straws and a floating toy alligator.
SEATING	There is seating at the bar, as well as tables available both by the bar and out back. When it's warm enough, there are tables outside on Amsterdam Avenue.
AMBIENCE/CLIENTELE	Brother Jimmy's provides a taste of the south for the stuffy residents of the Upper West Side. Alumni from southern colleges and universities use Brother Jimmy's as a haven during college football and basketball seasons, while those looking for some southern hospitality come to Brother Jimmy's year round for the food, booze, and country music.
EXTRAS/NOTES	Great food and drink specials occur just about every day of the week. Thursday is ladies night with $1 beers and margaritas; Saturday from 12-4 PM patrons can stuff their faces with 35¢ wings and $8 pitches of beer; and Sunday is all-you-can-eat ribs day. Brother Jimmy's favors southern roots, too, offering a 25% discount off food for those with a valid southern ID.
OTHER ONES	• The Original Brother Jimmy's, 1485 2nd Ave. (between 77th St. and 78th St.), Manhattan 10021, (212) 288-0999 • Brother Jimmy's The Bait Shack, 1644 3rd Ave. (at 92nd St.), Manhattan 10128, (212) 426-2020 • Brother Jimmy's in the Dining Concourse at Grand Central Station, Manhattan 10017, (212) 661-4022

—Alexa Kurzius

MANHATTAN

Burritoville
(See p. 81)
Mexican
166 W.72nd St., Manhattan 10023
Phone: (212) 580-7700

Burritoville
(See p. 81)
Mexican
451 Amsterdam Ave., Manhattan 10024
Phone: (212) 787-8181

Café con Leche
Laidback Latino cuisine.
$$
424 Amsterdam Ave., Manhattan 10024
(between 80th St. and 81st St.)
Phone (212) 595-7000 • Fax: (212) 595-0936
www.cafeconlechenyc.com

CATEGORY	Caribbean
HOURS	Daily: 11 AM-11 PM
SUBWAY	Take the 1 to 79th Street or the B,C to 81st Street.
PAYMENT	VISA MasterCard AMERICAN EXPRESS
POPULAR DISH	Maduros (Sweet Plantains), Cubano sandwich with fries, empanadas.
UNIQUE DISH	At a mere $14 dollars, the paella is a steal.
DRINKS	Amazing sangria, wines, cafe con leche (of course!), and other tasty coffee drinks.
SEATING	Many small two-person tables that can be pulled together to accommodate larger parties
AMBIENCE/CLIENTELE	Cozy, small, and nicely decorated—it all adds up to a great place for a date or an intimate group of friends.
EXTRAS/NOTES	Cheap food and huge portions. They also have a great weekend brunch menu. Prices are reasonable all the time, but try lunch for truly jaw-dropping discounts.
OTHER ONES	• Upper West Side: 726 Amsterdam Ave. (bet. 95th St. & 96th St.), Manhattan 10024, (212) 749-9200

—Kashlin Michaels

Café Lalo
Satisfy your sweet tooth for breakfast or dessert!
$$$
201 W. 83rd St., Manhattan 10024
(between Amsterdam Ave. and Broadway)
Phone (212) 496-6031 • Fax: (212) 874-1578
www.cafelalo.com

CATEGORY	Bakery and Coffee Shop
HOURS	Mon-Thurs: 8 AM-2 AM
	Fri: 8 AM-4 AM

MANHATTAN

	Sat: 9 AM-4 AM
	Sun: 9 AM-2 AM
SUBWAY	1 to 79th Street
PAYMENT	Cash only
POPULAR DISH	Chocolate! Chocolate! Chocolate! Whether mixed with coffee flavors or fruit in a dessert, this is chocolate heaven. Also offers over 100 cakes, pies, and tarts.
UNIQUE DISH	Real whipped cream that tops desserts and excellent Belgian waffles. Brunch served from 8 AM-4 PM on weekdays and 9 AM-4 PM on weekends.
DRINKS	Coffee drinks. Hot chocolate. Cider. Milkshakes. A new bar with top-shelf alcohol, dessert wines, and after dinner drinks.
SEATING	Tiny and crowded with tables. You'll be bumping elbows with your neighbors, but the sugar high might keep you from noticing.
AMBIENCE/CLIENTELE	Regulars claim the tiny size of the place adds to its "cute" factor and makes it a super cozy spot for couples.
EXTRAS/NOTES	This cafe had a cameo in *You've Got Mail*, which might be part of the reason it draws such large crowds. Still, it's the desserts that keep them coming back for more. Delivery available with a $15 minimum order.

—Kashlin Michaels

Columbus Bakery
A lazy day Café.
$$
474 Columbus Ave., Manhattan 10024
(between 82nd St. and 83rd St.)
Phone (212) 724-6880 • Fax: (212) 724-8413

CATEGORY	Bakery and Café
HOURS	Daily: 8 AM-10 PM
SUBWAY	B,C to 81st Street.
PAYMENT	VISA MasterCard American Express Discover
POPULAR DISH	Amazing oatmeal, which means amazing oatmeal cookies, too! The fresh-baked breakfast pastries and bagels are delicious for breakfast, lunch, or a snack.
UNIQUE DISH	Many of the savory dishes here are actually as healthy as they are delicious. With a number of low fat and organic menu options, you won't feel guilty about indulging in a tasty post-meal treat.
DRINKS	Coffee, wine, tea
SEATING	A cute neighborhood cafe with both indoor and outdoor seating
AMBIENCE/CLIENTELE	Lively and busy, but you can still take time to enjoy your meal here. Especially popular with Upper West Side families . . . and their dogs.
EXTRAS/NOTES	This is one cafe that won't kick you out for loitering, so take your time and enjoy your coffee or pastry. Delivery available.

—Kashlin Michaels

MANHATTAN

Docks Oyster Bar and Seafood Grill
(See p. 113)
Seafood
2427 Broadway (at 89th St.),
Manhattan 10024
Phone: (212) 724-5588

El Rey de la Caridad Restaurant
Beans and rice with a twist of bachata, merengue, salsa, boleros, and Marc Anthony
$$
973 Amsterdam Ave., Manhattan 10025
(at W. 108th St.)
Phone (212) 222-7383/2107 • Fax (646) 698-6560

CATEGORY	Dominican
HOURS	Daily: 7 AM-Midnight
SUBWAY	1, 9 to 103rd or 110th St.
PAYMENT	VISA, MasterCard, American Express, Discover
POPULAR FOOD	Yellow rice flecked with onion and green pepper with a bowl of red beans—*arroz y habichuelas rojas; carne guisada* (beef stew), *carne asada* (roasted beef) and *maduros* (sweet plantains fried in butter)
UNIQUE FOOD	Traditional soups include cow feet, hen, pig ears, tripe, soupy squid with rice; octopus salad, octopus stew, octopus in garlic sauce, goat stew, *mofongo* (mashed fried green plantain with pork)
DRINKS	*Café con leche,* beer, soda, juices (orange; carrot; orange and milk; orange, carrot, and milk; oats), lemonade, soda, malts, and shakes (papaya, *mamey,* pineapple, banana, oats and milk, wheat, passion fruit)
SEATING	Plenty of tables for about 20, and seven at the counter
AMBIENCE/CLIENTELE	Casual and homey atmosphere of families, cabbies, neighborhoodies, and the occasional Columbia student.
EXTRAS/NOTES	Communicating your order can be a bit tricky as a majority of the staff speaks only a little English. Another hint: It'll be tough, but try not to stuff yourself silly with the toasted buttered bread that comes before every meal as the portions here are huge—expect to leave with a doggie bag, distended gut, and the satisfied glow that comes with good food at good prices. Lunch special served every day of the week until 4 PM. Free delivery with no minimum.

—*Marie Estrada*

"It is ridiculous to set a detective story in New York City. New York City is itself a detective story."
—*Agatha Christie*

MANHATTAN

Famous Famiglia
Comfortable and tasty New York semi-chain pizza joint.
$

734 Amsterdam Ave., Manhattan 10025
(at W. 96th St.)
Phone (212) 864-7193
www.famousfamiglia.com

CATEGORY	Pizzeria
HOURS	Daily: 9 AM-1 AM
SUBWAY	1, 9, 2, 3 to 96th St.
PAYMENT	American Express, Discover, MasterCard, Visa
POPULAR FOOD	Cheese and Sicilian slices
UNIQUE FOOD	Garlic knots
DRINKS	Sodas and some juices, teas
SEATING	Seats about 30 in six booths where four people can sit, four booths for two
AMBIENCE/CLIENTELE	Casual, neighborhood atmosphere draws families alongside the usual *pizza-nos*.
EXTRAS/NOTES	Even though the city is overrun with hundreds of pizza joints, including more than a few with the word "Famous" as part of their title (including a branch of the Ray's pizza dynasty which are known variously as Ray's Famous, Ray's Original, and Ray's Famous Original), the small Famous Famiglia chain manages to live up to the name by offering some of the best slices and whole pies anywhere. Each location is clean and staffed by friendly red-shirted guys with Italian accents who routinely call customers "Boss" or "Chief" and have been reputed to knock a nickel or dime off the price, rounding down to the nearest dollar. Customers dine in on pasta just as often as they get a slice to go on a paper plate (eating half of it before they're out the door). In the summer they have an Italian ice cart outside, and throughout the week men and women stop in late at night for a snack on their way home from dates or a night out. Always bustling, Famous Famiglia is a neighborhood—and New York—institution. Other Famous Famiglias at Newark Airport, Terminals A and C, and, mysteriously, in Ann Arbor, MI.
OTHER LOCATIONS	Sixth Avenue to the Hudson: 61 Chelsea Piers, 10011, (212) 803-5552 • Sixth Avenue to the Hudson: 686 Eighth Ave., 10036, (212) 382-3030 • Flatiron/Union Square/Gramercy: 1630 Broadway, 10019, (212) 489-7584 • Upper East Side: 1284 First Ave., 10021, (212) 288-1616 • Upper East Side: 1398 Madison Ave., 10029, (212) 996-9797 • Upper West Side: 734 Amsterdam Ave., 10025, (212) 749-1111 • Upper West Side: 2859 Broadway, 10025, (212) 865-1234 • Harlem: 4007 Broadway, 10032, (212) 927-3333

—Jeff Gomez

MANHATTAN

The Flame Restaurant
The Flame burns bright for late nights.
$$$
893 9th Ave., Manhattan 10019
(between 9th Ave. and 58th St.)
Phone (212) 765-7962

CATEGORY	Coffee Shop
HOURS	Daily: Noon-Midnight
PARKING	A,C,B,D,1 at 59th St./Columbus Circle
PAYMENT	VISA, MasterCard, American Express, Discover
POPULAR DISH	The "New Yorker" omelet with lox and onion is a nice, healthy tribute to the city, but the "Belgium Waffle Sundae," Belgium waffles topped with your favorite ice cream topping, nuts, and whipped cream, is the best cure for a stubborn sweet tooth.
UNIQUE DISH	The typical chicken and fish platters are available, but the calorie-conscious can take advantage of the Weight Watchers menu.
DRINKS	Coffee, tea, soda
SEATING	Many booths of various sizes
AMBIENCE/CLIENTELE	The service is fast and friendly. The booths are wide and the lights are bright—great for a late night visit.

—*Emily Isovitsch*

Good Enough To Eat
Comfort food that's, well, you know
$$
483 Amsterdam Ave., Manhattan 10024
(at 83rd St.)
Phone (212) 496-0163 • Fax: (212) 496-7340
www.goodenoughtoeat.com

CATEGORY	Bakery
HOURS	Mon-Thurs: 8 AM-10:30 PM Fri: 8 AM-11 AM Sat: 9 AM-11 PM Sun: 9 AM-10 PM
SUBWAY	Take the 1 to 86th Street.
PAYMENT	VISA, MasterCard, American Express
POPULAR DISH	For breakfast, lunch, and dinner, an array of dishes that will leave you feeling warm, fuzzy, and likely very tired. Fluffy omelets, bacon, grits, mac and cheese, and meatloaf with mashed potatoes are all favorites. Portions are large, so you won't leave hungry.
UNIQUE DISH	Pumpkin French toast and chocolate-chip coconut pancakes. A few vegetarian and organic choices on the menu.
DRINKS	A wonderfully diverse, decidedly international beer list. Wine also available.
SEATING	Indoor and outdoor seating. They also cater, but if you don't have room for them, they can make room for you—the whole restaurant is available to be rented out on Christmas Eve and New Year's Eve. They also take reservations for Mother's Day, Thanksgiving and Valentine's Day.

MANHATTAN

AMBIENCE/CLIENTELE Comfort food in a kitschy country atmosphere: think red barn, white picket fence, and a cow motif—sort of like a high-rent Cracker Barrel. Service is excellent and the place is regularly filled with families and well-to-do UWS types.
—*Taylor Marqs*

Haru Japanese Restaurant
(See p. 128)
Sushi/Japanese
433 Amsterdam Ave., Manhattan 10024
Phone: (212) 579-5655

Hummus Place
(See p. 46)
Middle Eastern
305 Amsterdam Ave., Manhattan 10023
Phone: (212) 529-9198

Hungarian Pastry Shop
"Divine" European pastries.
$$
1030 Amsterdam Ave., Manhattan 10025
(at 111th St.)
Phone (212) 866-4230

CATEGORY Coffee Shop
HOURS Mon-Fri: 8 AM-11:30 PM
Sat: 8:30 AM-11:30 PM
Sun: 8:30 AM-10:30 PM
SUBWAY Take the 1 to 110th Street.
PAYMENT Cash only
POPULAR DISH Croissants served with apricot jam, Dobos, Linzer tarts.
UNIQUE DISH Authentic Hungarian sour cherry strudel, Sacher Torte
DRINKS Free refills on coffee! Hot chocolate and tea also served.
SEATING The laidback atmosphere means people linger with their beloved laptops, so seating is sometimes difficult to come by.
AMBIENCE/CLIENTELE Offering a cozy atmosphere conducive to reading or studying, this place is a frequent haunt of Columbia students. And, of course, the free refills on coffee certainly don't hurt those long study sessions.
EXTRAS/NOTES A great spot for those visiting the nearby Cathedral of St. John the Divine.
—*Taylor Marqs*

MANHATTAN

Jerusalem Restaurant
Middle Eastern good enough to gladden the heart of the most unabashed pitaphile.
$$
2715 Broadway, Manhattan 10025
(between W. 103rd and W. 104th Sts.)
Phone (212) 865-2295

CATEGORY	Syrian/Middle Eastern
HOURS	Mon-Sat: 10 AM-4 AM Sun: 10 AM-Midnight
SUBWAY	1, 9 to 103rd St., 2, 3 to 96th St.
PAYMENT	Cash only
POPULAR FOOD	Falafel combination sandwiches, lamb *shawarma* gyro—with choice of lettuce, tomato, onion, *tahina*, pickled radishes, and lemon juice in an oven-warmed pita
UNIQUE FOOD	Everything is exceptional here, so design your own sandwich or platter using any one or all of the following: falafel, hummus, *baba ganoush*, feta, *tabouli* spinach, grape leaves, fava beans, *shawarma*, shish kebab, chicken, grilled onions, olives, hot peppers, pickled radishes; Platters also come with pita; on the counter is red sauce in a metal bowl called *shtta* in Arabic and *harif* in Hebrew—take it easy with this stuff or you'll be hurtin' in the mornin.'
DRINKS	Turkish coffee, Jerusalem Tea, and fully stocked icebox filled with Snapple, soda, and bottled water
SEATING	Tables for five inside, five at the counter; storefront seating, low table with four chairs surrounded by potted plants
AMBIENCE/CLIENTELE	Feels like you've stepped into your uncle's kitchen right in the middle of him telling a story about the good old days in Syria—small, and everyone knows and everyone loves the charming manager, Ali.
EXTRAS	Seat yourself at the counter, and as you decide on what to order, Ali (sometimes accompanied by his lovely wife Fatma) will surely hand you a piece of fresh pita with oh-so-smooth hummus or *baba ganoush*—to titillate your taste buds. While you wait, order a Turkish coffee and you'll see it done the right way—in an old steel canister on the stove.

—Marie Estrada

Max Caffé
Fine wine and smart talk with the Columbia crowd.
$$$
1262 Amsterdam Ave., Manhattan 10027
(between 122nd and 123rd)
Phone (212) 531-1210
www.maxsoha.com/caffe_home.html

CATEGORY	Coffeehouse
HOURS	Daily: 8:30 AM-12:30 AM
SUBWAY	Take the 1 to 116th St. or 125th St., or the A,C,B,D to 125th St.

MANHATTAN

PAYMENT	VISA, MasterCard, American Express, Discover
POPULAR DISH	The small, Italian-American menu specializes in appetizers, salads, and paninis.
DRINKS	Max's boasts a nice selection of coffees and teas, as well as a delightfully diverse wine list. Beer is also available.
SEATING	There is ample seating. Patrons have the option of sitting at tables and chairs or in one of the well-worn Victorian-style couches.
AMBIENCE/CLIENTELE	The dark, eclectic decor attracts a diverse crowd of Columbia University students, as well as area residents. Study groups share coffee and conversation for hours, while other patrons enjoy leisurely dinner and drinks.
EXTRAS/NOTES	Intellect permeates the cozy atmosphere. Absorb the conversations around you, or strike up your own philosophical arguments with your friends. Reminiscent of a European cafe, Max Caffé is a great place to come relax and while away the day with a book.
OTHER ONES	• Max Soha, 1262 Amsterdam Ave. (at 123rd St.), Manhattan 10027, (212) 531-2221

—*Alexa Kurzius*

THE HARLEMS

Dinosaur
Massive tastes at this legendary BBQ joint.
$$$
646 W 131st St., Harlem 10027
(between Broadway and Riverside Dr.)
Phone: (212) 694-1777
www.dinosaurbarbque.com

CATEGORY	Southern/BBQ/Comfort Food
HOURS	Tues-Thurs: 11:30 AM-11 PM Fri/Sat: 11:30 AM-Midnight Sun: Noon-10 PM
SUBWAY	Take the 1 to the intersection of Broadway and 125th St.
PAYMENT	VISA, MasterCard, American Express, Discover
POPULAR DISH	Under the Riverside Drive Bridge you will taste some of the most savory, down-home flavors your tongue will encounter once, and then ever after, again and again. You won't be able to stay away from these smoky meats and rich sides. Dinosaur is a self-proclaimed "Honky Tonk Rib Joint", and you mustn't miss out on the succulent pork ribs, slathered in their trademark sauce. If ribs aren't your thing, you can still feast on barbequed chicken, pulled pork, steaks, and catfish, loaded up in combo platters. And to complement these succulent meats, they've got your mac & cheese, salt potatoes, BBQ beans, Creole potato salad, gingered applesauce, and coleslaw. And if you're a real party-pooper… yes they have salads too.

MANHATTAN

UNIQUE DISH	Korean Beef Ribs... what the heck? Despite the Southern focus of the menu, this one is in there!
DRINKS	Sodas, coffees, and all. But barbeque this good calls for some iced tea or lemonade, if you're doin' it right.
SEATING	There is plenty of seating in several different rooms that are large, albeit crowded. That's okay; the more the merrier.
AMBIENCE/CLIENTELE	It's dim and comfy inside, with tables crowded in a lively space where people chat, laugh, sing and stomp. On the nights when the live music is playin' and the patrons are a-drinkin' at the bar and at their tables, you can barely hear your own voice.
EXTRAS/NOTES	Check the website for the events calendar to see when Dinosaur will be filling up with jazz and blues notes next. Dinosaur also sells boxes and bottles of their famous rubs and sauces, so the meat-luvin' fun need not stop when you leave.
OTHER ONES	• Dinosaur's other locations are in Syracuse and Rochester. Check the website for addresses.

—*Dynasty Blackburn*

Famous Famiglia
(See p. 147)
Italian/Pizza
4007 Broadway, Manhattan 10032
Phone: (212) 927-3333

Manna's Soul Food Restaurant
(See p. 184)
American Soul Food
51 E. 125th St., Manhattan 10035
Phone: (212) 360-4975

Manna's Soul Food Restaurant
(See p. 184)
American Soul Food
486 Lenox Ave., Manhattan 10037
Phone: (212) 234-4488

Massawa Restaurant
A slice of East Africa in Morningside Heights.
$$
1239 Amsterdam Ave., Manhattan 10027
(corner of W. 121st St.)
Phone (212) 663-0505/0545 • Fax (212) 663-1800

CATEGORY	Eritrean and Ethiopian
HOURS	Daily: 11:30 AM-Midnight
SUBWAY	1, 9 to 116th St.

PAYMENT	VISA, MasterCard, American Express, Discover
POPULAR FOOD	*Timtimo* (red lentils, yellow split peas, chopped red onions, and garlic cooked in berbere sauce), special *tebsie* (cubes of tenderloin tips sautéed with green peppers, onions, tomatoes, and a hot spice)
UNIQUE FOOD	*Fitfit* (spicy and addictive salad of fresh green hot peppers tossed with chopped *injera*, tomato, onion, and olive oil)
DRINKS	Have the hot spiced tea with cardamom, cinnamon, cloves, and other spices; coffee, espresso, cappuccino, iced tea, Perrier, variety of juices and soda, domestic and foreign beer
SEATING	Tables for 20
AMBIENCE/CLIENTELE	Refined décor, with tables set near enough to achieve intimacy—far enough apart so that the convivial hum of voices never disturbs conversation
EXTRAS/NOTES	Super deal during-the-week Luncheon Buffet until 2 pm and Massawa Lunch Specials until 4 pm. During dinner hours, expect to pay more and there's lag time between food ordering and food arriving—but the glorious food is well worth the wait.

—Marie Estrada

A Yank's Guide to New York BBQ

Before going any further, I should mention that I've only had real barbecue (i.e. south of the Mason-Dixon Line) once in my life, twice if you count the Salt Lick stand at Austin-Bergstrom International Airport. Yet I've had the fortune to come of age (well, drinking age, at least) in what is quite possibly the finest moment for barbecue in New York City. Ten years ago, BBQ in New York meant overcooked ribs doused in sweet, mass-produced barbecue sauce. No more.

The renaissance in New York BBQ can probably be traced to the opening of **Blue Smoke**, in 2002. Danny Meyer, a restaurateur who has shaped New York dining over the past twenty years as much as anyone, opened Blue Smoke to celebrate the diverse barbecue tradition: the menu features St. Louis Spare Ribs, Memphis Baby-Back Ribs, Texas Salt & Pepper Beef Ribs, and Kansas City Ribs. Try all four in a ribs sampler that will set you back $25, but that can easily be shared by two. For sides, the Mac 'n Cheese is a standout and the hush puppies are solid, as well. For those on a particularly tight budget, the regular 9oz burger—Blue Smoke is in the same restaurant "family" as the Shake Shack—can be split into two 4 ½oz burgers at no extra charge. As befits a restaurant of Blue Smoke's pedigree, the décor here is more interesting than your typical barbecue joint. The dining room has a large skylight, red booths, and vaguely rustic looking decorations. The restaurant is also connected to the Jazz Standard, a fancy, but relatively unstuffy jazz club downstairs. Though covers range from $15-$30, you can enjoy 'cue with the show at the same price as upstairs.

Daisy May's BBQ USA, which opened in a forgotten corner of Manhattan a year after Blue Smoke, offers far less sophisticated digs—they've recently expanded from a park bench out front to cafeteria seating inside—but the barbecue is equally serious. The Memphis Dry Rub Pork Ribs are a revelation. Easily the best of their

MANHATTAN

kind in Manhattan, the meat is so moist and flavorful, one would be foolish to sully it with barbecue sauce. If you're craving wet, the Kansas City Sweet and Sticky Pork Ribs are quite tasty, if less extraordinary. The sides at Daisy May's are, in a word, decadent. Sweet Potatoes with Brown Sugar are rich and creamy—more pudding than potato. The Rustic Creamed Corn with New York State Cheddar and Creamy Coleslaw—both tasty—live up to their shared descriptive adjective. You'll want to be sharing these sides.

In early 2005, Paul Kirk, self-described "Kansas City Baron of BBQ," opened **RUB**—which stands for Righteous Urban Barbecue, easily one of the dumbest acronyms ever thought up. If the ribs here aren't quite as succulent as the offerings at Blue Smoke or Daisy May's, all will be forgiven with your first bite of RUB's signature "burnt ends," deliciously juicy brisket bits cooked twice and perfectly seasoned. Of the sides, greasy, deep fried onion straws are insanely addictive and the best of the bunch. If your arteries will tolerate further abuse, the deep fried Oreos deliver a perfect balance of sweet and savory for dessert.

Harlem's **Dinosaur Bar-B-Que** has less distinguished roots than some of its Manhattan brethren—it is the third of three barbecue restaurants with origins in Syracuse, New York—but the ribs are legit. The Sweetheart Deal for Two—a full rack of ribs and four (!) sides for $26.95—might be the biggest bargain in New York 'cue. None of the sides rise to the level of Daisy May's, but the Salt Potatoes, slaw, and beans all do the trick. It's a hike to get to—you have to take the very local 1 train to 125th St. and walk a few blocks north and west of the exit—but they offer pitchers of beer and live music on Fridays and Saturdays, so you might want to stay for a while.

One hopes that Ft. Greene's **The Smoke Joint**, which replaced the perennially beloved Cambodian Cuisine this past year, will also be staying for a while. The flank steak, beef ribs, and pork spare ribs are all delicious and, at $7, Hacked and Stacked beef, pork or chicken sandwiches are a steal. Their Mac 'n Cheese, with a slightly spicy kick, is definitely among the best in all of New York. Collard greens and "jointrub" seasoned fries and corn on the cob don't disappoint, either. The service is particularly friendly and, as befits the borough, the place feels more like a collaboration between friends—it is, actually—than the product of market research and focus groups.

If The Smoke Joint is unabashedly "Brooklyn," two of the latest additions to the barbecue scene owe their inspiration to Texas. Manhattan's **Hill Country** draws the connection more clearly. Pictures of workers at Texas's famed Kreuz market adorn the walls and Kreuz's sausages are on the menu. As at its Lockhart, Texas forbearer, meat is ordered by the pound at Hill Country, in this case from young men in eighties-style Houston Astros caps at a counter in the back. Delicious, melt-in-your mouth Beef Brisket, served moist (preferable) or lean, is definitely the way to go, though the pork ribs aren't bad either. Sides and dessert, though plentiful in number, don't particularly distinguish themselves and the décor, well, think chain restaurant, with pictures of Texas in place of sports jerseys on the wall.

Brooklyn's **Fette Sau**, another new, by-the-pound barbecue joint, is, by comparison, all about atmosphere. A neon-lit sign in front opens to a narrow, former auto-body shop driveway that has now been filled with long picnic tables. The scene inside is

best described as "industrial chic," with bright overhead lights, a cement floor, converted tractor seats for bar stools, and butchers diagrams of beef, lamb, and pork on the wall. Beef shoulder and brisket or pork ribs do the trick and the bar is well stocked with a wide-variety of bourbons and local beers, the latter served in re-purposed glass jars of varying sizes. Fette Sau doesn't serve New York's best barbecue—let's not even talk about the sides—but it makes up in appearance, both in décor and clientele, what it lacks in substance. It is in Williamsburg, after all.

Where to Find Them:

Blue Smoke: 116 E. 27th St. nr. Park Ave. South, Manhattan 10016, (212) 447-7733, http://bluesmoke.com
Hours: Mon-Weds 11:30 AM-11 PM, Thu/Fri 11:30 AM-1 AM, Sat Noon-1 AM, Sun Noon-11 PM

Daisy May's BBQ USA: 623 11th Ave. (at 46th St.), Manhattan 10036, (212) 971-1500, http://daisymaysbbq.com
Hours: Mon 11 AM-9 PM, Tues-Fri 11 AM-10 PM, Sat Noon-10 PM, Sun Noon-9 PM

RUB: 208 W. 23rd St. (near 7th Ave.), Manhattan 10011, (212) 524-4300, http://rubbbq.net
Hours: Mon-Sat Noon-11 PM, Sun Noon-10 PM

Dinosaur Bar-B-Que: 646 W. 131st St. (at 12th Ave.), Manhattan 10027, (212) 694-1777, www.dinosaurbarbque.com/nycIndex.php
Hours: Mon Closed, Tue-Thurs 11:30 AM-11 PM, Fri/Sat 11:30 AM-Midnight,
Sun Noon-10 PM

The Smoke Joint: 87 S. Elliot Pl. (near Lafayette St.), Brooklyn 11217, (718) 797-1011, www.thesmokejoint.com
Hours: Sun-Thurs 11 AM-10 PM, Fri/Sat 11 AM-11 PM

Hill Country: 30 W. 26th St. (near Broadway), Manhattan 10010, (212) 255-4544, www.hillcountryny.com
Hours: Sun-Thurs 11:30 AM-11 PM, Fri/Sat 11:30 AM-Midnight

Fette Sau: 354 Metropolitan Ave. (near Havermeyer St.), Brooklyn 11211, (718) 963-3404
Hours: Sun-Thurs 5 PM-2 AM, Fri/Sat 5 PM-4 AM

—*Ben Wieder*

Sisters Caribbean Cuisine
Utterly divine eclectic Caribbean and Southern, prepared with a sophistication seldom seen at prices this reasonable.
$$
1931 Madison Ave., Manhattan 10035
(enter at E. 124th St.)
Phone (212) 410-3000

CATEGORY	Caribbean/Trinidadian/Guyanese/Southern
HOURS	Daily: 9 AM-9 PM
SUBWAY	4, 5, 6 to 125th St.

MANHATTAN

PAYMENT	VISA, MasterCard, American Express, Discover
POPULAR FOOD	Choice of 12 main dishes; the most favorite for lunch or dinner are the stewed chicken from Trinidad (savory and robust but not spicy) and the delightful and smoky jerk chicken—served with rice and vegetables; and there is a truly enlightened vegetable plate that doesn't make vegetarians feel like second class citizens. Sneak in the pineapple tart (it's home made).
UNIQUE FOOD	Guyanese/Trinidadian *callaloo* prepared with okra, crushed garlic, and, alas, secret spices
DRINKS	Canned and bottled soda, health drinks, *sorrel*, homemade lemonade, coffee, tea, and hot chocolate
SEATING	Seats 12 at tables
AMBIENCE/CLIENTELE	Intimate, friendly, and relaxed—tastefully framed family photos, and fresh flowers everyday at the counter; Sisters makes the urban asphalt and grime seem very, very far away
EXTRAS/NOTES	There's something reminiscent of a country home about Sisters, established in 1995 by two sisters from Guyana. During the morning hours of the workweek, service is thankfully swift and you can be in and out with your sautéed codfish or eggs with grits and bacon in no time. But the food—breakfast, lunch, or dinner—is truly worth lingering over.

—Marie Estrada

Slice of Harlem
(See p. 156)
Pizza Joint
2527 Eighth Ave., Manhattan, 10030
Phone: (212) 862-4089

Slice of Harlem II
Deep dish pizza slice or pie that'll make you wanna puta your fingers to your lips and kissa the world!
$$
308 Lenox Ave., Manhattan 10027
(between W. 125th and W. 126th Sts.)
Phone (212) 426-7400

CATEGORY	Pizzeria
HOURS	Mon-Thurs: 6:30 AM-10 PM Fri: 6:30 AM-Midnight Sat: 6:30 AM-Midnight Sun: Noon-10 PM
SUBWAY	A, B, C, D to 135th St.
PAYMENT	VISA, MasterCard, American Express
POPULAR FOOD	Full-meal deep dish pepperoni slice, the lasagna pie made with ground beef and ricotta cheese, the Hawaii pie made with Canadian bacon, pineapple, scallions, and Gruyère cheese, and the Sweet Garden no sauce pie made with grilled

MANHATTAN

	asparagus, zucchini, broccoli rabe, peas, Fontina cheese
UNIQUE FOOD	Harlem Bayou covered with generous amounts of shrimp, clams, and mussels
DRINKS	Bottled water, Stewart's soda, Nantucket Nectars, Snapple, 2-liter soda, coffee, tea, hot chocolate
SEATING	Two levels of seating: big groups, package-toting shoppers, baby carriages—this large, bright, and friendly place can surely accommodate
AMBIENCE/CLIENTELE	Much respect to the fine slice and pies put out by the Original Slice of Harlem, but this baby sister to the Lenox Ave. location most definitely gives big sis some competition as "Harlem's finest brick oven pizzeria."
OTHER ONES	• Harlem: 2527 Eighth Ave., Manhattan, 10030, (212) 862-4089

—*Marie Estrada*

Tremes Jamaican Restaurant and Bakery

Neighborhood Jamaican joint you wish were in your neighborhood.

$$

2086 Seventh Ave. (aka Adam Clayton Blvd.), Manhattan 10027
(between W. 124th and W. 125th Sts.)
Phone (212) 678-9881

CATEGORY	Jamaican
HOURS	Mon-Thurs: 7 AM-10 PM Fri/Sat: 7 AM-Midnight Sun: 8 AM-9 PM
SUBWAY	2, 3 to 125th St.
PAYMENT	Cash only
POPULAR FOOD	A wide selection of standard Jamaican fare, including patties, *roti*, fried dumplings, sweet fruit cakes and spice buns; be sure to check out the daily lunch specials, which consist of GENEROUS portions of curry chicken/goat, barbecue chicken (Tuesday), barbecue ribs (Thursday), oxtail, and jerk chicken—lunch specials are served with combinations of rice and beans, plantains, cabbage, collard greens, yams, and macaroni and cheese
UNIQUE FOOD	Authentic Jamaican favorites like saltfish and *ackee*, codfish, and *escovietch*
DRINKS	Wide assortment of Jamaican Roots Drink, locally made juices, sea moss, ginger beer, coffee, tea, and soda
SEATING	Tables inside for 15 and a cozy counter for two
AMBIENCE/CLIENTELE	Filled with neighborhood folk—good place to eat (or study) alone
EXTRAS/NOTES	The food at Tremes is no secret in Harlem. If you want the barbecue chicken or ribs experience of a lifetime, better show up before noon on Tuesday/Thursday, respectively and get in line.

—*Scott Gross*

THE BRONX

THE BRONX

Banao

Filipino all-you-can eat buffet in a Bronx mini mall? Gloria, Cori—perhaps even Imelda—would surely approve.
$$

5677 Riverdale Ave, The Bronx 10471
(between W. 258th and W. 259th Sts.)
Phone (718) 601-9900/9660

CATEGORY	Filipino Buffet
HOURS	Tues-Thurs: 11 AM-9 PM Fri/Sat: 11 AM-10 PM Sun: 9 AM-9 PM
SUBWAY	1 to 231st and Broadway, then B7 bus to W. 258th St.
PAYMENT	VISA, MasterCard, American Express, Discover
POPULAR FOOD	Among the 15 different entrees available, the most popular are the Filipino national dish, *adobong manok at baboy* (pork and chicken stewed in soy sauce, vinegar, garlic, peppercorn and bay leaf), pork barbecue (grilled marinated pork on skewers), *tilapia* in sesame (flash-fried *tilapia*, sesame seeds, tamarind sauce), and *sinigang* (tamarind soup with beef, fish, or pork)
UNIQUE FOOD	*Paksiw na bangus* (milkfish cooked in vinegar and spices), *binagoongan baboy* (pork cutlets stewed in shrimp paste and vinegar), *adobong pusit* (squid stewed in vinegar and spices), *dinuguan* (pork pieces and green papaya in beef and pork blood, *laing* (taro leaf with shrimp paste and pork in coconut milk), *turon* (plantain and jack fruit in spring roll wrapper), cassava cake (ground cassava in sweet coconut milk)
DRINKS	*Calamanci* (Filipino style lemonade—*calamansi* is difficult to find in the states, so *calamansi* juice from concentrate is used for this beverage), mango juice, cantaloupe juice, guava juice, soda, coffee, tea, and hot chocolate
SEATING	Twenty-five at tables
AMBIENCE/CLIENTELE	An all-you-can-eat breakfast, lunch and dinner buffet in a cozy dining area with wooden artifacts and textiles native to the Philippines
EXTRAS/NOTES	Banao's buffet also includes a number of dishes that will satisfy the pickiest of picky vegetarians: vegetarian curry (wheat gluten, carrots, potato and peppers in a curry coconut sauce); *pinakbet* (eggplant, squash, okra, string beans sautéed in garlic, onion, and tomatoes); *ensaladang ampalaya* (bitter melon with tomato and onion in vinegar dressing); *ensaladang talong* (broiled eggplant, tomatoes, onion, in sweet and sour dressing); eggplant omelette; *lumpiang sariwa* (mixed vegetables wrapped in crepe with sweet sauce); sautéed string beans; and Bicol Express (green chillies and coconut milk). Gracious owners Victoria and Marc Greenberg named the restaurant after a town in Iriga City, Philippines, the hometown of Victoria's father. Located in the Skyview Shopping Center. Karaoke on Tuesday nights after 8 pm.

—Marie Estrada

THE BRONX

Edy's
Eclectic home away from home.
$$
5901 Riverdale Ave., The
Bronx 10471
(corner of W. 258th St.)
Phone (718) 549-8938

CATEGORY	Ice Cream Parlor / Soup Shop
SUBWAY	1 to 231st and Broadway, then B7 bus to 258th
HOURS	Daily: 10 AM-2 AM
PAYMENT	Cash only
POPULAR FOOD	Potato leek soup, seafood gumbo with a generous amount of shrimp and lobster; soups change daily and with the whim of the owner, but there's always one vegetarian option available; soups come with fresh bread
UNIQUE FOOD	Custom theme and character ice cream cakes
DRINKS	Espresso, cappuccino, milkshakes
SEATING	Tables for 12
AMBIENCE/CLIENTELE	Ultra pretty—long, open and narrow, brightly lit, with potted plants and fresh flowers mingling with stuffed animals, ballerina figurines, children's artwork, tin tables and yellow vinyl seats
EXTRAS/NOTES	You'll feel completely at ease chatting with the owner, a songwriter of Dutch origin, who started Edy's with his wife (she's the artist behind the gorgeous ice cream cakes). But, if you're on the move, Edy's has the perfect indulgences to carry out: gourmet soup, freshly cut flowers, Italian cappuccino, and decadent ice cream dessert—yum.

—Marie Estrada

Belmont's Little Italy of The Bronx
Drive, ride, strap-hang, and hoof-it out to this beautifully preserved relic of what the borough once was...

Anyone familiar with the history of New York's outlying neighborhoods—in the outer boroughs and in Upper Manhattan—knows the story. Prosperous working class suburbs witnessed a decades-long decline during the Post-War Years as insensitively placed highways and interstates paved over bustling commercial districts. And no other borough suffered more than The Bronx, where the Model City of mid-century decayed into the expansive slums of the 1970s, where the Grand Concourse's diminished challenge to the Champs-Elysées challenged only the good taste of those who joked about it, and where the name Robert Moses is still greeted with dread. But certain Bronx enclaves held the line against decline. And of these unlikely success stories, none is more fondly noted than that of Belmont, where a collection of Italian (and now also Albanian) businesses on and around Arthur Avenue are still known collectively as Little Italy of The Bronx.

Here, trench-coated men and a scattering of limousines—some credit these, or what they imagine these represent, with the neighborhood's survival—patrol freely along the storefronts. And

THE BRONX

the pizzerias, cafes, rated restaurants, and an extraordinary array of specialty shops draw customers from across the five boroughs. Nowhere near as commercial or touristy as its Manhattan counterpart, Little Italy of The Bronx hides hundreds of gourmet bargains for those willing to drive, ride, strap-hang, and hoof-it out to this beautifully preserved relic of what the borough once was.

A hunk of cheese all by itself can make a good and inexpensive meal. **Casa Della Mozzarella** *(604 E. 187th St., (718) 364-3867. Mon-Sat: 7:30 am-6 pm, Sun 7:30 am-1 pm.)* boasts a full deli case, 110 lb. hunks of provolone hanging from the ceiling, and a window through which you can watch the cheese-makers themselves ladling gooey mozzarella from their enormous pots. In addition to the cheese (including a mozzarella and provolone roll), choose from meats, olives, and assorted antipastos.

But you need not stop at cheese. A few more feet, in fact, and you'll have a whole sandwich. **Calabria Pork Store** *(2338 Arthur Ave., (718) 367-5145. Mon-Sat: 7 am-5:30 pm.)* begs a visit from the staunchest vegetarian. Enter and you're greeted by the enticing pungency of a thousand salamis. Hanging from the ceiling and in various states of aging (don't be put off by the occasional spot of mold, that's part of the game), these amazing salamis represent what may be one of the objectively coolest culinary offerings in New York. They're joined in the case by various fresh pork sausages, and elsewhere by big wheels of fresh cheese. Then grab a loaf of bread—*pane de casa* is the most popular kind—at nearby **G. Addeo & Sons Bakery** *(2352 Arthur Ave., (718) 367-8316)* And if you're ready for dessert, grab some biscotti.

If not, try the clams at **Randazzo's Seafood** *(2337 Arthur Ave., (718) 367-4139)*. A full-service seafood store, Randazzo's operates a clam cart out front from which the willing may purchase and consume ice-cold, freshly killed raw clams at six for $4. They'll pull the shells apart; you add lemon and sauce and eat. If that doesn't come naturally to you, go inside and choose some fresh fish to take home and cook. And if you plan to cook anyway, celebrated **Biancardi's** butcher shop, across the street, bears checking out *(2350 Arthur Ave., (718) 733-4058. Mon-Sat: 8 am-6 pm.)*. It's hard to miss, anyway: their specialties—baby lambs, kid goats, rabbits—hang fully-furred by their hind legs in the front window. But it's a full service butcher and you can obtain tamer fare as well from the helpful staff.

For dessert, try a cannoli with a cup of espresso at **De Lillo Pastry Shop** *(606 E. 187th St., (718) 367-8191. Daily: 8 am-7 pm)*. In business since 1925, De Lillo offers several cases full of eye-catching confections, along with a small eating area.

It's not easy to get to Little Italy of the Bronx. The closest train stop is Fordham Station, which serves Metro-North's Harlem Line. If you want to take a subway, your best bet is the D to Fordham Road: walk east on E. 188th St until you hit Arthur Ave. Then turn right. It's a pretty long walk, and it takes you through some neighborhoods that may frighten you. If you're driving, there's probably a highway nearby.

—Mayu Kanno and Joe Cleemann

THE BRONX

Little Bit of Jam
Tasty Jamaican alongside a fine and famous slice.
$$
Phone (718) 549-8893
3033 Tibbett Ave., The Bronx 10471
(at W. 231st)

CATEGORY	Jamaican Pizzeria
HOURS	Mon-Sat: 6 AM-Midnight Sun: Noon-Midnight
SUBWAY	1 to 231st St.
PAYMENT	Cash only
POPULAR FOOD	Go entirely Jamaican and have the treat of your life; the popular dishes are the oxtail, stewed chicken and goat, and Tuesday's curried shrimp—all come with rice, peas, and choice of carrot, cabbage, or plantains; wash it all down with a slice of Jamaican rum cake and a shot of Irish Moss.
UNIQUE FOOD	Have the Ital Stew and a side of yellow rice and peas or make your own vegetable platter from the twelve vegetable, bean, and starch options including Middle Eastern-style okra, macaroni and cheese, spinach and garlic, dumplings, and yams.
DRINKS	Various seasonal juices such as cane, fruit punch, vegetable, and a variety of smoothies; Caribbean drinks include Irish Moss, carrot and Bbet, Agony, Double Trouble, and Root
SEATING	Seats eight at two-person tables.
AMBIENCE/CLIENTELE	Bright and welcoming railroad style space with an impressive mural painted by the artist known as Regal, "stone-cold" speaker system, and 35-inch TV; friendly staff and customers
EXTRAS/NOTES	If you're not in the mood for Jamaican fare, try the utterly simple but divine slice of pizza made with fresh dough and fresh stewed tomatoes—prepared by none other than acclaimed King and Creator of the first Shamrock-shaped Pizza.

—Marie Estrada

Sam's Soul Food Restaurant & Bar
The only reason to ever visit this part of The Hub.
$$
596-598 Grand Concourse, The Bronx 10471
(between 150th and 151st St.)
Phone (718) 665-5341 • Fax (718) 665-1409

CATEGORY	American Soul Food
SUBWAY	2, 3 to 149th Grand Concourse
HOURS	Mon-Weds: 11 AM-10 PM Thurs-Sat: 11 AM-11 PM Sun: 2 PM-8 PM
PAYMENT	VISA MasterCard AMERICAN EXPRESS
POPULAR FOOD	The catch of the day with two sides is always a pleasantly tasty surprise; also try the hickory smoked barbecue pork ribs, home made Southern-style meat loaf, smothered pork chops, oven baked Virginia ham (made with cloves,

THE BRONX

	cinnamon, pineapple); and last but not least, jerk chicken
UNIQUE FOOD	Cajun burger, stewed chicken (chunks of chicken prepared with root vegetables in a savory tomato herb sauce)
DRINKS	Full bar
SEATING	Tables for over 100
AMBIENCE/CLIENTELE	Huge and expansive space with several different rooms—empty in the afternoon, hopping during dinner and late night when the bar crowd kicks in
EXTRAS/NOTES	There are three parts to Sam's—Sam's Take Out, Sam's Bar, and Sam's the Dining Room Restaurant. Sam's Take Out includes a sit-down counter that seats about eight comfortably in front of the grill, and is open Thurs-Sat until 1 am. Sam's Bar is open Mon-Wed: 11 am-2 am, Thurs-Sat: 7 am-4 am, and Sun: 2 pm-10 pm. Live Blues, Jazz, Reggae, and Karaoke in the evening dining room and bar.

—Marie Estrada

Tibbett Diner

Feel miles away from the urban grind at this homey secluded diner.
$$
3033 Tibbett Ave.,The Bronx 10471
(just south of W. 231st St.)
Phone (718) 549-8893

CATEGORY	Diner
HOURS	Daily: 11 AM-10:30 PM
SUBWAY	1to 231st St.
PAYMENT	VISA, MasterCard, American Express, Discover
POPULAR FOOD	Daily specials: Friday's chicken pot pie, Saturday's lamb shank, Sunday's prime rib; also chicken caesar salad
UNIQUE FOOD	Utterly decadent Disco Fries: french fries with melted cheese and thick brown gravy
SEATING	Thirteen booths with plenty of seats and 10 at the counter
DRINKS	Egg creams, coffee, herbal and black tea, hot chocolate, fountain soda, mineral water, and milk
AMBIENCE/CLIENTELE	Flowered curtains with pink and mauve dominated décor; older neighborhood folk, friendly and helpful staff
EXTRAS/NOTES	Huge portions—you'll have leftovers to last at least another two meals.

—Marie Estrada

QUEENS

QUEENS

Alba Pizza
Crispy crusts make the detour worthwhile.
Since 1965
$$
137-65 Queens Blvd., Queens 11432
(at Main St.)
Phone (718) 291-1620

CATEGORY	Pizza
HOURS	Mon-Thurs 11 AM-11 PM
	Fri-Sat: 11 AM-Midnight
	Sun: 11 AM-11 PM
SUBWAY	F to Van Wyck Blvd.
PAYMENT	Cash only
POPULAR FOOD	All manner of calzones and pasta meals, but the real treats are the slices and the garlic knots; brisk business ensures freshness, and thinly kneaded crusts are crispy right out of the oven, raising undiscovered Alba to a special status among NYC pizzerias.
UNIQUE FOOD	Sausage, chicken, and vegetable rolls.
DRINKS	Soda and iced tea.
SEATING	Booth seating for 40, many just eat on the run.
AMBIENCE/CLIENTELE	As new immigrants arrive from Russia, the Caribbean, Asia, and Latin America, Alba remains a fixture in Forrest Hills; always crowded with local school kids and commuters coming back from the subway.

—Esti Iturralde

Austin House
Colossal menu packed with old-time Queens neighborhood flavor.
$$
72-04 Austin St., Queens 11375
(at 72nd Ave.)
Phone (718) 544-2276

CATEGORY	Diner
HOURS	Daily: 7 AM-Midnight
SUBWAY	E, F, G, R to 71st St. and Continental Ave.
PAYMENT	VISA MasterCard American Express Discover
POPULAR FOOD	Great big buttery pancakes, lox, eggs, and onion omelette; sandwiches galore; broiled steaks and fish.
UNIQUE FOOD	When asked to suggest something on the menu, waiters scratch their heads and point to the abundant rotating specials—it would be hard not to find something there, even chopped liver.
DRINKS	Egg creams and milk shakes; beer and wine, too, "but this is a family place".
SEATING	Seats 60 in booths, 10 at counter.
AMBIENCE/CLIENTELE	Breakfast through dinner, chatty older women whose dye jobs match their turquoise jewelry discuss, among (a few) other things, their grandchildren.
EXTRAS/NOTES	Greek and Italian dishes are on the menu, too. Good luck finding a seat during Sunday brunch, a testament to its quality.

—Esti Iturralde

Empanadas Uncovered

The past several years have seen a comfort food renaissance in New York City. From The Burger Joint to Daisy Mae's to Otto, childhood favorites, where paper and plastic often take the place of fine china and crystal stemware, have wrested some of the spotlight from Manhattan's white linen establishments. Out-of-towners have set up shop in the Boroughs five, while some of Manhattan's top chefs—Mario Batali and Laurent Tourondel come to mind—have rediscovered their roots. Down the block, the tapas bar has elevated snacking to haute cuisine, allowing famously non-committal New York diners to order exactly what they want—a little bit of everything.

I've been surprised, observing (and enjoying!) this explosion of small plates and soul food, by a conspicuous absence at the table: the supreme snack of our southerly neighbors, the empanada. Taking its name from the Spanish verb "empanar," which means "to cover in a pastry case," empanadas are baked or fried patties filled with a variety of sweet and savory fillings. Nearly every South American country has its own take on the empanada: Argentine empanadas are most commonly filled with beef and a variety of accompaniments, ranging from chopped egg to raisins; Chilean empanadas go heavier on the onion; Colombian empanadas can include potato and are served with Aji, a cilantro heavy sauce; and, in Mexico, empanadas are typically a dessert item.

In spite of their overwhelming popularity throughout South America, empanadas have barely taken root north of the equator. Like tamales a generation ago, they seem to be more commonly found in the home kitchen than on a restaurant menu. (In a 2004 Coca-Cola commercial, one college roommate eats a plate of homemade empanadas sent by the second roommate, Tito's, mother. He manages to smooth things over with a can of Coke—an unintended commentary on American cultural imperialism if I've ever seen one).

My first introduction to empanadas came several years ago, at **La Fusta** in Elmhurst, Queens. An Argentine steakhouse, La Fusta serves large beef and chicken empanadas as a starter. One empanada sets you back $2.50 and two are generally enough to make an inexpensive and delicious meal. The beef empanadas are served in a crispy, fried white wheat shell and chopped eggs and olives add flavor and texture to the mix. Though the baked chicken empanadas aren't bad, the beef variety is clearly the standout. Chimichurri, a garlic and cilantro based sauce, comes on the side. Legend has it that its name derives from the cries of European explorers, to "give me curry!" Whatever its origin, chimichurri is one addictive condiment and a perfect accompaniment to either of La Fusta's empanadas (not to mention most of the rest of the menu). After eschewing butter with our bread in favor of chimichurri on my most recent visit, my companions and I engaged in a round of "what wouldn't you eat it with?" I drew the line at chocolate, but I could probably be convinced otherwise.

In nearby Corona, **Empanadas del Parque** explores the varieties of empanada eating experience and adds a few new twists of

QUEENS

their own. The twenty-plus varieties come in either corn, white or whole wheat flour shells and fillings range from old standbys like beef and chicken to shredded pork, spinach, plantain and even pineapple. And that's before you get to the dessert empanadas. Standouts on recent visits include the jalapeno and queso, spinach and ricotta and shredded pork. The beef is a bit dry, particularly in comparison to La Fusta's offering, but a liberal application of the Aji served on the side takes care of the problem and gives a nice kick. Empanadas range from $1.25 to $1.75 and three to four should be sufficient, depending on your appetite. Homemade ice pops, $1.25 each, are a sweet way to end the meal and flavors include rice pudding, dulce de leche and coffee. Alternately, have your empanadas to go (seating in the small storefront is severely limited) and take a quick stroll to the **Lemon Ice King of Corona**, a few blocks away.

Empanadas are a harder find in the multitude of Manhattan's eats, but a few oases do exist. In a pinch the empanadas at **Gauchas Empanadas** uptown (try the Guacha Picante) or **Ruben's Empanadas** downtown will do. On warm days in the summer my beer man at Central Park serves empanadas *tambien*, though I've stuck with Budweiser so far. The **Caracas Arepas Bar**, a tiny mom and pop joint (literally—the husband and wife duo who own the place just gave birth) serves an interesting take on the empanada—large, flaky crusts enclose beans, cheese, vegetables and/or meat. Though good, they taste almost like sealed versions of the restaurant's namesake, which is the superior product.

For your time and money, you're better off heading to **Empanada Mama** in Hell's Kitchen—an offshoot of the Mama's Empanadas chain in Queens, and purveyor of Manhattan's finest, and most varied, 'das. The lime green and yellow walls suggest Mello Yello, but there's nothing mild about these patties. Fried is the way to go—the spicy chicken, 'Pernil,' and ground beef empanadas are all delicious—crispy shells and moist, flavorful fillings. Soups, salads, and specials are all listed as 'Mama's' domain, but the dessert empanadas aim for higher company. In addition to sweet plantain with cheese and caramel with cheese, Empanada Mama gives a nod to the king with the Elvis, a peanut butter and banana filled white wheat patty. Three savory empanadas, a side order of the smooth and plentiful guacamole (served with crispy plantain chips) and one Elvis later and you've got yourself a regal meal, all for under fifteen bucks.

Where to Find Them:

La Fusta: 80-32 Baxter Ave., Elmhurst, Queens 11373, Phone: (718) 429-8222 • Fax: (718) 458-7747, Hours: M-F 11:30 AM-11 PM., Sat 11 AM-Midnight, Sun 2:00 PM-11 PM,
www.lafustanewyork.com

Empanadas del Parque: 56-27 Van Doren St., Corona, Queens 11368, Phone: (718) 592-7288, Hours: Sun-Weds 7 AM-10 PM, Thurs-Sat 7 AM-11 PM
www.empanadascafe.com/main.html, (Cash only)

Lemon Ice King of Corona: 52-02 108th St., Corona, Queens 11368, Phone: (718) 699-5133

Gauchas Empanadas: 1748 1st Ave. (Between 90th St. and 91st St.),

QUEENS

Manhattan 10128, (212) 360-6400, http://gauchasnyc.com, (Cash only)

Ruben's Empanadas:

- 505 Broome St. (At Watts St.), Manhattan 10013, (212) 334-3351

- 15 Bridge St (Btwn Whitehall & Broad), Manhattan 10004, (212)509-3825

- 64 Fulton St (Btwn Cliff & Gold), Manhattan 10038, (212) 962-5330

- 122 1st Ave., (Btwn 7th & St. Mark's), Manhattan 10009, (212) 979-0172

Caracas Arepas Bar : 93 1/2 E. 7th St. (At 1st Ave.), Manhattan 10009, (212) 529-2314, Hours: Tues-Fri 5:30 PM-10:45 PM, Sat/Sun: Noon-10:45 PM, http://caracasarepabar.com/index.html

Empanada Mama : 763 9th Ave. (At 51st St.), Manhattan 10019, (212) 698-9008, Hours: Daily: 10:30 AM-Midnight

—Ben Wieder

The Bagel House
Queens' dark horse contender for Citywide Bagel title.
$
3811 Ditmars Blvd., Queens 11105
(at 38th St.)
Phone (718) 726-1869

CATEGORY	Bagel Shop
HOURS	Daily: 5:30 AM-7:30 PM
SUBWAY	N,W to Ditmars Blvd.
PAYMENT	Cash only
POPULAR FOOD	Sticks faithfully to the basics: plain, sesame, salt, pumpernickel, everything, garlic, whole wheat, and poppy—all are exceedingly fresh, with a slightly hardened crust surrounding the perfectly chewy, gummy dough that makes up a bagel's heart and soul; various flavors of homemade cream cheese include veggie, walnut raisin, and olive pimiento; add it to your bagel for an extra buck or so.
UNIQUE FOOD	Mini-bagels, with fillings like *sorpressata* and Swiss cheese; a selection of focaccia pizza: the Luna features mozzarella, oven-dried tomato, goat cheese, and zucchini, while the Frescha is topped with mozzarella, fresh tomato, and basil.
DRINKS	Coolers stocked with everything from orange and tomato juice to Gatorade and Snapple; the coffee is consistently fresh
SEATING	Most patrons are in and out, but a six-seat counter offers a view of Ditmars Blvd.; clientele ranges from parents stopping by after church on Sundays to young singles fighting through their weekend hangovers

QUEENS

AMBIENCE/CLIENTELE The Bagel House also offers a range of typical fare: egg sandwiches, muffins, and bagel sandwich choices like grilled chicken with roasted peppers and fresh mozzarella or smoked turkey, brie, sundried tomato and honey mustard. While there's no real 'ambience' in the traditional sense, during the fall and winter you may be asked for your thoughts on the weekend's Jets game while at the register

—*John Hartz*

How Do You Say HUNGRY? In...
EUROPE

English: *I'm hungry. I need to eat. I'm famished. I'm starved. I need some grub. Feed me!*
Croatian: *gladan sam.*
Czech: *mam hlat.* Sounds like: mom lot.
Danish: *jeg er sulten.* Sounds like: yai air SOOL-ten.
French: *J'ai faim.* Sounds like: zhay feh (as in family).
German: *Ich bin hungrig or (Ich habe hunger.).* Sounds like: Ick (as in icky) bin hungrick.
Greek: *Ego peenao!* (accent on the 'o' in Ego and on the 'a' in 'peenao'; the g in Ego is gutteral)
Basque: *gose naiz!*
Italian: *Mio habes famo.* Sounds like: Meeo awbes fawmo.
Polish: *Jestem glodny.*
Portuguese: I'd like breakfast.: *Queria tomar o pequeno almoço.*
I'd like lunch: *Queria tomar o almoço.*
I'd like dinner: *Queria tomar o jantar.*
Russian: *ya hochu est.*
Swedish: *Jag är hungrig.* Sounds like: Yag (as in father eyr long as in bear hoongrg.)
Spanish: *Tengo hambre.*

Baluchi's Indian Food
A citywide opportunity for feasting on spicy Indian.
$$$
113-30 Queens Blvd., Queens 11375
(at 76th Rd.)
Phone (718) 520-8600
www.baluchis.com

CATEGORY Northern Indian
HOURS Noon-3 PM, 5 PM-11 PM
Sat/Sun: Noon-11 PM
SUBWAY F to 75th Ave.
PAYMENT VISA MasterCard AMERICAN EXPRESS
POPULAR FOOD *Tikka masala* is reportedly the "number one seller," but powerfully spicy dishes like the *vindaloo* and complex ones like the *saagwala* deserve special praise.
UNIQUE FOOD Baluchi's shrimp curry is a specialty
DRINKS Full bar
SEATING About 100 at tables

QUEENS

AMBIENCE/CLIENTELE	Baluchi's wins points in the details, from the earthy colors to the gorgeous wall hangings; no garish Christmas lights reminding you of the less couth Indian joints on E. Sixth Ave.
EXTRAS/NOTES	The 50 percent discount on all in-house menu prices applies to lunch and sometimes even to dinner (depending on location), making Baluchi's an incredible steal. Take-out and delivery available. Lunch prices until 3 pm.
OTHER ONES	9 locations around Manhattan. Check website for one near you.

—*Esti Iturralde*

Blue Sea Café
Some of the better breakfast specials in Queens.
$$
3020 30th Ave., Queens 11102
Phone (718) 274-7704

CATEGORY	Diner with Delivery
HOURS	Call for hours
SUBWAY	N to 30th Ave.
PAYMENT	Cash only
POPULAR FOOD	All the baking is done on the premises, so try the pastries: French crullers, angel wings, and muffins are the favorites. American and Greek specials go over well with clientele: beef gyro platter, burgers and fries
UNIQUE FOOD	The breakfast special (5 am-11 am, on premises only): even the most expensive—corned beef hash with two eggs, home fries, toast, juice, and coffee—is cheap; the other six are cheaper, sometimes much cheaper, and are all filling like the American Breakfast: two eggs, any style, with bacon, ham, or sausage, and home fries, toast, juice, and coffee or tea—and the coffee is good
DRINKS	Coffee, tea, juice, milk, no booze
SEATING	35-40 seats, half of which line the wavy-shaped blue counter
AMBIENCE/CLIENTELE	As you might have guessed, whoever painted the Blue Sea Café didn't pinch pennies on the blue paint; local crowd

—*Joe Cleemann*

Bohemian Hall & Beer Garden
New York City's last great beer garden, featuring hearty Czech specialties. Like beer.
Since 1910
$$
29-19 24th Ave., Queens 11105
(between 29th St. and 31st St.)
Phone (718) 728-9776 • Fax (718) 728-9278
www.bohemianhall.com

CATEGORY	Bar and restaurant
HOURS	Mon, Wed/Thurs: 5 PM-10 PM

QUEENS

	Fri: 6 PM-10 PM
	Sat: Noon-11 PM
	Sun: Noon-10 PM
SUBWAY	N, W to Ditmars Blvd.
PAYMENT	VISA MasterCard
POPULAR FOOD	A range of Czech and Eastern European staples, such as: homemade kielbasa, Hungarian beef goulash with dumplings, roast pork with dumplings and sauerkraut, and schnitzel with potatoes or fries.
UNIQUE FOOD	As an appetizer, the head cheese with bread and onions; not to be missed: the deep-fried cheese stuffed with ham and potatoes.
DRINKS	The Czechs are world renowned for their beer, and the Bohemian Hall delivers on two excellent examples via its taps: Staropramen and Pilsner Urquell, in sizeable beer hall-worthy steins.
SEATING	The bar is somewhat cramped, with five large booths, two or three smaller tables and about ten stools; the outdoor garden features 60-80 large picnic tables, arranged in rows beneath the leafy old-growth canopy.
AMBIENCE/CLIENTELE	Bohemian Hall continues as a social venue for the local Czech and Slovak community, but it also draws from across the Queens (and at times, Manhattan) spectrum. The garden is open year-round, but it gets cold in the winter. During weekends in the spring and summer you can catch live entertainment, including various locally produced plays and musical events. Be warned: the quality of these events can vary widely, and sometimes you need to purchase a ticket to the show to get into the garden.
EXTRAS/NOTES	Owned by the Bohemian Citizen's Benevolent Society, the beer garden is the last of its kind in New York City. It was going strong from its construction in 1910 until after World War II, when interest in the cultural activities offered at the hall dwindled. But Czechoslovakia's 'Velvet Revolution' in 1989 sparked a revival for both the Benevolent Society and the Bohemian Hall. Czech President Vaclav Havel paid a visit in the late 1990s, and the hall currently under consideration for inclusion on the National Register of Historic Places. It has been recognized as a Queens landmark through the Queensmark program.

—*John Hartz*

"I miss New York. I still love how people talk to you on the street - just assault you and tell you what they think of your jacket."

—*Madonna*

QUEENS

Cafe Bar
It's a cafe. It's a bar. It's a cafe bar.
$$$
32-90 36th St., Astoria,
Queens 11106
(at 34th Ave.)
Phone (718) 204-5273

CATEGORY	Greek
HOURS	Mon-Thurs 9:30 AM-2 AM
	Fri-Sat: 9:30 AM-3 AM
	Sun: 9:30 AM-2 AM
SUBWAY	Take the N,W to Broadway, then walk 5 blocks, hang a right and walk to 34th Ave; or take the R,V,G to Steinway St., get out at the 34th Ave. exit and walk up to 36th St.
PAYMENT	Cash only
POPULAR DISH	The vegetarian friendly, Greek inspired menu has quite a few standouts. The hot and cold assorted mezze plates are great for the social eaters. The salami and grilled haloumi sandwich is key for a salt fix. And, on the opposite end of the spectrum, assuage your sweet tooth with CB's sublime Nutella and banana crepe topped with vanilla ice cream.
UNIQUE DISH	Despite the joint's reputation as a night spot, CB's best meals are proffered early in the day. They really know how to fluff an egg. Drop by in the AM for their fantastic Cypriot Breakfast with all the accoutrements typical of the Greek table. The outdoor tables fill up quick for their weekend brunch. A heads-up to those used to a prix-fix: everything's a la carte, even the coffee.
DRINKS	Cafe Bar is like a bottomless well of every drink imaginable. They do great cocktails, boozy coffees, have a good beer selection, make a mean smoothie, and froth up a near perfect frappe. However, with Manhattanish price tags on the beverages, drinking will double your bill.
SEATING	Plop down on one of Cafe Bar's mismatched couches, lucite chairs, or swivel bar stools, that is, if you can find an empty one. Weekends and warm weather evenings will have you hawk-eyeing the room for people paying their bill.
AMBIENCE/CLIENTELE	It's a little bit East Village tragically hip, a little bit Euro-trash, a little-bit grandma's attic, and a little bit ya-ya's kitchen. On weekends, expect a crowd. The vibe is always chill and, though crammed on weekends, on weekdays it's a great spot to relax with a good book.
EXTRAS/NOTES	There's always potential for a celeb sighting when the cameras are rollin' at Kaufman Astoria Studios just across the street. Cafe Bar also offers super-cheap internet access.

—Jen Sotham

QUEENS

Cevabdzinica Sarajevo
Bosnian-style Hungry-man sandwiches.
$$
37-18 34th Ave., Queens 11103
(at 37th St.)
Phone (718) 752-9528

CATEGORY	Deli-ish
HOURS	Daily: 10 AM-10 PM
SUBWAY	R, G to Steinway; N to Broadway
PAYMENT	Cash only
POPULAR FOOD	The specialty (and what just about everyone orders) is *cevapi*, grilled ground meat shaped to look like a sausage: hollow out half a loaf of bread, stuff it with the *cevapi*, some onions, and a very light tomato sauce… and *that* is how you make a sandwich.
DRINKS	Soda, juice
SEATING	A few tables, seats about 19
AMBIENCE/CLIENTELE	One of the newer eating places in Astoria, it already fills with hardcore regulars looking for a taste of home (home being Sarajevo); the owners are very friendly and always more than happy to give newcomers a rundown of the menu and make recommendations

—*Larry Ogrodnek*

Fatty's Café
Everyone loves a fatty
$$$
25-01 Ditmars Blvd., Astoria 11105
(at Crescent St.)
Phone (718) 267-7071
www.fattyscafenyc.com

CATEGORY	Restaurant Bar
HOURS	Mon-Thurs: 2 PM-11 PM Fri: 2 PM-Midnight Sat: 11 AM-Midnight Sun: 11 AM-10 PM
SUBWAY	Take the N train to Ditmars Blvd. Turn left onto Ditmars and walk 5 blocks to Crescent Street. Fatty's is on the left.
PAYMENT	Cash only
POPULAR DISH	This creative menu with a Latin flair can please even the pickiest of eaters. Some standouts include the empanadas, the jalapeno turkey burger, and the grilled skirt steak. The sweet potato fries kill.
UNIQUE DISH	Fatty's $9 brunch, which includes a mimosa, bloody Mary or limeade, is where it's at. Alongside traditional egg choices are unique delights like the Eggless Sunnyside Up (polenta corn cakes stuffed with provolone) and The Fatty (egg, sweet sausage patty, and choice of cheese on an English muffin).
DRINKS	Kill last night's hangover at brunch with a mango mimosa or a cafe con leche. Fatty's also has a nice beer selection, and the mixologist has truly mastered the art of the mojito.
SEATING	As it's fairly small, expect a wait at peak times, especially brunch. On nice days, come early to score a coveted table in Fatty's outdoor garden.

QUEENS

AMBIENCE/CLIENTELE An aesthetically charming space with shifting local art adorning the walls, Fatty's draws the usual suspects: young, alive, and inspired. That said, being in Astoria, it's refreshingly absent the too-cool-for-school attitude that you would find in a Williamsburg joint.

EXTRAS/NOTES Long after the waitresses stop slinging Cubano sandwiches, the mellow bar scene keeps this little corner cafe aglow. Also, if you're trekking out from the "Big Island" during daylight hours, Astoria Park, just blocks away, offers a nice alternative to "that other park."

—Jen Sotham

Jackson Diner
Legendary: put Jackson Heights on the Indian culinary map.
$$
37-47 74th St., Queens 11372
(at 37th Ave.)
Phone (718) 672-1232 • Fax (718) 396-4164

CATEGORY Northern Indian/Buffet
HOURS Sun-Thurs: 11:30 AM-10 PM
Fri/Sat: 11:30 AM-10 PM
SUBWAY E, F, V, G, R to Roosevelt Ave.; 7 to 74th St./Broadway
PAYMENT Cash only
POPULAR FOOD Diners salivate over the Tasting of Three (fish, chicken *malabar*, and *samosa*), the *Murg* (Chicken) *Tikka Makhanwala*, and luscious lamb dishes like the *Korma*; the all-you-can-eat lunch buffet provides the best of all worlds (weekdays: 11:30 am-4 pm)
UNIQUE FOOD Most dishes are northern Indian standards; a little extra scratch buys goat curry
DRINKS Full bar
SEATING Seats 150 at long tables
AMBIENCE/CLIENTELE Jackson hosts an eclectic crowd, reflective of the mind-boggling diversity of the greater neighborhood—culinary pilgrims come from all over, however, drawn by the Diner's reputation.
EXTRAS/NOTES The name is an artifact of the restaurant's early history. In 1983, the Indian owners took over an American-style restaurant, only gradually adding their native dishes to the usual hamburger-and-milk-shake fare. Needless to say, the tandoori really caught on, and while the newer, more colorful, and bigger location (since 1998) bears no resemblance to a diner, there was no sense in fooling with a lucky name.

—Esti Iturralde

Jaiya
(See p. 118)
Thai
81-11 Broadway, Queens 10006
Phone: (718) 651-1330

175

QUEENS

Joe's Shanghai
(See p. 12)
Chinese
13621 37th Ave., Flushing, Queens

Last Stop Café
Home-style food at Mom's prices.
$
22-35 31st St., Queens 11105
Phone (718) 932-9419

CATEGORY	American/Diner
HOURS	Daily: 4 AM-Midnight
SUBWAY	N, W to Ditmars Blvd.
PAYMENT	VISA MasterCard American Express Discover
POPULAR FOOD	Breakfast is served until 3 pm; breakfast special before 11 am—two eggs; hash browns; toast; bacon, sausage, or ham; coffee; and juice for $3.50 at press time; real New York pizza—ask for it cooked well done; assortment of Italian dinners for under $10; soups made on the premises.
UNIQUE FOOD	*Stracciatella* Soup—chicken broth, spinach and whisked eggs
DRINKS	Soda, Snapple, and one of the best bottomless cups of cheap-o coffee in NYC
SEATING	Small dining room is packed for breakfast and lunch, especially during the weekends
AMBIENCE/CLIENTELE	Two TVs (usually are tuned to CNN or trash talk shows during the day) distract from the cheesy subway murals on the walls; crowd is Astoria locals ranging from old to young, straight to gay and everything in between—everyone gets treated like they've been longtime customers (though the wait staff definitely notices who tips well and who doesn't)

—*Michael Connor*

Los Amigos
Saloon atmosphere: Vamoos, Jose's on his way.
$
22-73 31st St., Queens 11105
(at 23rd Ave.)
Phone (718) 726-8708 • Fax (718) 956-8855

CATEGORY	Mexican Eat-in/Take-out
HOURS	Daily: 11 AM-4 AM
SUBWAY	N, W to Ditmars Ave.
PAYMENT	VISA MasterCard American Express Discover
POPULAR FOOD	Seven different combination platters, served with rice and refried beans, include various combinations of burritos, tacos, *chimichangas*, enchiladas, and more; for something cheaper, choose from seven varieties of soft tacos; servings are generous; food is tasty.
DRINKS	Full bar: beer, wine, liquor; juice and soda
SEATING	About 35 seats and six stools at the bar
AMBIENCE/CLIENTELE	Los Amigos draws the white middle class professionals who are in increasing numbers

making Astoria their home, and real, live Mexicans who have done likewise; it's dark, decorated with old bullfighting advertisements and Pancho Villa recruitment posters

—Joe Cleemann

McCann's Pub & Grill
Old fashioned bar-and-grill standbys done right.
$$
36-15 Ditmars Blvd., Queens 11105
(between 35th and 36th St.)
Phone (718) 278-2621, 278-2039 • Fax (718) 762-5126
www.McCannsPubNYC.com

CATEGORY	Bar and grill
HOURS	Mon-Sat: 10 AM-4 AM
	Sun: Noon-4 AM
SUBWAY	N,W to Ditmars Blvd.
PAYMENT	Cash only , but there's an ATM downstairs
POPULAR FOOD	Food is outstanding and extremely fresh, if basic: the deluxe hamburgers, served with steak fries, lettuce, tomato, onion and pickle range from a straightforward burger to the bacon cheeseburger; the grilled chicken salad is outstanding
UNIQUE FOOD	McCann's offers some excellent food and drink combination specials; to wit: on Tuesdays, any burger with a pint goes for $10.00; Thursdays bring an order of wings with a pitcher of beer for just $10.00
DRINKS	All the usual alcoholic suspects, highlighted by a well-pulled pint of Guinness
SEATING	Fairly small as far as floor space goes, McCann's manages to squeeze in five large tables along the wall, plus a couch in the rear and about 15 stools at the bar
AMBIENCE/CLIENTELE	Primarily a younger Astoria crowd, particularly on weekends, but McCann's also draws a fair share of middle-aged visitors
EXTRAS/NOTES	There are many great things about McCann's, but perhaps the greatest is that it is what it says it is: a BAR and GRILL. It comes complete with Irish bartenders and waitresses, and a decent selection of draught beer. But unlike so many bars, the grill is not an afterthought. Also, there are a couple of pool tables in the back room. The big screen (eight ft.) television, and its 20 or so 25-inch cousins, come in handy during sports seasons, since McCann's is a sports bar at heart. It can become a very passionate (and crowded) place during big games that involve the local squads.

—John Hartz

How Do You Say HUNGRY? In...
THE MIDDLE EAST

Arabic: *ænæ gæ'æn!* Sounds like: jaw'aan.
Hebrew: *ani raev (reeva)*
Farsi: *goshnameh*or *gorosneh-am.*

QUEENS

Neptune Diner
A dominant diner in the heart of Greek America. Since the 1950's
$$

31-05 Astoria Blvd., Queens 11102
(between 33rd St. and 31st St., where the Grand Central Pkwy. approaches the Tri-boro)
Phone (718) 278-4853

CATEGORY	Diner
HOURS	24/7: "We threw away the key," they tell us.
SUBWAY	Astoria Blvd. (N, W)
PAYMENT	VISA, MasterCard, American Express
POPULAR FOOD	It's a diner, so pretty much everything under the sun (and under the sea) is available: grab a full breakfast for around $6—pay more and you can skip lunch; heaping Greek specials like *souvlaki* won't break the bank either; nearly a dozen varieties for burger range from a plain 1/3-pound hamburger to a Deluxe Twin Cheeseburger.
DRINKS	Full bar
SEATING	Seats 150 (about 15 at the counter)
AMBIENCE/CLIENTELE	A diner right down to its fieldstone façade; inside, you get booths, a bar (backed by a long mirror), big plate glass windows, personal jukeboxes (brings lots of quarters if you groove on the sultry sounds of Kenny G), etc.; drawing the usual truckers, oldsters, and hipsters, each at their designated time.

—*Joe Cleemann*

Nick's Pizza
Simplicity, elegance, taste—pizza as art.
$$
108-26 Ascan Ave., Queens 11375
(at Austin St.)
Phone (718) 263-1126

CATEGORY	Pizzeria
HOURS	Mon-Thurs: 11:30 AM-9:30 PM
	Fri: 11:30 AM-11:30 PM
	Sat: 12:30 PM-11:30 PM
	Sun: 12:30 PM-9:30 PM
SUBWAY	E, F, G, R to 71st St. and Continental Ave.
PAYMENT	Cash only
POPULAR FOOD	No lengthy menu here to distract from the masterpiece: exquisite gourmet pizza pies on a thin crust caressed with fresh basil.
UNIQUE FOOD	They've got ricotta pizzas, too, and for those who can't decide, half-whites and half-reds
DRINKS	Beer and wine
SEATING	A cozy capacity of 40, seated at tables
AMBIENCE/CLIENTELE	Behind a vintage storefront and lined with black-and-white photos of the neighborhood in the olden days, Nick's beckons families at dinnertime and young hipsters late on weekends.
EXTRAS/NOTES	Their motto seems to be "No slices!" for why partition such a perfect canvas? Choice toppings serve to enhance rather than bury. A large serves two perfectly. Salads are big enough to split. No

QUEENS

delivery, no slices, but whew, there's take-out. And if you're in the neighborhood, there's another bigger restaurant in Long Island.

OTHER ONES • Long Island: 272 Sunrise Hwy., 11570, (515) 763-3278

—Esti Iturralde

Peking Duck Forest
Excellent taste and value for a sit-down Chinese meal.
$$$
107-12 70 Rd., Queens 11375
(at Austin St.)
Phone (718) 268-2404 • Fax (718) 268-7431

CATEGORY	Chinese
HOURS	Mon-Thurs: 11:30 AM-11 PM
	Fri/Sat: 11:30 AM-Midnight
	Sun: Noon-11 PM
SUBWAY	E, F, G, R to 71st St. and Continental Ave.
PAYMENT	VISA MasterCard AMERICAN EXPRESS
POPULAR FOOD	Usual favorites are done with extra freshness and taste: chicken *lo mein*; beef with broccoli—never oily or bland, and served in filling portions
UNIQUE FOOD	The chef's pride, a crispy Peking duck heads the specialty list; other noteworthy dishes include fresh lobster and sea bass.
DRINKS	Full bar
SEATING	Seats 60 at tables
AMBIENCE/CLIENTELE	Frequented by couples on a casual date gearing up for a movie at the Midway; adults and families enjoying a quiet dinner
EXTRAS/NOTES	With free delivery, Peking Duck Forest keeps a large local clientele. But given its soft music, ambient lighting, diligent waiters, and free parking, why not sit down and stay awhile?

—Esti Iturralde

Sal, Kris & Charlie Deli
The "Sandwich King of Astoria" consolidates his awesome power!
$
33-12 23rd Ave., Queens 11105
(between 33rd St. and 35th St.)
Phone (718) 278-9240

CATEGORY	Deli
HOURS	Mon-Sat: 5 AM-5 PM
	Sun: 5 AM-4 PM
SUBWAY	N,W to Ditmars Ave.
PAYMENT	Cash only
POPULAR FOOD	Real simple, real cheap: get a gigantic deli sandwich, usually for less than $5
DRINKS	Pull what you want out of the refrigerated case
SEATING	Carry out
AMBIENCE/CLIENTELE	Small, but well staffed; great deals on great sandwiches draw all kinds: if the cops and the taxi drivers like it, it ought to be good . . . you'll

QUEENS

find both at Sal, Kris & Charlie Deli, and not a few prison guards on lunch break from nearby Riker's Island.

EXTRAS/NOTES During lulls, this old-timer used to hand out free samples—surprisingly delicate combinations of (usually) sweet peppers and cheese that revealed the artist's understanding of how delicatessen flavors work together. I was sad to hear he's gone. But that artistry still goes into each sandwich.

—*Joe Cleemann*

Sweet-N-Tart
(See p. 21)
Chinese
13611 36th Ave. Flushing, Queens 11354
Phone: (718) 661-3380

Uncle George's Greek Tavern
Good, greasy, sloppy Greek food.
$$
33-19 Broadway, Queens 11106
(at 33rd St.)
Phone (718) 626-0593

CATEGORY	Diner-y
HOURS	24/7
SUBWAY	R, G to Steinway; N to Broadway
PAYMENT	VISA MasterCard American Express Discover
POPULAR FOOD	*Dolmades* (stuffed grape leaves), lamb stew with spinach (Thurs and Sun), *pastitsio*, baby shark, *spanakopita*.
DRINKS	Soda, beer, wine by the kilo
SEATING	Plenty of seating at tables
AMBIENCE/CLIENTELE	The cheap, tasty Greek food, as well as wine by the kilo (served in '70s shiny metal pitchers) draws a big crowd at all hours of the evening: dinnertime, there's typically a neighborhood family crowd and Uncle George's is filled with talking, laughing and Greek music from the jukebox
EXTRAS/NOTES	When your order arrives, it won't be much more than an enormous mess of food piled on as much as one plate can handle. The relaxed atmosphere and great Greek food are what keeps people coming back to Uncle George's. Even though Uncle George's is open 24/7, at off-peak times the menu is limited. This is the most requested place to eat when my parents come to visit.

—*Larry Ogrodnek*

QUEENS

Viva El Mariachi
An authentic, friendly, and festive Mexican hangout.
$$
33-11 Broadway, Queens 11105
(at 34th St.)
Phone (718) 545 4039

CATEGORY	Mexican diner
HOURS	Daily: 8 AM-Midnight
SUBWAY	R, G to Steinway; N to Broadway
PAYMENT	VISA, MasterCard, American Express
POPULAR FOOD	*Tinga* (spicy chicken) Tostada, Chorizo Taco (sausage taco), *Huevos con Chorizo* (eggs with sausage), Enchiladas *Verdes*, but nothing settles a hangover like a plate of eggs, rice, and beans
DRINKS	Mexican sodas, shakes, coffee, tea, beer, fresh juices
SEATING	A counter with about a dozen seats and ample table seating as well.
AMBIENCE/CLIENTELE	Viva El Mariachi is very choice for that long weekend breakfast in Astoria; customers will be busy talking about the previous night's escapades, current events, or just reading the paper; staff is very friendly and more than willing to make recommendations to help you try out the entire menu.
EXTRAS/NOTES	If you are in serious chow-down mode, head straight to the counter. It comes right up to your chin for those times when your hands are just slowing you down. The extra height also helps those who are more enthusiastic about eating than keeping track of napkins.

—Larry Ogrodnek

Zygos (Libra) Taverna
"Home style" Greek food: delicious, greasy, Greek!
$$
22-55 31st St., Queens 11105
(between Ditmars Blvd. and 23rd Ave.)
Phone (718) 728-7070

CATEGORY	Greek *Taverna*: eat-in, take-out, free deliveries over $10
HOURS	Daily: 11 AM-Midnight
SUBWAY	N,W to Ditmars Blvd.
PAYMENT	VISA, MasterCard, American Express, Discover
POPULAR FOOD	The gyro (don't get cute on the pronunciation, just say JAI-rho), the *souvlaki*, the *donner*… they're great and cheap; upgrade to "platter" size and you more than double the price in exchange for French fries and salad.
UNIQUE FOOD	*Tzatziki* (a yogurt, garlic, and cucumber sauce, served with toasted pita) isn't unique to Zygos, but you get a good bowl of it here; check out the "Dishes of the Day" on the menu: Leg of Lamb with potatoes is fantastic; *mousakas* comes highly recommended

BROOKLYN

DRINKS Wine (try the *retsina* for a change), soda, beer, coffee
SEATING Seats around 50
AMBIENCE/CLIENTELE Authentic *taverna* style: snug and not-too-light, with various Greek odds and ends on display (including photos of Greek-American über-celebrity Telly Savalas)... the centerpiece of the dining area is three-dimensional mural of downtown Athens; "blinker" Christmas lights simulate the energy consumption habits of Greek homeowners and shopkeepers.
EXTRAS/NOTES This kind of food —greasy and mouthwatering— usually gets passed off as "home style," but one wonders whether this is really the style of food that Greeks, a Mediterranean, seafaring people, would prepare in their homes on a day-to-day basis. Maybe on special occasions.

—Joe Cleemann

BROOKLYN

BROOKLYN

NORTH BROOKLYN

Amin
(See p. 75)
Indian
140 Montague St., Brooklyn 11201
Phone: (718) 855-4791

Cube 63 Brooklyn
(See p. 5)
Japanese
234 Court St., Brooklyn 11201
Phone: (718) 243-2208

Manna's Soul Food Restaurant
Comfort by the pound . . .
$$
829 Broadway, Brooklyn 11206
(between Park Ave. and Ellery St.)
Phone (718) 218-8575 • Fax: (718) 218-9543
www.mannasrestaurants.com

CATEGORY	Southern/Soul Food
HOURS	Mon-Sat: 8 AM-9 PM Sun: 8 AM-8 PM
SUBWAY	Take the J,M,Z train to Flushing Avenue. Metered parking is available, but not advisable due to how busy the street is.
PAYMENT	Cash only
POPULAR DISH	At $4.29/lb for both the hot entrees and cold salads, it's hard to go wrong at Manna's. Just keep in mind that soul food staples like mashed potatoes and candied yams are quite weighty—the bill can add up quickly. Depending on how hungry you are, expect to spend around $10. Crowd favorites include the fried chicken and collard greens, along with several varieties of ribs and wings.
UNIQUE DISH	Sometimes odd items crop up on the menu, like calamari or the ubiquitous "oriental chicken." Everything's edible, but stick to comfort food and you'll never go wrong.
DRINKS	Nothing earth-shattering here: standard sodas, water, and bottled juices line the wall in coolers in the back. Homemade lemonade and iced tea are also available.
SEATING	Cafeteria style: tables abound, with 6-8 chairs per table. Seats about 100.
AMBIENCE/CLIENTELE	Not at all glamorous, but the food's worth it. Groups can easily find seating, but take-out is a good option for those who are picky about ambiance. While not romantic or sophisticated, Manna's is clean, bright, and, unlike a lot of

BROOKLYN

buffets, the food is brought out regularly and kept fresh. Can't complain about the service either: it's self-serve! Styrofoam trays are used whether you eat in or out. Things can get a little crowded during the meal-time rush, particularly dinner. With a huge mix of families, students, and off-duty cops, everyone can find something here.

EXTRAS/NOTES Manna's has been around since 1984, with the first location still operating in Harlem. Four others have opened since then. At this Brooklyn location, cash-strapped foodies can take advantage of the on-premises ATM before loading up. If your kid has a hankering for collard greens and peach cobbler, Manna's does has some high chairs available, and they appear to be used often. Families frequently stop by either to eat-in or grab take-out for home. Keep in mind, a half hour before closing, the dining room closes and everything must be take-out.

OTHER ONES Harlem: 51 E. 125th St., Manhattan 10035, (212) 360-4975
• Harlem: 486 Lenox Ave., Manhattan 10037, (212) 234-4488
• Sixth Avenue to the Hudson: 2331 8th Ave., Manhattan 10027, (212) 749-9084

—*Jennifer Treuting*

Sushi Excellent
(See p. 7)
Sushi/Asian
234 Court St., Brooklyn 11201
Phone: (718) 667-5362

DOWNTOWN BROOKLYN EAST

Chez Lola
Their own clever tagline is: "Le Bistro sans Frontieres".
$$$$
387 Myrtle Ave., Brooklyn 11205
(between Clermont Ave. and Vanderbilt Ave.)
Phone (718) 858-1484
www.bistrolola.com

CATEGORY French
HOURS Mon-Sat: 5 PM-11 PM
SUBWAY Take the G to Clinton-Washington, or the B,M,Q,R to Dekalb, or the C to Lafayette.
PAYMENT Cash only
POPULAR DISH The spicy salmon burger with chipotle mayo is divine. A good size, served with a wedge of lemon and a sweet bun, it melts in your mouth when you bite into it.
DRINKS Full bar, with a great wine selection.

BROOKLYN

SEATING	The seating is spacious and inviting. In warm weather, ask to be seated on the gorgeous black-and-white-tiled outdoor patio, where you can dine beneath the branches of a huge mulberry tree.
AMBIENCE/CLIENTELE	Be prepared to run into plenty of Fort Greeners, as they're pouring out of the woodwork to eat and critique this quiet, relaxing new restaurant by the owners of Chez Oskar.
OTHER ONES	• Chez Oskar, 211 Dekalb Ave., Brooklyn 11205, (718) 852-6250

—Mina Stone

Chez Oskar
"Le funky French bistro."
$$$
211 Dekalb Ave., Brooklyn 11205
(at Adelphi St.)
Phone (718) 852-6250
www.chezoskar.com

CATEGORY	French
HOURS	Sun-Thurs: 11 AM-Midnight Fri/Sat: 11 AM-1 AM
PARKING	Take the G train to Clinton-Sashington or the C to Lafayette.
PAYMENT	VISA MasterCard AMERICAN EXPRESS Discover
OPULAR DISH	The spicy lamburger is a dense bite of deliciously juicy meat topped with goat cheese and served with fries. For lighter fare, the salade nicoise, served with a choice of tuna or salmon, is a favorite.
UNIQUE DISH	Get in touch with your inner Francophile. Start with steak tartare (served with a raw quail egg and croutons), classic escargots (buttery, snaily goodness), or the house-cured foie gras, then move on to the mustard rabbit entrée, served with caramelized fingerling potatoes, pearl onions, and garlic confit.
DRINKS	Full bar.
SEATING	Large indoor dining room with outdoor seating during the warmer months.
AMBIENCE/CLIENTELE	A huge outdoor seating area makes this one of the best summer places in Fort Greene. That, and the constant supply of drinks, live music, and funky neighborhood characters.
OTHER ONES	• Chez Lola, 387 Myrtle Ave., Brooklyn 11205, (718) 858-1484

—Mina Stone

Di Fara Pizzeria
(See p. 65)
Pizza Joint
1424 Ave. J, Brooklyn 11230
Phone: (718) 258-1367

BROOKLYN

DUB Pies NYC
Let them eat pie.
$

193 Columbia St., Brooklyn 11231
(between Sackett St. and DeGraw St.)
Phone (646) 202-9412 • Fax (617) 216-1947
www.dubpies.com

CATEGORY	Dessert/Snack
HOURS	Sun-Weds: 10 AM-10 PM Thurs-Sat: 10 AM-Midnight
SUBWAY	Take the F or G to Carroll; 61 Bus also available.
PAYMENT	VISA MasterCard American Express Discover
POPULAR DISH	Mince pie (ground beef with onion gravy), chunky steak (chopped sirloin), and curry vegetarian are all mouthwateringly good.
UNIQUE DISH	What is a meat pie? Unless you have been to Australia or New Zealand, you probably don't know. A meat pie resembles a miniature pot pie, with soft, flaky crust, and stuffed with a variety of fillings. "They are what we eat down under," says Anna the manager in a twangy accent. "In New York, you eat pizza or hotdogs." As far as I know you won't find this down-under delicacy anywhere else in New York, maybe the U.S. "We ship pies as far away as California," says Anna. "It's mostly Aussies and New Zealanders living in the States who have heard about us and are looking for a taste of home." I think it is safe to say these munchies are authentic. It is definitely safe to say they are really, really tasty.
DRINKS	Drip coffee is Fair Trade, organic Sumatra Mandehling. They also have a variety of espresso drinks. Staff is very particular about how they steam their milk, how they grind their coffee. It is good every time.
SEATING	Limited, with only a couple of tables. Come with yourself.
AMBIENCE/CLIENTELE	DUB has an industrial feeling exterior, but a warm interior. Locals come in for the coffee—and the free Wi-Fi. Open late for its neighborhood, DUB is a great place to hang out, listen to the Aussie news on an overhead television, do a bit of work, or enjoy conversation with the proprietor.
EXTRAS/NOTES	A group of friends from New Zealand and Australia opened DUB Pies in an effort for cultural ambassadorship. You'll regularly find Haley or Anna working the counter. They are a wealth of warmth and information about their culture.

—*Ryan Auer*

Habana Outpost
The first solar-powered restaurant with a Brooklyn attitude.
$$

757 Fulton St., Brooklyn 11205
(at South Portland St.)
Phone (718) 858-9500
www.ecoeatery.com

CATEGORY	Cuban

BROOKLYN

HOURS Weds-Fri: 4 PM-Midnight
Sat/Sun: Noon-Midnight
SUBWAY C train to Lafayette
PAYMENT Cash only
POPULAR DISH The most popular dish at Habana is, by far, the Mexican corn. Might sound boring, I know, but the second you taste the sweet corn, which is grilled and topped with tangy mayo, cheese, and lime, you too will be a Fort Greene regular.
UNIQUE DISH The Cuban sandwich is a favorite, but ultimately it's not about the food at Habana. It's a neighborhood block party every weekend there. Regulars wait for their food for an hour and still come back the next day for more. It's just that much fun.
DRINKS Ice cold coronas, draft beer, frozen margaritas and mojitos, and, of course, for the little ones, *jarritos*! (Mexican soda)
SEATING There is limited indoor seating, but you don't go to sit inside. Large outdoor communal picnic tables are the key to success here.
AMBIENCE/CLIENTELE Habana Outpost is the first solar- and wind-powered restaurant to serve catfish wraps, Mexican corn, and various other delicious Cuban delights to Fort Greeners. It's eco- and kid-friendly and the place is always bustling. On any given night, you could bump into your cousin, her boyfriend, his ex-girlfriend, his ex-girlfriend's uncle, and your neighbor's dog.
EXTRAS/NOTES Like Demeter mourning Persephone, Habana Outpost closes down from November until March, but it's a summer place at heart anyway. Be sure to check out movie nights on Sundays at 8 PM and, if you're feeling especially energetic, try mixing your own drink on Habana's patented stationary bike blender (okay, so I made up the part about the patent).
OTHER ONES • Café Habana, 17 Prince St., Manhattan 10012, (212) 625-2002

—*Mina Stone*

Eating & Drinking Green in NYC

With all this talk of climate change and methane-polluting meat production, what is the modern omnivore to do? Embrace the green foodie within. Check out these top-rated restaurants that are also committed to the slow food movement by supplying locally and minding their carbon footprints.

Franny's
Leave it to a Brooklyn pizzeria to make a politically delicious statement.
295 Flatbush Ave. (between Prospect Pl. & St Marks Ave.), Brooklyn 11217, (718) 230-0221, www.frannysbrooklyn.com

Habana Outpost
Eat grilled corn on compostable plates. Drink solar-powered mojitos. Sit outside on recycled-plastic picnic tables. Enjoy the

BROOKLYN

ultimate eco-eatery/community space.
757 Fulton St. (at S. Portland Ave.), Brooklyn 11217, (718) 858-9500, www.ecoeatery.com

Blue Hill
It doesn't get more seasonal and local than "This Morning's Farm Egg," direct from Stone Barns, a biodynamic farm and educational center 30-miles upstate.
75 Washington Pl. (at 6th Ave), Manhattan 10011, (212) 539-1776, www.bluehillnyc.com

iCi
Enjoy your summer salad greens, fresh from Added Value, a not-for-profit farm in Red Hook.
246 DeKalb Ave. (at Vanderbilt Ave.), Brooklyn 11205, (718) 789-2778, www.icirestaurant.com

Ronnybrook Milk Bar
Got grass-fed, hormone-antibiotic-pesticide-free, non-homogenized milk? Get your calcium fill straight from this Hudson Valley dairy farm.
Chelsea Market, 75 Ninth Ave. (between 15th St. and 16th St.), (212) 741-6455, www.ronnybrookmilkbar.com

Appellation Wine & Spirits
Natural, green-friendly wine? Save the world, one organic-biodynamic drink at a time.
156 10th Ave. (between 19th St. and 20th St.), (212) 741-9474, www.appellationnyc.com

For those ready to be eating and drinking green at home, you can get involved in Community-Supported Agriculture (www.justfood.org) and/or join the Park Slope Food Coop (http://foodcoop.com).

—*Emily Tsiang*

Ici
The creme de la creme of the Dekalb restaurant row
$$$$
246 Dekalb Ave., Brooklyn 11205
(between Vanderbilt Ave. and Clermont Ave.)
Phone (718) 789-2778
www.icirestaurant.com

CATEGORY	Nouveau American/American Bistro
HOURS	Tues-Thurs: 8 AM-10 PM Fri/Sat: 8 AM-11 PM Sun: 8 AM-10 PM
SUBWAY	Take the G train to Clinton-Washington.
PAYMENT	VISA MasterCard
POPULAR DISH	The poached eggs, served on top of Anson Mills raw milk cheddar grits, have got to be one of the most beautiful brunch taste sensations ever experienced - somewhere between delightful and dangerous.
UNIQUE DISH	Because the chefs are committed to local farms and sustainable natural foods, the food at Ici is healthy and delicious.

DRINKS	A selection of natural or low-sulfite wines
SEATING	Large, spacious dining room, with an adorable backyard
AMBIENCE/CLIENTELE	You feel like you're eating in a Brooklyn brownstone—warm and inviting.
EXTRAS/NOTES	"Upstairs at Ici" is available for private parties.

—*Mina Stone*

The Pratt Coffee Shop
Greasy, gritty, and always bustling—the diner of your dreams
$$

274 Hall St., Brooklyn 11205
(between Willoughby Ave. and Dekalb Ave.)
Phone (718) 622-0185

CATEGORY	Coffee Shop
HOURS	Mon-Fri: 6 AM-8 PM Sat/Sun: 6 AM-6 PM
SUBWAY	Take a walk if you're close enough and admire the historic brownstones or Pratt Institute's lush urban campus.
PAYMENT	Cash only
POPULAR DISH	Among the house specialties, the mountainous Greek salad is choice, piled high with green peppers, crumbly feta cheese, black olives, and melt-in-your-mouth grape leaves.
UNIQUE DISH	A cult favorite is the split-pea soup, thick as a stew and with oily crouton blocks bobbing on its dense surface. Served only on Thursdays, the soup is enough to make you a frequent visitor, whether you live in the neighborhood or not.
DRINKS	While they do offer beer, and a glass of wine comes with any dinner entree, most people stick to coffee.
SEATING	Seats about fifty. The booths are large and comfortable enough for an evening of caffeinated brainstorming, and small tables near the wall-sized mirror allow you to admire yourself while eating your gyro. Counter seating is also available (if you don't mind socializing with the staff).
AMBIENCE/CLIENTELE	A favorite of locals and University circles, The Pratt Coffee Shop is the kind of noisy, crowded joint out-of-towners picture when they think of New York. The Greek-owned establishment reflects the growing gentrification of its surrounding neighborhood, with a mixed clientele of aging academics, tattooed art students, and young local families. The waitresses are no-nonsense and efficient, so don't expect to decipher anything on your check except the total.
EXTRAS/NOTES	The owner, Nick, has been known to thank regulars for their patronage with a gigantic cookie courtesy of the management.

—*Samantha Charlip*

BROOKLYN

Rice: DUMBO
Trendy eatery featuring the world's most versatile starch
$$
81 Washington St., Brooklyn 11201
(between Front St. and York St.)
Phone (718) 222-9880
www.riceny.com

CATEGORY	Asian
HOURS	Mon: Noon-11 PM
	Tues-Sat: Noon-11 PM
	Sun: Noon-11 PM
PARKING	Take the A,C to High Street, or the F to York Street.
PAYMENT	Cash only
POPULAR DISH	Rice, rice, and rice. Many different kinds, any way you can think of having it, and featuring lots of add-ins like meats, tofu, and sauces.
UNIQUE DISH	While most of the food is of the pan-Asian variety, there are also tamales, Mexican chicken soup, and vegetarian meatballs.
DRINKS	The usual suspects, but also ginger lemonade, Thai iced coffee, hibiscus iced tea, Vietnamese coffee, fresh pressed juices, and warm pear cider.
SEATING	Many small tables and outdoor deck seating during nice weather
AMBIENCE/CLIENTELE	Asian-inspired, minimalist décor; dimly lit, warm atmosphere; pleasant, attentive servers
EXTRAS/NOTES	Take out and delivery available, with a $10 minimum order. They serve a delicious, reasonably priced brunch on the weekends from 10 AM-4 PM.
OTHER ONES	• Flatiron/Union Square/Gramercy: Rice: Lexington, 115 Lexington Ave., Manhattan 10016, (212) 686-5400
	• Rice: Mott St., 277 Mott St., Manhattan 10012, (212) 266-5575
	• Fort Greene: Rice: Fort Greene, 166 Dekalb Ave., Brooklyn 11217, (718) 858-2700

—*Taylor Marqs*

Rice: FORT GREENE.
(See p. 191)
Asian
166 Dekalb Ave., Brooklyn 11217
Phone: (718) 858-2700

"A hundred times have I thought New York is a catastrophe, and fifty times: It is a beautiful catastrophe."
—*Le Corbusier*

BROOKLYN

DOWNTOWN BROOKLYN WEST

Crave
Where Blue Hill, Payard, and Nobu find a home in Brooklyn
$$$$
570 Henry St, Brooklyn 11231
(at 1st Pl.)
Phone (718) 643-0361 • Fax: (718) 643-0385
www.craveus.com

CATEGORY	Nouveau American/American Bistro
HOURS	Mon: Closed
	Tues-Thurs: 6 PM-10:30 PM
	Fri/Sat: 6 PM-11 PM
	Sun: 6 PM-10:30 PM
SUBWAY	F,G at Carroll St.
PAYMENT	VISA, MasterCard, American Express, Discover
POPULAR DISH	Whether you're craving the ten-ounce beef burger (a delicious reminder of why you'll always be a carnivore) or treating your sophisticated foodie-buds to pan-fried rainbow trout over mango orzo, this friendly neighborhood bistro does the fusion thing very well.
UNIQUE DISH	Chocolate chili cake with maple ginger snap ice cream. Yeah, it's already calling your name.
DRINKS	A fine selection of wines
SEATING	19 seats inside, 10 outdoors; A tapas seating area is in the works.
AMBIENCE/CLIENTELE	This is the neighborhood haute cuisine the locals are trying to keep uniquely theirs. In other words, don't let anyone know I told you.
EXTRAS/NOTES	Chef-partners Debbie Lyn and Marco Morillo are trained by some of the culinary art's finest. Before opening Crave, Lyn refined her techniques at Payard and Nobu, and Morillo at Palladin, Atlas, Blue Hill, and Marseilles. This duo does not disappoint.

—*Emily Tsiang*

Just Desserts

No matter what your mood, if you've got a sweet tooth in New York City, it's sure to be satisfied if you know where to look. Some places are better suited for certain occasions than others though, so know before you go!

Junior's is great for a group of friends or a low-key family get-together, and with claims of having "the world's most fabulous" cheesecakes, why not try it? Go to the Brooklyn location for the most authentic experience and retro feel—the Manhattan locations don't measure up to the original. Besides fantastic cheesecake, you can treat yourself to an old fashioned ice cream soda or "mountain high" sundae. Beware—this isn't just hype; portions are extremely generous and lend themselves to sharing. Keep in mind, however, that this isn't the most romantic spot you could find if you're

BROOKLYN

hoping to impress a date.

Cheesecake, no matter how good, might not warm your cold bones during a chilly New York winter. Cold weeks in January call for more drastic measures: **Max Brenner** can offer up a variety of luxury hot cocoas, molten chocolate cakes, or, if you really need to thaw your frozen digits, chocolate fondue for two. Warm your hands by your own personal fire: the fondue comes with a small pot of fire along with a pile of marshmallows and fruit.

If you're not in the mood for doing your own, but still want to warm up, traditionalists can stop by the **Hungarian Pastry Shop** on the Upper West Side. Perfect for a cold rainy night, this cozy café's selection of pastries, strudels, and cakes go wonderfully with a hot cup of tea or coffee, not to mention a tight budget. This is the type of place you'd love to linger over—bohemian and eclectic, yet incredibly intimate and warm: the atmosphere practically begs you to stay. Unfortunately, others will inevitably have the same idea—expect a small, erudite crowd at this Columbia University hangout. Go solo and enjoy the scenery and the carbs, or bring some friends and discuss twentieth-century art.

For moments when extreme comfort is in order, hit up **Rice to Riches** in SoHo. As you probably surmised, rice pudding is their specialty, with over twenty different flavors ranging from vanilla (for the purists) to hazelnut chocolate bear hug. And even if your choice of pudding is traditional, the décor most certainly isn't. If you're okay eating a dessert that's been around since Henry the VIII in a place that the Jetsons would frequent, then have no worries. Space-age design and neon lights surely can't detract from the comfort and warmth of a good pudding, right?

While chocolate fondue between friends, a soul-satisfying pudding, or a perfectly flaky pastry and cup of tea might be great for a cold winter's night or a damp rainy day, those same might not be as appealing in the middle of July. Instead, head downtown where you have your pick between two icy indulgences: gelato and ice cream. The main difference between these two frozen delights? Air content: gelato is denser due to its relatively low content of air bubbles and ice crystals, leading to a creamier, smoother product.

For superior gelato, try **il laboratio del gelato** in the LES, with flavors like honey lavender, toasted almond, and ultra decadent mascarpone, as well as more established favorites. Fans, take note: the laboratio delivers, and many of your favorites can also be found at local retailers. Meanwhile, farther south, the **Chinatown Ice Cream Factory** churns out (pardon the pun) new spins on old favorites; lychee, black sesame, and wasabi are among the more audacious offerings, but you can also find standbys like rocky road. Be flexible and go early: both the lab and the factory are known to run out of popular flavors early, especially on hot days. Also, both places are more inclined for take-out or stand'n'eat.

Junior's
386 Flatbush Avenue Extension at Dekalb Avenue
Brooklyn, New York 11201

BROOKLYN

Telephone: (718) 852-5257

Hours:
Sunday-Wednesday 6:30am 12:30am,
Thursday until 1am, Friday and Saturday until 2am

Max Brenner
841 Broadway (Cross Street: Between 13th Street and 14th Street)
New York, NY 10003
Tele: (212) 388-0030
www.maxbrenner.com

Hours:
Mon-Thu 8am-11pm
Fri-Sat 8am-1am
Sun 9am-11pm

Hungarian Pastry Shop
1030 Amsterdam Ave (Cross Street: 111th Street)
New York, NY 10025-1724
Tele: (212) 866-4230

Hours:
Mon-Fri 8am-11:30pm
Sat 8:30am-11:30pm
Sun 8:30am-10:30pm

Rice to Riches
37 Spring Street
New York, NY
212.274.0008 Open: Sun-Thu 11am-11pm; Fri & Sat 11am to 1am

il laboratorio del gelato
95 Orchard St New York, NY 10002
212-343-9922
www.laboratoriodelgelato.com
Hours: 10AM-7PM daily

Chinatown Ice Cream Factory
65 Bayard Street Manhattan Chinatown New York, NY 10013
Phone: (212) 608-4170
www.chinatownicecreamfactory.com

Hours: Sun-Sat: 11:00am - 10pm or 11pm (Depending on weather.)

—*Jennifer Treuting*

"New York had all the iridescence of the beginning
of the world. The returning troops marched up Fifth
Avenue and girls were instinctively drawn East and North
toward them—this was the greatest nation and there was
gala in the air".
—*F. Scott Fitzgerald*

BROOKLYN

Floyd NY
Come for the brews, stay for the bocce
$$
131 Atlantic Ave., Brooklyn 11201
(between Henry St. and Clinton St.)
Phone (718) 858-5810
www.floydny.com

CATEGORY	Sports Bar
HOURS	Mon-Thurs: 5 PM-4 AM
	Fri: 4 PM-4 AM
	Sat/Sun: 11 AM-4 AM
SUBWAY	Take the F,G to Bergen Street.
PAYMENT	VISA, MasterCard, American Express
POPULAR DISH	Though there is no kitchen in the Floyd NY, it has its place in a dining guide because the Chip Shop next door delivers an English style breakfast to soccer (er, football) viewers on Saturdays and Sundays.
DRINKS	Draft beers like Brooklyn Lager, Stella, and Newcastle are reasonably priced and liquor drinks are stiff. The bar also features an assortment of bourbons sure to please the palate of even the most discriminating of Kentuckians. The "Crapacopia" is a tin pail filled with six of America's most uninspired and ironically-beloved beers—like Schlitz, Schmidt, and PBR. It's sure to please the palate of even the most *un*discriminating of Kentuckians.
SEATING	A huge space filled with old, comfy couches as well as the usual barstools
AMBIENCE/CLIENTELE	A laidback, dimly lit, refreshingly unpretentious bar, where Carroll Gardens and Brooklyn Heights residents come to drink beer, watch English Premiership Football, and play bocce ball on the 40 ft. indoor clay court. Yes, you read that right, there's an indoor bocce court and Floyd hosts NYC's only year-round bocce tournament.
EXTRAS/NOTES	Happy hour is everyday from 5 PM-7 PM.

—Charles Battle

PROSPECT PARK

2nd Street Café
Eclectic American food + table paper and crayons
$$$
189 7th Ave., Brooklyn 11215
(at 2nd St.)
Phone (718) 369-6928 • Fax: (718) 369-6804
www.2ndstreetcafe.com

CATEGORY	Nouveau American/American Bistro
HOURS	Mon-Thurs: 8 AM-10:30 PM
	Fri: 8 AM-Midnight
	Sat: 8:30 AM-Midnight
	Sun: 8:30 AM-10:30 PM
SUBWAY	There is limited metered street parking on 7th Avenue, and free (read: hard to get) parking on

BROOKLYN

the side streets. The 7th Avenue bus stops near by, and there's an F train stop at 9th Street and 7th Avenue. The B and Q train at 7th Avenue and Flatbush Avenue also isn't too far away.

PAYMENT VISA MasterCard

POPULAR DISH The mac and cheese succeeds because of its simplicity; it doesn't need any of those fancy ingredients that other restaurants throw in. And you can taste the difference that "grass fed free range" makes in the rib eye steak. Many of the dishes here sound familiar, but it's the little touches that make them so memorable: creamy nutmeg dressing on a goat cheese salad, crab cakes with cilantro tartar sauce.

UNIQUE DISH Even in restaurant-laden Park Slope, 2nd Street Cafe provides a nice balance between eclectic American offerings and good old-fashioned comfort food. It is also sensitive to the needs of vegetarians, offering a number of salads, a veggie burger, vegetarian chili, and a BBQ tofu sandwich.

DRINKS Beer, wine, and the usual sodas.

SEATING There are many tables available and, weather-permitting, the restaurant nearly doubles in size with outdoor seating. The dining area isn't tiny, but it is cozy and all the tables are in one room.

AMBIENCE/CLIENTELE A mixed crowd of older Park Slopers, who've watched the gentrification of the neighborhood, and young families partially responsible for said gentrification. 2nd Street offers a kids' menu and you'll likely see a fair number of children there, drawing with the paper and crayons available on each table. Their artwork (and maybe that of their parents?) covers the walls and ceiling.

EXTRAS/NOTES Breakfast, lunch, and weekend brunch are served. After 9 PM most days (6 PM on Sundays) a burger and beer will only run you $9 total. Daily specials frequently change, depending on the season, but Tuesday is Turkey Dinner Night.

—Alicia Kachmar

200 Fifth
40 beers on tap + 30 TVs = good weekend
$$
200 Fifth Ave., Brooklyn 11217
(between Union Street and Sackett Street)
Phone (718) 638-2925
www.200-fifth.com

CATEGORY Sports Bar
HOURS Mon-Weds: 4 PM-1 AM
Thurs: 4 PM-2 AM
Fri/Sat: 11 AM-3 AM
Sun: 11 AM-1 AM
SUBWAY There is limited street parking in this area. The R train at 4th avenue and Union Street is only one block away. All trains at Atlantic Avenue are a short walk, and the 5th Avenue bus makes a stop nearby.
PAYMENT VISA MasterCard AMERICAN EXPRESS DISCOVER

BROOKLYN

POPULAR DISH Unlike a lot of sports bars, 200 Fifth boasts a full menu not limited to pub grub and finger food. In general, the cuisine is American or Continental, focusing on seafood, steaks, and Italian dishes.

UNIQUE DISH The four types of Buffalo wings and ribs are worth the pile of napkins you'll need to eat them, but there are also many good fork-and-knife options like blackened catfish, steak au poivre, and penne arugula. Entrees are more expensive than typical bar food, but appetizers are affordable and there's even a "bargain menu."

DRINKS With 40 beers on tap, and many other beers by the bottle, there is something for everyone. Sure, you'll find the usual draft choices, such as Guinness, Stella, and Yuengling, but take advantage of the variety and try one of the more obscure Belgium beers or the house brew, 200 Fifth Lager. 28 kinds of wine and 4 kinds of champagne, there are also 11 special martinis. Try the Coney Island Breeze, a concoction of cranberry vodka, Midori, grapefruit juice, and sour mix. The curiously named Violetta packs quite a punch with Stoli vanilla, Godiva chocolate liqueur, and Kahlua. If the martini and beer selection doesn't impress you, there are many alcoholic "ice cream drinks" on the menu as well.

SEATING There are many tables on the restaurant side of 200 Fifth, but there are also booths and counter seats on the bar side. During weekend sports events, the pool table is often replaced with more tables and chairs.

AMBIENCE/CLIENTELE 200 Fifth has a solid neighborhood following and, during football season, Sunday games bring out the regulars. The restaurant side is more family-oriented, but there are several televisions and a small bar there, too. All ages and sexes are represented, but like most sports bars the largest contingent is twenty-something males.

EXTRAS/NOTES 200 Fifth offers a kids' menu and there are paper and crayons on each table on the restaurant side. Happy hour is Monday through Friday until 7 PM; $3 beers and bar drinks should make you very happy indeed. There's a pool table in back, and weekend nights there's a DJ. With 30 televisions, you can watch almost any game, match, or contest, and that includes soccer, NASCAR, golf, even boxing.

—*Alicia Kachmar*

Beast
Deals that can tame even the most ferocious . . . you see where I'm going with this, right?
$$
638 Bergen St., Brooklyn 11238
(at Vanderbilt Ave.)
Phone (718) 399-6855 • Fax: (718) 399-6877
CATEGORY Neighborhood bar
HOURS Mon-Tues: 6 PM-2 AM

BROOKLYN

Weds-Fri: 6 AM-2 AM
Sat/Sun: 11 AM-2 AM

SUBWAY Take the B,Q to 7th Avenue, or the 2,3 to Bergen St. Metered parking also available.

PAYMENT

POPULAR DISH Beast specializes in small plates and tapas, using fresh seasonal ingredients. Rustic offerings include boar sausage, roast vegetables, and various other Mediterranean-style dishes. The food is delicious, but pricier than the drinks. Bargain hunters should go for the brunch offered on weekends between 11 AM and 3 PM. Most entrees start at $11.95, and range from French toast to chorizo to homemade granola to skirt steak. For two bucks extra, you can add a mimosa, draft beer, or Bloody Mary. Night owls, beware: the kitchen closes at 10:30 PM weeknights.

DRINKS With two happy hours, any drink has the possibility to be a hit. Go between 4 and 7 PM any day of the week, 10 and midnight on weeknights, or midnight to 2 AM on weekends. Well drinks and tap beers are only $3, so sit back and indulge. Beers on tap include local Brooklyn favorites and also some Belgian and Czech selections. Besides the beer, Beast has an extensive wine list and is planning to have regular tastings and events. For the winos out there, quartinos (1 ½ glass servings—perfect to share) are a great option, but bottles and single glasses are also available.

SEATING Besides the front bar area (seats maybe 20, at the rather generous bar as well as at tables), Beast has a back room with tables seating 2-4 people.

AMBIENCE/CLIENTELE Definitely a hidden gem, Beast is low-key, unpretentious, and just a little bit Goth: gargoyles, candles, and other touches adorn the front and back rooms. Don't worry though, instead of coming off as emo, gloomy, or over-the-top, the effect is warming and cozy. The front room is lively and social—full of groups and couples with a busy bar and tables, while the back is usually quiet and intimate (great place to bring a date as you can actually hear what you're both saying). Whatever your mood and whoever you are, Beast is sure to please. Its friendly staff and laid back atmosphere attract young professionals, artists, and neighborhood residents alike.

EXTRAS/NOTES Unleash your inner dork with "Pocket Protector" Trivia, Mondays at 10 PM. Prizes include bottles of wine and, of course, eternal glory. If you're of the female persuasion, it's worth noting that Thursdays are ladies' night, with happy hour all night long at the bar. Also, if socializing, people-watching, and drinking aren't enough for you, Beast has a number of board games at your disposal.

—*Jennifer Treuting*

BROOKLYN

Buttermilk
Indie rock(ers) meets board games meets office chairs meets grandparents.
$$

577 Fifth Ave., Brooklyn 11215
(at 16th St.)
Phone (718) 788-6297

CATEGORY	Hipster neighborhood bar
HOURS	Daily: 6 PM-4 AM
SUBWAY	There is a parking lot one block away on 5th Avenue and street parking, but your best bet is to take the R train to Prospect Ave. (and Fourth Ave.). The F train at Fourth Ave. and 9th St. is also close.
PAYMENT	VISA MasterCard American Express Discover
POPULAR DISH	No food is served at Buttermilk. So why is it mentioned here then? Why, because on Wednesday nights, free pizza is had by all, and you can't get much cheaper than free. As is customary in New York bars that don't provide edibles, one is welcome to order in from neighborhood restaurants.
DRINKS	Go for the cheap beer, in bottles and on tap, but better yet, go for the cheap mixed drinks. I like to refer to them as "Brooklyn cheap," because of their 4/1 liquor to mixer ratio. It may not be a "good" drink, but it's definitely a value. They carry some commonplace beers that, oddly enough, are sometimes difficult to find in New York bars, such as Rolling Rock and Busch. Other than that, take advantage of the bar's non-drink amenities.
SEATING	If you like having your choice of large communal tables, vinyl booths, aluminum office chairs, or old-school desks, this is the place for you. The desks, with notebook-sized writing surfaces, are slightly slanted, which makes for an interesting challenge when setting down your drink.
AMBIENCE/CLIENTELE	If you thought you'd never bump into your indie rocker co-worker and your grandmother's doppelganger at the same Brooklyn bar, drinking the same cheap beer and pumping quarters into the jukebox, think again. The crowd is generally of the young, hipster persuasion, but on any given night there could be a handful of older folks, tapping their feet to Death Cab or the Pixies. Buttermilk might also be the only bar to feature both free Atari night and the monthly "CasHank Hootenanny Jamboree," an open jam featuring Johnny Cash and Hank Williams tunes. Watch or play an engrossing round of Connect-Four or Scrabble while listening to a gaggle of flannel-clad, skinny-legged guys playing washboards and jugs.
EXTRAS/NOTES	There's no sign out front, and with blinded windows and a single door, you could easily pass by this place. Look for the hipsters smoking out front.

—*Alicia Kachmar*

BROOKLYN

Christie's Jamaican Patties
Affordable take-out patties in an affordable neighborhood
$

387 Flatbush Ave., Brooklyn 11238
(at 8th Ave.)
Phone (917) 682-2848

CATEGORY	Jamaican
HOURS	Daily: 10 AM-10 PM
PARKING	Parking on Flatbush Ave. is not easy, as there are few spots and constant traffic. The 2 and 3 trains at Grand Army Plaza are very close, and the B and Q trains at 7th Ave. are not much farther.
PAYMENT	Cash only
POPULAR DISH	Most customers come for the cheap patties, which are all under $2 and come in chicken, beef, and vegetable varieties. While beef seems to be the most popular, I favor the chicken, which boasts a lot of spice and flavor. The vegetable is a lot less greasy than the meat varieties, but is still packed with the same amount of punch. And when you can try all three for under $6, you can afford to grab a beverage, too (which you'll need to cool down your mouth).
UNIQUE DISH	The jerk chicken is spicy enough to have you downing Jamaican sodas at a rapid pace, but you won't regret it. Unlike many Jamaican eateries that tone down the spices for their respective gentrified neighborhoods, Christie's doesn't let you off that easy. Tired of the more standard patties or jerk chicken? Try the curried oxtail or curried goat and then finish your meal with one of Christie's desserts, which include coca bread, bread pudding, and Lalaloo rolls.
DRINKS	No alcohol, but a wide variety of Jamaican sodas. With names like "Irish Moss," "Magnum," and "Sour Sop," one can't help but be curious about the flavors.
SEATING	Seating is limited, with only a few small tables.
AMBIENCE/CLIENTELE	Christie's is more of a take-out joint, so there is a constant flow of customers: the father and son on their way home from work and school, trying oxtail for the first time; the regulars who don't even need to glance at the menu; the construction workers, police officers, and high school students who come to Christie's for the delicious BBQ chicken wings.
EXTRAS/NOTES	While there are definitely kids present, it's not exactly a kid-friendly establishment; there are no high chairs, no bathroom, and many of the foods are too spicy for a child's palette. Still, on any given night you might run into the daughter of one of the Christie's employees, riding around the restaurant on her scooter.

—*Alicia Kachmar*

BROOKLYN

Franny's
*Wine and brick-oven pizza
with a philosophy*
$$$

295 Flatbush Ave., Brooklyn 11238
(between St. Marks's Ave. and Prospect Pl.)
Phone (718) 230-0221
www.frannysbrooklyn.com

CATEGORY	Italian
HOURS	Mon: closed
	Tues-Thurs: 5:30 PM-11 PM
	Fri: 5:30 PM-11:30 PM
	Sat: Noon-11:30 PM
	Sun: Noon-10 PM
SUBWAY	Limited street parking is available, but public transit is encouraged. Several buses travel on Flatbush Avenue. The B and Q trains at 7th Avenue are a block and a half away. The 2 and 3 trains at Bergen Street are only two and a half blocks away.
PAYMENT	VISA MasterCard AMERICAN EXPRESS DISCOVER
POPULAR DISH	The menu can vary slightly depending on what is in season, but most patrons come for the pizza, which is cooked in an old wood-burning brick oven. Franny's philosophy centers on sustainable agriculture: using local ingredients and using them in season. All of the pizzas are fantastic, especially those with buffalo mozzarella and a simple tomato sauce. The combination of fresh ingredients and made to order service can be tasted in such a simple dish.
UNIQUE DISH	The meats at Franny's also fall under the sustainable agriculture category; no hormones or antibiotics are used. In addition, they are cured in-house, and the "house-made sausage" is pleasantly spiced and vastly different from the sausage at a regular pizza joint.
DRINKS	There is an extensive wine and beer list available, and the waiters are adept at giving suggestions. Wine-tasting is allowed before committing, which is always a sign that a restaurant cares about its patrons and service. There are several unique cocktails, including the Lime Greyhound, a concoction of vodka, Campari, and lime and grapefruit juices.
SEATING	Franny's is medium-sized, but it becomes crowded very quickly most days of the week. On weekends, the wait for a table will be longer. Outside seating is available when the weather permits.
AMBIENCE/CLIENTELE	Franny's feels a lot like the two gentrified neighborhoods surrounding it: young, professional, trendy. Manhattanites and others definitely make the trek to Brooklyn because of all the positive press. There are often a few very small children, but the tables are very close and the sheer loudness doesn't make it too kid-friendly, even for the ubiquitous kid-toting couples in the 'hood.
EXTRAS/NOTES	Although Franny's can be crowded, the food and drinks are worth the wait. The husband and wife

team both contribute their personal philosophies and affinities to this traditional Italian cuisine spot. Sweatshop-free t-shirts are for sale and information about the locally-grown ingredients is available.

—*Alicia Kachmar*

Geido
Save your frequent flyer miles and skip Kyoto—Brooklyn's just as good
$$$
331 Flatbush Ave., Brooklyn 11217
(between Park Pl. and Prospect Pl.)
Phone (718) 638-8866

CATEGORY	Japanese
HOURS	Mon: Closed
	Tues-Thurs: 5:30 PM-10:45 PM
	Fri/Sat: 5:30 PM-11:15 PM
	Sun: 5:30 PM-10:15 PM
SUBWAY	B,Q at Seventh Ave.; 2,3 at Bergen St.
PAYMENT	VISA, MasterCard, American Express
POPULAR DISH	If you had a new dish each time you came to Geido, it'd be a few weeks before you'd have to repeat. The wide-ranging menu can be intimidating, especially since all of its offerings are delicious. While all of the food is wonderful, Geido is known for having some of the best sushi in the 'hood (especially their Battera rolls), as well as excellent okonomiyaki, a thick Japanese pancake made with a variety of ingredients including cabbage, squid, and vegetables, topped with sauce and bonito flakes. If you still have room for dessert, try the tempura-fried banana with green tea ice cream.
UNIQUE DISH	Look at the chalkboards once you're seated. Seasonal items and specials are listed here that might not appear on the menu. Pumpkin croquettes, for instance, were a wonderful find.
DRINKS	Beer, Wine, Sake, Soujou.
SEATING	Tables for couples as well as small groups, along with seating at the sushi bar. Tables can be combined for larger groups.
AMBIENCE/CLIENTELE	When you walk in, the first thing you'll notice is the bright and colorful graffiti covering the walls: drawings, notes, scrawls, all of it fun and upbeat. It's not unusual to see a toddler gamely using chopsticks two tables away from a group of hipsters. The food here is great and attracts a variety of people from the Slope and surrounding 'hoods. Be prepared to navigate around strollers earlier in the evening. Later on in the night, the crowd skews toward young professionals. Despite the masses of people that Geido draws, the staff remains pleasant, though they sometimes clear plates a bit quickly, especially during rush hours.
EXTRAS/NOTES	Geido has lunch hours Thursday through Sunday from noon to 2:30 PM.

—*Jennifer Treuting*

BROOKLYN

Joya
(See p. 206)
Thai
215 Court St, Brooklyn 11201
Phone: (718) 222-3484

Park Slope Taqueria
(See p. 204)
Mexican
74 7th Ave., Brooklyn 11215
Phone: (718) 398-4300

Purity Diner
*Park Slope hospitality . . .
and free coffee refills!*
$$$
289 7th Ave., Brooklyn 11215
(at 7th St.)
Phone (718) 840-0881

CATEGORY	Coffee Shop
HOURS	Sun-Thurs: 6 AM-12:30 AM
	Fri/Sat: 6 AM-6 AM
SUBWAY	Take the F to 7th Ave./9th St.
PAYMENT	VISA MasterCard American Express Discover
POPULAR DISH	The French toast, pancakes, and Belgian waffles are all very good choices here. Breakfast is served all day (naturally) and offers the best value for your money, especially when you add eggs for a minimal extra charge. The 95¢ coffee (which includes free refills) rounds out a perfect meal.
UNIQUE DISH	Beyond the standard diner fare of burgers and omelets, Purity also offers Greek wraps, spanikopita, grape leaves, and soups like lobster bisque and clam chowder. And be sure to check for the daily specials, too. This neighborhood does not have too many traditional diners like this one and, although the prices are not exactly cheap, the food is consistently good and the atmosphere is a nice change from the trendy restaurants that keep popping up nearby.
DRINKS	There are a few wine and beer choices, but try an egg cream or milkshake instead. Clean living never tasted so good.
SEATING	A number of tables and booths, all in one large dining room.
AMBIENCE/CLIENTELE	Regulars are very comfortable here, and they hang around drinking coffee and watching the news on the diner's one television. While the clientele tends to be on the older side, there are also plenty of mixed groups, presumably with grandchildren, grandparents, and parents all at one table. Maybe it's the black-and-white photos of Brooklyn and, specifically, the neighborhood, or the old tin ceilings and brick walls, but there's a definite sense of history here.

BROOKLYN

EXTRAS/NOTES	There are many high chairs available, and although there isn't a kids menu per se, the diner food is certainly kid-friendly. The service is great; food arrives hot and fast.

—*Alicia Kachmar*

Rachel's Taqueria
Burritos for the baby-lovin' Brooklynites.
$$
405 5th Ave., Brooklyn 11215
(between 7th St. and 8th St.)
Phone (718) 788-1137
www.rachelstaqueria.com

CATEGORY	Mexican
HOURS	Daily: 11 AM-11 PM
PARKING	There is street parking available, but as with most restaurants in New York, public transportation is the easiest option. Take the F or R train to the 4th Ave./9th St. stop and walk from there. If you must drive, then I suggest double-parking and taking advantage of the fast, cafeteria-style to-go service.
PAYMENT	Cash only
POPULAR DISH	The Park Slope Vegetarian Burrito is my favorite dish, not just because it combines two of my favorite things—the neighborhood of Park Slope and vegetarian cuisine—but because it's really cheap and tasty! The burrito comes with your choice of red or black beans, rice, guacamole, pico de gallo, sour cream or nonfat yogurt, cheese, and lettuce. All that for $6.25, and I have yet to finish a PSV in one sitting because I, like so many others, end up eating far too many chips in between bites of burrito.
UNIQUE DISH	In addition to cheap burritos, corn on the cob, and the best chicken mole I've had in New York, Rachel's also offers a delicious rotisserie chicken, marinated for two days before slow-roasted. The princely sum of eight dollars will get you a whole chicken, beans, rice, pico de gallo, and tortilla chips. And, as with most menu items here, you'll likely ask for some foil to wrap up your leftovers.
DRINKS	Fresh lemonade, jarritos (Mexican soda), and regular soda are available. For the adults, Rachel's offers beer and red sangria. During the summer months, watermelon juice is a refreshing treat.
SEATING	Indoor seating is limited, especially when it gets busy on the weekends. If you dine during the summer, however, the outside garden nearly doubles the size of the place.
AMBIENCE/CLIENTELE	Can it be authentic Mexican cuisine if there are only Gringos eating it? Well, Park Slope is populated by young professionals, many of them stroller-pushing, and it seems they like their burritos as much as their babies. Rachel's is definitely supported by its neighbors, as indicated by the I-just-got-off-the-subway-and-need-dinner look its patrons often display. Laptop cases slung around their shoulders, iPods on pause, these

	rushed Brooklynites favor the cafeteria-style ordering that will put dinner on the table in five.
EXTRAS/NOTES	The bright colors, variety of lighting, vintage rock posters, and classic rock music all make Rachel's a very stimulating and vibrant environment. In other words, there's a lot here to distract the kids, not that they need much distraction when food is prepared and served in under five minutes.
OTHER ONES	• Park Slope: Park Slope Taqueria, 74 7th Ave., Brooklyn 11215, (718) 398-4300

—Alicia Kachmar

Soda Bar and Lounge
Soda fountain turned beer fountain.
$$
629 Vanderbilt Ave., Brooklyn 11238
(between Prospect Pl. and St. Marks Ave.)
Phone (718) 230-8393

CATEGORY	Lounge
HOURS	Mon-Weds: Noon-2 AM Thurs-Sun: Noon-4 AM
SUBWAY	There is some street parking available, but getting here via subway is more reliable. The 2,3 trains at Bergen Street or Grand Army Plaza are about equidistant from Soda. The Q and B trains at 7th Avenue are also nearby.
PAYMENT	VISA MasterCard American Express Discover
POPULAR DISH	The menu at Soda consists of "bar food," but the fact that it's actually good makes it stand out from a lot of bars. Offerings include fish and chips, burgers, chicken wings, pizza, salad, and even pierogies. Everything comes in a no-frills basket and, fortunately, such Spartan presentation is reflected in the prices, which range from about $3.50-$8.50.
DRINKS	There are about 15 beers on tap here and, at happy hour, these $3 drafts are hard to resist. Occasionally there are other drink specials such as $10 pitchers of Brooklyn Lager. The Vanderbilt—named for the street where the bar is located—is a martini with lime juice. I'm not usually one for martinis, but this simple concoction is extraordinarily tasty. Wine-by-the-glass is a cheap option and most mixed drinks are made strong.
SEATING	The main bar has a few tables and cherry red fountain-style bar stools, recalling its former life as a German-owned ice cream parlor in the 1930's. There's also a large lounge area with old comfy chairs and ottomans and a garden/patio in back, weather permitting.
AMBIENCE/CLIENTELE	Soda frequently feels low-key, no matter how crowded it gets on weekends, now that the surrounding neighborhood is becoming more popular. One gets the feeling a lot of regulars are populating the place, waiting for favorite seats and ordering their usual drinks. Patrons come in pairs or groups, rather than singularly, but

BROOKLYN

even as a single walk-in, the atmosphere is not intimidating.

EXTRAS/NOTES Happy hour will get you $3 drafts, sure, but what really make Soda unique are its events. There are weekly movie nights, often with a short film to start, and there has even been a craft fair on the premises. Although the bar has no website detailing the schedule, events are advertised in the window.

—*Alicia Kachmar*

Song
Trendy atmosphere without paying for it!
$$
295 5th Ave., Brooklyn 11215
(between 1st St. and 2nd St.)
Phone (718) 965-1108

CATEGORY Thai
HOURS Sun-Thurs: 5 PM-11 PM
Fri/Sat: 5 PM-Midnight
SUBWAY Take the R to Union St., or the F to 4th Ave./9th St.
PAYMENT Cash only
POPULAR DISH There are so many dishes to recommend here. The Pad Thai is excellent, as are the curries. Tofu tod, an appetizer, illustrates how perfectly this restaurant fries tofu: crispy on the outside and soft on the inside. Dishes are appropriately spicy, but not overpowering. The mango salad is a good starter.
UNIQUE DISH Nothing too crazy on the menu, but it should be noted that portions are huge; easily big enough for two people or for next day leftovers. And because most dishes are under $7, this is an exceptionally affordable spot for a date.
DRINKS There is a full bar, with beer and wine. They make a great mojito (the mint is actually muddled!). The mango martini is a unique choice if you're in the mood for something sweet.
SEATING There are many tables, as well as an outdoor seating area with grass and floor pillows when the weather allows it.
AMBIENCE/CLIENTELE Once you've been to Song, you'll keep coming back, especially if your abode is down the street. There are definitely neighborhood regulars here, but Manhattanites are hearing good things and are starting to make the trek out to Brooklyn.
EXTRAS/NOTES This is a great place to go with a big group of people, as the wait staff will rearrange tables for you. A DJ spins very loud music later in the evening—for better or worse. But hey, if your date is going badly, at least you'll have an excuse to keep silent.
OTHER ONES • Prospect Park: Joya, 215 Court St. (at Warren St.), Brooklyn 11201, (718) 222-3484

—*Alicia Kachmar*

BROOKLYN

Tea Lounge
Luscious lattes in hipster heaven.
$$
350 7th Ave, Brooklyn 11215
(at 10th St.)
Phone (718) 768-4966
www.tealoungeny.com

CATEGORY	Coffee house, Tea room and Wine bar
HOURS	Mon-Fri: 7 AM-Midnight Sat/Sun: 7 AM-2 AM
SUBWAY	F train to 7th Avenue in Park Slope. Also plenty of area parking.
PAYMENT	VISA, MasterCard, American Express, Discover [ATM]
POPULAR DISH	Cookies, sandwiches, and enormous cupcakes!
DRINKS	Best lattes in the city, though I'm partial to their vegan chocolate chip and oatmeal cookies. Beer, wine, coffee and tea. Famous for their hot chocolates.
SEATING	Sofas and chairs, which are comfy and great for lounging
AMBIENCE/CLIENTELE	Caters to hipsters and urban artists.
EXTRAS/NOTES	Tea Lounge is one of the few places in Park Slope that's well worth the half-hour trip from Manhattan. I love the coffee, I love the tea, I love the couches, and I love the people. A great place to while away the hours munching on oatmeal cookies and soy lattes (i.e. forget Starbucks!)
OTHER ONES	• 254 Court St. (between Kane St & Butler St.), Brooklyn (718) 624-5683 • 837 Union St. (between 6th Ave. and 7th Ave.), Brooklyn (718) 789-2762

—*Aly Walansky*

Uncle Moe's Burrito & Taco Shop
(See p. 109)
Mexican
341 Seventh Ave., Brooklyn/Park Slope 11215
Phone: (718) 965-0006

"New York is nothing like Paris; it is nothing like London; and it is not Spokane multiplied by sixty, or Detroit multiplied by four. It is by all odds the loftiest of cities. It even managed to reach the highest point in the sky at the lowest moment of the depression."

—*E.B. White*

BROOKLYN

Union Hall
The bocce, beer, and books bar.
$$

702 Union St., Brooklyn 11215
(between 5th Ave. and 6th Ave.)
Phone (718) 638-4400
www.unionhallny.com

CATEGORY	Trendy joint
HOURS	Mon-Fri: 4 PM-4 AM Sat/Sun: 12 PM-4 AM
PARKING	Limited street parking is available, but the subway or bus is your best bet. The R train at 4th Avenue and Union Street is only one block away, and the Atlantic Avenue trains aren't too far either. The 5th Avenue bus also stops nearby.
PAYMENT	VISA MasterCard American Express Discover
POPULAR DISH	This ain't your typical bar food, even though most of it is of the finger food variety. Opt for the beer cheese, potstickers, or mini sirloin burgers made with bacon, scallions, and Guinness beer.
UNIQUE DISH	If you're feeling really gutsy, order the "Saga Cheese Balls," deep fried Apple Cinnamon Cheerios covered in bleu cheese and served with a pear brandy and chestnut puree. Most menu items are priced in the $6-9 range.
DRINKS	Brooklyn is known for affordable boozing, relative to Manhattan at least, and Union Hall is no exception. Union Hall has a fully-stocked bar, a perk one can't always find in this neighborhood. Choose from twelve beers on tap, including Yuengling, Lagunitas IPA, Chimay, and Hoegaarden. There are also several reasonably priced wines available. Choose one of the many kinds of Scotch and get comfortable in one of the bar's couches. If Scotch doesn't give you that warm, fuzzy feeling, order milk and cookies from the menu and wax nostalgic.
SEATING	In a city where space is rare, Union Hall is a 5,000 square foot oasis. There are plenty of tables and couches, and there's even another bar downstairs where patrons can enjoy live music or other events (seating downstairs changes depending on the event). In fair weather, check out the small outdoor garden on the side.
AMBIENCE/CLIENTELE	The night time brings crowds to Union Hall, most of which consist of young neighborhood professionals and hipsters. The latter tend to hang out downstairs, listening to live indie rock. Upstairs there is a jukebox and two indoor bocce courts, so the noise level can be high.
EXTRAS/NOTES	Eccentric events in the downstairs bar include a Spelling and Grammar Bee and a Secret Science Club. Numerous bathrooms prevent the beer-induced lines found in so many bars. Happy hour runs from 4-7 PM, and regulars know it's a good idea to arrive before the after-work crowd does.
OTHER ONES	Floyd NY is a sister bocce bar in Carroll Gardens/Brooklyn Heights; same owner and similar clientele.

—Alicia Kachmar

BROOKLYN

Veggie Castle
Converted White Castle offers healthy, creative, and colorful vegan meals and baked goods.
$$

2242 Church Ave., Brooklyn 11226
(at Flatbush Avenue)
Phone (718) 703-1275

CATEGORY	Jamaican/Vegan
HOURS	Sun-Thurs: 10 AM-11 PM Fri-Sat: 10 AM-Midnight
SUBWAY	Q to Church Ave., 2, 5 to Church Ave.
PAYMENT	Cash only
POPULAR FOOD	Lunch specials for $5 include rice and beans, a choice of vegetables, and entrees ranging from baked tofu in a tangy barbecue pineapple sauce, to a curry or barbecue soy with stewed carrots and onions; also try their famous veggie burgers and vegan macaroni and cheese
UNIQUE FOOD	Veggie Castle bakes its own patties (soy, *callaloo*, veggie, soy chicken), cassava balls, and cakes (some made without eggs, lard, or yeast); apple cinnamon, pumpkin, and banana nut breads
DRINKS	Over 42 fresh juices and smoothies, each prescribed as its own remedy "to cure what ails ya" are what makes this restaurant unique; try the #1 Cold and Flu, the #10 Memory, the #16 Fatigue or the #34 Green Juice. *Hungry?* can't vouch for their therapeutic powers, but we promise they'll work wonders for your taste buds.
SEATING	Plenty of comfortable seating for parties ranging from two to 20
EXTRAS/NOTES	Veggie Castle operates out of an old White Castle—basically a 180-degree turnaround from its predecessor. After your meal, be sure to check out the Castle's natural foods and supplement section, stocked with everything from oat bran and unbleached wheat flour, to the very same protein powders and spirulina used in the restaurant's juice concoctions. The Castle also sells ginseng, sea moss, *baji*, and locally grown bee pollen, honey, and molasses.

—*Scott Gross*

SOUTH BROOKLYN

Brennan and Carr
Hot wet beef and soggy buns make for lowbrow, artery-clogging goodness
Since 1938
$$$

3432 Nostrand Ave., Brooklyn 11229
(at Ave. U)
Phone (718) 646-9559
http://brennanandcarr.kpsearch.com/df/default.asp

CATEGORY	Sandwich Shop

BROOKLYN

HOURS Mon-Thurs: 11 AM-Midnight
Fri-Sun: 11 AM-2 AM

PARKING Parking is never a problem with two free lots. The nearest subway stop is Ave. U at E. 16th Street, about a half mile away. Both the Nostrand Ave. bus and the Ave. U bus stop are within feet of the restaurant.

PAYMENT Cash only

POPULAR DISH Roast beef with cheese sandwich, double dipped in beef broth (first the beef, then the entire sandwich). They try to get all low-carb with a roast beef plate—minus the bun, plus carrots and string beans—but the broth-infused bread is where it's at. The grilled chicken sandwich on the menu tones down the "no girls allowed" vibe.

UNIQUE DISH The roast beef is served on soggy buns and often eaten with a knife and fork (due to the double dippage). While this may seem strange or even unappealing at first, regulars swear that it's the best sandwich in Brooklyn, New York City, America . . . maybe even the world.

DRINKS Domestic beer served in frosty mugs.

SEATING Small shack with 2 dining rooms. Lots of small tables.

AMBIENCE/CLIENTELE The same little old roast beef shack with a dimly-lit interior has been slinging beef since 1938. The back room has a portrait of George Washington with a scribbled-on mustache that old timers insist has been there from the beginning. The clientele mainly consists of multi-generational, working-class locals and the occasional hipsters or foodies who have heard the lore.

EXTRAS/NOTES Everything served at this little Irish shack could be found on a kids menu (hot dog, hamburger, roast beef sandwich, chicken wings, french fries). Rumor has it that "first cut" beef exists for valued customers. Grumpy old men, cops, construction workers, and families pack the place for lunch and dinner.

OTHER ONES • 65 North Village Ave., Rockville Centre, NY 11570, (516) 594-0920

—Eddie McNamara

Seasonal Sabor: Authentic Comida Latina at the Red Hook Ball Fields

The Scene: A complex of unkempt ball fields at the corner of Clinton Street and Bay Street in Brooklynís Red Hook neighborhood. Tarpaulin and rope lean-tos cover folding tables and makeshift grills. Mexicans, Hondurans, Ecuadorians, and Caribbeans all carousing, cooking, corralling kids, or kicking soccer balls. Music boxes blasting. Flags flying proudly. This is New York multicultural splendor.

The Food: All the Latino staples are available: tacos, corn on the cob, quesadillas, taquitos, tamales, ceviche, freshly sliced mangoes and watermelons. Vendors cook homemade tortillas fresh on a griddle, and they grill beef, chicken, and chorizo. Melting cheese

BROOKLYN

is freshly grated. Topping cheese is freshly crumbled. Radishes are chopped finely, pickled onions and cabbage slaw are scooped out of large tubs. Lime and cilantro are served with everything.

The Best: The Haurache. Start with a thick tortilla and a layer of blackbeans; add your choice of chicken, beef, or pork; then add toppings, as many as you want: lettuce, pickled onions, crumbled Mexican cheese, salsa verde, pico de gallo, hot sauce, or sour cream ("crema").

The Drink: Some vendors sell beer out of paper bags. Sodas are around. If you're slightly more daring, you could try the horchata, a dark punch, heavily sugared, and smacking of cinnamon.

The When: I don't know who oversees this gathering. Perhaps no one. Everything about it is informal. What I can tell you is that it starts around the beginning of May and it goes until some time in October. On the weekends in between, vendors hawk their fare regardless of the weather.

The How (Much): Very few stands have listed prices. Most people I know pay around three or four dollars for larger items, less than two dollars for small plates and for fruit, and one dollar for drinks. But I get the impression that if you know the vendor, or you speak Spanish, or you look like you might, you pay a bit less.

—Ryan Auer

Gino's Focacceria

Friendly staff, generous portions of delicious Italian classics.
$$
7118 18th Ave., Brooklyn 11204
(between 71st St. and 72nd St.)
Phone (718) 232-9073

CATEGORY	Neighborhood Italian restaurant
HOURS	Mon-Thurs: 11 AM-8 PM Fri/Sat: 11 AM-9 PM
SUBWAY	N. or W. to 18th Ave.
PAYMENT	Cash only
POPULAR FOOD	You can't go wrong with any of the pastas served *al dente*—particularly with tender calamari in a marinara sauce or in a light vodka sauce; eggplant is prepared just how it should be—lightly breaded without a hint of grease
UNIQUE FOOD	For the adventurous: *Vasdette* roll (boiled cow spleen on fresh-baked roll with ricotta and parmesan)
DRINKS	Mineral water, beer, wine, coffee
SEATING	Ample seating: six large booths and 10-12 tables
AMBIENCE/CLIENTELE	Chianti bottles and the Italian flag are a nice touch, but locals come for the food, not the ambience
EXTRAS/NOTES	Dinner entrees include salad bar and warm bread—a real bargain.

—Julia Pastore

BROOKLYN

Joe's of Avenue U
*Sicilian peasant food that puts
Ma's sauce to shame*
$$$
287 Avenue U, Brooklyn 11223
(between McDonald Ave. and Lake St.)
Phone (718) 449-9285 • Fax: (718) 449-5841

CATEGORY	Italian
HOURS	Mon-Sat: 11 AM-8:30 PM Sun: closed
PARKING	Plenty of metered and street parking The B3 bus stops in front; the F train stops one block away on McDonald and Avenue U.
PAYMENT	Cash only
POPULAR DISH	Panelle special: deep fried ground chick pea fritter on a roll topped with a heap of ricotta cheese and a dash of parmesan. - Falafel's better cousin.
UNIQUE DISH	Tripe with tomato sauce, peas, and potatoes is the dish that sets Joe's apart from the standard Italian restaurant. Organ meat isn't supposed to taste or smell this good.
DRINKS	Beer, wine, Manhattan special
SEATING	Large dining room with booths and tables.
AMBIENCE/CLIENTELE	Straight out of Palermo, Joe's provides a taste of home for the large Italian immigrant community surrounding it. It's a local institution and old Brooklyn at its best.

—*Eddie McNamara*

Sahara
*Perfect for a Coney Island daytrip
or a spontaneous gastronomic
adventure*
$$$
2337 Coney Island Ave., Brooklyn 11223
(between Ave. U and Ave. T)
Phone (718) 376-8594 • Fax: (718) 339-6382

CATEGORY	Middle Eastern
HOURS	Daily: Noon-Midnight
SUBWAY	Being that the place is always packed, finding a spot is difficult. For stress-free parking, take the Q train.
PAYMENT	VISA, MasterCard, American Express, Discover
POPULAR DISH	Lamb reigns king among patrons of Sahara. Try it in the doner kebab, shish kebab, lamb chops, adana kebab, or just watch it roast on the spit at the front counter.
UNIQUE DISH	If you're looking for a diet-free, decadent evening choose the Cigarette Boerek, a log of phyllo swollen with feta and pan-fried with a generous dollop of oil. This dish is good for big groups because it's so rich your senses won't be able to handle more than one.
DRINKS	Excellent Turkish coffee, brought to your table in a big gold contraption that looks oh-so-extravagant. Worth the price just to watch them pour it for you.
SEATING	The space looks like the setting for a Bar Mitzvah—banquet-style rooms with large, round

tables and wine glasses filled with ice water, in other words, plenty of room for big families. There is also some seating in the back garden, a low-light, tarp-covered enclave which is a perfect shelter from the Atlantic breezes. Still, call ahead for reservations because this place fills up fast.

AMBIENCE/CLIENTELE Sahara is the perfect combination of disarming kitsch and solid Turkish cuisine. The atmosphere is a cheerful clamor of clinking silverware and hardy conversation. They've even got dancing, so wear good shoes. This is a fun, family-oriented environment.

EXTRAS/NOTES Sahara is family-owned and has grown from a tiny storefront to a huge multi-room eatery. But some regulars say the success of the restaurant may have gone to the owners' heads. These dissenters say the staff is not as friendly and efficient as they once were and the food is sometimes—gasp—overcooked!

—Samantha Charlip

STATEN ISLAND

STATEN ISLAND

Go-Go Souvlaki King
Go Greek or not at this "something for everyone restaurant of the '90s."
$$

2218 Hylan Blvd., Staten Island
(corner of Lincoln Ave.)
Phone (718) 667-0880

CATEGORY	Greek Diner
HOURS	Sun-Thurs: 7:30 AM-2 AM
	Fri/Sat: 7:30 AM-5 AM
BUS	S78, S79
PAYMENT	VISA, MasterCard, American Express, Discover
POPULAR FOOD	Fabulous gyros and kabobs with fresh meat and vegetables, great falafel with Go-Go's famous white sauce (which is more like mayo than *tahini*).
UNIQUE FOOD	If you love grease, go for the Mexi-Special tacos, burritos, or nachos with spicy cheese, or any of the fried fish dishes.
DRINKS	Draft beer in large or jumbo, lemonade, milk shakes, soda
SEATING	Ten booths and one large table that seats 18
AMBIENCE/CLIENTELE	Friendly, chatty service—clientele keep to themselves—maybe because of the amazing Pac-Man to play or endless sports on the tube
EXTRAS/NOTES	With over 20 burger options, various fish sandwiches, Italian specialties, cold salad platters, Southern food, and even quiche choices, see for yourself if Go-Go's has the "largest menu on the East Coast."

—*Laura Russo*

Island Roti Shop and Bakery
Delish Trinidadian with an East Indian flare.
$$

65 Victory Blvd., Staten Island 10301
(at Bay St.)
Phone (718) 815-7001

CATEGORY	Trinidadian West Indian
HOURS	Mon-Sat: 10 AM-9 PM
BUS	S48, S61, S62, S66, S67 buses all stop at Victory and Bay
PAYMENT	Cash only
POPULAR FOOD	*Roti* (here, it's prepared as a large spicy sandwich made with flat Indian *naan*) with beef, chicken, shrimp, and veggies; potato and channa; the tasty sides that come with the spicy dishes: spinach, *dal* (soupy lentils), fried plantains
UNIQUE FOOD	*Roti* with goat, chewy conch, mild pumpkin, spinach (*aka bhaji*) or shrimp; *accra* codfish cake; Trinidad's answer to the knish, the *aloo* pie; fresh turnovers in apple, strawberry and pineapple, coconut tarts, currant rolls and drops (cookies)
SEATING	Standing room/carry-out only
DRINKS	Variety of Trinidadian and American sodas

STATEN ISLAND

AMBIENCE/CLIENTELE The ambience encourages you to find a bench in the tiny park a block away, where Victory meets Bay.
EXTRAS/NOTES Until recently, the proprietor offered Trinidad-style Chinese food; ask with a smile and he might oblige you with a taste.

—Jessica Nepomuceno

Lakruwana
The best of the new Sri Lankan eateries on S.I.
$$

3 Corson Ave., Staten Island 10301
(south of the intersection of Victory Blvd. and Bay St.)
Phone (718) 876-9870

CATEGORY Sri Lankan
HOURS Daily: 10 AM-10:30 PM
BUS STOP S48, S61, S62, S66 and S67 buses to Victory or Bay
PAYMENT Cash only
POPULAR FOOD The most popular dishes showcase the Dutch and Portuguese influences on what would otherwise be an entirely East Indian influenced cuisine. Try fish or vegetable cutlets (croquettes); hoppers (delicate bowl-shaped rice flour crepes, to dip and drape with curry); lamb black curry (toasting the spices before cooking provides a deep, rich, lingering hotness); *kotthu roti* (naan sandwiches) with chicken, pork, beef or fish. B*iryani* rice dishes come with vegetable, chicken, beef, lamb or shrimp—ideal for the less adventurous eater.
UNIQUE FOOD Try the *lamprais* (*basmati* rice with meat curry, veggies and spices steamed in a banana leaf); squid curry; kingfish curry; vegetable curry (depends on what is in season: a recent veggie curry included cashews, yucca, turnip, and lentil in a fragrant sauce).
DRINKS Delicious Ceylon black tea with nickel-sized chunks of ginger, soda
SEATING Tables for 20-25
AMBIENCE/CLIENTELE Much more elegant than one expects for the area—walls are accented with white and rich red, decorated with brass Buddhist statuary; chairs are harder than you'd like, but the overall effect is warm and homey; service is warm and attentive and the clientele includes adventurous Staten Islanders looking for an alternative to Italian or Chinese, as well as members of the growing Sri Lankan community in the area. I would (and will) bring my parents here without thinking twice.
EXTRAS/NOTES The kitchen will make your food as spicy or mild as you like. Menu is very friendly to vegetarians. Lakruwana has a sister restaurant on 44th and Ninth in Manhattan; it has had glowing reviews in the *New York Times*, the *New York Post* and *Zagat*. Its owner lives on Staten Island, hence this tiny outpost of the older, more established eatery.

STATEN ISLAND

	The chef at the Staten Island location, Sanjay, also takes an occasional turn at the burners at the sister restaurant in Manhattan.
OTHER ONES	• Midtown: 358 W. 44th St., 10036, (212) 957 4480

—Jessica Nepomuceno

Los Lobos
Authentic Mexican alongside utterly forgettable pizza
$$

194 Bay St., Staten Island 10301
(at Victory Blvd.)
Phone (718) 420-9472

CATEGORY	Mexican / Pizzeria
	Daily: 11 AM–10:30 PM
BUS	S48, S61, S62, S66, S67 to Victory or Bay
PAYMENT	VISA, MasterCard
POPULAR FOOD	*Huevos revueltos* with red or green salsa (scrambled eggs with hot or hotter sauce) come with beans and fresh corn tortillas or fluffy bread; soft corn tortilla tacos, three per order: *Suadero* (beef shoulder), *cecina* (salted beef), *al pastor* (pork in tangy barbecue sauce), or *pollo* (chicken) have has a satisfying mound of meat, choice of red or green salsa, and a pile of freshly chopped and fragrant cilantro. The *chuleta a la mexicana* is excellent for dinner (meaty pork chops with tomato, onions and jalapeños, accompanied by the savor of long-simmered beans and rice).
UNIQUE FOOD	Join the weary hordes over their bowls of *panzila y pozole*, a hearty beef tripe soup made with hominy and shredded pork—guaranteed to cure any lingering hangovers—which is good, since it's served Saturdays and Sundays only
DRINKS	Chase the eats with a tall frosty *licuado* (milk shake) made with blended fruits like guanabana, papaya, guava, and mango; during warmer months, cool off with an *agua fresca*, potent fresh fruit juice dependent on what's in season; soda and, jarringly (some might say), sweet Mexican sodas. Mexican and American beer, as well
SEATING	Eight bare bones tables seat around 30.
AMBIENCE/CLIENTELE	Brightly lit and linoleum underfoot—while waiting for your tacos, gaze at the cultural cacophony on the walls: Mexican kitsch straight from Chi-Chi's fame mixed with movie stills from Mafia movies. TV will most likely be tuned to Telemundo Channel 47—good fun when the variety shows are on. Count on the jukebox to be blasting mournful Mexican pop and *rancheros*
EXTRAS/NOTES	There used to be a sign on the wall that said "Two beer minimum"—evidently, off duty workers found Los Lobos to be the perfect happy hour joint. The situation has since calmed down. Free delivery.

—Jessica Nepomuceno

STATEN ISLAND

Mommie Marcy's Place, Inc.

Stick-to-your-ribs home cooking that showcases the influence of East Indians on West Indian cuisine.

$$

11 Corson Ave., Staten Island 10301
(One block south of the intersection of Victory Blvd. and Bay St.)
Phone (718) 815-1507

CATEGORY	West Indian
HOURS	Mon-Thurs: 10:30 AM-9 PM
	Fri/Sat: 10:30 AM-10 PM
BUS	S48, S61, S62, S66, S67 to Victory or Bay
PAYMENT	Cash only
POPULAR FOOD	Beef, chicken, vegetable, shrimp patties; macaroni and cheese, jerk chicken, stew fish (available Fridays only), stew oxtails; chicken, vegetable, beef, goat, oxtail *roti* (made with flat bread)
UNIQUE FOOD	Chewy, spicy curry goat; cow heel soup—hearty!; *roti* skin; potato and chick pea sandwich; bake and saltfish—similar to *bacalao* (salt cod soaked in water and cooked again); *callaloo* (Fridays), mildly sweet and nutty coconut bread
DRINKS	Try the Jamaican and Trinidadian soda—but there's also mauby, and sorrel, virility-boosting sea moss, and tangy carrot juice and peanut punch.
SEATING	Carry out
AMBIENCE/CLIENTELE	Tiny, dimly lit. Get the local scoop from Caribbean-American community newspaper; music from the islands on the boombox. Usually full of locals getting their *roti* and patty fixes

—Jessica Nepomuceno

Nunzio's Pizzeria

"Over 60 years of specializing in pizza!"
Since 1942
$$
2155 Hylan Blvd., Staten Island 10306
(between Midland and Zwicky Aves.)
Phone (718) 667-9647

CATEGORY	Italian/Pizza
HOURS	Mon-Sat: 11 AM-11 PM
	Sun: 11 AM-8 PM
BUS	S78, S79, S51, S81
PAYMENT	Cash only
POPULAR FOOD	Nunzio's Neapolitan made with whole plum tomatoes, mozzarella, grated pecorino romano and olive oil over an incredible thin crust.
UNIQUE FOOD	You can get Hero sandwiches here such as potato and egg, pepper and egg, mozzarella omelette, sausage and peppers, eggplant, or veal patty.
DRINKS	Small 7 oz. bottle of old fashioned Coke, Stewart's root beer, orange and cream soda, beer (Budweiser, Molson, Coors Light, Heineken)
SEATING	About 15 seats in the back

STATEN ISLAND

AMBIENCE/CLIENTELE Even youngsters will feel a sense of nostalgia in this old and friendly pizzeria—there's nothing strange about getting the wrong order here. Fantastic old photos of the pizzeria and an autographed one of Bruno Kirby
EXTRAS/NOTES Pizza sold by the slice or by the pie.
—*Laura Russo*

"[New York] isn't like the rest of the country - it is like a nation itself - more tolerant than the rest in a curious way. Littleness gets swallowed up here. All the viciousness that makes other cities vicious is sucked up and absorbed in New York."

—*John Steinbeck*

GLOSSARY

Our glossary covers many of those dishes that everyone else seems to sort of know but we occasionally need a crib sheet. As for ethnic dishes—we've only covered the basics.

adobo (Filipino)—a stew of chicken, pork, or fish traditionally flavored with garlic, soy sauce, white vinegar, bay leaves, and black peppercorns.

aduki beans—small, flattened reddish-brown bean; sometimes used as a confectionery.

affogato (Italian)—literally poached, steamed or plunged; actually scoops of assorted ice-cream "plunged" in espresso, often topped with whipped cream.

agua fresca (Latin America)—(also agua natural) flavorful drink that's somewhere between a juice and a soda. We like horchata and tamarindo!

albondigas (Latin American)—meatballs. In Mexico it's popular as a soup.

antojitos (Latin American)—appetizers (means "little whims").

ayran (Middle Eastern)—yogurt based drink, like lassi but flavored with cardamom.

au jus (French)—meat (usually beef) served in its own juices.

baba ganoush (Middle Eastern)—smoky eggplant dip.

bansan (Korean)—see panchan.

bao (Chinese)—sweet stuffed buns either baked or steamed; a very popular dim sum treat!

basbousa (Middle Eastern)—a Semolina cake of yogurt and honey.

bean curd (Pan-Asian)—tofu.

beignets—New Orleans-style donuts (sans hole) covered in powdered sugar.

bigos (Polish)—winter stew made from cabbage, sauerkraut, chopped pork, sausage, mushrooms, onions, garlic, paprika and other seasonings. Additional veggies (and sometimes red wine!) may be added.

bibimbap (Korean)—also bibibap, served cold or in a heated clay bowl, a mound of rice to be mixed with vegetables, beef, fish, egg, and red pepper sauce.

biryani (Indian)—meat, seafood or vegetable curry mixed with rice and flavored with spices, especially saffron.

black cow—frosty glass of root beer poured over chocolate ice cream.

blintz (Jewish)—thin pancake stuffed with cheese or fruit then baked or fried.

borscht (Eastern European)—beet soup, served chilled or hot, topped with sour cream.

bratwurst (German)—roasted or baked pork sausage.

bul go gi (Korean)—slices of marinated beef, grilled or barbecued.

GLOSSARY

bun (Vietnamese)—rice vermicelli.

café de olla (Mexican)—coffee with cinnamon sticks and sugar.

callaloo—a stew made with dasheen leaves, okra, tomatoes, onions, garlic, and meat or crab, all cooked in coconut milk and flavored with herbs and spices.

calzone (Italian)—pizza dough turnover stuffed with cheesy-tomatoey pizza gooeyness (and other fillings).

caprese (Italian)—fresh bufala mozzarella, tomatoes, and basil drizzled with olive oil and cracked pepper—a lovely salad or fixins' for a sandwich.

carne asada (Latin American)—thinly sliced, charbroiled beef, usually marinated with cumin, salt, lemon, and for the bold, beer; a staple of the Latin American picnic (along with the boom box).

carnitas (Mexican)—juicy, marinated chunks of pork, usually fried or grilled. Very popular as a taco stuffer.

carpaccio (Italian)—raw fillet of beef, sliced paper thin and served with mustard sauce or oil and lemon juice.

Cel-Ray—Dr. Brown's celery-flavored soda. Light and crisp—a must at any deli.

ceviche (Latin American)—(also cebiche) raw fish or shellfish marinated in citrus juice (the citrus sorta "cooks" the fish), usually served with tostadas. Crunchy, tart delight that happens to be low in fat and cholesterol. It's rumored that ceviche is a new favorite with models. While ceviche may not give you Kate Moss' looks, you can at least eat like her. Note: If you are looking to reap the low fat benefits of ceviche steer clear of the tostadas that accompany it; they are deep fried and most certainly fattening.

challah—plaited bread, sometimes covered in poppy seeds, enriched with egg and eaten on the Jewish sabbath.

cheese steak—see Philly cheese steak.

chicharrones (Mexican/Central American)—fried pork rinds, knuckle lickin' good.

chicken fried steak—it's STEAK—floured, battered and fried à la fried chicken.

chiles rellenos (Mexican)—green poblano chiles, typically stuffed with jack cheese, battered and fried; occasionally you can find it grilled instead of fried—¡que rico!

chili size—open-faced burger covered with chili, cheese, and onions.

chimichangas (Mexican)—fried, stuffed tacos.

chow fun (Chinese)—wide, flat rice noodles.

chorizo (Latin American)—spicy sausage much loved for its versatility. Some folks like to grill it whole and others prefer to bust it open, fry it up, and serve it as a side dish. Another favorite incarnation finds the chorizo scrambled with eggs for breakfast.

churrasco—charcoal grilled meat or chicken, usually served on a skewer.

GLOSSARY

cochinita pibil (Mexican)—grilled marinated pork, Yucatán style.

cocido (Spanish)—duck confit, chorizo, sausage, and preserved pork combined.

congee (Chinese)—(also jook) rice-based porridge, usually with beef or seafood.

corn dog—hot dog dipped in cornbread batter, usually served on a stick.

croque-madame (French)—grilled cheese sandwich, sometimes with chicken—no ham!

croque-monsieur (French)—sandwich filled with ham and cheese then deep-fried (occasionally grilled). Cholesterol heaven!

Cuban sandwiches (Cuban)—roasted pork sandwich pressed on Cuban rolls (which have a crusty, French-bread-like quality). Also see medianoche sandwiches.

cuitlacoche (Mexican)—Central Mexico's answer to truffles; technically, black corn fungus, but quite a delicacy!

dal (Indian)—lentil-bean based side dish with an almost soupy consistency, cooked with fried onions and spices.

dim sum (Cantonese)—breakfast/brunch consisting of various small dishes. Most places feature servers pushing carts around the restaurant. You point at what you want as they come by. Literally translated means: "touching your heart."

dolmades (Greek)—(also warak enab as a Middle Eastern dish) stuffed grape leaves (often rice and herbs or lamb and rice mixture).

döner kebab—thin slices of raw lamb meat with fat and seasoning, spit roasted with thin slices carved as it cooks.

dora wat (Ethiopian)—chicken seasoned with onions and garlic, sautéed in butter and finished with red wine.

dosa (South Indian)—(also dosai) oversized traditional crispy pancake, often filled with onion and potato and folded in half; bigger than a frisbee!

edamame (Japanese)—soy beans in the pod, popularly served salted and steamed as appetizers. Pop 'em right out of the end of the pod into yer mouth.

eggs Benedict—poached eggs, typically served with Canadian bacon over an English muffin, with hollandaise sauce.

empanada (Argentinian)—flaky turnover, usually stuffed with spiced meat; a favorite appetizer at an asado. Other Latin American countries also make their own versions of this tasty treat.

escovietch (West Indian)—cooked small whole fish in a spiced oil and vinegar mixture, served cold.

étouffe (Creole)—highly spiced shellfish, pot roast or chicken stew served over rice.

falafel (Middle Eastern)—spiced ground chickpea fava bean balls and spices, deep fried and served with pita.

GLOSSARY

feijoada (Brazilian/Portuguese)—the national dish of Brazil, which can range from a pork and bean stew to a more complex affair complete with salted beef, tongue, bacon, sausage, and more parts of the pig than you could mount on your wall.

filo (Turkish and Mediterranean)—(also phyllo) thin pastry prepared in several layers, flaky and good.

flautas (Mexican)—akin to the taco except this puppy is rolled tight and deep fried. They are generally stuffed with chicken, beef, or beans and may be topped with lettuce, guacamole, salsa, and cheese. They resemble a flute, hence the name.

focaccia (Italian)—flatbread baked with olive oil and herbs.

frites (Belgian/French)—also pommes frites, french or fried potatoes or "french fries".

gefilte fish (Jewish)—white fish ground with eggs and matzo meal then jellied. No one—and we mean no one—under fifty will touch the stuff.

gelato (Italian)—ice cream or ice.

gnocchi (Italian)—small potato and flour dumplings served like a pasta with sauce.

gorditas (Mexican)—fried puffy rounds of corn meal dough topped with beans, chipotle sauce, and cheese.

goulash (Hungarian)—a rich beef stew flavored with paprika, originally based on Hungarian gulyás, a meat and vegetable soup; often served with sour cream.

grits—staple breakfast side dish of grainy white mush topped with butter (or in joints where they really know what they're doing) a slice of American cheese.

gumbo (Creole)—rich, spicy stew thickened with okra (often includes crab, sausage, chicken, and shrimp).

gyros (Greek)—spit-roasted beef or lamb strips, thinly sliced and served on thick pita bread, garnished with onions and tomatoes.

har gow (Chinese)—steamed shrimp dumplings.

head cheese—(not cheese!) a sausage made from bits of calf or pig head. Note: vegetarian version available at Alpine Village Market.

hijiki (Japanese)—a sun-dried and coarsely shredded brown seaweed.

hoagie—(also, Italian sandwiches, sub, grinder) huge flat oblong roll stuffed with deli meats and cheeses, pickled veggies, and onions.

horchata (Mexican/Central American)—cold rice and cinnamon drink, sweet and heavenly. One of the tastiest aguas frescas this side of the border.

huevos rancheros (Mexican)—fried eggs atop a fried tortilla with salsa, ranchero cheese, and beans.

humita (Chile/Argentina)—tamale.

hummus (Middle Eastern)—banded garbanzo beans, tahini, sesame oil, garlic, and lemon juice; somewhere between a condiment and a lifestyle.

GLOSSARY

hush puppies (Southern U.S.)—deep fried cornmeal fritter, in small golf ball size rounds. Originally used to be tossed to dogs to hush 'em up.

iddly (South Indian)—small steamed rice flour cakes served with coconut dipping sauce.

injera (Ethiopian)—flat, spongy, sour unleavened bread. Use it to scoop up everything when you eat Ethiopian food, but be forewarned: it expands in your stomach.

jamaica (Mexican/Central America)—hibiscus flower agua fresca.

jambalaya (Creole)—spicy rice dish cooked with, sausage, ham, shellfish, and chicken.

jollof (West African)—a stew or casserole made of beef, chicken or mutton simmered with fried onion, tomatoes, rice and seasonings.

galbi (Korean)—(also kal bi) marinated barbecued short ribs.

kabob (Middle Eastern)—(also shish kabob) chunks of meat, chicken, or fish grilled on skewers, often with vegetable spacers.

kamonan (Japanese)—noodles with slices of duck.

katsu (Japanese)—pork.

kielbasa (Polish)—smoked sausage.

kimchi (Korean)—pickled vegetables, highly chilied- and garlicked-up. Some sweet, some spicy, some unbelievably spicy. Limitless variations.

knockwurst (German)—(also knackwurst) a small, thick, and heavily spiced sausage.

korma (Indian)—style of braising meat or vegetables, often highly spiced and using cream or yogurt.

kreplach (Jewish)—small pieces of noodle dough stuffed with cheese or meat, usually served in soup.

kutya (Ukrainian)—traditional pudding made with wheat-berries, raisins, walnuts, poppy seeds and honey.

lahmajune (Armenian/Turkish)—a meat (most often lamb) pizza.

larb (Thai)—minced chicken or beef salad spiced with lemon juice, sweet onion, mint leaves, and toasted rice powder, served in a lettuce cup or with cabbage.

lassi (Indian)—yogurt drink served salted or sweetened with rose, mango, or banana.

lychee—red-shelled southeast Asian fruit served in desserts and as a dried snack (known as lychee nuts).

machaca (Northern Mexican)—shredded meat jerky, scrambled with eggs, tomatoes, and chiles.

macrobiotic—diet and lifestyle of organically grown and natural products.

makdoos (Middle Eastern)—miniature eggplant stuffed with walnuts and garlic, marinated with olive oil.

GLOSSARY

mandoo (Korean)—dumplings.

marage (Yemen)—vegetable soup.

mariscos (Pan-American)—seafood.

masala (Indian)—blend of ground spices, usually including cinnamon, cumin, cloves, black pepper, cardamom, and coriander seed.

matzo brie (Jewish)—eggs scrambled with matzo.

medianoche sandwich (Cuban, also midnight sandwich)—roast pork, ham, cheese and pickles pressed on a sweet roll.

mee krob (Thai)—salad appetizer covered in fried noodles.

menudo (Mexican)—soup made of tripe, hominy, and chile, stewed with garlic and spices. A hangover remedy, and what Mexican families eat before or after Sunday mass.

mofongo (Dominican)—mashed green plaintains with pork skin, seasoned with garlic and salt.

mole (Mexican)—thick poblano chile sauce from the Oaxacan region served over chicken or other meats. Most popular is a velvety black, mole negro flavored with unsweetened chocolate and raisins. Also available in a variety of colors and levels of spiciness depending on chiles and other flavors used (amarillo, or yellow, for example, uses cumin).

Monte Cristo sandwich—sliced turkey, swiss cheese, mustard, and ham sandwich, on French toast, fried, and dusted with powdered sugar. Served with sides ranging from syrup to jam to pickles.

moussaka (Greek)— alternating layers of lamb and fried aubergine slices, topped with Béchamel sauce, an egg and cheese mixture, and breadcrumbs, finally baked and brought to you with pita bread.

muffuletta—New Orleans-style hero sandwich stuffed with clod cuts and dripping with a roasted pepper and olive salad.

muj chien don (Vietnamese)—crispy squid in a little salt and pepper.

mulitas (Mexican)—literally, little mules; actually, little quesadillas piled up with meat, veggies, and other goodies.

mung bean—small green bean, eaten as a vegetable or used as a source of sprouts. May also be candied and eaten as a snack, or used to make bean curd.

musubi (Japanese)—rice ball, sometimes filled with bits of salmon or seaweed, or a sour plum. Hawaiian version features SPAM. Delicious grilled.

naan (Indian)—flat bread cooked in a tandoor oven.

niçoise salad (French)—salad served with all the accoutrements from Nice, i.e. French beans, olives, tomatoes, garlic, capers, and of course, tuna and boiled egg.

pad Thai (Thai)—popular rice noodle stir-fry with tofu, shrimp, crushed peanuts, and cilantro.

GLOSSARY

paella (Spanish)—a rice jubilee flavored with saffron and sprinkled with an assortment of meats, seafood, and vegetables, all served in a sizzling pan.

panchan (Korean)—the smattering of little appetizer dishes (kimchi, etc.) that magically appear before a meal of soontofu or barbecue; vinegar lovers rejoice.

pastitsio (Greek)—cooked pasta layered with a cooked meat sauce (usually lamb), egg-enriched and cinnamon flavored Béchamel, grated cheese, and topped with a final layer of cheese and fresh breadcrumbs.

patty melt—grilled sandwich with hamburger patty and melted Swiss cheese.

pescado (Spanish)—literally means fish; can be served in a variety of ways, baked in hot rock salt (a la sal), coated in egg batter and fried (a la andaluza), pickled (en escabeche) and even cooked in wine with onions and chocolate and served with mushrooms (a la asturiana).

Philly cheese steak—hot, crispy, messy sandwich filled with thin slices of beef and cheese from…where else?…Philadelphia.

pho (Vietnamese)—hearty rice noodle soup staple, with choice of meat or seafood, accompanied by bean sprouts and fresh herbs.

pico de gallo (Mexico)—(also salsa cruda) a chunky salsa of chopped tomato, onion, chile, cilantro. In Jalisco it's a jicama and orange salad sprinkled with lemon juice and chile powder.

pierogi (Polish)—potato dough filled with cheese and onion boiled or fried.

pigs-in-a-blanket—sausages wrapped in pastry or toasted bread then baked or fried; or, more informally, breakfast pancakes rolled around sausage links. Dip in syrup for extra fun!

plantain (Central American)—cooking banana from tropical regions. When ripe and yellow it's often served fried as a breakfast side dish. While it's green and unripe it's used to make yummy chips available at neighborhood markets.

po' boy—New Orleans-style hero sandwich with seafood and special sauces, often with lemon slices.

pollo a la brasa (Central/South American)—rotisserie chicken.

porgy—various deep-bodied seawater fish with delicate, moist, sweet flesh.

pozole (Mexican)—pork soup with corn, onions, hominy, and dried chiles. Sliced and diced cabbage and radishes are also used as garnish. Very popular come the Christmas season—so good it makes you wish it was Xmas everyday.

pulpo enchilado (Spanish)—octopus in hot sauce.

pupusa (Salvadorean)—round and flattened cornmeal filled with cheese, ground porkrinds, and/or refried beans, which is cooked on a flat pan known as a comal. The indigenous term literally means "sacred food." No doubt ancient civilizations concur with modern opinion that the pupusa is a sublime treat.

GLOSSARY

quesadilla (Mexican)—soft flour tortilla filled with melted cheese (and, sometimes, fancier fare).

raita (Indian)—yogurt condiment flavored with spices and vegetables (often cucumber) or fruits—the necessary core component to balance hot Indian food.

ramen (Japanese)—thin, squiggly egg noodle, often served in a soup.

Reuben (Jewish)—rye bread sandwich filled with corned beef, Swiss cheese, and sauerkraut and lightly grilled.

roti (Indian)—round flat bread served plain or filled with meat or vegetables.

S.O.S.—creamed beef on toast and a staple of all U.S. military mess halls; affectionately called shit on shingles.

samosa (Indian)—pyramid shaped pastry stuffed with savory vegetables or meat.

sashimi (Japanese)—fresh raw seafood thinly sliced and artfully arranged.

satay (Thai)—chicken or shrimp kabob, often served with a peanut sauce.

sauerkraut (German)—chopped, fermented sour cabbage.

schnitzel (English/Austrian)—thin fried veal or pork cutlet.

seitan (Chinese)—wheat gluten marinated in soya sauce with other flavorings.

shabu shabu (Japanese)—hot pot. Cook thin sliced beef and assorted vegetables in a big hot pot at your table—served with a couple of dipping sauces and rice.

shaved ice—Hawaiian snow cone. Ice with various juices/flavorings (from lime or strawberry to sweet green tea and sweetened condensed milk). Non-Hawaiian incarnations are called raspado and slush.

shawarma (Middle Eastern)—pita bread sandwich filled with sliced beef, tomato, and sesame sauce.

shish kabob—see kabob.

sloppy joe—loose, minced meat sandwich with sauce on hamburger bun.

soba (Japanese)—thin buckwheat noodles, often served cold with sesame oil-based sauce.

som tum (Thai)—green papaya salad.

soontofu (Korean)—boiling hot soup with soft tofu, your choice of protein elements (mushroom or kimchi for vegetarians, seafood, pork for non) served with a variety of kimchis and rice.

sopes (Mexican)—dense corn cakes topped with beef or chicken, beans, lettuce, tomato, and crumbled cheese.

souvlaki (Greek)—kebabs of lamb, veal or pork, cooked on a griddle or over a barbecue, sprinkled with lemon juice during cooking, and served with lemon wedges, onions and sliced tomatoes.

GLOSSARY

sorrel (Caribbean)—sweet hibiscus beverage served cold.

spanakopita (Greek)—filo triangles filled with spinach and cheese.

spelt—ancient type of wheat, commonly used to make flour without traditional wheat flavor.

spotted dick (British)—traditional pudding.

sushi (Japanese)—the stuff of midnight cravings and maxxed out credit cards. Small rolls of vinegar infused sticky rice topped (or stuffed) with fresh raw seafood, sweet omelette, or pickled vegetables and held together with sheets of seaweed (nori).

Suzy Qs—(also Curly Qs) Spiral-cut french fries (they look sort of like those confetti spirals).

tabouli (Middle Eastern)—light salad of cracked wheat (bulgur), tomatoes, parsley, mint, green onions, lemon juice, olive oil, and spices.

tahini (Middle Eastern)—paste made from ground sesame seeds.

tamale (Latin American)—Latin America's contribution to nirvana. Each nation has its own take on the tamale, but in very basic terms it is cornmeal filled with meat and veggies wrapped in corn husk or palm tree leaves for shape, then steamed. There are also sweet varieties notably the elote, or corn, tamale. A favorite during the holidays, the tamale is surely the sumptuous culprit of many a person's Yuletide bulge. Note: We understand that due to the tamales' versatility we cannot do it full justice in our definition. We can only encourage you to get your hands on some and indulge.

tamarindo (Mexican)—popular agua fresca made from tamarind fruit.

tandoori (Indian)—literally means baked in a tandoor (a large clay oven). Tends to be a drier form of Indian dish than, say, curries.

tapenade (Provençale italian)—chopped olive garnish; a delightful spread for a hunk of baguette.

taquitos (Mexican)—(also, flautas) shredded meat or cheese rolled in tortilla, fried, and served with guacamole sauce.

tempeh (Indian)—a substance made from soaking and boiling soy beans, inoculating with a fungus, packing into thin slabs and allowing to ferment. A great source of protein!

teriyaki (Japanese)—boneless meat, chicken, or seafood marinated in a sweetened soy sauce, then grilled.

thali (Southern Indian)—sampler meal comprised of several small bowls of curries and soup arranged on a large dish with rice and bread.

tikka (Indian)—marinated morsels of meat cooked in a tandoor oven, usually chicken.

tilapia—a white fish often served in the Tropics.

toad in the hole (British)—herb sausages baked in thick savory Yorkshire pudding mix.

tom yum gung (Thai)—lemongrass hot-and-sour soup.

tong shui (Chinese)—medicinal soups.

GLOSSARY

torta (Mexican)—Spanish for sandwich or cake.

tostada (Mexican)—traditionally a corn tortilla fried flat; more commonly in the U.S. vernacular the frilly fried flour tortilla that looks like an upside down lampshade and is filled with salad in wannabe Mexican restaurants.

tzatziki (Greek)—the best condiment to come out of the Greek isles; fresh yogurt mixed with grated cucumber, garlic, and mint (or corriander, or both).

udon (Japanese)—thick white rice noodles served in soup, usually bonito broth.

vegan/vegetarian—"Vegan" dishes do not contain any meat or dairy products; "Vegetarian" dishes include dairy products.

warak enab (Middle Eastern)—see dolmades.

Welsh rarebit (British)—(also Welsh rabbit) toast topped with melted cheese cream, and ale, usually served with Worcestershire sauce (very hot and spicy).

wet fries—french fries with gravy on top.

wet shoes—french fries with chili and cheese on top.

yakitori (Japanese)—marinated grilled chicken skewers.

zeek (Southern U.S.)—catfish, shrimp, and tater salad.

ALPHAPETICAL INDEX

200 Fifth, 196
212 Restaurant & Bar, 135
24 Prince, 23
2nd Street Café, 195
7A Café, 35

A

Abbey Pub, 140
Ace Bar, 126
Alba Pizza, 166
The Algonquin Hotel, 77
Amin, 4, **75**, 184
Amy's Bread, 78
Angel's Share, 36
Annie's, 137
Appellation Wine & Spirits, 189
Arturo's, 63
A Salt and Battery, 79
Austin House, 166
Awash Ethiopian Restaurant, 141

B

Babycakes, 37
The Bagel House, 169
Bagels on the Square, 64
Baluchi's Indian Food, 170
Banao, 160
Beard Papa's Sweet Café, 79, **99**, 143
Beast, 197
Better Burger, 142
B & H Dairy Restaurant, 36
Biancardi's, 162
Black Bear Lodge, 67
The Black Fence, 126
Blockheads, 2, 11, **111**, 125, 137
Blue Hill, 189
Blue Ribbon Sushi, 25
Blue Sea Café, 171
Blue Smoke, 153
Bohemian Hall & Beer Garden, 171
Bone Lick Park, 79
Boss Tweeds, 67
Bread Bar at Tabla, 111
Bread and Olive, **2**, 39, 125
Brennan and Carr, 209
Brother Jimmy's, 143
Bubble Lounge, 24
Buddha Bar, 80
Burritoville, 2, 4, 39, **81**, 100, 125, 138, 144
Buttermilk, 199

C

Café Bar, 173
Café Con Leche, 144
Café Habana, 4, **25**
Café Lalo, 144
Café Medina, 100
Cafeteria, 38
Café Viva, 101
Café Zaiya, 112
Caffe Reggio, 64
Calabria Pork Store, 162
Caracas Arepas Bar, 168
Casa Della Mozzarella, 162
Centovini, 26
Cevabdzinica Sarajevo, 174
Chez Brigitte, 82
Chez Lola, 185
Chez Oskar, 186
Chickpea, **40**, 125
Chinatown Ice Cream Factory, 193
Chino's, 40
Cho Dang Gol, 126
Chow Bar, 83
Christie's Jamaican Patties, 200
Chumley's, 76
Columbus Bakery, 145
The Comfort Diner, 38
Corner Bistro, 84
Cosmic Cantina, 102
Crave, 192
Crepe Café, 27
Crif Dogs, 41
Cube 63, **5**, 184

D

Daisy May's BBQ USA, 153
Dash Dogs, 5
Dawgs on Park, 142
De Lillo Pastry Shop, 162
DeMarco's, 65
Di Fara Pizzeria, 186
Dinosaur, **151**, 154
Dirty Bird To Go, 84
Divine Bar West, 112
Docks Oyster Bar and Seafood Grill, **113**, 146
Double Down Saloon, 126
Down the Hatch, 66
DUB Pies NYC, 187
Dumpling House, 6

E

Ear Inn, 28
Edy's, 161
Eisenberg's Sandwich Shop, 102
EJ's Luncheonette, 39
El Castillo de Jagua Restaurant, 41

ALPHAPETICAL INDEX

El Cocotero, 85
El Rey de la Caridad Restaurant, 146
Elvie's Turo-Turo, 42
Empanada Mama, 168
Empanadas del Parque, 167
Ess-a-Bagel, 104
Essex, 6
Excellent Dumpling House, 7

F

Famous Famiglia, 86, 87, 104, 138, **147**, 152
Fatty's Café, 174
F & B, **86**, 142
Fette Sau, 154
The Flame Restaurant, 148
Flea Market, 39
Flor's Kitchen, 43
Floyd NY, 195
Foodbar, 38
Frank Restaurant, 44, **49**
Franny's, 188, **201**
Fried Dumpling, 8
Frutti di Mare, 44

G

G. Addeo & Sons Bakery, 162
Gauchas, 138
Gauchas Empanadas, 168
Geido, 202
Gino's Focacceria, 211
Go-Go Souvlaki King, 216
Golden Unicorn, 9
Goodburger, 116
Good Enough To Eat, 148
Gourmet Wok, 127
Gray's Papaya, 142
Grey Dog Coffee, 45, **87**
Guss's Pickles, 136
Gyu-Kaku, **45**, 117

H

Habana Outpost, **187**, 188
H & H Bagels, 104
Halal Cart, 116
Halal Chicken and Gyro, 115
Halal Food, 116
Halal Vendor, 115
Hampton Chutney Co., 29
Haru Japanese Restaurant, 105, 117, 128, 138, 139, 149
Hill Country, 154
Holy Basil, 46
Home's Kitchen, 105

Hop Kee Restaurant, 10
Hummus Place, **46**, 88, 149
Hungarian Pastry Shop, **149**, 193

I

iCi, 189
il laboratoria del gelato, 193
Ini Ani Espresso & Wine Bar, 10
'Ino, 88
'Inoteca, 4, **88**
Island Burgers and Shakes, 129
Island Roti Shop & Bakery, 216
Ivo & Lulu, 29

J

Jackson Diner, 175
Jaiya, **118**, 175
Jerusalem Restaurant, 150
Joe's of Avenue U, 212
Joe's Pizza, **68**, 88
Joe's Shanghai, **12**, 130, 176
Joya, 203
Junior's, 192
Just Salad, 117

K

Kalustyan's, 118
Karahi Indian Cuisine, 30
Katz's Delicatessen, **13**, 142
Kenka, 47
Kettle of Fish, 77
Klong, 11, **48**
Knife and Fork, 3
Kuma Inn, 14
Kwik Cart, 115

L

Lakruwana, 131, **217**
La Fusta, 167
Lannam, 119
La Paloma Burritos, 130
Last Stop Café, 176
L'Ecole, 3
Lederhosen, 89
Lemon Ice King of Corona, 168
Lenox Lounge, 77
Lil' Frankie's, 49
Lips, 90
Little Bit of Jam, 163
Little Veselka, 50, **59**
Los Amigos, 176
Los Lobos, 218
Lovely Day, 30
Lupe's East L.A. Kitchen, 31

ALPHAPETICAL INDEX

M

Mama's Food Shop, 50
Mamoun's Falafel, 52, **68**
Manapaty Milant Corp., 120
Mandoo Bar, 131
Manna's Soul Food Restaurant, 91, 152, **184**
Massawa Restaurant, 152
Max, 50
Max Brenner, 193
Max Caffe, 150
May May Chinese Gourmet and Bakery, 136
McCann's Pub & Grill, 177
Mei-Ju Vege Gourmet, 14
Meskerem, **69**, 132
Mishima, 121
Moe's Falafel, 105
M & O Grocery & Imported & Domestic Products, 32
Molly's Pub & Restaurant, 106
Momme Marcy's Place, Inc., 219
Momofuku Noodle Bar, 51
Moustache, 91
Murray's Bagels, 104
Mustang Grill and Tequila Lounge, 139

N

Neptune Diner, 178
New Green Bo, 16
New Pasteur, 15
Nick's Pizza, 178
Nunzio's Pizzeria, 219

O

Old Devil Moon, 39
Old Town, **106**, 142
Once Upon A Tart, 33

P

Palacinka, 33
Panna II Garden Indian Restaurant, 52
Paris Commune, 38
Park Slope Taqueria, 203
Patriot Saloon, 126
Peanut Butter & Co., 70
Peking Duck Forest, 179
Pho Bang Restaurant, 17
Pick a Bagel on Third, 104
Pinkberry, 92, **132**, 139
Pink Pony, 17
Pizza Booth, 70

P.J. Clarke's, 4, **121**
Podunk, 53
Pommes Frites, 54
The Pratt Coffee Shop, 190
Pravda, 34
Pret A Manger, 4, 92, **122**
Pretzel, Hot Dog, and Sausage Cart, 123
Primitivo Osteria, 3
Proof, 67
Public, 11, 18
Purity Diner, 203

Q

Quartino Bottega Organica, 55

R

Rachel's Taqueria, 204
Rafiqi's Halal Carts, 115
Rainbow Falafel, 107
Randazzo's Seafood, 162
Rare Bar and Grill, 92, **124**
Rene Pujol, 3
Republic, 108
Ruben's Empanadas, 168
Rue Des Crepes, 92
Rice, 92, 108, **191**
Rice to Riches, 193
Rocking Horse Mexican Café, 39
Ronnybrook Milk Bar, 189
Rosario's Pizza, 136
RUB, 154

S

Sahara, 212
Sala, **56**, 93
Sal, Kris, & Charlie Deli, 179
Sammy's Halal, 115
Sam's Sould Food Restaurant & Bar, 163
Sarabeth's West, 38
Sisters Caribbean Cuisine, 155
Slice of Harlem, 156
The Smoke Joint, 154
Soba-ya, 56
Soda Bar and Lounge, 205
Song, 206
Soup and Smoothie Heaven, **133**, 136
Spice, 57, **93**
The Spotted Pig, 94
The Stanton Social, 19
St. Dymphna's, 57
Sticky Rice, 20
Sucelt Coffee Shop, 94

ALPHABETICAL INDEX

Sushi Excellent, 185
Sushisamba, 25, 58, **95**
Sweet-N-Tart, **21**, 180
Sylvia's, 38

T

Taim, 96
Tea Lounge, 207
Tea & Sympathy, 39
Temple in the Village, 71
T.G. Whitney's, 66
Thalia, 3
Tibbett Diner, 164
Tiengarden Vegan and Natural Kitchen, 58
Todai, 133
Tortilla Flats, 96
Town Tavern, 72
Tremes Jamaican Restaurant and Bakery, 157
Two Boots, 59, **97**, 98, 125, 134

U

Uncle George's Greek Tavern, 180
Uncle Moe's Burrito & Taco Shop, **109**, 207
Union Hall, 208

V

Veggie Castle, 209
Verlaine, 11, **22**
Veselka, 59
The Viceroy, 38
Vinny Vincenz, 109
Viva El Mariachi, 181
Viva Herbal, 60
Vol de Nuit, 73

W

White Horse Tavern, 77
'Wichcraft, 22, **74**, 98, 110, 134
Wo-Hop Restaurant, 22
Woorijip, 134

X

Xunta, 62

Y

Yakitori-Taisho, 61
Yatagan Kebab House, 75
Yonah Schimmel Knishery, 136

Z

Zygos (Libra) Taverna, 181

CATEGORY INDEX

American (a little bit of everything)
Crave, 192
Crif Dogs, 41 (Hipster bar/restaurant)
Ici, 189
Mama's Food Shop, 50
2nd Street Café, 195
24 Prince, 23
Thalia, 3
Two Boots, 59, **97**, 98, 125, 134 (Cajun/Creole/pizza)

American Pubs
Ace Bar, 126 (Dive Bar)
Beast, 197
Black Bear Lodge, 67
Boss Tweeds, 67
Double Down Saloon, 126 (Dive Bar)
Down the Hatch, 66
Kettle of Fish, 77
Lips, 90 (Transvestite Bar/Restaurant)
McCann's Pub & Grill, 177
Molly's Pub & Restaurant, 106
Old Town, **106**, 142
Patriot Saloon, 126 (Dive Bar)
P.J. Clarke's, 4, **121**
Proof, 67
Rare Bar and Grill, 92, **124**
T.G. Whitney's, 66
The Back Fence, 126 (Dive Bar)
Town Tavern, 72
Union Hall, 208
White Horse Tavern, 77

Argentinean
Gauchas, 138
La Fusta, 167

Armenian
Babycakes, 37 (Armenian bakery)

Australian
DUB Pies NYC, 187
Public, 11, **18**

Bagels
Austin House, 166
Bagels on the Square, 64
Ess-a-Bagel, 104
H & H Bagels, 104
Murray's Bagels, 104
Pick a Bagel on Third, 104
The Bagel House, 169

Bakery
Babycakes, 37
Beard Papa's Sweet Café, 79, **99**, 143
Café Lalo, 144
Café Zaiya, 112
Columbus Bakery, 145
G. Addeo & Sons Bakery, 162
Once Upon A Tart, 33 (French Bakery)

Barbecue
Blue Smoke, 153
Bone Lick Park, 79
Daisy May's BBQ USA, 153
Dinosaur, **151**, 154
Hill Country, 154
Fette Sau, 154
RUB, 154
The Smoke Joint, 154

Belgian
Vol de Nuit, 73

Bosnian
Cevabdzinica Sarajevo, 174

British
Pret A Manger, 4, 92, **122** (Sandwich shop)

Brunch
Cafeteria, 38
EJ's Luncheonette, 39
Flea Market, 39
Foodbar, 38
Old Devil Moon, 39
Paris Commune, 38
Rocking Horse Mexican Café, 39
Sarabeth's West, 38
Sylvia's, 38
Tea & Sympathy, 39
The Comfort Diner, 38
The Viceroy, 38

Burger Joint
Corner Bistro, 84
Ear Inn, 28
Goodburger, 116
Island Burgers and Shakes, 129
Rare Bar and Grill, 92, **124**

Café
7A Café, 35 (open 24 hours)
Flea Market, 39
Grey Dog Coffee, 45, **87**

CATEGORY INDEX

Just Salad, 117
Palacinka, 33 (European cafe)
Rocking Horse Mexican Café, 39
Tea & Sympathy, 39

Cajun/Creole
Two Boots, 59, **97**, 98, 125, 134

Caribbean
Café Con Leche, 144
Island Roti Shop & Bakery, 216
Ivo & Lulu, 29
Momme Marcy's Place, Inc., 219
Sisters Caribbean Cuisine, 155

Cart or Stand or Misc.
Chinatown Ice Cream Factory, 193
Cho Dang Gol, 126
Crepe Café, 27
Dash Dogs, 5
Halal Cart, 116
Halal Chicken and Gyro, 115
Halal Food, 116
Halal Vendor, 115
Just Salad, 117
Kwik Cart, 115
Moe's Falafel, 105
Peanut Butter & Co., 70
Pretzel, Hot Dog, and Sausage Cart, 123
Rafiqi's Halal Carts, 115
Randazzo's Seafood, 162 (Clam Cart)
Sammy's Halal, 115

Chinese
Dumpling House, 6
Excellent Dumpling House, 7
Fried Dumpling, 8
Golden Unicorn, 9
Gourmet Wok, 127
Hop Kee Restaurant, 10 (Cantonese)
Home's Kitchen, 105 (Some vegetarian dishes)
Joe's Shanghai, **12**, 130, 176
May May Chinese Gourmet and Bakery, 136
Mei-Ju Vege Gourmet, 14 (Vegetarian)
New Green Bo, 16
Peking Duck Forest, 179
Sweet-N-Tart, **21**, 180

Tiengarden Vegan and Natural Kitchen, 58 (Chinese Vegan)
Wo-Hop Restaurant, 22

Coffee Shop
Café Lalo, 144
Grey Dog Coffee, 45, **87**
Purity Diner, 203
The Flame Restaurant, 148
The Pratt Coffee Shop, 190

Crêpes
Rue Des Crepes, 92

Cuban
Café Habana, 4, **25**
Habana Outpost, **187**, 188

Czech
Bohemian Hall & Beer Garden, 171

Deli
Calabria Pork Store, 162
Casa Della Mozzarella, 162
Cevabdzinica Sarajevo, 174 (Bosnian Deli)
Katz's Delicatessen, **13**, 142
M & O Grocery & Imported & Domestic Products, 32
Sal, Kris, & Charlie Deli, 179

Desserts
Chinatown Ice Cream Factory, 193
De Lillo Pastry Shop, 162
Edy's, 161 (Ice Cream Parlor)
Hungarian Pastry Shop, **149**, 193
il laboratorio del gelato, 193
Junior's, 192
Max Brenner, 193 (Chocolate Specialties
Pinkberry, 92, **132**, 139
Rice to Riches, 193 (Rice Puddings)

Diner
Austin House, 166
Blue Sea Café, 171 (will deliver)
Eisenberg's Sandwich Shop, 102
Last Stop Café, 176
Neptune Diner, 178
Tibbett Diner, 164
Viva El Mariachi, 181

CATEGORY INDEX

Dive Bar
Abbey Pub, 140
Ace Bar, 126
Double Down Saloon, 126
Patriot Saloon, 126
The Back Fence, 126

Dominican
El Castillo de Jagua Restaurant, 41
El Rey de la Caridad Restaurant, 146

Eastern European
Bohemian Hall & Beer Garden, 171
Little Veselka, 50, **59**
Veselka, 59

Eclectic/International
Knife and Fork, 3
Pommes Frites, 54 (fries)
The Spotted Pig, 94 (European restaurant/pub)

Empanadas
Caracas Arepas Bar, 168
Empanada Mama, 168
Empanadas del Parque, 167
Gauchas, 138
Gauchas Empanadas, 168
La Fusta, 167
Lemon Ice King of Corona, 168Ruben's Empanadas, 168
Ruben's Empanadas, 168

Eritrean
Massawa Restaurant, 152

Ethiopian
Awash Ethiopian Restaurant, 141
Massawa Restaurant, 152
Meskerem, **69**, 132

European Fast Food
F & B, **86**, 142
Vol de Nuit, 73 (Belgian Beer and Frites)

Filipino
Banao, 160 (buffet)
Elvie's Turo-Turo, 42

French
Chez Brigitte, 82
Chez Lola, 185
Chez Oskar, 186
L'Ecole, 3
Once Upon A Tart, 33 (Bakery)
Pink Pony, 17
Rene Pujol, 3

German
Lederhosen, 89

Greek
Café Bar, 173
Go-Go Souvlaki King, 216
Neptune Diner, 178
Uncle George's Greek Tavern, 180
Zygos (Libra) Taverna, 181

"Green" Food Products
Apellation Wine & Spirits
Blue Hill, 189 (eggs)
Franny's, 188 (Brooklyn Pizzeria)
Habana Outpost, **187**, 188 (Cuban restaurant)
Ici, 189 (Nouveau American, American Bistro)
Ronnybrook Milk Bar, 189

Guyanese
Sisters Caribbean Cuisine, 155

Hallal Food
Halal Cart, 116
Halal Chicken and Gyro, 115
Halal Food, 116
Kwik Cart, 115
Halal Vendor, 115
Rafiqi's Halal Carts, 115
Sammy's Halal, 115

Hot Dog
Better Burger, 142
Dawgs on Park, 142
F & B, **86**, 142
Gray's Papaya, 142
Katz's Delicatessen, **13**, 142
Old Town, **106**, 142
Papaya King, 142

Indian
Baluchi's Indian Food, 170
Bread Bar at Tabla, 111Hampton

CATEGORY INDEX

Chutney Co., 29
Jackson Diner, 175
Karahi Indian Cuisine, 30
Kalustyan's, 118
Panna II Garden Indian Restaurant, 52

Irish Pub
St. Dymphna's, 57

Italian (see also Pizzeria)
Caffe Reggio, 64 (Italian cafe)
Centovini, 26
Cevabdzinica Sarajevo, 174
Frank Restaurant, 44, **49**
Franny's, 188, **201**
Frutti di Mare, 44
'Ino, 88
'Inoteca, 4, **88**
Gino's Focacceria, 211
Joe's of Avenue U, 212
Lil' Frankie's, 49
Max, 50
Max Caffe, 150 (Italian American food, European coffee house atmosphere)
Nunzio's Pizzeria, 219
Primitivo Osteria, 3
Quartino Bottega Organica, 55 (Organic Italian)
Vinny Vincenz, 109

Jamaican
Christie's Jamaican Patties, 200
Chumley's, 76
Little Bit of Jam, 163
Tremes Jamaican Restaurant and Bakery, 157
Veggie Castle, 209 (Jamaican-Vegan)

Japanese
Cube 63, **5**, 184
Blue Ribbon Sushi, 25
Geido, 202
Gyu-Kaku, **45**, 117 (Japanese steakhouse)
Haru Japanese Restaurant, 105, 117, **128**, 138, 139, 149
Kenka, 47 (sushi)
Mishima, 121
Momofuku Noodle Bar, 51
Soba-ya, 56
Sushisamba, 25, 58, **95**
Temple in the Village, 71 (Korean Japanese vegetarian buffet)
Yakitori-Taisho, 61

Jewish
B & H Dairy Restaurant, 36

Knishes
Yonah Schimmel Knishery, 136

Kosher Pickles
Guss's Pickles, 136

Kosher
B & H Dairy Restaurant, 36
Ess-a-Bagel, 104

Kosher Items Available
Café Viva, 101
H & H Bagels, 104
Viva Herbal, 60 (organic/vegan/kosher pizzas)

Korean
Cho Dang Gol, 126
Temple in the Village, 71 (Korean Japanese vegetarian buffet)
Woorijip, 134

Latin American
Caracas Arepas Bar, 168
Fatty's Café, 174
Sucelt Coffee Shop, 94

Lounge
Bubble Lounge, 24
Buddha Bar, 80
Divine Bar West, 112
Lenox Lounge, 77
Mustang Grill and Tequila Lounge, 139 (Tex-Mex)
Pravda, 34 (Russian Lounge)
Tea Lounge, 207
Soda Bar and Lounge, 205
The Stanton Social, 19
Verlaine, 11, **22** (Vietnamese lounge)

Mediterranean
Café Medina, 100
Kalustyan's, 118

Mexican
Blockheads, 2, 11, **111**, 125, 137
Burritoville, 2, 4, 39, **81**, 100, 125, 138, 144

238

CATEGORY INDEX

Cosmic Cantina, 102
La Paloma Burritos, 130
Los Amigos, 176
Los Lobos, 218
Lupe's East L.A. Kitchen, 31
Park Slope Taqueria, 203
Rachel's Taqueria, 204
Rocking Horse Mexican Café, 39
Tortilla Flats, 96
Uncle Moe's Burrito & Taco Shop, **109**, 207
Viva El Mariachi, 181 (Diner)

Middle Eastern

Bread and Olive, **2**, 39, 125
Chickpea, **40**, 125
Hummus Place, **46**, 88, 149
Jerusalem Restaurant, 150
Mamoun's Falafel, 52, **68**
Moustache, 91
Rainbow Falafel, 107
Sahara, 212
Taim, 96
Yatagan Kebab House, 75

Pan-Asian

212 Restaurant & Bar, 135 (Pan Euro/Asian Neighborhood Bar)
Chino's, 40
Chow Bar, 83
Kuma Inn, 14
Mandoo Bar, 131 (Dumpling House)
Republic, 108
Rice, 92, 108, **191**
Todai, 133 (Buffet)

Pizzeria

Alba Pizza, 166
Buttermilk, 199 (Bar, no food except free pizza Wednesdays)
Café Viva, 101
Di Fara Pizzeria, 186
DeMarco's, 65 (Take-out)
Famous Famiglia, 86, 87, 104, 138, **147**, 152
Franny's , 188
Joe's Pizza, **68**, 88
Little Bit of Jam, 163 (Jamaican Pizzeria)
Nick's Pizza, 178
Nunzio's Pizzeria, 219
Pizza Booth, 70
Rosario's Pizza, 136 (& Fried Rice Balls)
Slice of Harlem, 156
Two Boots, 59, **97**, 98, 125, 134 (Cajun/Creole/pizza)
Viva Herbal, 60 (organic/vegan/kosher pizzas)

Pub (American)/Bar & Grill/Restaurant/Bar

Essex, 6

Russian

Pravda, 34 (Russian Lounge)

Sandwich Shop

Brennan and Carr, 209
Pret A Manger, 4, 92, **122**
Soup and Smoothie Heaven, **133**, 136
'Wichcraft, 22, **74**, 98, 110, 134

Seafood

Docks Oyster Bar and Seafood Grill, **113**, 146

Southern American/Soul Food

Annie's, 137
Blue Smoke, 153
Brother Jimmy's, 143
Daisy May's BBQ USA, 153
Dinosaur, **151**, 154
Dirty Bird To Go, 84
Lenox Lounge, 77
Manna's Soul Food Restaurant, 91, 152 Old Devil Moon, 39
Sam's Soul Food Restaurant & Bar, 163
Sisters Caribbean Cuisine, 155
The Smoke Joint, 154

Spanish

Sala, **56**, 93
Xunta, 62

Sports Bar

Brother Jimmy's, 143
Floyd NY, 195
200 Fifth, 196

Sushi

Blue Ribbon Sushi, 25
Haru Japanese Restaurant, 105, 117, **128**, 138, 139, 149

239

CATEGORY INDEX

Kenka, 47
Mishima, 121
Soba-ya, 56
Sushi Excellent, 185
Sushisamba, 25, 58, **95**

Syrian
Jerusalem Restaurant, 150

Sri Lankan
Lakruwana, 131, **217**

Tea House
Podunk, 53
Tea Lounge, 207

Thai
Holy Basil, 46
Jaiya, **118**, 175
Joya, 203
Klong, 11, **48**
Lovely Day, 30
Song, 206
Spice, 57, **93**
Sticky Rice, 20

Trinidadian
Island Roti Shop & Bakery, 216
Sisters Caribbean Cuisine, 155

Turkish
Yatagan Kebab House, 75

Ukrainian
Yatagan Kebab House, 75

Vegetarian/Vegan
Babycakes, 37
B & H Dairy Restaurant, 36
Mei-Ju Vege Gourmet, 14 (Chinese)
Temple in the Village, 71 (Korean Japanese vegetarian buffet)
Tiengarden Vegan and Natural Kitchen, 58 (Chinese Vegan)
Veggie Castle, 209 (Jamaican-Vegan)

Vegetarian Selections Available
Awash Ethiopian Restaurant, 141
Banao, 160
Blockheads, 2, 11, **111**, 125, 137 (Mexican)
Café Bar, 173
Café Medina, 100
Café Viva, 101
Edy's, 161 (Soup Shop & Ice Cream Parlor)
Good Enough To Eat, 148
Home's Kitchen, 105
Island Burgers and Shakes, 129
Little Bit of Jam, 163 (Jamaican Pizzeria)
Jerusalem Restaurant, 150
Just Salad, 117
Kalustyan's, 118
May May Chinese Gourmet and Bakery, 136
Manapaty Milant Corp., 120 (Gourmet Take-out)
Rachel's Taqueria, 204
Rainbow Falafel, 107
Rue Des Crepes, 92
Soup and Smoothie Heaven, **133**, 136
Tortilla Flats, 96
Veselka, 59
Viva Herbal, 60 (organic/vegan/kosher pizzas)

Venezuelan
El Cocotero, 85
Flor's Kitchen, 43

Vietnamese
Lannam, 119
New Pasteur, 15
Pho Bang Restaurant, 17
Verlaine, 11, **22** (Vietnamese lounge)

West Indian
Island Roti Shop & Bakery, 216
Momme Marcy's Place, Inc., 219

Wine Bar
Centovini, 26
Ini Ani Espresso & Wine Bar, 10
Tea Lounge, 207

CONTRIBUTORS

Ryan Auer is a contributing editor for the Bloomsbury Review and an affiliate of the Damaris Rowland Literary Agency. At the time of this writing, he was living in Brooklyn with his soon-to-be fiancée, dreaming about owning two pugs (so they can play with each other), and cogitating on the value of a Masters degree in journalism. Ryan graduated from Boston College in 2004 with a degree in philosophy.

Charles Battle is a writer, editor, musician, and displaced Southerner living in Greenwich Village. He holds liberal arts degrees from the University of North Carolina at Chapel Hill and Boston University, so he can tell you where to find a good meal for under $5.

Dynasty Blackburn doesn't care what you think.

Tom Brennan is a writer in New York.

Samantha Charlip is a writer and devoted gourmand living in Williamsburg, Brooklyn. Her writing has been published in The SN Review and Academic Journal of Film & Media. She is always looking for work that involves free food.

Alexandra Collins, originally from Maine, lives in New York City and currently works at ELLE Decor magazine after having been with Vogue for almost two years. She also contributes to City Magazine.

Brian Crandall is a writer in New York.

Tracey David presently spends her time in a myriad of fields, each one having nothing to do with the other. She works for the NIH in Vaccine Research, does freelance wedding planning, volunteers at a local art gallery, and serves as a local travel agent to most who know her. However, her one true passion is simple: food and drink!

Mike Dooly is no longer a resident of the greatest city in the universe, but vows to return someday, as not only has his heart been left there, his stomach has as well. Somehow, Mike is becoming a functioning and responsible member of society in Seattle, where people at crosswalks wait for the light to change before crossing the street and only use their car horns occasionally. What a bunch of freaks.

Jane Elias is a freelance copy editor who often finds herself both hungry and thirsty. She earned her MFA in creative writing from NYU and still continues to search for practicable ways to put her undergraduate English degree to work. She lives in Brooklyn, NY.

Brett Estwanik is a writer in New York.

Stephanie Hagopian has been an avid "foodie" since she hit the streets of New York and she enjoys spreading her love of tasty nourishment and potent potables to all who are willing to listen. A tight budget coupled with exorbitant Manhattan rent frequently combats her fervent love for the social scene, but she's developed a keen ability to sniff out those amazing deals that have somehow managed to survive on the island.

Marnie Hanel is a writer in New York City. When she waitressed, customers with laptops and bottomless coffee cups annoyed her. Now, she is one of them.

Graham Harrelson is a twenty-something sports marketing professional living in New York City. She's a southern belle by trade and proud to be a true Tar Heel (as in North Carolina) fan.

CONTRIBUTORS

Mary Higgins is a writer in New York.

Emily Isovitsch works as an award show manager in New York. A native of Atlanta and a lover of southern food, she spends her nights trying to work her way through the New York restaurant scene. So far it's been pretty good for her.

Alicia Kachmar is a teacher-turned-freelancer, lending her talents to the worlds of writing, designing, and crafting. In her spare time she enjoys baking cookies, crocheting sea creatures, listening to the wise words of children, biking in Brooklyn, cooking vegetarian food, and reading library books. She is currently researching how to turn these all into a high-paying gig with benefits.

Growing up in suburbia, **Alexa Kurzius** moved to New York City for its restaurants and bars. And for a job. In between her demanding schedule on the social circuit, Alexa works as an editor at an advertising agency. Her favorite color is yellow.

Jessica Lapham is currently pursuing a B.A. in communication at the University of Southern California. Having spent the past two summers working, exploring, and tasting New York City, she hopes to return after graduation and make a career out of it.

Laura Lee Mattingly is a book editor living in the East Village.

Eddie McNamara is a freelance writer and reigning "world's greatest sideburns" champion.

Kashlin Michaels is a writer in New York.

Sara Popovich, a graduate of the University of North Carolina at Chapel Hill (go Tar Heels!), currently attends Brooklyn Law School and will graduate in June of 2008, after which she plans to practice Immigration Law in New York City. Though romantically involved with the editor of this book, she unfortunately received no special treatment when it came to deadlines.

Emily Roberts likes to eat and drink tasty things. She also likes to read and write. She dislikes being called a "hip librarian," even though she is a librarian and she does have tattoos. She also dislikes it when people refer to her husband as a "guybrarian," even though he is both a guy and a librarian. She and her guybrarian husband live in Fort Greene.

Pamela Schultz is an attorney in Manhattan. A transplant from the South, she appreciates tasty food with a bite; you'll never hear her claim anything is too spicy. She lives with her dog, Wags, and occasionally blogs undercover.

Jen Sotham is a freelance writer and New York native, who currently teaches English in Busan, South Korea. Jen's words have appeared in New York Resident, The Citizen Travel Guides, and iToors travel podcasts; she was also a core food writer for LIC Ins&Outs. When she's not writing, teaching, or playing guitar, she can usually be found with a mouthful of kimchi.

Mina Stone is a resident of Fort Greener, private chef, and fashion designer. Food obsessed and proud of it!

Jennifer Treuting works as a freelance writer and filmmaker. Her work has appeared in festivals around the country, including the E. Vil Film

CONTRIBUTORS

Fest of New York City, San Diego's International Children's Film Festival, and the ION Festival in Los Angeles. She lives in Brooklyn and wishes she had a pet.

Emily Tsiang. Always hungry and always exploring. Passionate about cities, food, and the environment, she supports her gastro-travel addiction by working as an urban economic development specialist for the City of New York. When not frolicking around the world, Emily can be found biking around her fabulous Fort Greene neighborhood in Brooklyn. Check out emilytsiang.com.

Sarah Turcotte is an associate editor at ESPN The Magazine. She's also a frequent contributor to several travel and lifestyle publications. Technically, she lives in New York, but she's never there.

Born and raised in the South, **Jessica Tzerman** currently lives in Manhattan and works for a magazine.

Aly Walansky is a writer and editor who passes the time between deadlines eating out too much, happy hour jumping, and raising a ruckus in the indie rock scene. She lives in New York City with her two dogs and three cats—living the American dream of domestic overcrowding—and blogs daily about her bizarre antics at http://sheknows.com/blogs/alytude/. Her work can be found in FHM, HOOTERS Magazine, High Times, INKED, OK!, The Knot, BizBash, and many other publications.

Camilla Warner couldn't be happier discovering bars and restaurants all over the world. Her food journalism has been published in multiple newspapers. She is probably seeking out a Hungry?- or Thirsty?-worthy spot at this very moment.

Ben Wieder has lived in three of New York's five boroughs. Staten Island wasn't one of them.

We at the Hungry? City Guides love to find a great value eatery or meet a friend at that little-known bistro down the alley and behind the theater. That's why we created our Guides, to share the little dining and drinking secrets that the locals don't want you to know.

Unfortunately, discovering a fun new spot to eat is far from the minds of many Americans. A 2006 study found over 25 million Americans reported that they didn't have the resources to consistently put food on the table.*

The good news is there's a lot you can do to help. Whether it's time, money, or food donations, you can make a difference. Here are a few organizations we like:

New York City Coalition Against Hunger
www.nyccah.org

Hunger Action Network of New York State
www.hungeractionnys.org

The Food Bank for New York City
www.foodbanknyc.com

Robin Hood Foundation
www.robinhood.org

As you explore the world of eating in New York City, please remember those who are still hungry.

HUNGRY? CITY GUIDES

Eat Well. Be Cool. Do Good.

*www.hungerinamerica.org